WHAT'S GOING ON?

WHAT'S GOING ON?

CALIFORNIA AND THE VIETNAM ERA

Marcia A. Eymann and Charles Wollenberg, Editors

Diane Curry, Photograph Editor

OAKLAND MUSEUM OF CALIFORNIA

UNIVERSITY OF CALIFORNIA PRESS

BERKELEY LOS ANGELES LONDON

OAKLAND MUSEUM OF CALIFORNIA
Oakland, California

UNIVERSITY OF CALIFORNIA PRESS
Berkeley and Los Angeles, California

UNIVERSITY OF CALIFORNIA PRESS, LTD.
London, England

Library of Congress Cataloging-in-Publication Data

What's going on? : California and the Vietnam era / Marcia A. Eymann and
Charles Wollenberg, editors ; Diane Curry, photograph editor
 p. cm.
 Based on the Oakland Museum of California's exhibition demonstrating California's significant
role during the Vietnam era.
 Includes bibliographical references and index.
 ISBN 0-520-24243-2 (cloth : alk. paper).—ISBN 0-520-24244-0 (pbk. : alk. paper)
 1. Vietnamese Conflict, 1961–1975—California. 2. Vietnamese Conflict, 1961–1975—Social
aspects. 3. Vietnamese Conflict, 1961–1975—Influence. 4. California—History—1950–.
5. California—Social conditions—20th century. 6. Social movements— California—History—
20th century. I. Eymann, Marcia. II. Wollenberg, Charles. III. Oakland Museum of California.

F866.2.W48 2004
959.704—dc22 2004006308

Manufactured in Canada

13 12 11 10 09 08 07 06 05 04
10 9 8 7 6 5 4 3 2 1

OPPOSITE: photograph by Steve Shames/Polaris

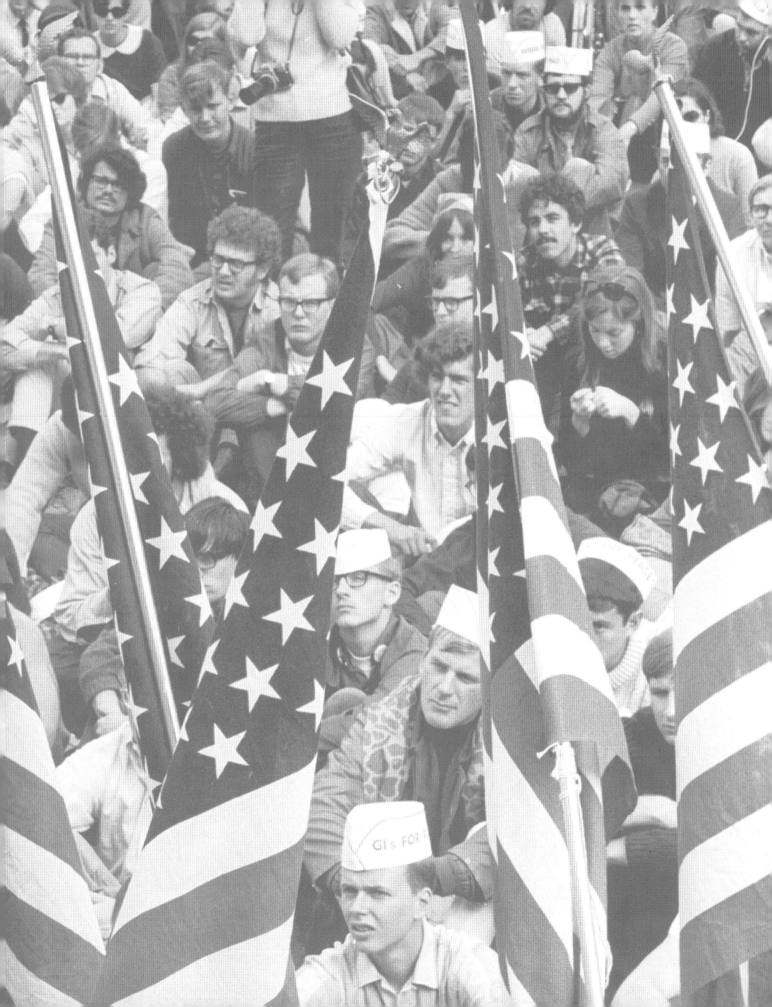

CONTENTS

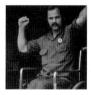

ACKNOWLEDGMENTS

This book and the exhibition of the same name have been made possible through generous support from the Oakland Museum Women's Board, the National Endowment for the Humanities, The James Irvine Foundation, The Clorox Company Foundation, and The Rockefeller Foundation.

In addition, we would like to acknowledge the wonderful work done by our photograph editor, Diane Curry, who has worked tirelessly on the book. A project of this scale could not be done without diligent researchers. Stacey Zwald, Maureen Fessler, Aimee Klask, and Rebecca Cohen have all assisted providing new documentation for this important era. Gordon Chun, our book designer, has, as always, made the entire publishing process go much more smoothly. Our editor at the University of California Press, Monica McCormick, has been a pleasure to work with, and we thank her for her help.

It is impossible to thank enough the museum's grants writer, Jerry Daviee. Jerry is a gifted writer and has believed in this project and provided tremendous moral support over the last four years. We also acknowledge the role of Dennis Power, the Museum's Director, whose enthusiasm and belief in this exhibition and book were key ingredients to making both projects possible.

It is important to thank all of the individuals who allowed us to come into their homes and interview them. It was a great leap of faith to trust, in some cases, total strangers and to recount very personal and emotional stories. Such openness has enabled us to expand beyond existing scholarship and reexamine the period from multiple perspectives. We also want to thank John Baky at LaSalle University and Anne Frank at the Southeast Asian Archive at the University of California, Irvine. Their Vietnam collections have been a tremendous resource for our research and documentation.

We wish to thank the authors for their hard work and dedication to this book. We hope that it will serve as a beginning for other publications to examine the period from multiple points of view. Last of all, I want to thank my husband, Steve Chaikin, for his patience during the work on the book and exhibition.

Marcia A. Eymann

ABBREVIATIONS AND TERMS

ACLU—American Civil Liberties Union

AFB—Air Force Base

AFL·CIO—the American Federation of Labor-Congress of Industrial Organizations

AGENT ORANGE—Plant defoliant used on the jungles of Vietnam, later found to have caused serious health problems for those in contact with it.

AMD—Advanced Micro Devices

ARPA—Advance Research Projects Agency

ARPANET—Advanced Research Projects Agency Network, of the U.S. Department of Defense; the global Internet's progenitor

ARVN—Army of the Republic of Vietnam

AWOL—Absent Without Leave

BTA—Business Technology Association

CDC—California Democratic Council

CHOPPER—helicopter

CIA—Central Intelligence Agency

COIN—COunter INsurgent Aircraft

CORE—Congress of Racial Equality

COYOTE—Call Off Your Old Tired Ethics

DES—Diethylstilbestrol, a synthetic estrogen drug that was given to millions of pregnant women primarily from 1938 to 1971. Use of DES during pregnancy was thought to prevent miscarriage and ensure a healthy pregnancy, but in fact it amplified health risks to both mother and child.

DMZ—demilitarized zone

DUST·OFF—Medical evacuation using a helicopter, which creates a lot of dust.

EEUU—Estados Unidos—Spanish for United States

FBI—Federal Bureau of Investigation

FNG—Fucking New Guy

FREEDOM BIRD—Nickname for the airplane that brought soldiers home.

FRIENDLY FIRE—A euphemism for air, artillery, or small arms fire from American forces mistakenly directed at American positions.

FSM—Free Speech Movement

FTA—Free the Army, or Fuck the Army

GE—General Electric

GI BILL—Provides up to thirty-six months of education benefits for college, business, technical, or vocational courses; correspondence courses; apprenticeship/job training; and flight training.

GPA—grade point average

LAPD—Los Angeles Police Department

LAWS—light antitank weapons

LULAC—League of Latin American Citizens

MBA—Master of Business Administration

MCAS—Marine Corps Air Station

MDM—Movement for a Democratic Military

MIA—Missing in Action

MIT—Massachusetts Institute of Technology

MPC—military payment certificates

NCO—Noncommissioned Officer

NOW—National Organization of Women

NSC—National Security Council

NVA—North Vietnamese Army

N-VAC—Nonviolent Action Committee

NWHP—National Women's History Project

OWL—Older Women's Liberation

PAC—Peace Action Council

POW—Prisoner of War

PRC—People's Republic of China

PTSD—Post-Traumatic Stress Disorder

R&D—research and development

R&R—Rest and Relaxation

RAND—Research and Development Corporation

REMF—Rear Echelon Mother Fucker

ROTC—Reserve Officers' Training Corps

SAG—Screen Actors Guild

SANE—Committee for a Sane Nuclear Policy

SDS—Students for a Democratic Society

SHORT-TIMER—individual with little time left on tour

SLANT—Self-Leadership for ALL Nationalities Today

SLATE—leftist student political organization in the late 1950s

SLICK—helicopter used to lift troops or cargo with only protective armaments systems

SMC—Spring Mobilization Committee, later known as Student Mobilization Committee

SNAFU—situation normal all fucked up

SNCC—Student Nonviolent Coordinating Committee

SOS—Stop Our Ships

SRV—Socialist Republic of Vietnam

TRW—Technology Company, auto industry, auto safety

UAW—United Auto Workers

UCLA—University of California, Los Angeles

UFW—United Farm Workers

US ORGANIZATION—Organization developed after the Watts Riots to promote the black community and understanding of its roots.

VC—Viet Cong

VDC—Vietnam Day Committee

VISTA—Volunteers in Service to America, part of the AmeriCorps national network of service programs

VVAW—Vietnam Veterans Against the War

VW BUG—Volkswagen Bug, German car

WILPF—Women's International League for Peace and Freedom

WLM—Women's Liberation Movement

YAF—Young Americans for Freedom

YSA—Young Socialist Alliance

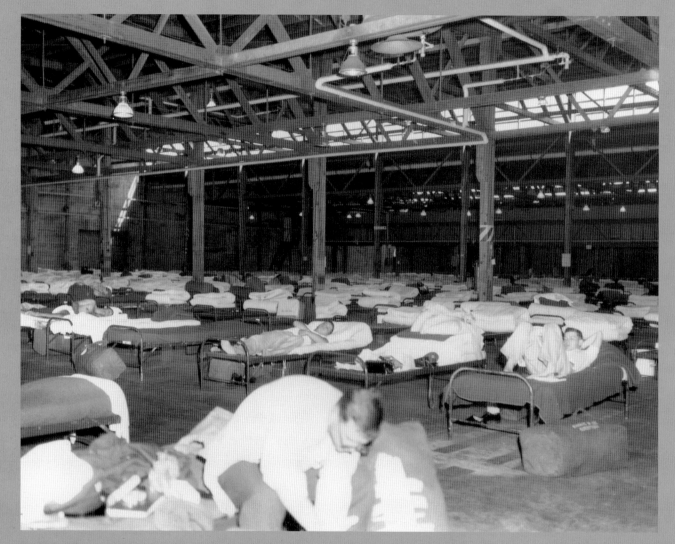

Building 590 at the Oakland Army Base filled with cots used for overnight billeting by soldiers on their way to Vietnam, 1967. This is the building that now houses the museum's collection storage.

INTRODUCTION

What's Going On?

California always has been a social laboratory and harbinger for the nation. What happens in the most populous (and diverse) state reverberates throughout the United States. No time was this more the case than during the late 1960s and early 1970s. . . .

—Kiron K. Skinner, Annelise Anderson, and Martin Anderson, *Reagan: A Life in Letters*, 2003

Marcia A. Eymann

IN 1990 I arrived in California from the Midwest seeing the state for the first time. I had moved to California to take the job of curator of photography in the History Department of the Oakland Museum of California. As part of my orientation to the museum I was given a tour of our collections facility, located on the then-active Oakland Army Base. After passing through a military guard station, we entered the grounds of the base. As we drove to our destination, we passed countless structures that reminded me of scenes from Hollywood World War II films with their classic 1940s military architecture. I have to admit a level of sheer pleasure as I imagined myself a part of one of these films, realizing that this base would not have looked much different in 1945 than it did in 1990. As we approached the collections facility, we parked in front of a set of padlocked wooden double doors, with a sign above it reading 22. Upon entering the building I was transported mentally to another movie (after all I was in California, the land of movies), this time the final scene of *Raiders of the Lost Ark,* showing aisle after aisle of shelving units holding a wide range of museum objects. This was a huge cavernous building with sheet metal roofing above

exposed, large wooden trusses that creaked and moaned to their own rhythm as we walked its bare concrete floor. It was cold and damp, more haunting than welcoming. As I toured down the artifact aisles, familiarizing myself with the range of the museum's collections, I could not help but notice the rather primitive signage attached to support beams and hanging from the trusses reading: "DO NOT LAY ON BED WITH FOOT GEAR ON," and "Thru This Door To Bay 4 Latrine," and finally "NO SMOKING IN BED." What was this building used for before us, I asked my colleague? She explained that during the Vietnam War troops would bunk overnight in this warehouse before being shipped overseas. "Wow, and they just left all of this stuff here?" I asked amazed. "Oh yeah, and there's more than just the signs. Check out the writing on the walls," she replied. So I did. Walking along the front wall of the building, I began reading graffiti left by soldiers in the 1960s and 1970s. Immediately what struck me was that the guys writing this were not just from California but from all across the country, and they were literally recording their last stop, after what had been for many a cross-country journey before leaving for war. These soldiers

used the walls mainly to record their names, where they were from, date of induction, and their "ETS" (estimated time of service) or, in other words, when they would return. Below Tony Earl tells you where he is from and where he is going but not when he will be back:

> "Tony Earl RVN [Republic of Vietnam] January 12, 1973, Indiana."

Others were poems demonstrating what was going through the minds of these young men and their attitudes about war:

> "Bob was here with plenty to do, Be back from NAM in '72. Left this town in '71, won't come back till my time is done."

> "If a man dies for his country, he is paying for something he will never collect."

Hundreds of markings covered the walls, giving me another view of what California was all about. I came to the Golden State with many stereotypes already implanted in my mind. Now that image of a state filled with hippies and antiwar protesters, with endless beaches and everything Hollywood, was being replaced by a new image, of scared and sometimes angry young men on their way to war leaving their mark to confirm that they were there and would return. California was a gateway to the war for hundreds of young men from all across the nation. This cold impersonal army warehouse marked the soldiers' last mainland stop on their journey to war. Their writings were the beginning of my journey in understanding a complex piece of California history, and the momentous role the state had played in events of the 1960s and 1970s.

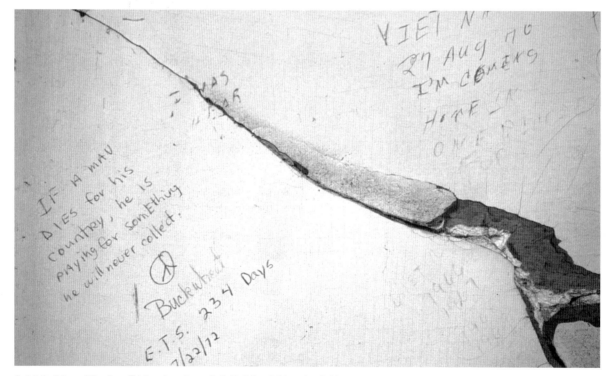

A detail of the soldiers' graffiti found on the walls in Building 590 at the Oakland Army Base.

CATHERINE BUCHANAN, PHOTOGRAPHER
OAKLAND MUSEUM OF CALIFORNIA

In 1999 I was asked to produce a small adjunct exhibit concerning the Bay Area during the Vietnam War, to bring a California focus to the touring photographic exhibition, *Requiem: By the Photographers Who Died in Vietnam and Indochina*. The museum would eventually back out of the traveling show, but in this process we realized that we had a great deal of information that merited a larger format display. A project team was formed to create an exhibition that would demonstrate California's significant role during the Vietnam era.

From the beginning everyone was aware of the sensitive nature of our topic. We understood that the topic meant working not only with living history but also with individuals for whom the wounds of war remained open. We soon discovered deeper scarring than anticipated. Thirty years was not enough time to heal. Many veterans of the era still carried trauma of the war, some bitter toward their service and treatment by the public and others continuing to suffer from Post-Traumatic Stress Disorder (PTSD). A number of veterans have felt and continue to feel that they had been stereotyped by the media as crazy or criminals. Like the veterans, some Vietnamese Americans living in California and the nation remain angry and politically charged by the loss of their homes and country, but also by the way in which they have been marginalized and dismissed by American society as a whole. Since the end of American involvement in the war in 1973 Vietnamese have been making America, and in particular California, their home but they are generally excluded from historical narratives of the war, and like the veterans, find themselves stereotyped by media. In addition to Vietnamese we could not forget refugees from Cambodia and Laos including the Hmong who fought side by side with U.S. troops against the Vietcong and also now call California

home. The range of individuals whose lives were impacted by war does not stop with veterans and refugees. Political activists, politicians, mothers, wives and the generation that has grown up since the end of the war continue to feel the effects of the Vietnam era.

This exhibition would be the first time a museum would do an in-depth historical study of how one region was changed by the Vietnam War. It provided an opportunity to look at the war from a myriad of perspectives that only exist in California and a new direction in interpreting a deeply contested and often stereotyped period in the history of the state. After discussions with scholars, veterans, former antiwar activists and Southeast Asian refugees, we decided to tell this story by allowing the voices of individuals who had lived through the time to present different perspectives and points of view. We believed that oral histories along with historical artifacts should be the interpretive thread of the exhibit, providing a range of experiences from the time demonstrating the complexity of the era. Music would play a similar role. The music in the 1960s and 1970s helped to shape people's attitudes during the war and still serves as a trigger for memory and emotions that can transport people to another time and place.

From the beginning the approach to this exhibition was the reverse of what is traditionally done in historical writing and exhibitions. Normally in conducting a project of this nature, in-depth research would first be conducted from which broad ideas and concepts developed. In the case of California and the Vietnam War we began with a series of broad statements portraying the California experience as an exaggerated version of the national experience. Due to the state's deep investment in the military-industrial complex, its importance as a center for both protest politics and conservative activism, as well as the state's identity politics, media indus-

tries, and the presence of the largest Southeast Asian refugee population in the nation, California was at the vortex of the storm created by the Vietnam War. To test the validity of our ideas the team conducted multiple interviews and read as much scholarship related to the war and California as we could locate. From there we began researching and validating our themes, the first of which related back to the graffiti at the army base. We believed that California during the Vietnam War served as a point of entry and departure for most of the troops. We also explored California as a major player in the nation's military-industrial complex. Validation came very quickly as I spoke to the official U.S. Army historian who told me that if you had been Army personnel unquestionably you would have processed through California on your way to the war or coming home from the battlefields. Indeed, between 1965 and 1968, 222,750 soldiers passed through just the Oakland Army Base alone en route to the Pacific. The graffiti had led us in the right direction, but there was more. During the Vietnam War, the Oakland Army Base was also the largest military port complex in the world. During the first eight years of the war more than 37 million tons of cargo passed through the base to and from Vietnam.

From the military we were led to the private sector. By the end of 1967, to speed up the arrival of troops and deal with the volume of soldiers who were rotating in and out of the military on one-year tours, the U.S. military began contracting with charter airlines to fly soldiers to Vietnam rather than ship by boat. One of the largest contracts was awarded to World Airways, also based in Oakland. Along with troop transport, World Airways in 1968 started Rest and Relaxation (R & R) flights for battle-weary troops from Vietnam to San Francisco, Australia, and Japan. In addition, it held the contract for the delivery of *Stars and Stripes*, the mili-

tary newspaper, to Vietnam from Japan, where it was printed. It would become famous as the airline that flew the last flight out of Da Nang at the end of the war in 1975 and as the carrier of the first airlift of Vietnamese orphans to the United States that same year.

Many other California bases and companies participated in the war effort. Through our research we were learning of California's heavy investment in the nation's military-industrial complex. By 1965 California was the leading recipient of defense dollars and had the largest number of military installations of any state.

The next phase of the project centered on the National Endowment for the Humanities (NEH). In a normal exhibition project of this size (6,000 square feet), one of the initial steps is to apply to the NEH for a planning grant. As part of this process, we placed our first conference call to our programs officer at the NEH. From earlier interviews we learned that people needed to tell their own stories of the time. So it was for our programs officer who described his experience as a marine, including his return flight from Vietnam. He knew he was home only when he finally caught sight of the Golden Gate Bridge.

The same conversation made clear that in order to receive an NEH grant we had to present a subject that was of national significance. It is easy to convince the NEH that events in Washington, D.C., or New York have national significance, but California was a much harder sell. In order to demonstrate California's importance, we argued that the tide of national events shifted in the 1960s, often moving from West to East. We had to move beyond the stereotype of California and the Bay Area, in particular, as only a bastion of liberalism and radical politics. We were going to have to break through the myth to understand the complexity of California life and politics.

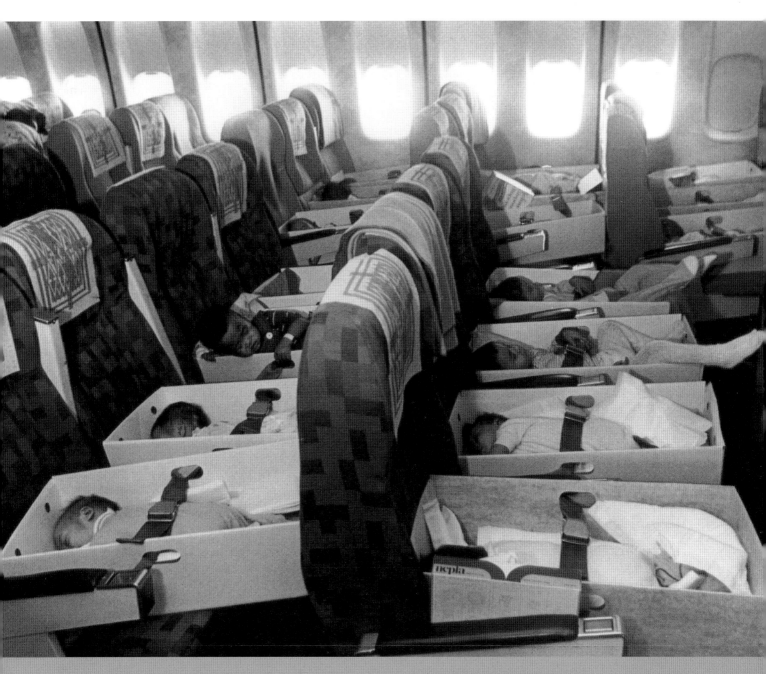

Interior of a World Airways plane during one of their flights for Operation Babylift, April 1975. For safety, the smaller children and infants were strapped into cardboard boxes donated by a local Oakland stationery store.

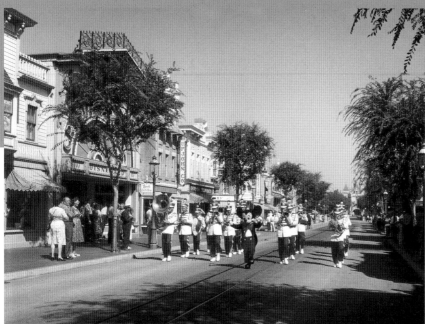

Disneyland's Main Street USA soon after opening, July 1955.

MIKE ROBERTS, PHOTOGRAPHER
OAKLAND MUSEUM OF CALIFORNIA

A diverse group of supporters at a Free Speech rally in front of Sproul Hall on the University of California, Berkeley campus, December 7, 1964.

HELEN NESTOR, PHOTOGRAPHER
OAKLAND MUSEUM OF CALIFORNIA, GIFT OF THE ARTIST

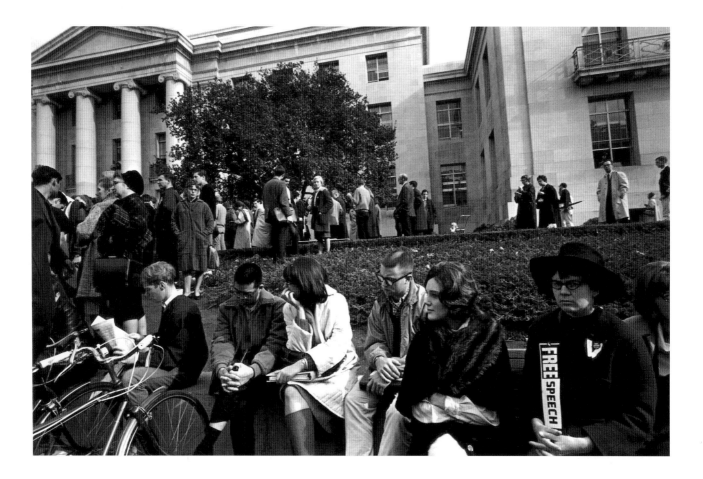

To accomplish this goal we began an analysis of California history beginning in the 1950s. California in the decades of the 1950s and 1960s, more than any other state, represented the American dream come true. In *Suburban Warriors*, Lisa McGirr writes, "No state in the nation in the mid-twentieth century represented the promises of the United States more than California." The West and, in particular, California have always been perceived as a place where an individual can literally reinvent himself or herself. It is the land of personal expression, innovation, and experimentation, providing an escape from the traditions and structure of the rest of the country. It expanded the dreams of what life could be for all Americans. In a 1945 *Life* magazine article the author predicted that the "California way of life . . . may in time influence the pattern of life in America as a whole." This prediction was to prove true as the state was flooded with new residents and postwar economic prosperity. The state projected the image of an idealized way of life with sunny weather, sandy beaches, and a suburban lifestyle. Images of Hollywood and Disneyland, and the music of the Beach Boys and Jan and Dean, became popular culture icons in the 1950s and 1960s. As the most suburbanized region in the world, California became the birthplace of national trends in fashion, music, film, and lifestyle.

By 1962 California was the most populous state in the nation and the home of a large percentage of the baby boom generation. Peaking in 1957, the baby boom continued until 1964, accounting for roughly one-third of the population at that time. In the 1960s seventeen-year-olds emerged as the largest single age group in America. They were quickly dubbed "the best and brightest," raised on patriotism, the promise of technology, and the fear of Communism and the bomb. They would swell California's educational system in the

> **No state in the nation in the mid-twentieth century represented the promises of the United States more than California.**
>
> **—Lisa McGirr**

1950s and in the 1960s, pushing it to become a national model for higher education and mecca for the youth culture of the era.

These same boomers, raised on the flag, apple pie, and duck-and-cover preparedness drills were infused with patriotism, hope for the future, and, paradoxically, social rebellion. The patriotism and optimism would carry a generation on an idealistic wave toward the New Frontiers promised by President John F. Kennedy. *Home Before Morning*, Lynda Van Devanter's 1983 biography, epitomizes this idealism when she writes, "I was part of a generation of Americans who were 'chosen' to change the world. We were sure of that." The rebellious side would lead to youthful activism focused against middle-American conformity. The Free Speech Movement on the University of California's Berkeley campus during the fall of 1964 epitomizes this rebellious activism. The student protesters initially represented a wide range of groups and clubs, including Students for a Democratic Society (SDS), Young Democrats, CORE (Congress of Racial Equality), The Independent Socialist Club, SLATE (a leftist student political organization), American Civil Liberties Union (ACLU), Women for Peace (also known as Women Strike for Peace), and the W.E.B. DuBois Club, as well as the Young Americans for Freedom (YAF), Young Republicans, and California Students for Goldwater. The activism of the boomer generation, on both the left and the right, focused on

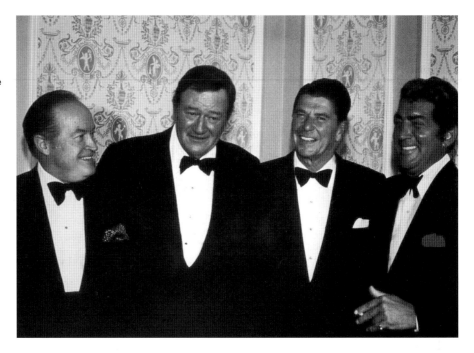

Bob Hope, John Wayne, and Dean Martin show their support for Republican nominee for governor, Ronald Reagan, during a "Californians for Reagan" event at the Ambassador Hotel in Los Angeles, 1966.

PHOTOGRAPH COURTESY OF RONALD REAGAN PRESIDENTIAL LIBRARY

resisting impersonal, bureaucratic structures—big corporations, big unions, and multiversities. The rebellion would take on greater strength and momentum as the boomer generation tackled the issues of the Vietnam War.

Raised on the cold war and educated more than any other generation, they were also the first to grow up with television. Both the television and film industries (predominantly located in California) promoted the ideology and tension of the cold war and legitimized the use of force to combat Communism. On both the small and the large screen boomers were inundated with a plethora of combat films and westerns portraying American military forces as omnipotent, all-powerful, and always right. At the same time, television served to politicize the boomers. They watched as civil rights activists were beaten and harassed by police officers in the streets in America's South. The nightly news brought these events into their homes and daily lives, pushing some young people to challenge the nation to live up to the ideals on which it was based.

Just as the antiwar movements also were composed of multiple factions and coalition groups, so too was the state as a whole. California during the era magnified the political split between conservative and liberal. The millions of Americans who migrated to the Golden State in the 1950s and 1960s to take new jobs in the defense industries settled into single-family homes, living out the American dream. In Southern California, in particular, some of these new westerners began a conservative political revolt. The migrants brought with them their wish for a new beginning and prosperity along with their American ideals as the "greatest generation" who had won World War II. Now they carried the torch of freedom and democracy for the world. Their staunch belief in the fight against Communism would lead them to campaign for Barry Goldwater in his 1964 presidential bid, and Ronald Reagan in his run for governor in 1966. As Jonathan M. Schoenwald states in *A Time for Choosing*, "If New York City in 1965 was a test case for conservative principles within and without the GOP,

California in 1966 offered a similar scenario as the gubernatorial election promised to serve as a referendum on the future of conservatism and liberalism." In that 1966 election Ronald Reagan, always a speaker who listened to his audience, took to heart the complaints he was hearing from the parents of the rebellious youth of the state. It was from these complaints that Reagan first coined his famous line of "cleaning up that mess in Berkeley," and used Middle America's reaction to the antiwar protests to win the governor's office. Reagan became the voice of the silent majority. His form of "cowboy conservatism" appealed to the American public and eventually would lead him to the White House in 1980.

California also dramatized the national split of Left and Right, "hawk vs. dove," through the personalities of Hollywood celebrities. Just as the nation split, so did Hollywood, albeit on a much higher profile level. On the right and representing the World War II generation was John Wayne, as well as other celebrities such as Bob Hope and Roy Rogers. On the left was a youthful Jane Fonda, along with Donald Sutherland, Warren Beatty, and others. This split was played out in the press and on film as Wayne's 1968 pro-war production of *The Green Berets* was counterpointed a decade later by Fonda's 1978 antiwar film, *Coming Home.* These films say as much about the nation's state of mind at the time they were made as they do about the celebrities who made them.

The significance of Jane Fonda and John Wayne became clear early in the project. Fonda was mentioned, positively or negatively wherever we went. She was one of the dominant figures to emerge from the period, partly because of her controversial nature, but also because of her Hollywood status. Wayne also came up numerous times, particularly with veterans who had been raised on his films and his portrayals of the heroic American fighting man.

The young men and women who went off to fight the war were permanently changed by what they did and saw in Vietnam. According to Vietnam veteran John Baky, "California was the Promised Land, and all of a sudden we finally got there as East Coast Boys and had to leave right away. And we weren't just leaving, look where we were going." California was their last connection with home and also the dream of what America had to hold and what they might never have the opportunity of truly experiencing.

During the war California would also be a base for antiwar activism in the military, and the state would play a major role in the veterans' movement that created Vietnam Veterans Against the War (VVAW), promoted groundbreaking treatment of PTSD and the effects of Agent Orange, and campaigned for disabled people's rights and the restructuring of the Veterans Administration. Just as these men and women had once traveled across country on their way to war, they traveled again as protesters to bring national attention to the rights of veterans of an unpopular war.

We still needed to address the Vietnamese and other war-related refugees from Southeast Asia. As with veterans, every effort was made to reach out to this community for its input. First we invited local Vietnamese American scholars and followed up with a series of community gatherings that would include both first- and second-generation Americans.

The community groups quickly let us know that we were to refer to them as refugees, not as immigrants, since they were forced to leave their homeland. California became home for the largest percentage of refugees from Vietnam, Laos, and Cambodia. Orange County in Southern California is the home of the largest Vietnamese

California was the Promised Land, and all of a sudden we finally got there as East Coast Boys and had to leave right away. And we weren't just leaving, look where we were going.

—John Baky

population outside of Vietnam, and San Jose has the largest Vietnamese community within a city's limits. The city of Long Beach has the largest population of Cambodians, and California's Central Valley is the place where many Hmong and Mien from Laos have relocated. In all of these cities and towns, strong, vibrant communities have been formed. California served as the point of entry for the refugees, and even though a large percentage were originally sponsored to move to other areas of the country, many found their way back to the Golden State. An educator who had worked in the refugee camps in Thailand told me of the trauma and struggle of the Hmong people who had fled Laos by foot into Thailand. In the camps the Hmong would talk of new beginnings with families in Fresno. Having grown up in England, the educator assumed that Fresno was a city in Thailand, and was surprised to find that Fresno was in California. The road to California was already well established by the early 1980s.

As a public institution, the Oakland Museum of California's mission is to examine the history of California and demonstrate its importance and uniqueness. As a public museum we use exhibitions and public programs to communicate this message with diverse audi-

ences. This book and the accompanying exhibition focus on how its citizen's lives were changed. The book and exhibition also examine how events in California reverberated across the nation, politically, socially, and culturally. They address the war in Southeast Asia only in the context of its impact on the lives of individuals now in the United States. We are challenging the reader and museum visitor to look at history through a new and different lens, not as seen from the battlefield but in light of direct repercussions of war in California during and after the war itself.

It is particularly difficult to discuss the Vietnam War since so many people experienced the events firsthand and are still profoundly influenced by them. There is a personal ownership of the time and what they saw and how their lives were changed. Each evening on the nightly news they saw the war unfold on their television screens and heard CBS News anchor Walter Cronkite complete his broadcast stating "And that's the way it is." And they believed that it was. Those images and experiences are still in their minds, just as the battles and losses are with veterans and refugees. Each has his or her own truth, but with this project we hope visitors will be challenged to look at that period through someone else's eyes. We must also engage a new generation that has grown up since the end of the war, whose primary source for information on the war is motion pictures and television.

Our book and exhibit have only scratched the surface of the multiple stories that could and need to be told. But what we can do is provide a beginning for Americans to understand how war transforms a society and individuals, and how that complex process of transformation continues long after the last treaty has been signed. We live today with the legacy of the Vietnam War, and as a nation we need to integrate that legacy

into our larger history. After four years of hard work and study, we hope we have contributed to that process with *What's Going On?* There are multiple themes that could have been explored in this publication, including the stories of Cambodian and Laotian immigrants, the origins of the alternative press, and the developments in music and art, but all books have a limit in size and scope. It is the editor's hope that others will continue the research and continue to examine the impact of the war on California and other regions of the nation.

This book deals with the major themes of the exhibit by going into greater depth than can be done in an exhibition format. Chapter one, by Charles Wollenberg, explains the role of California as a microcosm and magnification of the national experience. Marc Jason Gilbert's chapter provides key historical background on California's deep investment in the nation's military-industrial complex. In chapter three, Jules Tygiel provides an overview of the career of Ronald Reagan and the beginnings of his rise to power in the Golden State.

The next chapters focus on the social revolutions of the period, with R. Jeffrey Lustig analyzing the role of the antiwar movement in the state and Ruth Rosen discussing the roots of the women's movement. Clayborne Carson provides a personal account of the black power and black protest movements of the era, placing himself as student in the center of these events as they unfolded in California.

Chapter seven, by George Mariscal, explores the political movements of the Chicano/a community as related to the antiwar movement. He also tells the story of the Chicano veteran and the community's strong belief in the tradition of military service and in the conflict. John Burns in chapter eight also looks at the veteran experience, relating it directly to California. For many GIs during the war California represented "The World," and Burns discusses the role California played in a soldier's life. In chapter nine Khuyen Vu Nguyen examines the significance of memorials in processing and healing a community and the nation.

Noted Vietnam War scholar Robert D. Schulzinger summarizes the continuing legacy of the war in California, from Hollywood to the establishment of trade and diplomatic relations with Vietnam in the 1990s. In the final chapter Andrew Lam, a Vietnamese refugee himself, looks at the Vietnamese community in California today. In examining traditions and transitions of this diverse community, he provides an intimate portrait. Ben Tran's epilogue completes the book with an overview of the content emphasizing the multiple perspectives of the era.

All of the chapters work together to represent the range of stories of the era and to provide a sense of the complexity of the period and its continuing legacy.

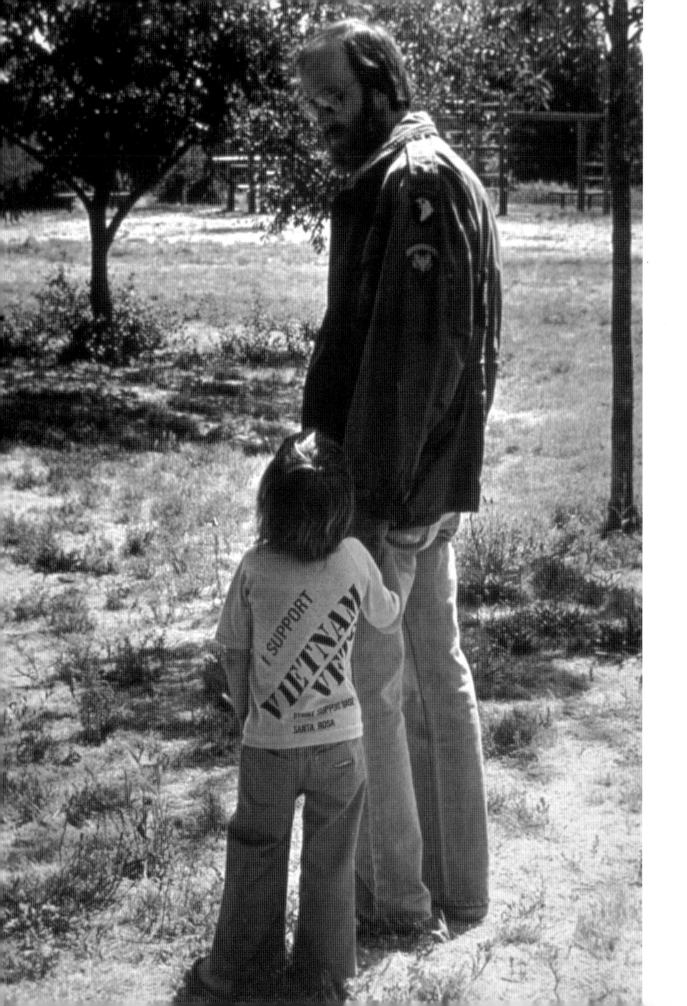

CHAPTER 1

California and the Vietnam War: Microcosm and Magnification

Charles Wollenberg

The Vietnam war stands as the sort of watershed event for American politics, foreign policy, culture, values, and economy in the 1960s that the Civil War was in the 1860s and the Great Depression was in the 1930s.

—Robert D. Schulzinger, *A Time for War: The United States and Vietnam*, 1997

IN THE MID-1960S Cherrie Olson had recently graduated from the University of Oregon and was living with three young women friends in San Francisco. "We had more freedom than any women in the U.S. ever had," she remembers. "We had mobility, looks and the pill." Olson was working as a flight attendant ("stewardesses," as they were called then) for World Airways, flying military charters between California and Vietnam. She spent weekends listening to rock groups like the Jefferson Airplane in Golden Gate Park and Crosby, Stills and Nash at the Fillmore Auditorium. She and her friends "passed joints back and forth. The air was blue with smoke. Then Monday, we left for Vietnam, putting people off on the tarmac at Ton Son Nhut air base."

She was in a San Francisco park one day, hearing Timothy Leary and Ram Dass say, "tune in, turn on and drop out," and the next day she was back in Vietnam. "It was instant. We were there, we were back, and then the next night we would watch the war on TV . . . San Francisco-Berkeley-Vietnam. You lived for the moment . . . Not many people have a front row seat watching the world change." For Cherrie Olson in the sixties, "the Vietnam War was the fulcrum," and so it was for many, perhaps most of her generation (*San Francisco Chronicle*, May 23, 1999).

Wallace Stegner believed that California is an exaggerated version of the American experience—"like the rest of the United States, only more so." This was

Vietnam veteran "Doc" Napp with his son, Shanti, at a veterans' hunger strike in Santa Rosa, California, c. 1985.

certainly true during the Vietnam War. Because of the state's location on America's Pacific shore, its concentration of military installations and industrial capacity, and its role in the development of protest politics, countercultural activities, and grass-roots conservatism, California was especially affected by the war. Events in California, transmitted nightly on the evening news, profoundly affected the rest of the nation. The state's experience was both a microcosm and a magnification of the national experience. Contemporary California, with its diverse population and social complexity, is also an ideal location for an examination of the profound effects of the Vietnam years on American life and culture.

American involvement in Vietnam stretches back to World War II, when the United States assisted Ho Chi Minh's guerrilla forces in their struggle against the Japanese occupation. After the war, however, America supported France's attempt to restore colonial authority, rather than allow Ho's Communist political movement to gain control of the country. When the French were defeated in 1954, the United States provided military and economic assistance to the Republic of Vietnam (South Vietnam) as it resisted what was then the Democratic Republic of Vietnam (North Vietnam) and its allied National Liberation Front (Vietcong). President Kennedy substantially increased American support in the early 1960s, sending in large numbers of military advisors. In 1964 Congress passed the Gulf of Tonkin Resolution, authorizing President Johnson to take direct military action. After U.S. aerial bombing failed to strengthen the South Vietnamese position, Johnson ordered regular American ground troops into Vietnam in the spring of 1965. For most Americans, this act marked the beginning of "the Vietnam War."

By 1965 California was the heartland of America's military-industrial complex, leading the nation in de-fense contracts and supporting an impressive array of military bases across the state. During World War II, Southern California's aircraft industry expanded dramatically, and in the 1950s, buoyed by cold war defense spending, it evolved into a modern aerospace-manufacturing complex. The industry expanded beyond its Southern California base, building new facilities in places like Santa Clara County, where it served as an important foundation for what was to become Silicon Valley. The state's heavy economic dependence on defense spending was supported by a strong public commitment to military readiness, patriotism, and anti-Communist politics. After 1965 this easily translated into popular support for military involvement in Vietnam. California's most successful politicians during the Vietnam era, Richard Nixon and Ronald Reagan, cut their political eyeteeth on the passionate anti-Communism of the post–World War II era.

Anti-Communist politics were also an important part of a new grass-roots conservative movement that emerged in California, particularly Orange County, in the postwar years. By the early sixties, thousands of middle-class men and women were gathering in suburban living rooms and kitchens, planning to overturn the dominant liberalism of Governor Pat Brown and Presidents Kennedy and Johnson. The new conservatives were passionately committed to an agenda that included a drastic reduction of government influence in economic and personal matters, an end to "social engineering," and a return to traditional American values. Some activists joined the John Birch Society and the Christian Anti-Communist Crusade. In 1964 California conservatives strongly supported Barry Goldwater's presidential campaign and the effort to pass Proposition 14, which overturned the state's fair housing law.

Another legacy of World War II was an important

Because of the state's location on America's Pacific shore, its concentration of military installations and industrial capacity, and its role in the development of protest politics, countercultural activities, and grassroots conservatism, California was especially affected by the war.

collection of military bases that played major roles in the Vietnam conflict. Many of the soldiers serving in Vietnam received their basic training at Fort Ord near Monterey. Marines were trained at Camp Pendleton in Southern California, naval personnel at the Navy's large installation in San Diego. Much of the air power used in Vietnam came from the Alameda Naval Air Station on San Francisco Bay and Castle and Beale Air Force bases in the Central Valley. Military supplies and ordinance flowed from the Oakland Naval Supply Center and the Concord Naval Weapons Depot. Many of the ground troops bound for Vietnam shipped out of Travis Air Field in Fairfield or the Oakland Army Base. And most personnel returned to these facilities when their tours of duty ended. For many servicemen and women from all over the United States, California was the last mainland stop on the way to Vietnam and the first mainland point of entry on the way home.

At the same time, California was a center of antiwar and countercultural activity. This was particularly true for the San Francisco Bay Area, which had a tradition of social activism that preceded the Vietnam War by many decades. In 1960 students from University of California's Berkeley campus protested against a meeting of the House Committee on Un-American Activities (HUAC) held at San Francisco City Hall. Also in the early sixties, young activists demonstrated against the discriminatory hiring practices of prominent San Francisco businesses, and local Women for Peace chapters campaigned vocally against nuclear weapons. In 1964 the Free Speech Movement exploded on the Berkeley campus. Although the protest initially concentrated on local university issues, by early 1965 Berkeley demonstrators had begun to articulate the broad critique of American society that came to be associated with the student-based New Left. The Berkeley uprising proved to be the first of a series of upheavals affecting campuses all over the United States during the late sixties. Opposition to the war was at or near the heart of most of these student movements.

One of the first large-scale protests against the war anywhere in the United States was the Vietnam Day demonstration on the Berkeley campus in May 1965. For the next five years, periodic antiwar actions occurred in Berkeley, culminating in 1970 in large and often violent protests against the invasion of Cambodia and the deaths of student demonstrators at Kent State and Jackson State Universities. Many other California campuses also experienced large demonstrations during the period, including the University of California, Santa Barbara, San Francisco State University, Stanford University, and the University of California, Los Angeles. Off-campus protests were common as well. In 1965 East Bay activists attempted to disrupt operations at the Oakland Induction Center and block troop trains by staging sit-ins on the Santa Fe railroad tracks. Antiwar marches clogged California city streets and filled public parks. One of the largest off-campus antiwar demonstrations was the Chicano Moratorium held in Los Angeles in 1970.

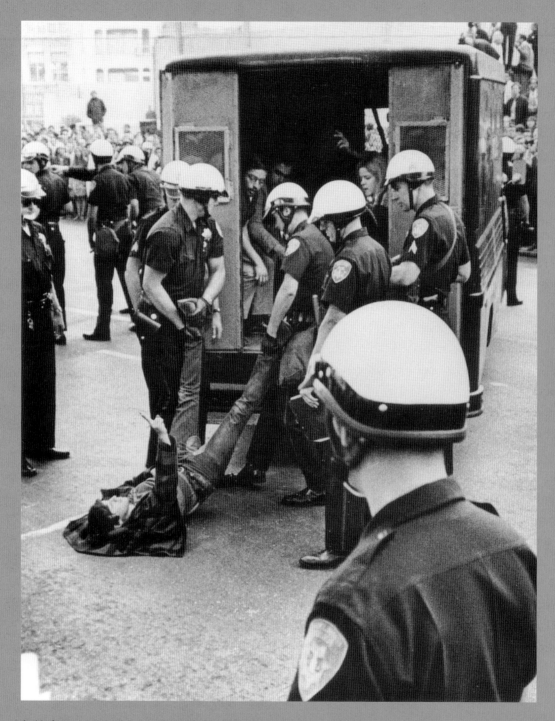

Antidraft protester practicing passive resistance while being arrested by Oakland police officers during the Stop the Draft Week protests at the Oakland Induction Center, October 1967.

The Chicano Moratorium is an example of the interaction between antiwar activity and the evolving ethnic consciousness of the sixties. In the summer of 1965, just a few months after President Johnson sent the first combat troops to Vietnam, the Watts riots swept through south central Los Angeles. It was the first in a series of great race and ethnic uprisings in American cities during the last half of the 1960s and an indication that the focus of the black protest movement was shifting from the rural South to the urban North and West. It also indicated a shift away from the movement's former commitment to nonviolence. Finally, Watts helped launch an era when assertions of ethnic identity and power became more important to many black leaders than integration into the American mainstream. In 1966 the Black Panther Party was organized in Oakland and the East Bay. Panther leaders spoke out against the war and proclaimed solidarity with "revolutionary movements" around the world. During the early years of the war, the Panthers were among the first black leaders to claim that African Americans were serving in disproportionately high number as combat troops and sustaining casualties in Vietnam.

Nineteen sixty-five was also the year of the Delano Strike in the San Joaquin Valley. The strike made César Chávez a national figure and became a rallying point for the new Chicano political movement that came of age in the sixties. Chávez's pacifism and the growing antiwar activism of young Chicano leaders were at odds with traditional Mexican American attitudes toward military service. Like many working-class youth, young Mexican Americans accepted membership in the armed forces as a rite of passage. As with blacks, Chicanos argued they were overrepresented on the combat and casualty rolls. By the time of the 1970 Chicano Moratorium, however, antiwar sentiment had become an important part of *barrio* politics in California. Opposition to the war was also part of the new Native American movement that sparked the occupation of Alcatraz Island in 1969. The war was a particularly sensitive issue for politically active Asian American youths. One Chinese American veteran remembers being ordered to stand in front of his platoon during basic training at Fort Ord. The drill sergeant told the men, "This is a gook. This is what the enemy looks like."

The antiwar effort also influenced the emerging women's liberation movement of the 1960s. While women activists enthusiastically participated in the mass protests, they sometimes criticized the gratuitous violence of their male colleagues. Women also resented being denied real power within the antiwar movement—too often their proscribed role was to prepare meals and take minutes. They sometimes reacted by forming separate all-female structures within the larger New Left coalition. By 1969 antiwar demonstrations in San Francisco and Berkeley included significant all-female contingents.

Antiwar activity was closely related to the "counterculture" movement that blossomed in California in the late sixties. By 1965 alternative lifestyles in the Haight-Ashbury were attracting national media attention and influencing people in communities from Greenwich Village to Venice, California. San Francisco bands like the Jefferson Airplane produced an "acid rock" sound that affected much of the music of the era. Southern California's vast entertainment industry communicated "sex, drugs, and rock and roll" to a broad audience and helped integrate at least a crude form of the counterculture into mainstream culture. The music of the sixties, with its often anti-establishment message and values, was a common experience shared by young troops in Vietnam and young antiwar activists at home.

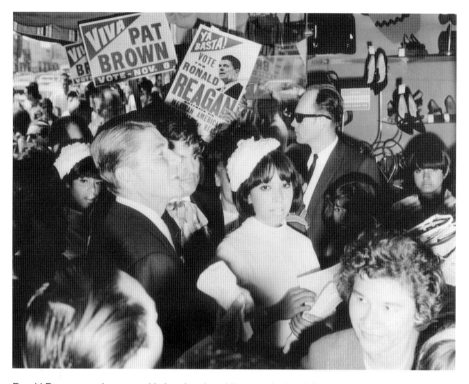

Ronald Reagan greeting a crowd in Los Angeles while campaigning during the governor's race, 1966.
LOS ANGELES TIMES COLLECTION, UCLA LIBRARY DEPARTMENT OF SPECIAL COLLECTIONS

The counterculture and political protests created a powerful backlash. In 1968 native son Richard Nixon won California's electoral votes by appealing to the patriotism of what was later called America's "silent majority." Even more important was the emergence of Ronald Reagan as the new conservative movement's most effective national advocate. When he ran for governor in 1966, Reagan won the election by defending patriotism, anti-Communism and the military, while condemning hippies and long-haired protesters. He promised "to clean up the mess in Berkeley," and during his first gubernatorial term, he twice ordered national guardsmen to occupy the University of California campus and put down mass demonstrations. As a political figure, Reagan was as much a product of California in the sixties as Ron Dellums or Mario Savio. Ultimately Reaganism, rather than New Left radicalism, turned out to be the political wave of the future for California and the nation at large.

For the first three years of the war, conservative politics helped to maintain support for the war effort, but by 1968 the broad public mood was changing. The Tet Offensive of that year was a public relations disaster for American military involvement. Although the North Vietnamese/Vietcong campaign was defeated, it signaled to the American people that the war was unlikely to end in the foreseeable future. Public opinion turned increasingly against the war, and President Johnson shocked and surprised the nation by choosing not to seek reelection. Liberal Democrats affiliated with the California Democratic Council (CDC) had long since broken with the Johnson administration. Robert Kennedy, campaigning on an antiwar platform, won the state's 1968 Democratic presidential primary, only to be

gunned down in Los Angeles's Ambassador Hotel by Sirhan Sirhan.

After taking office in 1969, President Richard Nixon sought a negotiated settlement while simultaneously widening the war. However, in 1971, facing an imminent reelection campaign, Nixon changed course, eventually supporting an end to the draft and adhering to a policy of "Vietnamization." Henceforth, the ground war would be fought by the South Vietnamese, with the United States supplying logistical and air support and continuing the heavy bombing of the north. Safely reelected but facing inquiries about Watergate, in 1973 Nixon negotiated the final cessation of American military activity and the withdrawal of remaining combat forces. Two years later, the fall of Saigon marked the end of the Republic of Vietnam and American involvement in Vietnamese affairs. The twenty-year American effort to prop up a non-Communist South Vietnam had come to an ignominious end.

With implementation of "Vietnamization" in 1971, the numbers of American servicemen and women returning to California began to exceed greatly those leaving for Vietnam. But there were few welcoming parades for the returning troops. Then and now, the country has remained decidedly ambivalent about the war, and veterans have borne a disproportionately heavy share of the nation's burden of frustration and doubt. A small but important minority of veterans has found the burden too heavy to bear and suffer deep psychological and spiritual wounds that have festered, rather than healed during the past quarter century. In California, some Vietnam veterans began what became a national movement, protesting against policies of both the federal government and traditional veterans organizations. The protests led to recognition of health problems associated with Agent Orange and Post-Traumatic Stress Disorder. Some of the former antiwar activists have also had difficulty coming back to the American mainstream. This is especially true for those who served prison terms or went into temporary exile abroad. Both veterans and former activists often share a common skepticism of authority and distrust of government. Vietnam produced a "credibility gap" that has never been completely repaired.

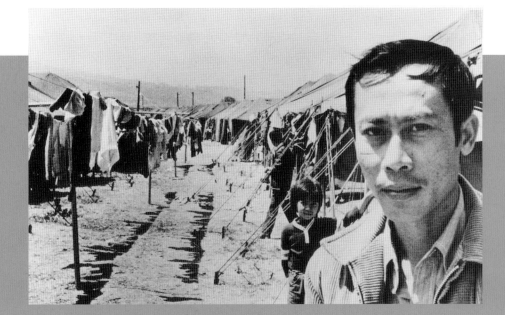

Le Tan Tranh at one of the temporary refugee camps established at Marine Corps Base Camp Pendleton, June 29, 1975. Camp Pendleton became the main West Coast reception center for the first refugees from Southeast Asia following the fall of Saigon in April 1975.

SACRAMENTO ARCHIVES AND MUSEUM COLLECTION CENTER, SACRAMENTO BEE PHOTO MORGUE COLLECTION

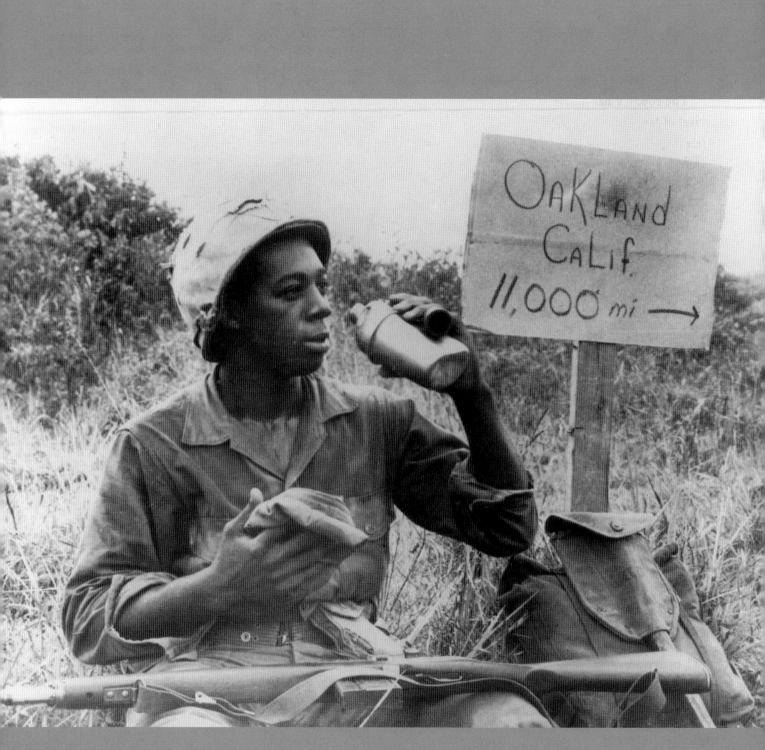

Thinking of home, Private First Class Clairborne L. Shaw of Oakland rests for a moment at Chu Lai, Vietnam, June 4, 1966.

The country has also been ambivalent about the arrival of large numbers of Southeast Asian refugees. After the fall of Saigon, the U.S. allowed thousands of former South Vietnamese government officials and military leaders to settle in America. Over the next decade, they were followed by even larger numbers of "boat people," Vietnamese of ethnic Chinese background, and Amerasian children of U.S. servicemen. America also accepted refugees from Laos and the "killing fields" of Cambodia. Although the government attempted to scatter the new refugee populations throughout the country in all fifty states, by the 1990s about half of the estimated one million people of Indochinese ancestry in the United States were living in California. Today the largest concentrations of Vietnamese outside Southeast Asia are in Orange County and Silicon Valley. The largest populations of Hmong outside the highlands of Laos and Thailand are in the central San Joaquin Valley. In the impact of refugee immigration as in so many other aspects of the Vietnam War, California was again like the rest of the nation, only very much more so.

Much of what Americans remember about the Vietnam era is based on the influence of media images. No war before or since has been so thoroughly documented by visual media—photography, cinematography, and, above all, television. TV brought images of the war's blood and guts into American living rooms and extensively covered the antiwar demonstrations, ethnic activism, and counterculture activity. Television also served as an effective platform for a new generation of media-savvy politicians, most notably Ronald Reagan. Popular movies have also provided dramatic images of

the period. Hollywood's contradictory interpretations of the war—from the flag-waving patriotism of *The Green Berets*, to the antiwar populism of *Platoon* and *Born on the Fourth of July*, to the melodramatic fantasies of *Deer Hunter* and *Apocalypse Now*—mirror the public's confusion about the meaning and purpose of the Vietnam conflict. Of course, like so much else about the Vietnam era in America, most of these movies were produced in California.

In 1975 Secretary of State Henry Kissinger declared that Americans needed "to put Vietnam behind us and concentrate on the problems of the future." That has proved far easier said than done. Former World Airways flight attendant Cherrie Olson is among the millions of Americans who were profoundly affected by a visit to the Vietnam Memorial in Washington. Standing in front of the memorial and remembering the young men she had accompanied back and forth across the Pacific, Olson realized that "I had stuffed my feelings inside. There were tears like you wouldn't believe. I'm still digesting it." Like Cherrie Olson, the nation still needs to digest the Vietnam War, not to reopen old wounds or argue old positions, but to come to terms with an important era in American history and understand its impact on contemporary American society and culture.

This can only occur through a process of sustained public inquiry, education, and discussion. There is no better place to start this process than in California, where the history and legacy of the Vietnam War remain larger than life, still another example of the state's exaggerated version of the American national experience.

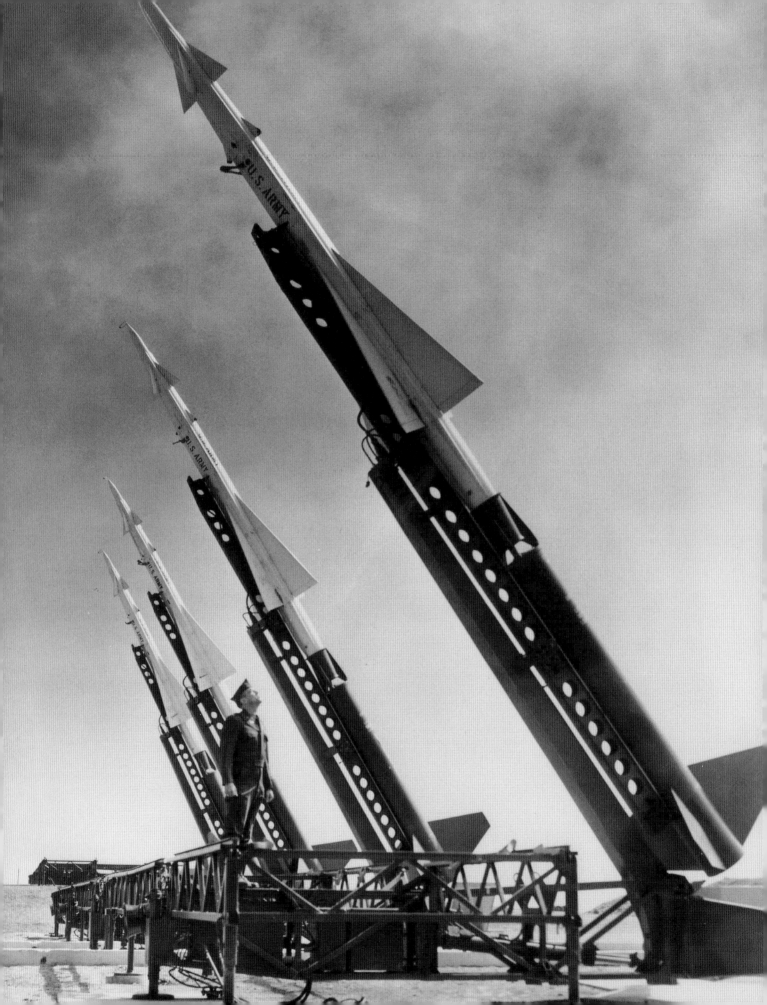

CHAPTER 2

Next Stop—Silicon Valley: The Cold War, Vietnam, and the Making of the California Economy

Marc Jason Gilbert

TO SOME CALIFORNIANS, President Eisenhower's valedictory warning about a "military-industrial complex" fostered by cold war defense-spending patterns remains a call to arms against all self-aggrandizing, elitist socio-economic orders. But to others, the term carries little pejorative meaning as those same spending patterns helped propel the state to its current rank as the world's sixth largest economy. The manner in which the cold war marked a watershed in California's economic history came as no surprise to that state's politicians, business leaders, military officials, and university administrators. Since World War I, these men and women had labored to meld the civilian and military sectors of their economy. This strategy served the state well through the Great Depression and was instrumental in the blossoming of its industries during World War II. It also produced an economy that became a leader in research and development (R & D) and capable of responding to any national industrial need, particularly aerospace engineering. It was thus perfectly suited to the production requirements of the cold war, an international competition characterized by nuclear and aerospace weaponry and the ever-expanding R & D resources such competition demanded.

Nike-Ajax guided missiles ready to go, October 1955. California defense contractor Douglas Aircraft was one of the companies involved in the missile's development.

OAKLAND TRIBUNE COLLECTION, GIFT OF ANG NEWSPAPERS, OAKLAND MUSEUM OF CALIFORNIA

As a result, most weapons closely associated with the cold war were developed in California, from the Polaris missile to the U-2, and from "smart bombs" to the Internet, which was initially devised as a means of preserving military communications after a nuclear strike. The cold war lent California's older military bases new leases on life and led to the opening of new ones to fuel local economic growth further. Between 1960 and 1970, California received twice as many defense dollars as its nearest competitors, New York and Texas, and benefited from local military payrolls that were also double that of any other state. It also attracted the lion's share of cold war era federal research and development dollars. Ultimately, California came to absorb more than 20 percent of the Department of Defense's cold war procurement expenditure. This massive federal spending, well managed by the state's private and public sectors so as to stimulate parallel growth in its agriculture and entertainment industries, helped California attain its current status as the nation's research and development capital and the possessor of an economy comparable to only a handful of nations.

Such growth did not come without a price. With the end of the cold war came retrenchment in federal spending, base closings, and reductions in Department of Defense payrolls that took the luster off California's R&D-driven national security and aerospace economic engines. This led to a beneficial further diversification of its economy, but the older cold war economy soon rose again to prominence. Since 2001 the "war on terrorism" and its attendant nuclear and biological threats have revived the very industries and economic sectors that had enjoyed unprecedented growth in the cold war era. This revival has not reached all sectors of the state's economy and seems to be perpetuating the uneven development that typifies all high technology and

"The Gateway to the Pacific," Travis Air Force Base, Fairfield, c. 1967. Travis became the busiest aerial port in the nation with the war in Vietnam, transporting thousands of tons of military equipment, supplies, and personnel to and from Southeast Asia every week.
OAKLAND MUSEUM OF CALIFORNIA

service-based industries. But California's economic culture is again poised to reap the fruits of global tension, much as its political culture deplores it.

Seen against California's larger cold war macroeconomic backdrop and its inherent cultural dissonance, the American war in Vietnam stands in high relief. Though much of the state's cold war economy was linked to broader concerns, such as the nuclear arms race and the "race for space," the economic influence of America's bitterest "brushfire war" holds a prominent place in the state's economic and cultural landscape. This is partly because California's connections to Vietnam were and remain so close. California was the traditional logistical base for the projection of American power across the Pacific and has otherwise long been involved in Asian affairs. It thus could not avoid playing a major role in any conflict there. The state's seaports and airfields were the points of departure for thousands of American soldiers bound for Vietnam and the closest points of refuge for Asian allies fleeing that theater of war: more than one-fourth of all

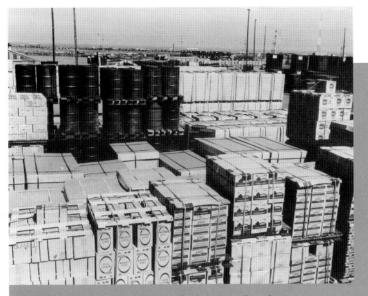

Supplies stacked on the docks at the Oakland Army Base for shipment to Vietnam, September 1965.

OAKLAND MUSEUM OF CALIFORNIA

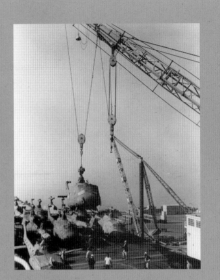

Loading helicopters bound for Vietnam aboard the cargo ship *Kula Gulf* at Pier 7, Oakland Army Base, 1967.

OAKLAND MUSEUM OF CALIFORNIA

Crew members watch military supplies being loaded aboard their freighter in Los Angeles Harbor, January 6, 1967. The ship was formerly used to haul freight cars and converted to carrying Army rolling-stock with the start of major combat operations in Vietnam.

LOS ANGELES TIMES COLLECTION, UCLA LIBRARY DEPARTMENT OF SPECIAL COLLECTIONS

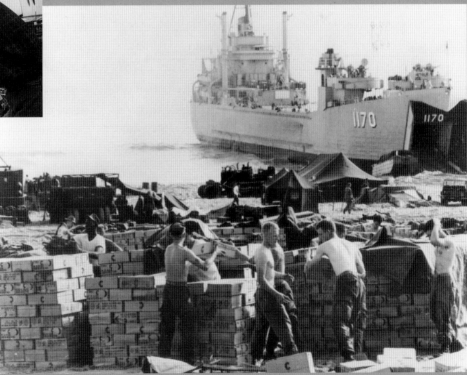

U.S. Army soldiers stack boxes of supplies on a beach in South Vietnam, 1969.

OAKLAND MUSEUM OF CALIFORNIA

Between 1960 and 1970, California received twice as many defense dollars as its nearest competitors, New York and Texas, and benefited from local military payrolls that were also double that of any other state.

postwar Vietnamese immigrants live in California. California-based banks and airlines served Vietnam's cities, while much of the munitions expended in Vietnam were developed in California and/or delivered to the battlefield by elements of the "Special Express" fleet operating between the Bay Area's Concord Naval Weapons Station and Vietnamese ports, such as Cam Ranh Bay. California's premier "think tank," RAND Corporation, developed and influenced the conduct of the "limited war" that was fought in Southeast Asia; the state thus provided the brains as well as the muscle of America's Vietnam War machine. As California was also the site of some of the largest public protests against the war itself, its relations with the people of Vietnam could not have been more intimate or complex.

These socio-political ties were cemented by economic relationships, large and small, from the local lumber purchased to build the model Vietnamese village at Camp Pendleton (used to train marines to conduct sweeps through Vietnamese hamlets) to the millions of postwar tax dollars generated throughout the state by war-exile Vietnamese–owned businesses. The brief examination of these economic ties that follows is not intended to take the full measure of the economic impact of the cold war on California. Its influence upon the state's population growth, rate of urbanization, and

the process of suburbanization each alone require lengthy treatment that cannot be afforded here. This chapter does, however, attempt to illuminate some important aspects of the economic impact of the cold war era on the history of California and seeks to explore just how closely the route taken by California from Sutter's Mill to Silicon Valley passed through Saigon.

FROM THE GOLD RUSH TO FORTRESS CALIFORNIA

In 1911 a Glenn Curtis–designed biplane landed on the deck of the armored cruiser USS *Pennsylvania* in San Francisco Bay and took off for its flight back to the mainland, a feat repeated shortly thereafter in San Diego with Curtis at the controls. These events marked much more than a milestone in aviation history. They heralded the beginning of a new industry that would help create an economy the world had not yet seen, one which would come to influence the course of a war in Southeast Asia half a century later.

Curtis came to California in 1910 to compete in an air race in Dominquez Hills. He spent much of the next decade utilizing the state's year-round good flying weather, its vast expanses of open land for aerodromes and test flights, and its few but ingenious light manufacturing facilities. He was soon joined by engineers Glenn Martin, Allan Lockheed, and Donald Douglas; for California offered something else that pioneering industrialists craved. The state was awash with capital and had few major traditional industries to siphon it away. Its lending institutions had made fortunes developing the state's agribusiness, a staple product since the Gold Rush era. By the Roaring Twenties, however, these lending institutions were seeking higher returns and were eager to bankroll new enterprises. They were also ready to extend funds to the precision-machine industries that a fledging aeronautic industry required.

The melding of venture capital with the entrepreneurial skill of California's air pioneers opened the door to explosive growth. By the 1930s every modern American aircraft manufacturer had plants in California save Boeing, which was established in the West Coast city of Seattle. The only ceiling to this growth was labor. The aircraft industries, like any high-technology start-up, required a loyal, low-cost workforce. Much of that labor was supplied by the migrations stimulated by the Great Depression and World War II.

The aircraft industry was not the only beneficiary of good weather, cheap land, readily available capital, and an eager, if desperate, workforce. The motion picture industry profited from the same economic patterns. Early on, it displayed the same insatiable need for inventive secondary manufacturing that characterized the aircraft industry. Both industries required an unending stream of solutions to their engineering problems and found them in abundance in the new California economy. In 1938 two Stanford University graduates, William Hewlett and David Packard, filled the first order for their company by selling a version of Hewlett's "audio oscilloscope" to the Walt Disney Company, which it employed in the stereo sound system for its groundbreaking film, *Fantasia*, in 1939. Hewlett-Packard's products, when incorporated into radar devices, also proved a boon for the aeronautical industry and for the military. It was this synergy across the entire spectrum of its electronics industry that was later to help fuel California's economic growth during the cold war and pave the road to its postwar high-technology–driven "new economy."

That so much of this road would be built by the military was a primary aim of California's city fathers. They hoped to add the military to the tax rolls already expanded by the aircraft and entertainment industries.

Roger W. Lotchin (*Fortress California, 1910–1961,* 1962) demonstrates how in the "boom and bust" years between the world wars California's urban leaders sought economic stability by joining forces with the military. The result was a civilian-military-industrial complex whose scope and pattern were first apparent in San Diego, where political and business leaders gave away valuable real estate in exchange for a military presence and its long-term economic stimulation. Other cities' leaders followed suit and were farsighted enough to join forces seeking to accommodate the military, much as urban centers elsewhere had accommodated steel mills or textile factories.

The state's university administrators pursued the same course. According to historian Rebecca Lowen (*Creating the Cold War University: The Transformation of Stanford,* 1997), these officials were so pressured by the Great Depression that they, too, sought the stability provided by closer relations with the military and industry. Due to their efforts, California's universities soon became dependent upon military as well as foundation and industrial patronage in the form of "sponsored research," which placed priority on research over teaching, determined the areas of inquiry open to faculty, and spurred administrators to take control over the appointment of faculty. Lowen argues that in the concept of the "federal grant university," both major building blocks of California's cold war economy were in place well before that conflict. The California Institute for Technology, for example, had provided valuable expertise to the aircraft industry since the 1920s.

Thus, prior to World War II, California was on track to develop a very large economy with only a modest level of traditional manufacturing, a process aided by a capacity to add on an industry and related job skills, rather than one industry and skills set replacing

another. Economists call this productivity and innovation-enhancing action "agglomeration." Further, each new industry had become adept at cross selling itself to the others and thus supported each other's growth. Noting this pattern, California's canniest observer, Carey McWilliams, has argued in many books and articles that the state was destined to flourish regardless of other national developments because its antecedents had produced an economy that operated on the "edge of novelty," i.e., infinitely flexible and capable of shifting to meet any new change in product demand or method of production.

To McWilliams, this explained the manner in which California was able to respond successfully to the stimulus of World War II. In his view, the war merely accelerated an expansion that would have otherwise occurred without it, but as a result of the war, "the process was greatly foreshortened." This wartime expansion was, nonetheless, impressive, particularly in regard to McWilliams's predictions regarding "the edge of novelty." During World War II, California's economy expanded exponentially as federal funds poured in to a state well suited to meet allied needs. Whereas in 1930 the federal government was spending $190 million in California, by 1945 its annual spending in the state reached $8.5 billion. While Lockheed had produced 37 airplanes in 1937, it built 18,000 airplanes during the war: collectively, Californian firms could produce 100,000 aircraft a year by war's end.

These production levels were met through the very capacity for innovation that McWilliams had believed was inherent in the state's economy. Richmond's shipyards could build a freighter in 250 days in 1940; by 1944, utilizing Henry Kaiser's revolutionary use of modular construction, the yards could produce a "Liberty Ship" at the average rate of one in 25 days. From the first flight of Curtis's biplane off the *Pennsylvania*'s deck in 1911 to the outbreak of World War II, America had produced eight aircraft carriers. Kaiser built fifty escort carriers alone in one calendar year. Hewlett-Packard and other California engineering firms, fulfilling their prewar promise, produced radar-jamming, sonar, and other devices. These not only helped win the war, but also set the stage for the postwar takeoff of California's modern electronics industry.

According to Lotchin and California State Archivist Kevin Starr (*Embattled Dreams: California in War and Peace, 1940–1950,* 2002), after World War II, California's politicians were determined to maintain the expansion of the state's defense-related industrial base, research facilities, and the number and size of its federal military bases. California's three leading metropolitan centers—Los Angeles, San Diego, and San Francisco—continued to work together to extend the connections they had built between military spending and urban growth; Lotchin contends that the emerging cold war became another means to that end. He demonstrates that the state's leaders employed scare tactics based on a deliberate overestimation of the Soviet threat in order to join their military partners in championing huge defense spending that would keep up the pace of economic growth. Los Angeles Mayor Sam Yorty "whipped up the lather of the Cold War to prevent defense spending cuts, and [San Diego Mayor] Bob Wilson whipped it up again to secure contracts for San Diego," generating a "windfall for contractors, universities and martial metropolises."

These leaders, via their role in university governance, furthered the growing parallel connection between California's public universities and the Pentagon. Secretary of the U.S. Air Force Harold Brown supervised funding for three high-altitude nuclear

explosions conducted by the California Institute of Technology in 1965. Four years later, he was chosen to serve as president of that institution, where he served for eight years before leaving to become secretary of defense. While Brown was president, Caltech was named codeveloper of a nuclear reactor for the Republic of Vietnam. Charles Hitch was a leading RAND Corporation Cold Warrior and a former assistant secretary and comptroller of the Department of Defense, an office that the University of California felt had prepared him to serve as president of the University of California at Berkeley at the height of the campus's antimilitary-industrial complex and antiwar fervor. Twenty-five years earlier, Berkeley had been a major academic participant in the Manhattan Project, the World War II effort to invent and produce the atomic bomb. By the 1950s the university was managing the federal government's new nuclear weapons laboratory at Livermore as well as the original weapons lab at Los Alamos, New Mexico.

THEY HAD A HAMMER

The Lawrence Livermore National Laboratory owes its existence to the detonation of the first Russian atomic bomb in 1949 and the assiduous exploitation of that event by its founder, Berkeley's Ernest O. Lawrence, a Nobel Prize winner and Manhattan Project scientist. Lawrence dreamt that Berkeley might one day monopolize atomic research and successfully used the Russian nuclear event to push the government into opening new nuclear laboratories in Northern California. The Livermore branch of the University of California Radiation Laboratory was created in 1952 and a weapons laboratory at Livermore was established that same year. According to its in-house history, the labs reflected the synergistic core of the California economy: close coop-

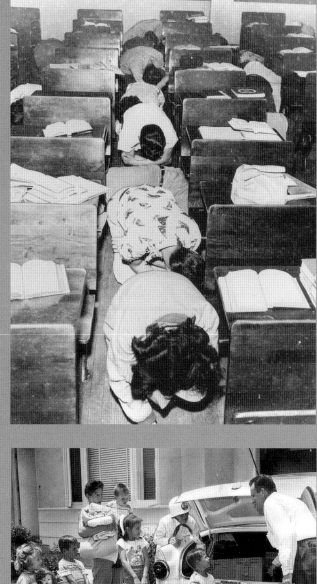

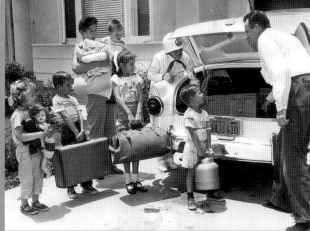

TOP: Students practice "duck and cover" during a civil defense drill at a Los Angeles elementary school, 1961.
HOLLYWOOD CITIZEN NEWS COLLECTION, LOS ANGELES PUBLIC LIBRARY

BOTTOM: The Billie Jack King family of El Monte participating in a civil defense drill, July 19, 1956. Block Warden Mrs. Opal Bashore, wearing helmet, assists the family with loading supplies into their vehicle.
HERALD-EXAMINER COLLECTION, LOS ANGELES PUBLIC LIBRARY

eration between the military and civilian communities. The Livermore laboratory has since been a boon to local civic boosters: at the height of the cold war, federal funding of the labs approached a billion dollars annually. Today, it boasts that it adds over a half billion dollars yearly to the regional economy. It also maintains that it both serves and provides resources to the region's major universities and to Silicon Valley.

Not everyone viewed the weapons laboratory with favor. Herbert York was a Berkeley graduate and professor with experience in nuclear weapons development when Lawrence appointed him as the first director at Livermore. However, this work and his later service as Director of Defense Research and Engineering in the Department of Defense convinced him that Eisenhower was right, not only about the military-industrial complex, but also the parallel concern the president had expressed that "in holding scientific research and discovery in respect, as we should, we must also be alert to the equal and opposite danger that public policy could itself become the captive of a scientific-technological elite." York concluded that, drunk on their expertise, America's technologists set the country on the course of an arms race that was both self-serving and futile. His protest against these developments was lodged in *Race to Oblivion* (1970), which was among the first of such critiques. However, even York could not anticipate how Livermore would become a magnet for antiwar sentiment, which began with a speech at the site by Linus Pauling in the 1950s and, if anything, is more robust today.

Yet, as with similar protests at the Stanford Research Institute, assaults on the Livermore lab and other university-connected war-related research centers had the opposite of their desired effect. Rather than close the laboratories or force universities to take a more active role in the direction of their programs, university administrators sought to distance themselves from moral outrage by lessening or abandoning their governing role. Responding to campus protest, the Lawrence Radiation Laboratory was divided into the Lawrence Berkeley Laboratory and the Lawrence Livermore Laboratory, at which time the weapons laboratory parted company from the university (though the university still runs both Livermore and Los Alamos weapons laboratories under a contract with the U.S. Department of Energy). With the end of the cold war, this seemed enough of a concession at the weapons laboratory as reductions in federal spending in support of the lab dropped by 45 percent. In response, it seemingly turned its swords to plowshares by directing its skills toward the lucrative task of dismantling the warheads it had designed. When the war on terrorism reopened the floodgates of federal spending, Livermore reinvigorated its nuclear and biological defense work and once again became a rallying point for the American peace movement. Yet, perhaps because this war has been sold as a "clash of civilizations," rather than political ideology, Livermore has been able to attract a new generation of engineers, many of whom had protested the very existence of the labs during the Vietnam War.

It would be wrong to single out the University of California's Lawrence Livermore National Laboratory as the only place where the rubber of California's academic-military-industrial juggernaut met the road during the cold war. Almost every major institution of higher education was involved in war-related research that also attracted antiwar demonstrations. These protests were fully warranted. The University of California campuses at Berkeley and Los Angeles won multiple grants for research into the use of chemical and biological weapons. However, for sheer impact on the war in

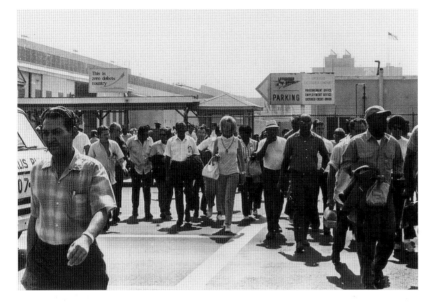

Shift change at Lockheed Aircraft Corporation in Burbank, c. 1968. Lockheed remained one of the major defense contractors throughout the years of the war.

LOS ANGELES TIMES COLLECTION, UCLA LIBRARY DEPARTMENT OF SPECIAL COLLECTIONS

Vietnam, no experimental stations played a greater role than those at two remote military bases, Edwards Air Force Base's Flight Test Center and the Naval Weapons Center at China Lake, where scientists from universities, industry, and the military took the technology of war to new heights.

A WEAPON-A-WEEK

The Flight Test Center at Edwards Air Force Base was and remains a world-renowned testing site, where virtually all aircraft developed during the cold war were put through their paces and competed for government contracts. Lockheed's nearby Skunk Works produced the most technologically advanced aeronautical machines the human mind can conceive, such as the SR-71. During the Vietnam era, the economic contribution made by the Skunk Works and Lockheed's premier missile facility at Sunnyvale, California, amounted to about $1 billion annually, approximately one-sixth of all Department of Defense contract work in the state. During the cold war, these plants ensured that Lockheed was perennially among the greatest recipients of federal R & D monies and, at the height of the Vietnam War

(1966–1970), it was the number one recipient of such funds, averaging half a billion annually. Without such testing facilities in California, much of these funds may well have gone elsewhere. As for Edwards Air Force Base itself, in 1969 it pumped $10 million ($48 million in 2002 dollars) into the local economy. Its impact on Kern County's economy is $80.4 million in goods, services, and contracts, and $365 million in federal employee payrolls.

Still, the Naval Weapons Center at China Lake (and its testing center at Point Magu) had a broader, if not larger, economic footprint and a more direct impact on the Vietnam War than Edwards Air Force Base. From 1966 to 1972, the Center was home to the Vietnam Laboratory Assistance Program (VLAP). This unit supplied scientific/technical advisors who provided quick, inexpensive fixes for problems emerging on the battlefields in Indochina, but also developed new weapons systems. Its output included the Walleye television-guided glide weapon, the Electronic Combat Range, the controversial Fuel Air Weapon, the even more controversial Cluster Bomb Unit (CBU), the Zuni missile, and night-vision devices. It also developed the Shrike, the first operational antiradar missile, which after 1965 became the most-fired guided weapon in Vietnam.

Robert McNamara did not exaggerate when he declared that 75 percent of the air-to-air and air-to-surface missiles were developed at China Lake nor were the staff there wrong to boast that they developed a

"weapon-a-week" during the Vietnam era. However, the most significant element of the VLAP achievement for this present study was not the number, but the nature of the weapons produced and the way they were developed. China Lake's output was dependent on the highest of high technology and, as at other California laboratories, used the integrated work of scientists from many disciplines and occupations. Typical of this integration was the upgrade provided for the Hughes Sidewinder Missile. Only at China Lake could Naval Air Weapons experts work with a local manufacturer (Hughes, now Raytheon) and other local civilian engineering companies to upgrade this staple U.S. air-to-air missile by reengineering it into a much more effective solid-state device. Only in California was this possible within so short a commute from the manufacturer's headquarters.

HOTEL CALIFORNIA

Edwards AFB and China Lake were, of course, only two of more than twenty major military bases or installations in California between 1950 and 1975. In any given year, these housed over 340,000 military personnel. Many of the bases became closely identified with the Vietnam War. The first combat troops dispatched to Vietnam were units of the First Marine Division, which left from Camp Pendleton for Beach Red near Da Nang in March 1965. The division's subsequent operations were covered by the First Marine Division's air wing, normally based at the El Toro Marine Corps Air Station (MCAS) near San Diego. The later buildup of American forces in Vietnam was largely accomplished by logistical centers headquartered at the Oakland Army Base, which then repeated the role it played during the Korean War as the largest port facility in the world. Air mobility units stationed at Travis,

McClellan, and other air force bases in California were key factors in sustaining the flow of troops leaving for and returning from Vietnam. These military personnel pumped millions into the California economy as they transited through nearby cities and transportation hubs. One of these hubs, the Oakland airport, was the headquarters of Department of Defense prime contractor World Airways, which during the war received annual contracts of approximately $23 million ($110 million in 2002 dollars) transporting troops to and from Vietnam. In 1967 alone, it was expected to fly 327 round trips to Vietnam or 838 million passenger miles. To permit World Airways to accomplish this task, the federal government provided more than $10 million for the expansion of the Oakland airport.

The Oakland airport expansion would seem to be the fulfillment of the dreams of California's civic leaders who sought to tie their local economies to the needs of the U.S. military. But this achievement was dwarfed by San Diego, which pioneered that concept. At the height of the Vietnam War, San Diego annually attracted over $28 million ($130 million in 2002 dollars) in local defense expenditures alone. In 2000, the most recent year figures are available, the Department of Defense provided $9.96 billion of the $114 billion gross regional product.

If the American war in Vietnam began with the departure of the marines from Camp Pendleton for Da Nang in 1965, it certainly ended there in 1975, when the last marine detachment returned to Camp Pendleton with over 50,000 Vietnamese refugees in tow (over 134,000 arrived between April and October). These refugees were taken to a resettlement center at El Toro MCAS, an event movingly described in the recent motion picture, *The Green Dragon* (2001). However, the history of the American military's "Hotel California"

has no monopoly on symmetry. For that, one must look to the RAND Corporation of Santa Monica, which was present at the creation of the cold and Vietnam wars and the "new" economy at whose birth it served as midwife.

FROM SANTA MONICA TO SAIGON

During World War II, both the United States military and its civilian defense industry partners came to acknowledge the enormous complexity that had come to characterize both modern industrial planning and national security policymaking. To meet this challenge, the U.S. military formed partnerships with civilian industries, private laboratories, and universities to address design and operational issues, such as the feasibility of building a jet-powered, carrier-based strategic bomber and the B-29 strategic bomber. In time, these operational research units came to include interdisciplinary teams of physicists, mathematicians, engineers, aerodynamicists, chemists, economists, and psychologists. Since the army air force had extensive wartime experience of these "think tanks," they naturally took the lead in seeking to expand these organizations' horizons to meet the challenges of the postwar world. In May 1948, Project RAND (Research and Development), codeveloped by the air force and Douglas Aircraft Company of Santa Monica, was incorporated as a nonprofit organization called RAND Corporation.

RAND's mission was "to further and promote scientific, educational, and charitable purposes, all for the public welfare and security of the United States of America." Though its concerns and interests ran, and still run, far beyond the needs of military decisionmakers, RAND's early work secured the public welfare largely by providing the brainpower for determining what would happen in the event of a nuclear war with the Soviet Union.

Thus, like their fellow scientists at Lawrence Livermore, RAND analysts were initially tasked with realizing warrior dreams, not the aspirations of American social reformers. RAND analyst Herman Kahn, author of *On Thermonuclear War* (1962), inventor of the concept of Mutual Assured Destruction, and model for the title character of Stanley Kubrick's film, *Dr. Strangelove,* was one of a stellar staff who was tasked with "thinking the unthinkable." Much of RAND's subsequent success was derived from the multidisciplinary nature and effective teamwork of these analysts, which encouraged confidence in America's war managers. Its "systems analysis" approach, moreover, promised cost-effectiveness and conveniently, if dangerously, reduced much of the complexity of postwar political struggles into a form digestible by policymakers. It is no wonder Pete Seeger sang these words in protest of the persuasive hubris projected by RAND's headquarters, which sat on a bluff above the Santa Monica pier: "They will rescue us from a fate worse than death with the touch of a push-button hand / We'll be saved at one blow from the designated foe, but who's going to save us from RAND?"

RAND's seemingly authoritative approach to security issues ensured that it enjoyed an endless supply of government contracts in the early nuclear age. Its analysts have advised virtually every president from Kennedy to Bush and influenced key cold war government policymakers, most particularly Secretary of Defense Robert McNamara, a champion of systems thinking and quantitative rational management and the architect of the Vietnam War. Impressed by RAND analysts Roland McKean and Charles Hitch's *The Economics of Defense in the Nuclear Age* (1960), McNamara made Hitch the Department of Defense's comptroller and appointed Hitch's closest RAND colleague, Alain

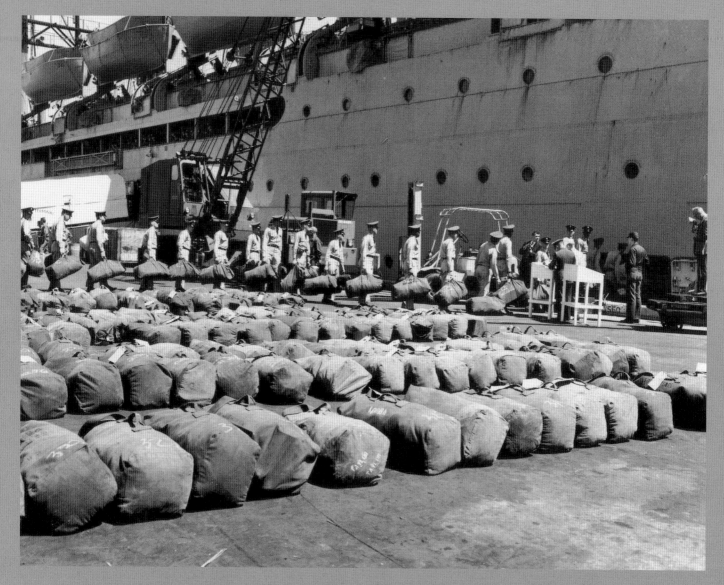

Army personnel waiting to board troop ships bound for Vietnam at the Oakland Army Base,
c. 1967. From 1965 to mid-1967, soldiers destined for Vietnam duty shipped via converted
World War II ships.

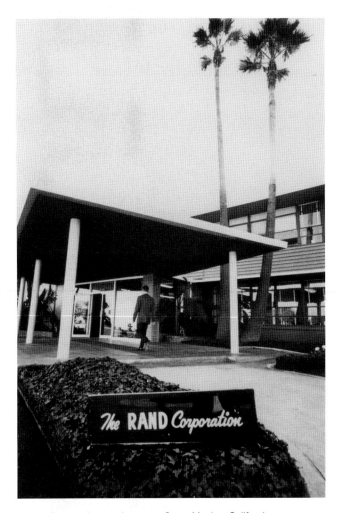

RAND Corporation headquarters, Santa Monica, California.

OAKLAND TRIBUNE COLLECTION, GIFT OF ANG NEWSPAPERS,
OAKLAND MUSEUM OF CALIFORNIA

America did not have to win the cold war's "brushfire conflicts." It merely had to prevent them from spreading. The best and the brightest at RAND devoted themselves to the study of how this could be done best. They eventually settled on an emerging military paradigm: counterinsurgency, in which wars for "hearts and minds" could be achieved more cheaply, but with the same confidence and precision, as the nuclear delivery systems RAND had previously designed.

Of course, wars of pacification fought on the cheap are not necessarily inexpensive or easily won. Counterinsurgent warfare required weapons of enhanced effectiveness to ensure the superior mobility and firepower of any soldiery employed in counterinsurgent operations. It took many years of several failing counterinsurgent and more conventional approaches before American political leaders, such as Assistant Secretary of Defense for International Security Affairs John McNaughton, an admirer of RAND's "systems analysis" approach, realized that limited war, at least in Vietnam, was a losing proposition.

Providentially, a "Limited War" was almost as well suited to grow California's economy as wars that promised Mutual Assured Destruction. The state's edge in high-technology weaponry, aeronautical inventory, and innovative industrial ethos quickly rose to the challenge of generating the force multipliers the U.S. military intended to counter the enemy's superiority in numbers, mobility, and knowledge of the geographic and human terrain. No state was better prepared to generate COunter INsurgent aircraft (COIN), either as refits or new aircraft. Reconfigured World War II attack aircraft, such as the A-26J (the first "gunship") and the famed AD-1 Skyraider or "Spad," were soon flowing off assembly lines of On-Mark Engineering in Van Nuys and Douglas Aircraft in Inglewood. Douglas also extended

Enthoven, Assistant Secretary of Defense for Systems Analysis. Such was RAND's reputation and place in government circles that it prospered even as the early nuclear age morphed into something more complex than even the development of space-based nuclear target acquisition capabilities, RAND's original forte.

"Limited War" was a term coined by RAND analyst and later consultant to the Department of Defense, William Kaufman. Kaufman advanced the idea that

Navy A-4 Skyhawk jets, many of them back from the Vietnam War, fill a maintenance hangar at Lemoore Naval Air Station in the Central Valley, February 7, 1967.

the service life of its A-4D Skyhawk by converting it into what its pilots considered the best attack aircraft ever built and its B-66 Destroyer became one of the war's premier reconnaissance and electronic counter-measure platforms.

With the unique level of connectivity that was typical of California industries, the effectiveness of what the state produced for the battlefields of Vietnam was measured by the very California firms (principally RAND and the Stanford Research Institute) that developed the strategy and produced many of the weapons required of them. RAND's promotion of systems analysis encouraged a belief among some policymakers like Robert McNamara that the conflict in Southeast Asia was merely an exercise in production, a war of attrition whose efficacy and progress could be measured by rational instruments, such as body counts. Since RAND and its sister institutions were both the chief progenitors and the chief evaluators of this approach to the war, California played a key role as an enabler of what James William Gibson (*The Perfect War,* 1986) called appropriately (if somewhat deterministically) "Technowar" in Vietnam.

However, no sooner had RAND helped bring "Technowar" to Vietnam than it began to be forced by its own institutional ethos and California roots to try to dismantle it. The air force had developed Project RAND, intending that it provide independent, non-partisan advice and analysis. It had also given RAND the freedom to choose its own subjects of analysis. To

those "think tanks" closer to the center of power in Washington, such freedom meant little in real terms, but working on the West Coast gave RAND staff and consultants a truer sense of their mission and the chutz-pah to pursue it. What RAND had given, it now strove to take away.

RAND's role in the unmaking of the Vietnam War began with George Tanham, who had studied the French war with the Vietnamese in the 1950s before becoming a RAND vice president. In 1963, while serving in Vietnam with United States Overseas Mission (the predecessor of the United States Agency for International Development), Tanham realized that the United States was not only failing to observe the lessons of the French campaigns, but also ignoring important human and cultural elements of counterinsurgent warfare that some of his fellow RAND analysts had minimized or overlooked. Tanham was among the first to realize that in Vietnam high-technology weaponry and massive fire-power were no substitute for good politics. By 1965, many of Tanham's colleagues working in Saigon as well as in Santa Monica came to the same conclusion.

Opposition to the war eventually extended to RAND's cofounder, Bernard Brodie, and even to the father of system analysis, Albert Wohlsetter, whose crit-icism of the war began in 1968 with a lecture on "The Mis-Lessons of Vietnam" attended by Henry Kissinger. Some credit for the war's end is due to Daniel Ellsberg, who, as a RAND consultant in the early 1970s, used its facilities to copy and make public the *Pentagon Papers,* an internal history of the war which detailed the De-partment of Defense's mistakes of omission and com-mission and the bright and shining lies that were developed to conceal them. If any redemption for its own complicity in those events can be so earned, RAND has found it in profound reexaminations of American

RAND's promotion of systems analysis encouraged a belief among some policymakers like Robert McNamara that the conflict in Southeast Asia was merely an exercise in production, a war of attrition . . .

counterinsurgency doctrine stressing the biblical admo-nition that unrest in the world comes primarily from justice denied, not worrisome revolutionary ideologies.

However, RAND also profited handsomely from its criticism of the American war machine in Vietnam. Col-lectively, its promulgation, investigation, and condem-nation of the Vietnam War helped boost its status to the forty-second largest recipient of all Department of Defense R & D funds. As the Vietnam War shuffled to its close, RAND dropped to forty-ninth. But the re-sumption of massive defense-related spending during the subsequent administration of President Reagan once again drove up its profits, particularly since its "Star Wars" program refocused the federal govern-ment's attention to what RAND claimed to know best ever since the beginning of America's high-technology arms race with the Soviet Union. This shift back to planning a nuclear war would be a factor in California's leadership role in the coming "new economy."

FROM SAIGON TO SILICON VALLEY

Without the distraction of a failing war in South-east Asia, RAND, the Stanford Research Institute, and the California university system and its partners in industry were able to devote all their energies and all of their Vietnam era profits to an area of research that had

been an important ancillary to their Vietnam R&D work: computing and computer networks. According to RAND's own official history, it invented the Internet, which is not an idle claim. Responding to the U.S. Air Force's sponsorship of research into the means by which it could preserve its command and control capabilities in the event of a nuclear strike, RAND analyst Paul Baran developed a system that had no central node and employed a method called "packet switching." He concluded that his system would provide not only a first strike–proof military communications network, but also a universal public communications system. Much of RAND's cold war research had been carried out under what was then known as the Advanced Research Projects Agency. It was thus logical that ARPA would fund the emergence of the new system under the rubric of ARPANET in 1968. The first test of the system came in September 1969 at the University of California, Los Angeles (UCLA), with additional nodes at Stanford Research Institute and the University of California, Santa Barbara. The only ex-California node, at the University of Utah, was essential for testing the remote log-in.

Much has been written about the further development of the Internet. But the story that has not been adequately told (and can only be suggested here) is how the stimulus to the California electronics industry, its high-technology businesses, its universities, and its R&D-driven economic sectors provided by the cold war enabled the state to be the place where high-speed computing, software development, and the Internet would generate the digital momentum leading to the nation's first "silicon" industrial terrain.

During the Vietnam War, California claimed pride of place as the R&D capital of America, a status it would never surrender. At the peak of the Vietnam War, the Department of Defense was spending over $6 bil-lion annually on R&D in California, but more impressive is that 84 percent of its electronics industry was consumed by the military, which helped drive the expansion of key players in the digital revolution of the 1990s. The most notable of these was Hewlett-Packard. With the beginning of the cold war, Hewlett-Packard's workforce and production rate began to double as it branched into defense work and other electronic measuring products. During the Vietnam War, Hewlett-Packard jumped almost two hundred places in its ranking as Department of Defense prime contractor and became a Fortune 500 company. From this commanding height it helped lead California's technology industry into the twenty-first century.

A similar story can be told about other prime movers/prime defense contractors in the making of the digital age. These included Control Data, one of the first players in computer manufacturing, Honeywell (which handled the first Internet message at UCLA), and California electronics firms such as Litton and TRW. More important, it included Fairchild Semiconductor, the developer of the integrated circuit and the first to produce one made entirely of silicon. Fairchild, of course, begat Intel, Philips Semiconductors, National Semiconductors, and AMD, which formed the basis of the semiconductor industry that earned their neighborhood the sobriquet of Silicon Valley. As E-market analyst Alexander Loudon notes in his online *History of the Internet,* "during the fifties the defense programs in the field of air, space and electronics strongly stimulated growth in Silicon Valley," largely because the purchase of semiconductors by the Department of Defense "amounted to approximately two-fifths of total production." Even Silicon Valley's greatest success story, the integration of digital technology into the film industry exemplified by Pixar's *Toy Story* (1995), is now tied to

Thanh Vu and Phuong Trang assemble computer circuit boards at a computer company in San Jose, c. 1990.

the military: the digital technology that gave life to toy GIs is currently being used to train real soldiers.

The connection between the cold war and Silicon Valley is most apparent when looking at Stanford Industrial Park, which was built by Stanford University to encourage the development of, and links to, high-technology industries. The park stood at the epicenter of an expanding circle of high-technology companies that became Silicon Valley. The largest tenant was Lockheed, the number one recipient of federal R&D funds during the cold war and possibly the chief financial beneficiary of the Vietnam War. Lockheed's presence was an indicator of the influence of the cold war on the rise of Silicon Valley, and a good example of the ability of California universities to build links with defense-related companies. Loudon notes that Lockheed supported the creation of an air and space department at

Stanford, which in return provided scientific advice and training for Lockheed employees. This pattern was continued by later arrivals, such as IBM (1952), NASA (1958), and Xerox (1970). By the late 1960s Defense Department annual spending (virtually all R&D) within the Palo Alto city limits alone was over $135 million ($648 million in 2002 dollars). It is thus perhaps less of a mystery why the Bay Area produced the critical mass of technology and techies that helped launch companies like Apple Computer in 1976.

Scholars have speculated on the reasons for Silicon Valley's supremacy in the high-technology industry. Some see it in the plethora of engineers produced by Stanford and Berkeley, others the state's noted propensity for networking. It is, however, more likely that the difference resides in the combination of the magnitude of California's cold war stimulus, the efficacy of its

hard-won civilian-military-industrial complex, and the unique networking business environment California had assiduously been building for decades, which the same complex had facilitated. It can be argued that it was this interconnectivity that drew national defense dollars to California, rather than the defense dollars that produced the famed interconnectivity. However, this is something of a "chicken or the egg" debate and here we are interested only in counting the eggs. The cold war certainly produced a golden harvest in federal expenditure, but for whom and to what end?

CONCLUSION

Studies of the economic impact of the cold war and its corollary, the Vietnam War, offer useful insights into their possible macroeconomic effects, such as their inflationary impact and their place in undermining America's faith in Keynesian economics. However, most admit that the truly important economic consequences of human conflict, its effects on communities, gender, and individuals, remain unexplained largely due to the paucity of data or necessarily counterfactual analysis that accompanies all post-mortems of wartime economies (a war's positive fiscal results do not mean that if the war had not occurred, real economic output would not have been greater). Anthony S. Campagna, in his *The Economic Impact of the Vietnam War* (1991), concludes that it is likely that the "military industrial complex benefited" from federal spending during the Vietnam War, but observes that any final assessment of the economic impact or "success" of war-related academic, labor, or factory profits would have to include several offsetting social costs: the lives destroyed or altered by the war; the possibly higher or more lasting value to the community of different federal funding patterns; the loss of more economically productive labor

due to wartime service, etc. He is not alone in finding that the loss of millions of lives in Indochina and almost 60,000 American lives in Vietnam (and the disruption of millions more lives in both Indochina and America) are not easily quantifiable or measurable against the total cost of the war in dollars to the U.S. government ($572 billion in 2002 dollars). Scholars therefore doubt whether a "true balance sheet" of such global conflicts can be drawn. The "limited" nature of the cold war's conflicts, such as Korea and Vietnam, make this effort even more problematic.

Macroeconomists thus provide little context for understanding the economic impact not merely of the cold war, but also of possible future "limited" conflicts. This essay has suggested that the California economy has always been closely tied to the military and the aerospace industry, and that this relationship helped generate a unique capacity for synergy that has fueled the growth of many sectors of the California economy during the past century and is likely to favor those same sectors in the no less perilous future. The structure of the state's economy ensured that the cold war in general and the Vietnam War in particular stimulated the state's technology sectors, swelled the tax coffers of the state's cities, enriched its universities and secured its industries' ability to attract federal R&D funding.

However, this cold war dividend has not been universal. The high-technology industries it sparked are not immune to recession or foreign competition. The domestic impact of the cold war included rents between the generations; distorted the relations between academe and commerce; and has raised ethical questions about national security that cannot be resolved by a "threat du jour" approach to the rest of the human community (though some will try). The recent discovery that Vietnamese and other Southeast Asian refugees have been

working under sweatshop conditions in the brightest jewel in the crown of California's cold war legacy, Silicon Valley, is just one reminder that the meaning of the cold war for the "California Dream" may not be as roseate as the current generation of boosters of the military-industrial complex would have us believe.

The road from Saigon to Silicon Valley, like the road to the Vietnam War itself, may have been paved with good intentions, but was also marked by an unshakable faith that, whatever the state's problems, a civilian-military alliance pegged to technological advance would always lead toward the economic light at the end of the tunnel. Some of California's most thoughtful leaders have been wary of that faith. The ambivalence of these civic leaders, students, and social activists toward the technological heart of their own economy was perhaps best expressed by California Congressman George Brown. Brown, who died in 1997, served as chairman of the House Committee on Science and a member of the Technology Assessment Board. Educated as an industrial physicist, Brown was a strong advocate for federal R&D spending, but he was "also someone who attempted to look beyond the conventional wisdom and challenge traditional thinking about science and technology and their role in society." In 1993 he concluded a speech before the American Association for the Advancement of Science, Science and Technology Colloquium, with these words:

> For the past fifty years, this nation has focused its resources on building weapons of inconceivable destructive power, and we have viewed the rest of the world as a chessboard designed to play out our own ideological struggle. . . . Now the Cold War is over, and our excuse for this behavior is gone.

> We need a new vision . . . a new direction, but what direction? Neither technology nor economics can answer questions of values. Is our path into the future to be defined by the literally mindless process of technological evolution and economic expansion or by a conscious adoption of guiding moral precepts? Progress is meaningless if we don't know where we're going. Unless we try to visualize what is beyond the horizon, we will always occupy the same shore.

Brown's references to "horizons" and "shores" call to mind Glenn Curtis standing on Coronado Island's hard-packed sand while teaching the navy's first pilots to fly; RAND analysts' view of the cosmos as a possible weapons platform; the earth's envelope as the only limit to Lockheed's finest men and machines soaring over Kern County; Concord's "Special Express" munitions barges sailing across the Pacific to Cam Ranh Bay; National Security consultant Daniel Ellsberg sitting on his small plot of land on Muir Beach contemplating his responsibility for these weapons' departure; students pushing the limits of wartime dissent by protesting chemical, biological, and nuclear weapons development at the Golden State's universities; refugees from Southeast Asia on the tarmac at El Toro MCAS looking out past the wire at a strange new world; Pixar's use of the newest digital technology to breach the bounds of traditional animation; and, finally, the use of that same technology to extend the visual horizons of the training simulators for America's newest weapons systems. This is the stuff of which California's economy, its dreams, and its nightmares, have been made for the past century and of which they may well continue to be made, at least until Californians and perhaps of necessity, all mankind, choose to make war no more.

CHAPTER 3

Ronald Reagan and the Triumph of Conservatism

Jules Tygiel

THE 1964 PRESIDENTIAL CAMPAIGN had not gone well for conservative Republicans. In nominating Arizona Senator Barry Goldwater they had, to be sure, wrested control of the party apparatus from its moderate eastern wing. But as the election approached, poll after poll showed Goldwater to be headed toward a crushing defeat at the hands of incumbent President Lyndon Johnson. Many Americans seemed particularly frightened by Goldwater's hawkishness on the war in Vietnam, particularly his suggestion of using tactical nuclear weapons to end the conflict.

Ronald Reagan, an actor and television host, had served dutifully as the state cochairman of the California Committee for Goldwater, speaking up and down the state on the candidate's behalf. During the preceding two decades, Reagan had completed a transformational political odyssey. At the end of World War II, he had returned from the military as one of Hollywood's highest-paid actors and a spokesperson for liberal political groups. As he grew more active in the Screen Actors Guild (SAG), he became increasingly alarmed by the presence of Communists in movie unions. By the late 1940s, as president of SAG, he had evolved into a militant anti-Communist, identifying left-wing actors as an informant for the FBI and assisting in the enforcement of the Hollywood blacklist. When his movie career faltered in the 1950s, Reagan became the host of the GE Theater and national spokesperson for General Electric, the show's sponsor.

Opening of GOP headquarters on Laurel Canyon Boulevard by the North Hollywood Republican Woman's Club, September 1958.

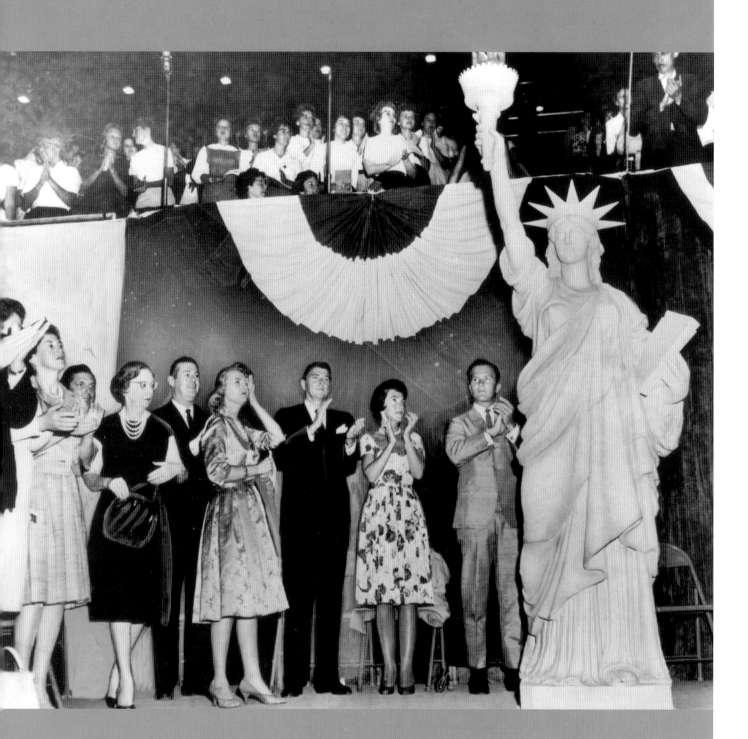

A Statue of Liberty replica symbolizes freedom at the Sports Arena in Los Angeles as participants at an anti-Communism rally, such as Pat Boone, Nancy Reagan and Ronald Reagan, applaud a speaker who warned of Red treachery, August 3, 1961. Some 16,000 persons attended the rally, devoted particularly to the youth of the nation.

During these years, Reagan's politics shifted dramatically to the right, as he spiced his speeches with attacks on taxes and government, and calls for a more militant anti-Communist foreign policy. By the early 1960s his often shrill conservatism proved too extreme even for General Electric, who canceled his contract in 1962. As the election year of 1964 approached, Reagan seemed to be drifting further and further out of the political mainstream. He was, however, about to begin an odyssey that would not only carry him to the White House, but also amid the turbulent divisions of the Vietnam War era, transform the nation's political consciousness.

On the speaking circuit, Reagan had developed into a spellbinding orator. Many felt that he conveyed the conservative message far more convincingly than Goldwater. In October 1964 Republican activists decided to tape Reagan giving a version of the speech he had honed and perfected over the years for broadcast to the nation on behalf of the campaign. Goldwater's campaign managers balked at the plan, fearing that an appearance by Reagan would reinforce Goldwater's image as an extremist. The candidate himself, however, watched the tape and endorsed its airing.

On October 27, 1964, the Republican Party bought half an hour of prime-time television on NBC. Reagan's talk, entitled "A Time for Choosing," made the case not so much for Goldwater as for conservatism. Reagan presented himself as a former Democrat, offering not a scripted tract, but his own words and ideas. Reagan employed statistics, examples, and anecdotes to demonstrate the foibles and excesses of government—the failure to balance budgets, the ironies of farm surpluses, the waste of welfare spending. In the realm of foreign affairs, he equated liberal policies of "accommodation" with the Soviet Union with pre-World War II "appease-

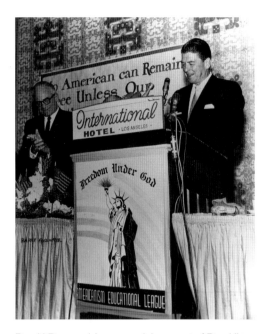

Ronald Reagan giving a speech in support of Republican presidential hopeful Barry Goldwater at the International Hotel in Los Angeles, 1964.

PHOTOGRAPH COURTESY OF RONALD REAGAN PRESIDENTIAL LIBRARY

ment." Reagan warned that "we are at war with the most dangerous enemy that has ever faced mankind," and invoked "the wife or mother whose son or husband died in Vietnam" and the soldiers dying there "for the rest of us" in that war. "You and I have a rendezvous with destiny," he concluded, shamelessly borrowing a phrase from liberal icon Franklin D. Roosevelt. "We will preserve for our children this, the last best hope of man on earth, or we will sentence them to take the last step into a thousand years of darkness."[1]

Reagan's apocalyptic vision and his attack on big government probably swayed few voters. One week later, Goldwater suffered a staggering defeat, in part because voters feared that he would drag us into a deeper war in Vietnam. But "A Time for Choosing" energized conservatives. Donations began to pour into the Goldwater campaign. Conservative leaders began to

envision Reagan as a potential presidential contender in 1968, or, at the very least, a California gubernatorial candidate in 1966. Overnight, Reagan became a political figure to be reckoned with, the standard-bearer for the conservative cause.

In the wake of the 1964 elections, however, that cause seemed to have a dim future, regardless of who its spokesperson might be. Not only had Johnson swamped Goldwater, Democrats also won overwhelming majorities in both houses of Congress. The thorough rejection of the Goldwater campaign seemed to have relegated conservatism back to the netherworld of the American political scene that it had occupied since the days of the New Deal. "The humiliation of their defeat was so complete," reported *Time* magazine, "they will not have another shot at party domination for some time to come."[2]

Conservatives in America at this time fell primarily into two groups: traditionalists—social and cultural conservatives who felt that the modern, liberal world had abandoned the natural Christian moral order; and economic conservatives—believers in laissez-faire capitalism as the essence of American freedom. Although substantial differences separated the two factions, they shared several common assumptions. Conservatives believed in eternal truths, established, as Goldwater wrote, by "the laws of God and nature." There existed an "objective moral order," based on individual responsibility, which the community must enforce to avoid chaos. The liberal emphasis on rationalism, moral relativism, and egalitarianism, underscored by a de-emphasis of religious faith, ignored these fundamental truths and led to permissiveness and moral decay.

To conservatives of all types, the expansion of government at the core of the liberal state both undercut the natural moral order and violated the precepts of a Constitution designed to limit governmental power. As Reagan would later state, the nation's problems "all stem from a single source: the belief that government, particularly the federal government, has the answer to our ills and that is to transfer power from the private to the public sector, and . . . from state and local governments to the ultimate power center in Washington."[3]

To economic conservatives, the expansion of government also violated the precepts of laissez-faire capitalism necessary for both true freedom and economic growth. Private property rights reigned transcendent. The government should not be able to redistribute wealth by confiscating property through taxation or welfare policies, nor could it override one's absolute property rights in order to eliminate discriminatory practices. State regulation of the economy both violated these precepts and prevented the more beneficial natural workings of the free market. Conservatives thus abhorred any forms of what they decried as "collectivism" or "centralizing."

Communism represented the most extreme variant of these trends, and both traditional and economic conservatives were uncompromisingly anti-Communist. Liberal domestic policy, they believed, sometimes unwittingly, sometimes deliberately, advanced the Communist agenda at home. Liberal foreign policy naively sought to "contain" Communism within its current boundaries rather than defeat it. Cold war conservatives called for an aggressive campaign against the Soviet Union and countries like North Vietnam, which they viewed as its satellite states.

The conservative emphasis on individualism and voluntarism left little room for concern for those who, due to personal misfortune or societal discrimination, had not shared in the general American affluence. There was relatively minimal sympathy or regard for the plight of African Americans trapped in the clutches of Jim

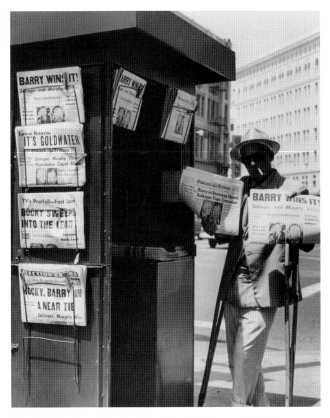

Barry Goldwater receives the Republican Party's nomination for president, 1964.

Crow segregation or other minorities facing discrimination. Indeed, the conservative movement, in particular the traditionalist wing, drew many of its supporters from southerners and religious fundamentalists, who in the past had formed the backbone of the Ku Klux Klan and other similar organizations.

The racial dynamics of the 1964 elections, the liberal landslide notwithstanding, offered a portent of how conservative doctrines could appeal to a broader constituency. In the Democratic primaries, Alabama Governor George Wallace, running against Johnson as a segregationist, had fared surprisingly well among midwestern blue-collar voters. Goldwater himself carried five southern states that had never before gone Republican.

The most obvious harbinger of discontent among white voters about the progress of civil rights appeared

in California. In 1963 Governor Pat Brown had pushed the Rumford Fair Housing Act through the state legislature. In keeping with the growing national commitment to civil rights, the bill banned discrimination in the sale or rental of most private dwellings in the state and posed penalties for real estate brokers found guilty of racial bias. It offered the mildest type of remedy against the pervasive racism in the California housing market. The California Real Estate Association nevertheless condemned the Rumford Act as "forced housing."[4] The California Republican Assembly proclaimed "the right to own and manage property" as a "God-given right not to be retracted by the whim of government."[5] The opponents of the Rumford Act collected signatures and placed an initiative, Proposition 14, on the 1964 statewide ballot seeking to overturn the civil rights legislation.

With ample financing and lavish flag-waving campaign materials, supporters of Proposition 14 portrayed the Rumford Act as a violation of American principles. They defined a new right—the "right to sell"—and openly defended what one Republican leader called "the right to discriminate," over the ability of minorities to escape bias.[6] Ronald Reagan, an ardent supporter of Proposition 14, later explained, "If an individual wants to discriminate against Negroes or others in selling or renting his home, he has a right to do so."[7] Californians sympathized with this message. In the same year that they rejected Goldwater by a margin of over a million votes, California voters approved Proposition 14 and the right to discriminate by almost a two-to-one margin.

Proposition 14 revealed the limits of white California's acceptance of civil rights measures. Other developments on both the national and state scene offered added promise for conservative mobilization. In California, in the waning weeks of the 1964 campaign, a new

force appeared that would help to reshape the state's political landscape. Students at the University of California's flagship campus at Berkeley, many of them veterans of the civil rights crusades of the South, protested vigorously against new campus restrictions on political activism. Over the next several years, Berkeley became a battleground between rebellious students and state and university officials. Militant students challenged not just restrictions on speech, most of which disappeared quickly, but the very nature of the modern university, and implicitly American culture and values.

Growing opposition to the war in Vietnam further fueled campus unrest. The burgeoning antiwar movement merged with student protests to create the image of a seemingly endless chaos on Berkeley and other campuses. By the mid-sixties members of the vast baby boom generation had also begun to experiment with drugs, adapt outlandish hairstyles and modes of dress, and challenge traditional sexual mores and religious conventions, developing a distinct "countercultural" lifestyle that confounded and angered mainstream America.

The drama of race relations also shifted in 1965 and 1966. In previous years, the Civil Rights movement had focused primarily in ending legal segregation in the South. The Civil Rights Act of 1964 and the Voting Rights Act of 1965 marked the triumph of this campaign. On August 11, 1965, however, less than a week after Lyndon Johnson had signed the Voting Rights Act into law, the African American community in the Watts section of Los Angeles exploded in a paroxysm of violence following the arrest of a drunk driver. By the time the National Guard could quell the disturbance nearly three dozen people lay dead, four thousand had been arrested and $40 million worth of property had been destroyed. Many liberals viewed the outburst as the inevitable result of the oppressive conditions in Watts and other black neighborhoods. Conservatives saw the uprising as further evidence of the breakdown of the civil order and rampant permissiveness.

The events in Watts, the first of many major urban riots that would plague the nation in the mid-1960s, signaled a transformation of the nation's racial focus from the South to the North and West, and from issues of integration to those of discrimination and economic opportunity that brought African American demands into more direct conflict with middle- and working-class whites across the nation. In 1966, black militants raised the banner of "Black Power," a nebulous concept, the rhetoric of which often implied a new racial separatism, visions of violence, and a rejection of American capitalism. In addition, other minority groups also began to protest their own conditions. In the fields of California's San Joaquin Valley, Mexican and Filipino farm workers walked off their jobs in September 1965. After a nine-month struggle under the able and inspirational nonviolent leadership of César Chávez, the farm workers won major victories, upsetting the traditional social and economic relationships in California farmlands.

In each of these areas—student militancy, the antiwar movement, Black Power, and minority rights—California appeared in the forefront of the maelstrom. Thus the political environment in 1966, when the state would choose a new governor, differed greatly from that of 1964. Republican leaders desperately needed a candidate who could unify the factions within the party and reach out more effectively than Goldwater had to moderate voters. A group of conservative businessmen and Republican campaign contributors believed that Ronald Reagan could be that man.

Converting Reagan into a viable candidate seemed a daunting task. Registered Democrats outnumbered

Republicans in the state by a three-to-two margin. Two-term incumbent Pat Brown had compiled a legislative record unrivaled in the state's history. Polls revealed that while most Californians were familiar with Reagan, a substantial proportion thought that he would be a poor choice for governor. Having focused most of his energies on national and international issues, Reagan possessed, in the description of one of his advisers, "zero" knowledge about California.[8] But Reagan and his campaign team constructed appealing themes to guide his candidacy, casting him as "citizen politician," uncorrupted by politics or power. Reagan breezed through the primary elections, easily defeating liberal San Francisco Mayor George Christopher.

Although the California governor's race was a state election in which foreign policy issues normally have no relevance, the war in Vietnam played a large role in the contest. The growing antiwar movement divided the Democratic Party. Democratic political consultant Fred Dutton described it as a "fierce symbol and ulcer eating away at the local level of support for moderate Democrats like Brown." The war, observed Dutton, "overrides any public issue or political ties in the state at present."[9] The rift appeared most ominously in the California Democratic Council (CDC), a federation of local Democratic clubs that had long been the backbone of Brown's political coalition. In 1965 the governor had backed the election of newspaperman Simon Casady as president of the CDC, but Casady emerged as an increasingly strident critic of the war. He attacked not only President Johnson, but also Democratic congressmen and Brown himself for supporting the war. When Casady ignored Brown's requests that he tone down his rhetoric, the governor demanded his resignation.

The conflict reached a head at the CDC convention in February 1966. Antiwar protesters heckled Brown as he delivered a speech supporting Johnson's policies. The following day he called upon the delegates to replace Casady with Gerald Hill. The motion carried by a relatively narrow 1,001 to 859 margin. When the CDC voted to endorse Brown's reelection, 700 of the 1,800 delegates abstained, many walking out of the hall in protest. Hill, the new CDC president, reaffirmed the CDC's opposition to the war.

Brown, who had doubts about the wisdom of the war, found himself on the horns of an insoluble dilemma. Support for the war alienated a growing number of his traditionally liberal constituency, but any gesture to accommodate the antiwar position struck others as disloyal and unpatriotic and threatened a split with a vengeful President Johnson. Vietnam had become a no-win issue for Brown in the gubernatorial campaign.

Reagan, on the other hand, wholeheartedly supported American intervention in Vietnam, but criticized the government's handling of the war. Like most conservatives he favored a policy of "Victory in Vietnam Instead of Defeat,"[10] calling for whatever escalation was necessary to stem the Communist tide. "We should declare war on North Vietnam," he asserted in 1965. "We could pave the whole country and put parking strips on it, and still be home by Christmas."[11] During the campaign, he charged antiwar protesters, "who send blood and money to the enemy," with treason, masquerading as "freedom of expression." He castigated the CDC's opposition to the war as liberal extremism.[12]

Vietnam and the offshoots of the antiwar agitation also had overtones in Reagan's most potent statewide issue. Even before he had announced his candidacy and before professional pollsters had detected it, Reagan had discovered that wherever he spoke "this university thing comes up." People repeatedly asked him about "the mess at Berkeley."[13] In his announcement speech

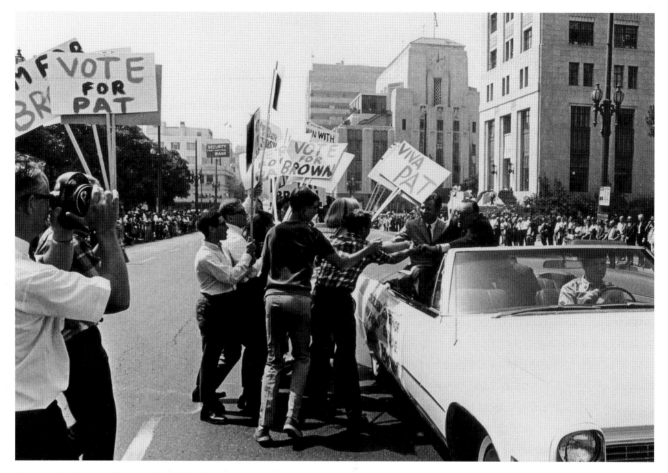

Governor Pat Brown riding with World War II hero Audie Murphy on a campaign trip to Los Angeles during the 1966 gubernatorial race, September 1966.

in January 1966 Reagan had raised this issue with rhetorical vehemence. "Will we meet [the students'] neurotic vulgarities with vacillation and weakness," he asked, "or will we tell those entrusted with administering the university we expect them to enforce a code based on decency, common sense, and dedication to the high and noble purpose of the university?"[14] Throughout the campaign, Reagan returned to this issue. "There is a leadership gap, and a morality and decency gap in Sacramento," he exclaimed, which had made it possible for "a small minority of beatniks, radicals and filthy speech advocates" to bring "shame to . . . a great university."[15]

As Matthew Dallek has written, the issue of morality, as exemplified by Berkeley radicals, became "a convenient catchall, an umbrella that allowed [Reagan] to weave together an effective and articulate assault on everything that happened in the state during Brown's tenure."[16] Reagan decried hippies as people who "act like Tarzan, look like Jane, and smell like Cheetah." He attacked the rise of welfare costs, asserting that working people had been "asked to carry the additional burden of a segment of society capable of caring for itself," but that preferred to make welfare "a way of life, freeloading at the expense of more conscientious citizens."[17]

Reagan managed to merge the antiwar and morality issues in a May 12 speech in which he excoriated the conduct of participants at a Vietnam Day Committee dance on the Berkeley campus. He characterized the goings-on as "so bad, so contrary to our standards of decent human behavior, that I cannot recite them to you from this platform in detail." Nonetheless, he described "nude torsos . . . twist[ing] and gyrat[ing] in provocative and sensual fashion," blatant sexual misconduct, and the omnipresent smell of marijuana.[18] University and county officials dismissed Reagan's allegations as exaggerations, but the charges rang true, and Reagan's disgust accurately reflected the sentiments of many of his fellow Californians.

The growing volume of Black Power voices gave Reagan additional ammunition. An inflammatory appearance by militant firebrand Stokely Carmichael offered Reagan the opportunity to connect Black Power and campus activism. "We cannot have the university . . . used as a base to foment riots from," retorted Reagan. The candidate pitched his appeal almost exclusively to white voters, rarely stopping in African American communities or addressing black audiences.[19]

Pat Brown, the incumbent governor, had little success in responding to these issues. Instead he came to embody the failure of liberalism to maintain the moral and social order. On Election Day, voters overwhelmingly chose the actor over the veteran politician, giving Reagan a margin of almost a million votes.

Reagan's victory was in part a triumph of personality—his ability to convey a sense of likable, unflappable affability and optimism. But, more importantly, Reagan had won because he sensed the growing disillusionment among white Americans with racial integration and the wretched extremes of the cultural, political, and antiwar protests of the 1960s.

Reagan decried hippies as people who "act like Tarzan, look like Jane, and smell like Cheetah."

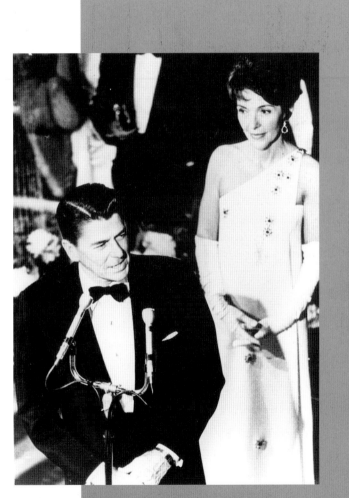

Nancy Reagan looks on as Governor Reagan gives a speech at the Governor's Inaugural Ball in Sacramento, January 1967.

PHOTOGRAPH COURTESY OF RONALD REAGAN PRESIDENTIAL LIBRARY

In doing so, Reagan had launched a transformation of the American political landscape. He had managed to unite conservatives and to reach out to moderates, reshaping the Republican Party. Campaigning as an "outsider" and a representative of hard-pressed white middle- and working-class Americans, he had helped to transform the message of conservatism from an ideology of the privileged elites to one with a populist base. Reagan's rhetoric encouraged a culture of victimhood among the affluent white majority, wherein unsung working people paid "exorbitant taxes to make possible compassion for the less fortunate," having "to sacrifice many of their own desires and dreams and hopes" in the process.[20] He ran as a patriotic American, offering a stark counterpoint to antiwar protesters who questioned not just the Vietnam conflict, but the overall role of the United States in the world order. These appeals enabled him to siphon off 40 percent of the traditionally Democratic labor vote and run extraordinarily well in the middle-class suburbs of Southern California. Over the next few decades, this coalition would shift politics rightward and, ultimately, vanquish the liberal alliance that had dominated America since the days of Franklin Roosevelt.

Ronald Reagan took the oath of office to become governor on January 3, 1967. In the most memorable line from his inaugural speech, he promised, "We are going to squeeze and cut and trim until we reduce the cost of government. It won't be easy and it won't be pleasant."[21] Reagan would quickly learn, however, that imposing his will on the government of California would be far more difficult than he, in his inexperience and naiveté, had envisioned.

Indeed, Reagan's first year in office seemed to demonstrate the pitfalls, rather than the benefits, of a "citizen politician." Lou Cannon, a veteran Sacramento newsman, wrote, "He was ignorant of state government, and most of those he brought to Sacramento knew little more than he did. Reagan had goals, but no programs. . . . He did not know how government functioned or the processes by which it reached his objectives."[22]

The new administration quickly discovered that many of California's largest expenditures in education and much-needed social services defied reduction and that a massive tax increase offered the only solution to an impending budget shortfall. The new levies reduced property taxes, but raised income, corporate, and sales taxes. Reagan signed into law a billion dollar tax boost, the largest in California or any state history.

But even as Reagan stumbled through his first year in office, he managed to present a positive public impression. For political collateral, he could always rely on "the mess at Berkeley" and the excesses of the burgeoning antiwar, New Left, and Black Power advocates and the counterculture to bolster his support among the electorate.

Reagan had made clear, even before taking office, that the situation at Berkeley would be among his first priorities. "No one is compelled to attend the university," he announced. "Those who do attend should accept and obey the prescribed rules or pack up and get out."[23] Reagan had determined to remove University of California Chancellor Clark Kerr, whose permissiveness he blamed for much of the chaos on the Berkeley campus. At the first regents meeting on January 27, Kerr played into the governor's hand, demanding a vote of confidence. The regents voted 14–8 to dismiss him, Reagan voting with the majority.

Reagan also continued to joust with political militants of various kinds. He repeatedly ridiculed the unkempt protesters. "Their signs say make love, not war. But they don't look like they could do much of either,"

he quipped. When students held up signs outside his limousine proclaiming, "We are the future," Reagan held up a piece of paper reading, "I'll sell my bonds."[24]

Reagan also received repeated boosts from African American militants. On May 2, 1967, nineteen Black Panthers, a self-proclaimed revolutionary group, descended on Sacramento provocatively displaying guns and rifles. The Panthers marched to the capitol building, made their way inside, and appeared fully armed on the floor of the assembly. The resulting photographs evoked horror throughout the nation. Reagan unhesitatingly attacked all such manifestations of radicalism and violence. African Americans, he proclaimed, "have to make a choice and quit listening to false prophets. You settle one thing with [black radicals] and they will be back with another point. Some of them think they have found a pretty good thing." When in 1968 the regents refused to allow Black Panther leader Eldridge Cleaver to teach a course at Berkeley, Cleaver led a crowd of five thousand people in Sproul Plaza in a "Fuck Ronald Reagan" jeer, challenging the governor to a duel. Reagan accepted if he could choose the weapons—words composed of more than four letters.[25]

During his years as governor, Reagan, reflecting the general conservative consensus, remained an ardent hawk on the Vietnam War. The United States, he proclaimed, should "win as quickly as possible," relying on the military to "recommend how to win it." He grew increasingly angry with Johnson, whom he blamed for "dragging on a winless war."[26] He seemed perplexed by the hostility shown by many toward military men who had fought in Vietnam. Reagan frequently staged prayer breakfasts and homecomings for returning veterans and prisoners of war. His consistent patriotism appealed to many Americans, even among those with reservations about the nation's Vietnam policy, but who felt uncom-

fortable allying themselves with the radical protesters who symbolized the antiwar movement.

Reagan's defiance of the political Left allowed him to sustain his popularity even as he learned how to govern. As indicated by the tax increase, Reagan proved more flexible than his critics expected or his rhetoric indicated. He learned to work with the legislature, which for all but two years of his tenure, was controlled by the

A supporter of the government's policies in Southeast Asia during the Vietnam Day Committee antiwar march, 1965.

HELEN NESTOR, PHOTOGRAPHER, OAKLAND MUSEUM OF CALIFORNIA, GIFT OF THE ARTIST

A young woman shows her support of U.S. troops in Vietnam during the Stop the Draft Week protests at the Oakland Induction Center, October 1967.

Democrats. When the issue of repeal of the Rumford Act came before the legislature, Reagan withheld his support, citing how much the issue "meant morale wise" to African Americans.[27] Even as he railed against the problems at the state's colleges, he consistently accepted increased spending for higher education.

Despite Reagan's harsh condemnations and tough talk, California campuses continued to spin out of control. Much of the Left, oblivious to the political realities and their increasing isolation from mainstream Americans, triggered confrontations that they imagined would radicalize students and lead to revolution. At San Francisco State College, efforts to create a Black Studies program evolved into mass protests, violent intimidation, and a student strike in late 1968. When President Robert Smith closed down the college, Reagan

called it "an unprecedented act of irresponsibility," vowing, "Those who want an education, those who want to teach, should be protected at the point of a bayonet, if necessary."[28] The California State University trustees, with Reagan's support, ultimately replaced Smith with S. I. Hayakawa, who captured the imagination of the nation, if not the campus, with his colorful defiance of militant students and faculty. At times their actions worsened rather than pacified conditions on campus, but in the popular mind, Reagan and Hayakawa earned respect for standing up to the protesters.

Reagan took a similarly hard line in February 1969, when the Third World Liberation Front blocked Sather Gate and threatened to close down the Berkeley campus. "I have just one message for the dissidents outside the gate," announced a dismissive Reagan. "Grow up."[29]

Reagan proclaimed a state of emergency and assigned the California Highway Patrol to quell the disturbance. In May radicals seized on an unpopular plan to convert an empty lot into a parking area in order to, in the words of leader Stew Albert, "suck Reagan into a fight." Protests degenerated into riots with militants hurling firebombs at assorted targets. Reagan concluded, not inaccurately, that "a revolutionary organization of professionals," determined "to [destroy] the nation's education system," now ran rampant in Berkeley.[30] In a show of force, Reagan called out the National Guard, an action that did little to resolve the overall chaos in Berkeley, but played well in the public arena.

Reagan won reelection in 1970. During the campaign, he had continued his attacks on antiwar protesters and the Left. He also resurrected his attacks on the welfare system. "Public assistance," he intoned, "should go to the needy and not the greedy."[31] During the first year of his second term, the state adopted the California Welfare Reform Act of 1971, a landmark bill that became a model for similar measures across the nation. The act simultaneously tightened eligibility requirements while simplifying the needs standards employed to determine inclusion. It elevated benefits for those remaining on the rolls by 43 percent and streamlined bureaucratic costs. The welfare caseload immediately began to plummet. More than 300,000 people were eliminated from the rolls during Reagan's second term. Much of this decline came from an improved economy and a nationwide end to the "welfare explosion" of the 1960s. Nonetheless, Reagan received justifiable credit for his leadership.

The Welfare Reform Act proved the high point of Reagan's governorship. At his urging, the legislature passed more than forty "law and order" bills, imposing harsher sentences for malefactors and strengthening the state's criminal justice system. The state's crime rate nonetheless continued to soar during his two terms as governor. Reagan's other major initiative came in the area of taxes. In 1973 he sent an initiative, Proposition 1, to the ballot dubbing it "the taxpayers' bill of rights."[32] The complicated proposition met widespread opposition and was doomed when Reagan joked that even he did not understand its complexities. But if the measure failed to pass, the issue of tax reform that Reagan had raised would blossom forth in an even more potent form in the following years.

Reagan completed his second term in January 1975. He had proved to be an able and popular governor. Much of his record could pass as easily as that of a liberal rather than that of a conservative. Under his governance, California had raised taxes and made its revenue system less regressive. The state budget had grown dramatically, though at a slower rate than in earlier years or in other states. He had increased welfare benefits, even while trimming the caseload. Through it all, he had continued to speak as a conservative; in later years he would describe his tenure as a triumph of conservative principles. To a degree it had been. Reagan had advanced the causes of welfare and tax reform. He had waged war against the forces of the New Left, black militants, and the counterculture and had won acclaim for his steadfast defense of anti-Communism, the war in Vietnam and traditional values. These issues would become the bedrock of the conservative resurgence of the 1970s and 1980s.

After leaving office in 1975 and setting his sights on the presidency, Reagan expressed a vision of the Vietnam War that would define the view of a generation of conservative insurgents and attract numerous adherents from the political center as well. Although Reagan's own perceptions of the origins of the Southeast conflict

Ronald Reagan's presidential inauguration in Washington, D.C., January 1981.

PHOTOGRAPH COURTESY OF RONALD REAGAN PRESIDENTIAL LIBRARY

often diverged from the truth, he believed that Vietnam had been a just, and even "noble war," "a collective act of moral courage." American soldiers had been forced to fight, "with one hand tied behind their backs by their own government." But, he repeatedly pronounced to enthusiastic audiences, "Let us tell those who fought in that war that we will never again ask young men to fight and possibly die in a war the government is afraid to win."[33]

Reagan's pollsters, as early as 1976, discovered a growing perception among many Americans that in the aftermath of Vietnam the United States had grown too passive and hesitant in its foreign policy. In his 1980 presidential campaign Reagan charged that we had lived with this "Vietnam syndrome . . . for too long." The United States had given way "to feelings of guilt as if we were doing something shameful." The lesson that Reagan drew from the Vietnam experience was "that if war comes we must have the means and determination to prevail or we will not have what it takes to secure the peace."[34] This was not the lesson promulgated by those who had supported the antiwar movement, but it proved an effective palliative for the broad cross section of Americans. They would elect Reagan to the presidency in 1980 and overwhelmingly reelect him in 1984. Indeed, the triumph of Reagan and his conservative ideology may well be the most significant legacy of California during the Vietnam War era.

NOTES

1. For the text of Reagan's speech, see Anne Edwards, *Early Reagan* (New York: William Morrow and Company, Inc., 1987).

2. Matthew Dallek, *The Right Moment: Ronald Reagan's First Victory and the Decisive Turning Point in American Politics* (New York: The Free Press, 2000), 69.

3. Lou Cannon, *Reagan* (New York: Perigee Books, 1982), 202.

4. Dallek, 51.

5. Kurt Schuparra, *Triumph of the Right: The Rise of the California Conservative Movement, 1945–1966* (New York: M.E. Sharpe, 1998), 104–5.

6. Ibid.

7. Lisa McGirr, *Suburban Warriors: The Origins of the New American Right* (Princeton: Princeton University Press, 2001), 205.

8. Dallek, 70.

9. Ibid., 22.

10. McGirr, 219.

11. Mark Green and Gail MacColl, *Reagan's Reign of Error* (New York: Pantheon Books, 1987), 33.

12. Dallek, 237; Schuparra, 135.

13. Cannon, 113; Edmund Morris, *Dutch: A Memoir of Ronald Reagan* (New York: Modern Library, 1999), 336.

14. Bill Boyarsky, *The Rise of Ronald Reagan* (New York: Random House, 1968), 139–40.

15. *San Francisco Chronicle*, September 9, 2002.

16. Dallek, 186.

17. William E. Pemberton, *Exit With Honor: The Life and Presidency of Ronald Reagan* (New York: M.E. Sharpe, 1998), 69; Boyarsky, 140.

18. Dallek, 192–93.

19. Cannon, 128; Boyarsky, 152.

20. Dinesh D'Souza, *Ronald Reagan: How an Ordinary Man Became an Extraordinary Leader* (New York: Free Press, 1997), 69.

21. Cannon, 122.

22. Cannon, 119.

23. Morris, 344.

24. D'Souza, 71–72.

25. Boyarsky, 205; W. J. Rorabaugh, *Berkeley at War: The 1960s* (New York: Oxford University Press, 1989), 84–85.

26. Boyarsky, 258; Morris, 383.

27. Schuparra, 145–46.

28. Cannon, 151.

29. Morris, 362.

30. Rorabaugh, 156; Morris, 362; Cannon, 152.

31. Cannon, 174.

32. Cannon, 189–90; Morris, 775.

33. Kiron K. Skinner, et al., *Reagan in His Own Hand: The Writings of Ronald Reagan That Reveal His Revolutionary Vision for America* (New York: Simon and Schuster, 2001), 479; Cannon, 271; Garry Wills, *Reagan's America* (New York: Penguin Books, 1988), 422.

34. Skinner et al., 481.

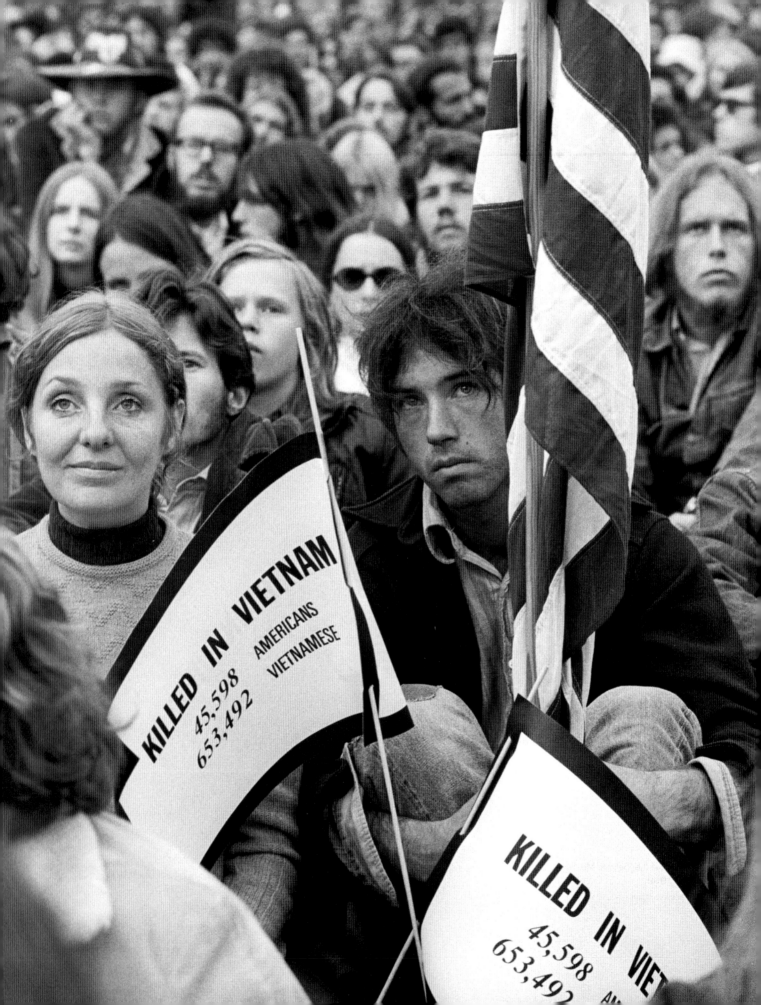

KILLED IN VIETNAM
45,598 AMERICANS
653,492 VIETNAMESE

KILLED IN VIE
45,598 A
653,492

CHAPTER 4

The War at Home:
California's Struggle to Stop the Vietnam War

R. Jeffrey Lustig

VIETNAM'S MADAM NHU came to California in late October 1963. Part Lady Macbeth, part Dragon Lady, she toured the country rallying support for her brother-in-law President Ngo Dinh Diem's beleaguered regime. It was the first time that most Americans had heard of Vietnam, but the day Nhu spoke at University of California Berkeley's Harmon Gymnasium was the last day of Diem's life and regime. A month later the chief in Washington, President John F. Kennedy, lay dead as well, Shakespeare's Macbeth having caught a political truth when he mused, "Blood will have blood."

All the players in the drama that soon gripped California were at Harmon Gymnasium that day: Madame Nhu representing a doomed regime in a civil war; the campus administration, like the United States government, providing an open forum but only one side of the story; and faculty sponsors and students standing in for a larger public that was concerned for orderly proceedings. And out in the street, excluded from the event, an infant California antiwar movement whose principal orator, Lenny Glaser, riveted the audience with prophecy as it exited the building. As activist Frank Bardacke remembers Lenny's words:

> You failed today. You failed your lesson in politics. And when you fail in politics it's a lot more serious than when you fail in a college course. When you fail in politics, you pay. And you are going to pay—in the jungles of Vietnam, in the deserts of Africa, in the pampas and mountains of Latin America. . . .

Participants in the Vietnam Moratorium protest in San Francisco, October 1969.

PHOTO BY STEVE SHAMES/POLARIS

The antiwar protests that emerged over the next few years on the campuses and in the communities of the state trying to staunch those costs wrote an indelible chapter in California history and shaped a social movement that transformed state politics and tens of thousands of lives in the process.

California was a natural epicenter for a national movement forced to invent itself outside the established institutions. It had always been a place for new beginnings and big ideas, a home to dreamers, con men, clairvoyants, and visionaries—a Land of Sunshine and Snake Oil. In the late fifties, Julius Lester, the Student Nonviolent Coordinating Committee (SNCC) writer announced, "While Fidel liberated the Sierra Maestra, the beat generation created a liberated zone in San Francisco."[1] Traditions like that are not without value in creating an opposition during wartime to the world's most powerful government.

PROLOGUE TO STRUGGLE

> The spirit of this country is totally adverse to a large military force.
>
> —Thomas Jefferson, 1807

Prior to World War II, America had always opposed large standing armies in times of peace, identifying them after its colonial experience with empire and aggression. The peace activism of the 1950s partly drew from this long tradition. During that decade groups like the Fellowship of Reconciliation, the Committee for a Sane Nuclear Policy (SANE), Women Strike for Peace, and Turn Toward Peace labored alongside direct-action pacifists to ban atmospheric nuclear testing, enact nonproliferation treaties, and promote disarmament. Their efforts, however, brought few victories. They left as

legacy for their successors not only inspiring examples but also evidence that the political system was curiously closed to logic in its military and nuclear policymaking.

Ngo Dinh Diem was installed as president of South Vietnam in 1955 after being introduced to Washington elites by University of California, Los Angeles (UCLA) Professor Wesley Fishel. Diem's repression soon forced his subjects into open protest and Buddhist monks into startling and tragic self-immolations. Madame Nhu famously referred to these as a barbecue—a remark indicative of the brutality with which the United States had become allied. Mistakenly seeing the protests as signs of a monolithic Communist bloc, American leaders embraced the South Vietnamese government's cause as their own.

At the same time, on America's West Coast rebellious youth had begun to defect from the silent generation. Jack Kerouac's protagonist in *Dharma Bums* (1958) called for a "rucksack revolution." Beyond the rucksack, the revolution entailed a scuttling of cold war practices. Not far from the beats' liberated zone, in May 1960, students from Stanford University, San Francisco State, and the University of California, Berkeley, ridiculed and publicly demonstrated against hearings by the previously feared House Un-American Activities Committee. Across the political spectrum, from Young Americans for Freedom (YAF) on the Right through Students for a Democratic Society (SDS) to the Young Socialist Alliance (YSA) on the Left, California's youth shed their elders' beliefs and found their own bearings. They joined the peace groups, the civil rights struggle, and organizations like Slate at Berkeley, a student group devoted to social and education reform.

I first heard about Vietnam at a Slate meeting in Berkeley in spring 1963. At that meeting, I discovered that there were already three contending proposals to

Jeff Lustig at a Free Speech rally on the University of California, Berkeley campus, 1964.

PHOTO BY PAUL FUSCO/MAGNUM PHOTOS

end the increasing American involvement in Vietnam. One position called for a unilateral cease-fire and United Nations–supervised negotiations to arrange for a non-Communist regime. Another favored immediate withdrawal of U.S. troops in line with the Geneva Accords, whatever the outcome. A third, withdrawal of U.S. troops in favor of the Vietnamese Communists. Those who attended such meetings in places like Berkeley, the San Fernando Valley, and throughout California, who read *I. F. Stone's Weekly* or the foreign press, understood as early as August 1964 that the Tonkin Bay Resolution, the closest thing the country had to a legal declaration of war, was the product of a staged pretext. By the end of 1964 more than 23,000 U.S. military personnel were in Vietnam. In response to the buildup, local activists called a small rally with folk singer Joan Baez at San Francisco's Union Square. When President Johnson

broke his campaign promises and escalated bombing into North Vietnam with operation Rolling Thunder on February 7, 1965, the antiwar spark fell on tinder which, though sparse, was well prepared.

1965: EMERGENCE OF THE ANTIWAR MOVEMENT

The California response to Johnson's action was surprisingly swift. Grounds for it had been laid by the recent Free Speech Movement (FSM) struggle on the Berkeley campus, and a web of contacts established in Los Angeles by the Peace Action Council (PAC) following a Pasadena talk by Senator Wayne Morse. Morse, a Republican from Oregon, had been one of only two legislators to oppose the Tonkin Bay Resolution. Both networks included hundreds of people who understood what the escalation meant and were prepared to act. Berkeley students marched on the local induction center. Demonstrations broke out at the Los Angeles and San Francisco federal buildings. Stanford University students rallied in protest. Unitarian ministers convening in Los Angeles along with the San Fernando Valley Peace Center, and later the Women's International League for Peace and Freedom (WILPF) and Valley Women for Legislative Action, called for a cease-fire and United Nations–supervised negotiations in South Vietnam.

The pace quickened over the course of the spring. In April, accompanying a 20,000-person SDS March on Washington, protesters staged rallies in San Francisco and Los Angeles. Fissures began to appear in mainstream organizations. The grassroots California Democratic Council, a group of 60,000 led by east San Diego publisher Sy Casady, became the first Democratic Party body in the country to oppose the war publicly. President Johnson's response to the protest was to dispatch another 20,000 troops to Vietnam.

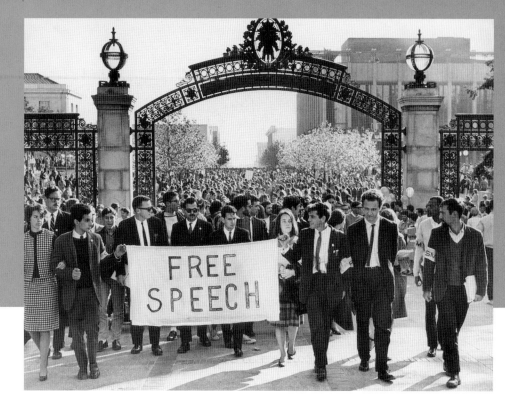

Free Speech protest, headed by the leaders of the movement including Mario Savio (second from right), passes through Sather Gate at the University of California, Berkeley, 1964.

OAKLAND TRIBUNE COLLECTION, GIFT OF ANG NEWSPAPERS, OAKLAND MUSEUM OF CALIFORNIA

Berkeley activists eyed the newly invented tactic of the campus teach-in and adapted it to California's over-sized ambitions. Taking advantage of the 1964 FSM victory providing students the right to assemble and organize political activity on campus, the Vietnam Day Committee (VDC) organized a thirty-six-hour, outdoor teach-in on the University of California campus. VDC planners later wrote that they saw that "the country's political party structure" provided no "outlet . . . to say 'no' to the war," and they set out to create such an out-let and new political space. They succeeded beyond their wildest dreams.

On May 21–22, crowds of up to 12,000 converged to listen to speeches about international law, Vietnamese history, and American foreign policy by nationally known scholars and policy experts. Attendees received advice on political strategy and nonviolent protest from veterans of the civil rights struggle and joined in protest songs with Joan Baez and Phil Ochs. They heard author Norman Mailer lambaste the president personally in words that also proved prescient: "You're a bully with an air force, and since you will not call off your air force, there are young people who will . . . hound you into nightmares and endless corridors, of night without sleep. . . . They will go on marches and they will make demonstrations against you which will never cease." The recent escalation in Vietnam and invasion of the Dominican Republic fresh in their minds, teach-in speakers were dissuaded from making any appeals to the Democratic Party. They appealed instead for massive civil disobedience. Historian Staughton Lynd drew applause when he called for "non-violent revolution."

In one stroke, the new movement succeeded in breaking the illusion of national pro-war consensus and in establishing its own moral and intellectual legitimacy. It also succeeded in placing the call for cease-fire and

immediate troop withdrawal at the center of the debate. That marked a departure from the older peace groups' posture of support for U.S. foreign policy. It also marked a departure from their cold war view of popular rebellions as standard-bearers for the presumed world communist bloc. Teach-in speakers argued that it was the United States that had installed Diem and encouraged him to betray the 1954 Geneva Accords and that the rebellion was originally a local insurgency against his rule. Speakers also posed the question: who was the United States, or even the United Nations, to dictate a sovereign nation's fate?

This and companion teach-ins around the state established the necessary foundation for any long-term protest: an independent analysis and point of view. The foundation was shored up and extended by the contributions of new alternative sources of information: pamphlets, books, magazines like *Ramparts*, underground newspapers like *The Berkeley Barb* and *Los Angeles Free Press*, and listener-sponsored radio stations KPFK and KPFA.

Antiwar activities gathered force throughout 1965. SDS regional offices were set up in Los Angeles and San Francisco, and new chapters formed in Southern California. People around the state began educating themselves about the issue, often starting with Robert Scheer's *How the United States Got Involved in Vietnam*. Different groups dispatched lecturers to churches and colleges, picketed induction centers, and opened draft counseling offices. They improvised "guerrilla" actions combining direct-action methods from the Civil Rights movement with a taste for the theatrical. They obstructed troop trains bound for the Oakland Army Base, followed napalm trucks to Port Chicago Naval Weapons Station in Contra Costa County in an official-looking truck, with flashing lights that blinked "Danger,

Members of the Hells Angels motorcycle club confront Vietnam Day Committee protesters at the Oakland border, October 1965. At the beginning of the war, members of the club were strongly anti-communist and supported U.S. policy toward Vietnam.

OAKLAND TRIBUNE COLLECTION, GIFT OF ANG NEWSPAPERS, OAKLAND MUSEUM OF CALIFORNIA

Napalm Bombs Ahead," and marched a distance of some twenty miles from the Claremont colleges east of Los Angeles to California State University, Los Angeles.

On October 15, 1965, over 100,000 people in sixty American cities and a dozen countries responded to the VDC's call for an International Day of Protest. Over 15,000 protesters responded with a peaceful march from Berkeley to the Oakland Army Base, where they were stopped by Oakland police officers and members of the Hells Angels motorcycle club at the Oakland border in a historic and briefly violent confrontation.[2]

By the end of the year, California had established a functioning antiwar movement, and one marked by characteristics that would distinguish it till the end of American involvement in the war. It was, first, like its national counterpart, heterogeneous, decentralized, and inclusive. It was guided by no central office, possessed of no single set of leaders, united by no single ideology.

It embraced liberals and radicals, secular and religious pacifists, Old and New Left. When the older cold war reformers tried to expel Communists, they were rebuked by nondoctrinaire radicals. Journalist Allen Zak warned them in the *Los Angeles Free Press,* "When the committees and their vigilantes beat the bush for reds, they beat the bush for thee."

The California movement also differed between the north and the south. In the Bay Area, PAC cochair Irv Sarnoff later noted, "the focus, the center of gravity . . . was campus-oriented. [But] the reverse . . . was true in the Los Angeles area," where the movement was community-based. There campus organizations "came to the Peace Action Council . . . for community support." If the mass demonstrations caught the public eye, it was the day-to-day work of the local groups, north and south, that provided the life and energy of the movement.

The movement and its groups were curiously unstructured. They lacked bylaws, fixed ideologies, often elected leaders. Berkeley's Campus Women for Peace, founded in 1962, epitomized the spirit when it announced, "Ours is a non-political group. We deal with issues, not parties or ideologies. . . . [We do] not have 'members' or 'officers.'" And in case anyone missed the point: "We are *not* an organization."[3]

The amorphous nature of these groups was a source of annoyance to campus deans, many Old Leftists and, one suspects, the FBI. But it was the expression of a positive choice. It was the sign of the continuing search, begun in the South by SNCC, for a new participatory kind of democracy. Activists sought to avoid the centralization and hierarchy of previous organizations. SDS leader Greg Calvert explained in 1967 that what counted in that organization was not "ideological clarity . . . or organizational stability," but only "that which creates *movement*."[4] California protesters early rejected the organizational methods of the lobby group and mass political party.

The antiwar movement was also roughly divided into three main strains, each with its own view of why the war happened and what it was about. One, called liberal, felt the war was only a misstep in an otherwise sound foreign policy. Rooted largely around the Democratic Party, the force of its counsel was weakened by the party's national divisions, its members' discomfort as champions of a minority cause, and their anxiety about antagonizing the president.

The pacifists, both secular and religious, based in organizations like the Palo Alto American Friends Service Committee, saw the war as a result of the deeper seductions of violence, and Americans' habit of letting their leaders conscript not only their bodies but their consciences. Urging an ethic of personal responsibility, their opposition to the war was thorough, their methods uncompromising, and their dedication to disengagement total.

The antiwar radicals joined them in also seeing the war as more than a mistake. For them it was a product of larger economic and political structures they identified as a new imperialism. Their resultant anti-imperialism was an outlook capable of embracing then-current critiques of technological society, racism, and materialism. "Our problem," the radicals concluded, "is in America, not Vietnam."[5] Demanding immediate withdrawal, they adopted direct-action methods, framed antiwar work as part of a multi-issue program, and aimed at effecting a larger social transformation.

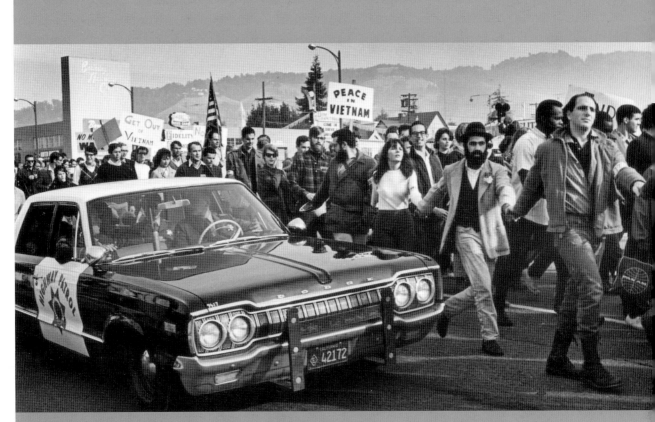

Vietnam Day Committee antiwar march from Berkeley to Oakland, 1965.

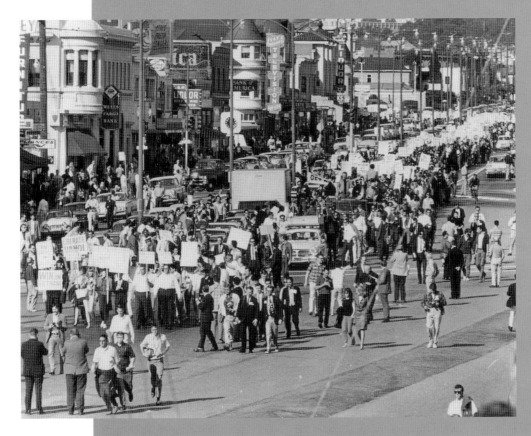

Some 15,000 people participated in the Vietnam Day Committee march, October 16, 1965. Note the small contingent of pro-war supporters at the front of the crowd.

1966–1967: THE MOVEMENT COMES OF AGE

The energy generated by the confluence of these protest streams under pressure from the increasing troop deployments intensified antiwar activity. On California campuses students continued to mobilize with rallies, teach-ins, and demonstrations against the army's Reserve Officers' Training Corps (ROTC) and against job recruiters from napalm manufacturer Dow Chemical. In Berkeley in May 1966, students held a war referendum, with "ceasefire and immediate withdrawal" topping five other possible positions.[6] Students around the state exercised the free speech right just won by the FSM by organizing off-campus activities. University of California Irvine students, for example, picketed El Toro Marine Corps Air Station in May 1966, and San Fernando Valley State College activists infiltrated Van Nuys Air Base and threw black crepe on the wings of departing bombers that November.

New community-based groups formed, especially in Los Angeles under PAC's aegis, until the coalition included 120 separate organizations and community peace centers, each creating protest space and providing a venue for their members' initiative. In March 1966, the Los Angeles arts community erected the renowned Artists Tower of Protest at La Cienega and Sunset Boulevards, with 400 antiwar panels painted by famous artists. The Valley Peace Center delivered thousands of voter pledge cards to congressmen in Washington. Protests occurred at post offices, civic buildings, and draft boards in places like Porterville, Visalia, and Santa Cruz. By summer 1969, 8,000 people, joined by a contingent of Camp Pendleton marines, converged on Nixon's Summer White House. Later that year, Fresno students sent a black plywood casket, papered on its inside walls with the names of the 45,000 Americans killed in Vietnam, to President Nixon.

Antidraft activity intensified with the expansion of Los Angeles SDS's successful high school organizing project, the opening of draft counseling offices around the state, and the founding in early 1967 of The Resistance, a pacifist organization that spread nationally, by Stanford student body president, David Harris. What had started as a small, marginalized protest began to attract important new constituencies. First among these was the religious community, starting in the Unitarian Church and spreading to a number of Protestant Churches, Jewish temples and, with the tireless efforts of the sisters at Immaculate Heart College in Los Angeles, at least one Catholic institution.

Second were civil rights groups after the Watts uprising of August 1965. SNCC and the Black Panther Party adopted an antiwar/antidraft position as early as 1966. The San Francisco–based SNCC *Movement* newspaper became a source of antiwar news. Martin Luther King Jr. chose Los Angeles to announce his opposition to the war in April 1967, identifying it as an obstacle to black economic progress. Activist Levi Kingston organized the South Central Freedom Draft Movement, which worked with Camp Pendleton marines.

Third, with an independent analysis established and a political base secure, some individual activists attempted to reenter the electoral arena on their own terms. Robert Scheer ran a watershed primary campaign against Jeffrey Cohelan, a cold war Democrat in California's Seventh Congressional District (Berkeley and parts of Oakland). He focused on the war, racism, poverty, and "the quality of life" and received 45 percent of the vote.

Close on the heels of Vietnam Summer, an effort aimed at local community organizing against the war, San Francisco's Proposition P was placed on the November ballot calling for a cease-fire and withdrawal of

troops (36 percent voted yes). Activists from the anti-war and Civil Rights movements formed the Peace and Freedom Party for the 1968 presidential election. It would remain for decades, in the words of historian Mike Davis, the most "viable, small, mass third-party" in the country.

Fourth, unknown to many protesters, California began to become a cauldron for GI antiwar protest. In late 1965 Master Sergeant Don Duncan, a Green Beret, quit his army career and moved to the Bay Area to begin writing and speaking against the war. He declared in the February 1966 *Ramparts*, "The whole thing was a lie. We weren't preserving freedom in Vietnam. There was no freedom to preserve. To voice opposition to the government meant jail or death. . . . We aren't the freedom fighters. We are the Russian tanks blasting the hopes of an Asian Hungary." African American marines at Camp Pendleton organized against the war and were disciplined during summer 1967. However, GI resistance to the war spread. Vietnam Veterans Against the War (VVAW) helped extend the message, as did the coffeehouses set up by peace activists near military installations, creating a safe place for GIs to have a free exchange of ideas without the control of superior officers. Californians Fred Gardner and Donna Mickelson began opening these near army bases in late 1967. Local activists near Camp Pendleton opened "The Green Machine" and six more coffeehouses in the state by 1970.

Large demonstrations continued to gather together local groups on a roughly semiannual schedule—in March 1966, for the Second International Day of Protest; in August 1966, for Hiroshima Day actions (bringing 10,000 people to San Francisco and hundreds for the first time to San Diego); in April 1967, for the huge Spring Mobilization rally of 75,000 at San Francisco's

A large crowd gathered at the dedication of the Artists Tower of Protest, built in West Hollywood, to hear ex-Special Forces Master Sergeant Don Duncan speak out against the war, February 26, 1967.
HERALD-EXAMINER COLLECTION, LOS ANGELES PUBLIC LIBRARY

Kezar Stadium. Growing labor support was clear at the Kezar march despite the pro-war stance of the national AFL-CIO. More than 7,000 union members joined the Kezar march, the Santa Clara Labor Council and various officials endorsed it, and Paul Schrade, West Coast director of the United Auto Workers (UAW), spoke at the rally. The days of small, marginalized protests were over. By November, over 40 percent of the public agreed that the war was "a mistake" and that withdrawal was necessary "as quickly as possible."[7]

The two events that revealed the changing character of the antiwar movement, burning images of the times into the memories of many for years to come, were the Century City demonstration in Los Angeles on June 23, 1967, and Oakland's "Stop the Draft Week," beginning on October 16, 1967. PAC and the Spring (later Student) Mobilization Committee (SMC) called the first of these to protest a visit of President Johnson to

Los Angeles. Following a rally at a local park, over 20,000 mostly mainstream, middle-class protesters set out to march past the Century Plaza Hotel where Johnson was staying. Without warning, according to organizer Irv Sarnoff, the Los Angeles police attacked protesters, transforming the march into a bloody rout and forcing a visibly shaken president to be airlifted off the hotel roof. Heads were broken, arrests made, and illusions dashed. Democratic Party leaders watched the assault on what they knew was their political base by the Los Angeles Police Department. Los Angeles became the first city in the country to break up an antiwar march with violence. President Johnson, Sarnoff notes, "from that point could not appear anywhere in the U.S. outside of a military base."[8]

A few months after this debacle, Bay Area activists operating out of SNCC *Movement* headquarters decided to up the ante themselves. Declaring it time to move "from protest to resistance," they announced plans to shut down the Oakland Induction Center the week of October 16–20. Pacifists from The Resistance had called for turning in draft cards during the same week. Though the two groups began with separate demonstrations on separate days, by Friday 10,000 militants and nonviolent pacifists engaged 2,000 local police and Alameda County Sheriffs in a general melee on the streets outside of the induction center. When they failed to halt the arrival and processing of inductees, the militants turned to mobile tactics, disrupted city traffic, and broke windows in nearby stores. The example spread to

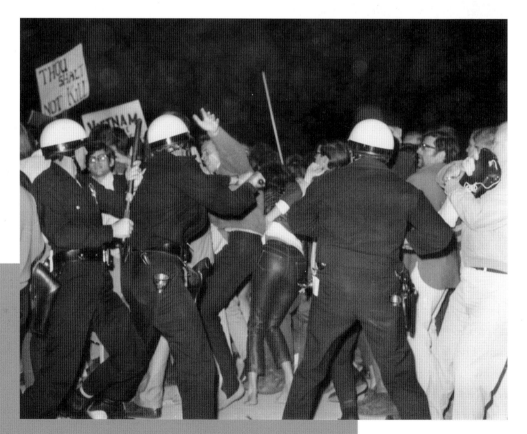

During the Century Plaza demonstration in Los Angeles, police push vigorously into demonstrators in an attempt to clear the streets of 10,000 protesters as President Johnson attended a fund-raising dinner, June 23, 1967.

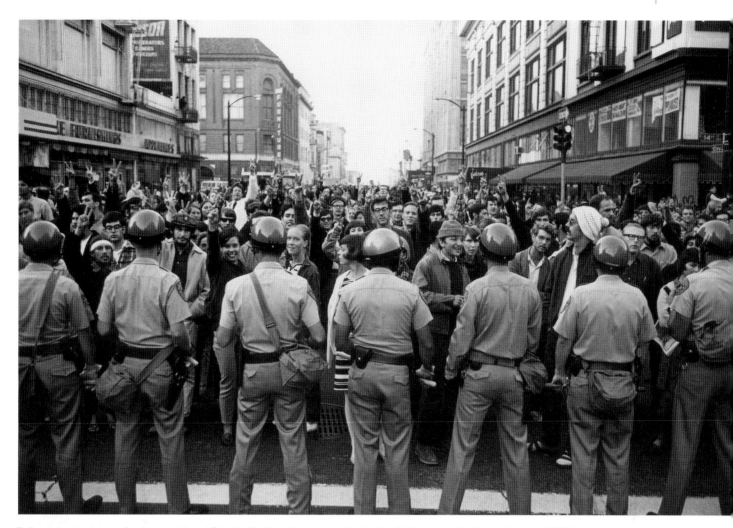

Police and protesters confront one another at Stop the Draft week protests in front of the Oakland Induction Center, October 1967.
PHOTO BY DOUGLAS WACHTER

other cities across the country, growing in size and fervor. After these events, talk about nonviolence in the movement gave way to assertions of a "right to self-defense."

In the midst of the Oakland event, a few inductees on a bus en route to the induction center flashed the "V" sign in solidarity with the demonstrators, thus inventing what would become the universal movement sign. The week also provided the context in which Minnesota Democratic Senator Eugene McCarthy announced in Los Angeles his candidacy for president on an antiwar ticket.

Hindsight, however, is misleading. The activity and excitement are readily remembered. Easily forgotten was the growing sense of futility and frustration that gripped many people as the war continued to escalate, increasing numbers of Vietnamese were killed and displaced, and repression grew at home. In late 1966 Secretary of Defense Robert McNamara announced that the conflict would end within the year. However, the war not only continued but also expanded. By early 1967 U.S. military personnel numbered more than 375,000 in Vietnam. Body bags multiplied. Congress failed to stop the carnage. Frustration for many periodically

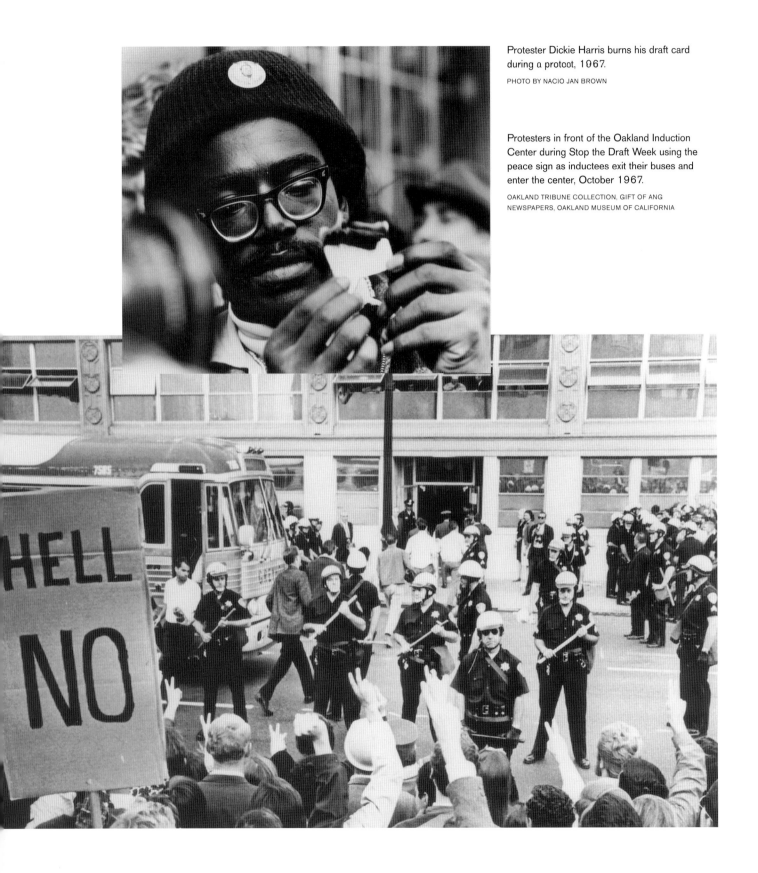

Protester Dickie Harris burns his draft card during a protest, 1967.

PHOTO BY NACIO JAN BROWN

Protesters in front of the Oakland Induction Center during Stop the Draft Week using the peace sign as inductees exit their buses and enter the center, October 1967.

OAKLAND TRIBUNE COLLECTION, GIFT OF ANG NEWSPAPERS, OAKLAND MUSEUM OF CALIFORNIA

turned into despair. In Panorama City in August 1967, Navy veteran J. D. Copping, brooding over the war, burned himself to death in the ultimate act of protest. In October 1967 a thirty-six-year-old Buddhist woman in San Diego did the same. A week later, fifty-five-year-old Florence Beaumont followed. A mother of two, she had been the mainstay of the San Gabriel Valley Council Against the War. After the invasion of Cambodia in May 1970, a fourth victim, George Winne, committed suicide in Revelle Plaza at the University of California, San Diego. California thus accounted for four of the seven known tragic self-immolations in protest against the war.

In these circumstances, activists struggled to find ways to maintain movement activism and pressure on the Johnson administration. Activist Jerry Rubin, working with the National Mobilization Against the War, proposed that the goal of the 100,000-person rally at the Pentagon at the end of "Stop the Draft Week," October 21, would be to "levitate" that menacing edifice and exorcise its evil. The proposal struck many as bizarre. But there was a subliminal logic to it. The movement had been engaged in a constant fight to create and re-create political space outside the established channels and to avoid being marginalized by politicians and mainstream media. Seen against that background, Rubin's idea can be understood as intended less to levitate the Pentagon than to lift the movement itself, to raise it by force of imagination out of the dead end to which it was afraid of being confined. Astonishingly, it worked. It made sense, moreover, that the idea had come from an emissary from California, home of the be-in and other social novelties.

But the countercultural drift evident with the gambit has also attracted serious criticism. Some historians have viewed it essentially as a self-indulgent prank, a retreat to the realm of the symbolic that indicated an escapism and flight from real politics, something that would alienate the middle class and did indeed reflect the doubtful course of the California movement. Viewing that drift in this way, Todd Gitlin in *The Sixties: Years of Hope, Days of Rage* (1987) wrote that the "new politics of alienation," the "millennial, all-or-nothing mood . . . [was] a poor training for practical politics." That verdict oversimplifies the dilemma faced by the antiwar movement, however, and misses a good deal of what was occurring.

The politics of the movement by the late 1960s turned increasingly in a symbolic direction. But conventional politics had never been open to it in the first place. The movement had not been built through conventional politics. The people who joined were not looking for training in practical politics; they were working to end a war that was fully backed by practical politicians. Nor were appeals to the majority of voters significant in enabling the protests to keep attracting new recruits. Part of the California movement's strength lay in its firm moral stand, its imagination, and its audacity in breaking through stale forms with fresh appeals. Another part lay in its ties, outside the narrow political channels, with the values and larger politics of the counterculture. Protester and hippie were different in degree and method; yet their efforts had sustained each other from the beginning. The social experiments (the free universities, communes, free clinics, free churches, food-buying co-ops, the Peace and Freedom Party, Diggers, San Francisco Newsreel, El Teatro Campesino, and the Mime Troupe) in the Haight-Ashbury and other enclaves around the state like Ocean Beach and Santa Monica, provided the energy, alternative values, and the ecology necessary to sustain an independent protest deprived of official standing. Those values were

capable of reaching out to kindred souls in ways interest-group politics did not. When the *Fresno Bee* announced the antiwar "Angry Arts Be-In" of May 1967, with readings by beat poets Robert Duncan and Galway Kinnell, it is significant that the article writer chose to begin: "A bit of Haight-Ashbury will bloom in Fresno this weekend."

That such politics had its dangers and limitations is true. That cultural rebellion also had casualties (not only the blown minds but also, for some later, a fantasy-driven politics) is also true. But the successes and tragedies were of a piece and inseparable, both signs of a break from familiar ways and of a politics forced to maneuver on narrow, often invented, terrain. Without that break, however, the West Coast movement would not have become what it was and the national movement itself might have been less successful.

1968–1970: CLIMAX OF CONFLICT

Alas, poor country,
Almost afraid to know itself. . . .

—William Shakespeare, *Macbeth*, IV, iii

The Tet Offensive of January 1968, which briefly seized control of provincial capitals and the U.S. embassy in Saigon, changed everything.[9] Within a month McNamara and General William Westmoreland, commander of U.S. Forces in South Vietnam, were gone. In two months, Johnson renounced a second term.

At home, Americans paid the price of their failed political lessons in growing violence. Within months of each other, Martin Luther King Jr. was murdered, and then Robert F. Kennedy in Los Angeles, after winning California's presidential primary on an antiwar plank.

Californians played a major role in the riot at Chicago's Democratic Convention in August 1968. Black Student Union demands sparked strikes at San Francisco State University in fall 1968, at Berkeley in spring 1969, and a number of conflicts in other places. In the perspective of the Black Student Union and other "Third World" groups, American minorities were internal colonies engaged, like the Vietnamese, in struggles for liberation. That spring in Berkeley, defenders of People's Park were beaten and arrested by Alameda County Sheriffs, and campus protesters fought pitched battles with police over Dow Chemical recruiters at San Jose State University and ROTC programs at other campuses.

Antiwar organizations became increasingly subject to surveillance and dirty tricks. By spring 1969 the California legislature was studying over a hundred bills that proposed stiffer punishments for students involved in sit-ins and campus takeovers. Vigilantes bombed antiwar offices (having started with the Berkeley VDC office in spring 1966), and in San Diego shot up antiwar meetings.[10]

In the face of these heightened stakes, local organizers continued to build support. The Valley Peace Center dispatched a Draftmobile to Los Angeles high schools, while other high schools hosted debates on the war. Fresno's Roosevelt High School conducted a poll on the war in 1969 in which 54 percent of the students voted in opposition to the war. The Pacific Counseling Service, with offices in Okinawa and Tokyo as well as on the West Coast, joined other draft counseling services in 1969 advising potential draftees and active-duty personnel on their right to oppose the war. Thirty SDS chapters emerged at state and junior colleges in Los Angeles. Local coalitions multiplied, those in the San Joaquin Valley joining together into the Valley Mobilization Committee by late 1969.

Mrs. Pat Arnold of the Valley Peace Center passes out antidraft information to students at
North Hollywood High School, October 8, 1967.

LOS ANGELES TIMES COLLECTION, UCLA LIBRARY DEPARTMENT OF SPECIAL COLLECTIONS

On April 26, 1968, a 30,000-person march in San Francisco, called by the SMC, was led by four active-duty soldiers, revealing a growing "war within the war." The antiwar military now included disaffected National Guard units, a growing underground GI press, and the Movement for a Democratic Military (MDM). The latter, founded by Camp Pendleton marines, soon spread through the San Diego naval complex, then to Alameda and beyond.[11] By 1971 there were more than twenty-six antiwar coffeehouses nationally and more than 144 underground GI papers (sporting names like *About Face* and *Attitude Check* at Camp Pendleton, *Travisty* at Travis Air Force Base in Fairfield, and *As You Were* at Fort Ord near Monterey), including some in Vietnam.

A contingent of 500 active-duty service people led the SMC-organized Civilian-GI March, October 12, 1968, in San Francisco, under the slogan "GIs and Vets March for Peace." Two days later the Presidio 27 "mutiny" erupted at San Francisco's Presidio stockade, announcing to the entire nation the change in mood that had occurred at a major disembarkation point for the war. Marines staged a violent brig rebellion at Camp Pendleton in August 1969.[12] California was now the point of contagion for an epidemic of GI resistance and combat refusals.

But with over a half-million troops in Vietnam the escalation continued, along with a growing repression at home and a recurring sense of futility.[13] Richard Nixon, who had taken office in 1969, refused to end the conflict, despite his campaign rhetoric. Open splits appeared in the movement leadership. The coalition builders, on one hand, strove to keep building public demonstrations focused on the single issue of the war in order to maximize the involvement of local groups. But many seasoned protesters, seeing that the roots of the war lay deeper than personality and party, decided that speaking truth to power was no longer enough. They saw the urgency of extending the resistance

Servicemen from all branches of the military participating in an antiwar march in
Los Angeles, c. 1969.

PHOTO BY JEFFREY BLANKFORT

beyond the campuses and felt that the country's ability to wage war had to be actually impaired.[14] These activists began to call themselves revolutionaries—no longer employing the qualifier "nonviolent." SDS broke in mid-1969 into separate fragments, some like the Weathermen, vowing to "Bring the War" home and veering in a less public and more hazardous direction.

West Coast coalition builders were, however, playing a large role in national organizations, some now helping to plan a huge Vietnam Moratorium for the end of 1969. This would mark the peak of antiwar protest and the emergence of a genuine mass antiwar movement. On October 15, 20,000 people turned out in protest at UCLA, a few thousand at University of Southern California, and hundreds in local communities throughout California. On November 15, a quarter-million people rallied in San Francisco, swollen by contingents from Fresno, Merced, Sacramento, and other cities. Several hundred marines paraded protest in Oceanside, near Camp Pendleton. Even GIs in Vietnam held supportive actions. *Life* magazine called the November dissent "without historical parallel" in America. Nixon's key national security advisor, Henry Kissinger, later reported that the White House grew to fear these demonstrations. Daniel Ellsberg believes they stayed the president's decision to carpet-bomb Hanoi and mine Haiphong harbor for two-and-a-half more years, saving many hundreds of thousands of lives.[15]

Continued mass mobilizations (like the first Chicano demonstration of 6,000 in East Los Angeles) alternated in early 1970 with violent actions (like the burning of the bank at Isla Vista and assault on Berkeley's ROTC building). In May this grim tempo led to an outburst of rage against Nixon's invasion of Cambodia and the Ohio National Guard murder of four Kent State students, along with the killing of students

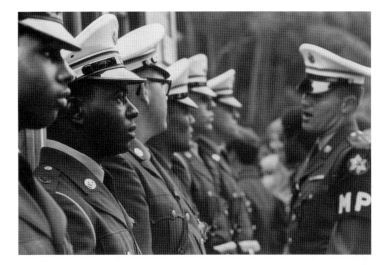

The soldiers under court martial for mutiny during the Presidio Trial, October 1968.

PHOTO BY JEFFREY BLANKFORT

at Jackson State College in Mississippi. In response strikes shut down nearly every major campus in California. Outraged student protesters clashed with police. Ensuing demonstrations drew 12,000 in San Diego and 10,000 in Sacramento, in addition to huge crowds in cities across the state. At Berkeley's Greek Theater, lawyer and former Slate leader Mike Tigar, citing relevant clauses of the United Nations Charter and U.S. Constitution, concluded in stentorian tones to a crowd of 10,000: "Today . . . the president of the United States is a war criminal, and my country is an international outlaw."

In late August the huge 25,000-person Chicano Moratorium march took place in East Los Angeles. Historian Frank Halstead judged it "the largest and most significant action of any oppressed nationality in the U.S. against the war in Vietnam." That event, the police assault on the demonstrators, and the murder of *Los Angeles Times* journalist Ruben Salazar spurred the growth of Chicano nationalism among the young, and broke the pro-war consensus among their older Mexican American leaders.

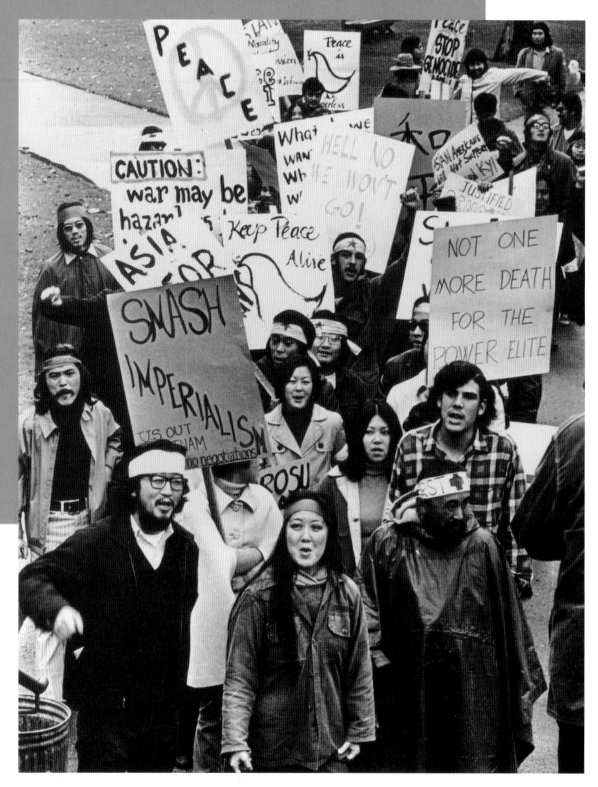

A group of demonstrators, most of them Asian American, marched on
Wilshire Boulevard in Los Angeles toward the Ambassador Hotel where
South Vietnam's vice president Nguyen Cao Ky spoke, December 3, 1970.

FROM AIR WAR TO PEACE ACCORD

If you're not asking the right questions, there are no right answers.

—Ani DiFranco[16]

The antiwar movement in California moved in new directions after May 1970. Remaining support for the war crumbled. Draft refusals multiplied. San Francisco and Marin County referenda revealed majorities favoring immediate withdrawal. Mass demonstrations continued at their half-year intervals—in April 1971 (with 300,000 in San Francisco, the largest ever on the West Coast) and in November 1971. Demonstrations broke out when Nixon resumed bombing of North Vietnam in April 1972, and in response to his horrific ten-day bombardment of that country, in late December 1972. During that onslaught U.S. planes dropped the equivalent of five Hiroshima-type bombs on soldiers and civilians of Hanoi and Haiphong, evoking from Europeans and Americans the charge of terror bombing.[17]

In June 1971 Daniel Ellsberg and Anthony Russo released the "Pentagon Papers" from Santa Monica's RAND headquarters, blasting away whatever pretenses remained for supporting the war—its causes, operation, and expected results.

But Nixon and Kissinger pressed on, trying without success to wrest victory from a project based on false premises. Their efforts cost 20,000 more American and hundreds of thousands of Vietnamese, Cambodian, and Laotian lives. The protests and flawed leadership, however, were taking a toll. "By 1969 the Army had ceased to function as an effective fighting force." By 1971 the U.S. military recorded seventeen AWOLs (Absent Without Leave) and seven desertions for every one hundred soldiers.[18] Nixon shifted to a new kind of war, one that withdrew troops, "Vietnamized" the ground war, and depended on punishing, often indiscriminate, American air assaults. It was a model to which the United States would return in later international conflicts.

Nixon's policy provoked the growth of the Stop Our Ship (SOS) movement. In the previously promilitary capital of San Diego, a popular vote was held in October 1971 to determine whether the aircraft carrier USS *Constellation* should sail for Vietnam. Fifty-four thousand San Diegans and 6,900 active-duty service-people participated, 82 percent and 73 percent respectively voting to keep the "Connie" home. The crew of the carrier USS *Coral Sea* in Alameda followed suit. A three-day rebellion occurring largely around racial issues closed Travis Air Force Base in May 1971. Sabotage kept the carrier USS *Ranger* from departing Alameda for duty in 1972. The "first mass mutiny in the history of the U.S. Navy," according to the *New York Times*, also delayed the *Constellation*'s departure from San Diego in November 1972. Thousands in uniform asked privately what Lieutenant John Kerry demanded publicly at the Vietnam Veterans Against the War (VVAW) march in Washington, April 1971: "Who wants to be the last man to die in Vietnam? How do you ask a man to be the last man to die for a mistake?"[19]

Revelations of the secret, unconstitutional wars in Cambodia and Laos moved the Democratic Party and Congress to finally act. Democrat and antiwar congressman Ronald Dellums was elected from the Bay Area's Seventh District in 1970. California Republican Pete McCloskey of Palo Alto broached impeachment of Richard Nixon even before Watergate. George McGovern, an antiwar senator from South Dakota, captured the Democratic presidential nomination in 1972. Moreover, a citizens' group, the Coalition to Stop the Convention, forced the Republicans to move their presidential convention from San Diego to Miami in the summer of

1972. Under fire from new quarters, and facing an impending Watergate debacle, the president finally signed the Paris Peace Accords of January 27, 1973. Two years later, the U.S.-backed South Vietnamese regime fell on April 30, 1975.

CONCLUSION

Over the course of a decade dissenting Californians built a mass protest against the war in Vietnam. In defiance of national politicians and constant efforts to discredit them, the dissenters prevailed in persuading thousands of fellow citizens of the truth of their convictions. These activists continued guiding new streams of protest into an ongoing movement. This movement did not just happen. It was not a fated product of the war or the times. "Before something happens," former Berkeley activist and San Diego native Frank Bardacke quipped, "people often think it's impossible. Right after it happens, they say it's 'easy to explain.' In twenty years it has become inevitable." But despite the way it may seem today, the growth of an antiwar movement was not inevitable. It was created and shaped by choices, by conscious plans made against the odds, and by a willingness to take risks to try to wrest events from their senseless and cruel trajectory.

The first step in the creation of a California antiwar movement was the founding of independent groups throughout the state from San Diego to Arcata. The second was the establishment of an autonomous point of view; the third, the painstaking day-to-day planning, self-education, and activity of these groups; and the last, their regular mobilization at large public demonstrations. Though the decentralization and eclecticism of these methods could often give rise to internal conflict and debate, it also provided the dispersed initiative and tactical flexibility without which the protest as a whole could never have overcome the large obstacles placed in its path.

California's antiwar movement also had significance beyond the war. It reestablished the legitimacy of dissent in a state which, before the hothoused unity of World War II and McCarthyism, had hosted a wealth of social experiments, novel ideas, and independent leaders. It paved a way for youth to escape the conformity and irrelevance of their 1950s role and act with integrity in the politics of the nation.

In pursuit of a political objective the movement was also forced to pioneer a new kind of politics. It was a politics in which people acted themselves instead of petitioning others to act for them, looked to the public good rather than private interests, and took their bearings from moral values rather than institutional agendas. Politics is said to be the art of the possible, but this politics was one that succeeded in disclosing *new* possibilities, unsuspected by the protesters' fellow citizens and dissembling leaders.

This is not to say that the California movement was successful in everything it attempted. Questions were raised that in its brief compass it was never able fully to answer. These remain for future protesters to address. How should participatory political organizations be structured to preserve bottom-up initiative and also sustain focused political activity over time? How should nonviolent politics be upheld in struggles to secure major social change and in a society prone to violence? Historian Nigel Young notes the activists' anti-imperialist stance permitted "an anti-capitalism independent of class analysis."[20] What would a class analysis keyed to modern corporate capitalist and racially divided America reveal? How, finally, can the victories of symbolic politics be transformed into long-term political advances? California's antiwar protesters did not succeed

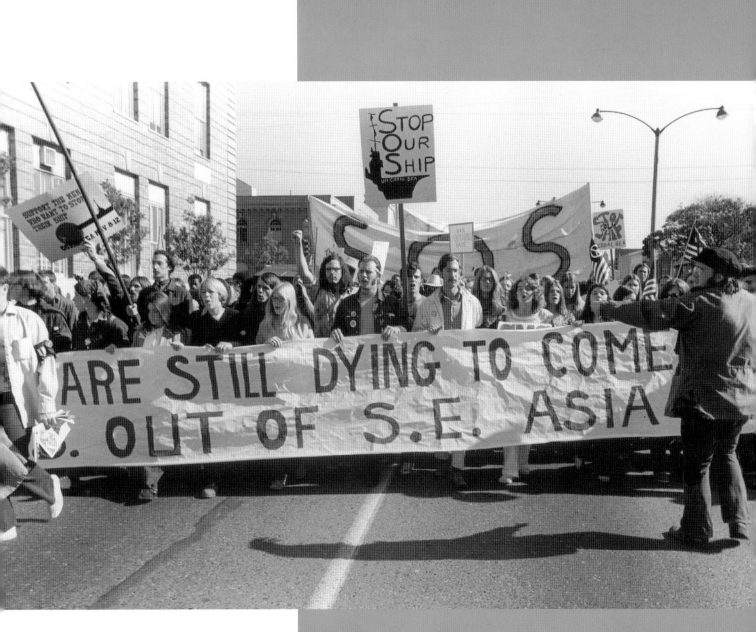

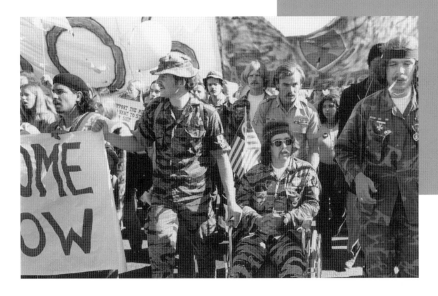

Stop Our Ship march down Geary Street in San Francisco, 1971.

PHOTO BY HAROLD ADLER

Vietnam Veterans participating in the Stop Our Ship march in San Francisco, 1971.

PHOTO BY HAROLD ADLER

in gaining the larger understanding and social footing necessary to answer these questions and sustain their struggles for a democratic foreign policy and new politics after the war.

Yet, starting from scratch, and relying only on their own indignation and commitment and the latent sense of justice of their fellow citizens, they did succeed in creating an ongoing movement unique in the country for its ties to the counterculture, its multi-ethnic involvement and the breadth of its GI resistance. They also helped reveal for all to see that the authorities and experts could be dead wrong on the fundamental issue of the day. In all this they helped to construct a national power capable of eventually constraining the options of the U.S. government in its efforts to destroy a popularly supported and determined struggle for national independence.

California's antiwar movement succeeded for a time, then, in "levitating" itself and the larger society. It spoke to a population increasingly enclosed in what poet Allen Ginsberg called a "Moloch . . . of cement and aluminum" and showed by its very existence that the future had not been closed off. The routes had not all been mapped. An informed and organized citizenry could still redefine the narrowed options presented by its leaders. That, finally, is what attracted the young and continues to intrigue Californians and the nation—not so much what the movement did, as what it was.

That is the period's real legacy. Whatever its limits and shortcomings, California's antiwar movement took the ingenuity for which the state is famous and boldly applied it beyond hula hoops, theme parks, or even computer chips to the more important art by which we govern ourselves. The movement represented political possibility. It embodied the search for new forms of participation—a search worth resuming, unless we wish to keep paying for failures of political understanding like those that Lenny Glaser had identified way back at Madame Nhu's speech in Berkeley in 1963.

Thanks to Maureen Fessler for invaluable and extensive research for this article; to Oakland Museum staff, Diane Curry and Stacey Zwald, for their help; and also to Nigel Young and Stew Albert, among others, for reviewing and making suggestions for this chapter.

NOTES

1. Julius Lester, *Search for a New Land: History as Subjective Experience* (New York: Dial Press, 1969), 30–31.

2. Sonny Barger, Hell's Angels leader, later denied regrets for his checkered career "except maybe [the affair with] the antiwar demonstrators." *Time*, May 26, 1980, 11.

3. Jackie Goldberg, Deborah Rossman, and Janet Salaff, in Campus Women for Peace statement, Fall 1964.

4. On principles of participatory democracy, see Kirkpatrick Sale, *SDS* (New York: Vintage Books, 1973), 317, 280.

5. SDS's Clark Kissinger, 1965, in Charles DeBenedetti, *An American Ordeal: The Antiwar Movement of the Vietnam Era* (Syracuse, N.Y.: Syracuse University Press, 1990), 114. The anti-imperialism implied an anticapitalist stance, but sixties activists first avoided the term capitalist because they felt it was "an inadequate description of the evils of America," Paul Potter explained, "a hollow, dead word tied to the thirties." The term also ignored racism and the problems of post-scarcity society. Fred Halstead, *Out Now! A Participant's Account of the Movement in the United States Against the Vietnam War* (New York: Monarch Press, 1978), 42–43.

6. Runners-up were: United Nations–supervised elections; cease-fire and negotiations; stay defensively; Lyndon Johnson's current position; and all-out escalation.

7. Fall 1967 polls, Halstead, 349, and DeBenedetti, 195.

8. A byproduct of the debacle was the creation a few months later in Los Angeles of Another Mother for Peace, an organization which would grow to national importance and 236,000 members by 1972.

9. The Tet Offensive beginning on January 31, 1968, put provincial capitals, major cities, and the U.S. embassy in Saigon under attack. It took several weeks for U.S. and South Vietnamese troops to retake all of the captured cites, including the former imperial capital of Hue.

10. Sale, 547, 550. Steven Roberts, "FBI Informer Is Linked to Right-Wing Violence," *New York Times*, June 23, 1975.

11. Resistance to Vietnam posting occurred, for example, in Los Angeles's First Squadron of the 18th Armored Cavalry. *Los Angeles Times*, October 4, 1968. See H. W. Haines, Introduction to Haines, ed., "GI Resistance: Soldiers and Veterans Against the War," special issue, *Vietnam Generation* 2, no. 1 (1990): 3–7; and J. Hayes, "The War within the War," in Haines, ed., 9–19. On the deeper struggle between contemporary military demands and American citizen-soldier traditions and ideals, see Richard Moser, *The New Winter Soldiers* (New Brunswick: Rutgers University, 1996).

12. Robert Sherrill, "Anderson by the Sea: The Pendleton Brig," *The Nation*, September 15, 1969, 239–42.

13. At their peak in April 1969, 543,000 U.S. troops served in Vietnam; 45,000 troops had been killed up to that time, 155,000 wounded.

14. See Mike Klonsky, "Toward a Revolutionary Youth Movement," December 1968; Sale, 506–7. "Speak truth to power" was a Quaker phrase and titled a 1955 American Friends Service Committee policy paper.

15. DeBenedetti, 285; Halstead, 492.

16. *The Nation*, January 7, 2002, 23.

17. DeBenedetti, 344; Halstead, 696–97. The casualties from the 1965–66 bombings had been reported by the CIA as "about 80 per cent civilian," already marking them as terroristic. *The Pentagon Papers: New York Times Selections* (New York: Bantam Books, 1971), 513.

18. At the final count 3,000,000 Americans served in Vietnam, of whom 300,000 were wounded and 58,000 killed, 46,000 in combat. Statements on the demoralization in the military: David Cortright, "Black GI Resistance during the Vietnam War," in Haines, ed., 50–64; Moser, 77–80; and B. D. Ayers, "Army Is Shaken by Crisis in Morale and Discipline," *New York Times*, September 5, 1971.

19. DeBenedetti, 308.

20. Nigel Young, *An Infantile Disorder? The Crisis and Decline of the New Left* (Boulder: Westview, 1977), 182–83.

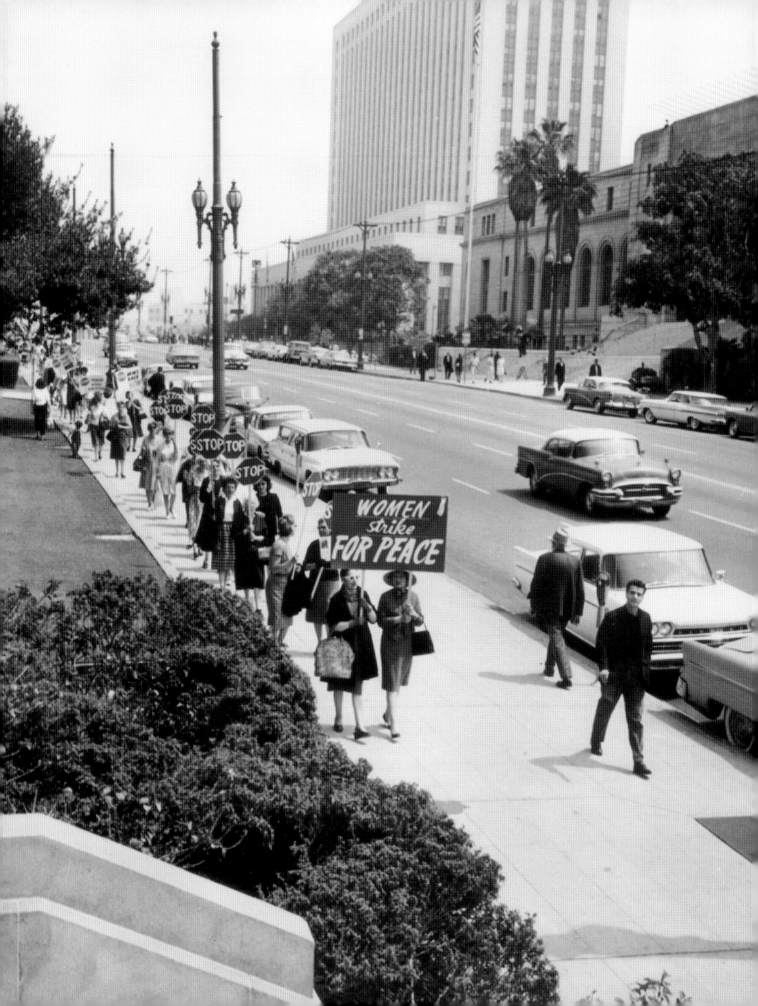

CHAPTER 5

The Feminist Revolution in California

Ruth Rosen

BURSTS OF artillery fire, mass strikes, massacred pro-testers, bomb explosions—these are our images of revo-lution. But some revolutions are harder to recognize: no cataclysms mark their beginnings or ends; no casualties are left lying in pools of blood. Though people may suf-fer greatly, their pain is hidden from public view.

Such was the case with the women's liberation movement in California. Activists did not hurl tear gas canisters at the police, burn down buildings, or fight in the streets. But they did subvert authority and trans-form society in dramatic and irrevocable ways; so much so that young women who come of age in the twenty-first century may not even recognize the America that existed before the feminist revolution.

The Vietnam War helped launch that revolution, by igniting protest and prompting women to question all kinds of received authority. Before the revolution, during the 1950s, women lived in a different world. Newspaper ads separated jobs by sex; employers paid women less than men for the same work. Bars often refused to serve women; banks routinely denied women credit or loans. Some states even excluded women from jury duty. Radio producers considered women's voices too shrill to be on air; television executives believed women did not have enough credibility to anchor the news; no women ran big corporations or universities, worked as firefighters or police officers, sat on the Supreme Court, installed electric equipment, climbed

Members of Women Strike for Peace march in Los Angeles to protest the resumption of nuclear weapons testing, April 27, 1962.

Young women participate in the 1960
Democratic Convention in Los Angeles
as hostesses, July 1960.

HOLLYWOOD CITIZEN NEWS/VALLEY TIMES
COLLECTION, LOS ANGELES PUBLIC LIBRARY

telephone poles, or owned construction companies. All hurricanes bore female names, thanks to the widely held view that women brought chaos and destruction to society.

As late as 1970, Dr. Edgar Berman, a well-known physician, proclaimed on television that women were too tortured by hormonal disturbances to assume the presidency of the nation. Few people knew more than a few women professors, doctors, or lawyers. Everyone addressed a woman as either Miss or Mrs., depending on her marital status, and if a woman wanted an abortion, legal nowhere in the United States, she would be forced to risk her life with a quack in a back alley if she failed in her search for a competent and compassionate physician. The public believed that many rape victims had probably "asked for it," most women felt too ashamed to report it, and no language existed to make sense of marital rape, date rape, domestic violence, or sexual harassment. Just two words summed up the hid-

den injuries women suffered in silence: "That's life."

The great accomplishment of the women's movement was to name and address these hidden realities. Once named, they could be debated. Once debated, people could lobby for legislation, change institutions, and challenge customs.

With its long and colorful tradition of nurturing both political and cultural dissidents, California played a central role in fomenting that revolution and in "naming" the hidden injuries in women's lives.

As was the case elsewhere, the Civil Rights and antiwar movements spawned several generations of women who recognized, with considerable anguish and anger, that neither traditional liberalism nor the politics of the New Left was addressing what equality could mean for modern working women. As these women activists learned to see the world through their own eyes—through their participation in the Civil Rights, free speech, student, and antiwar movements—they gradu-

ally came to understand that they had not even begun to name the secrets that shaped women's lives.

The change came swiftly and was most visible and concentrated in the San Francisco Bay Area, home of both the Free Speech Movement (1964) and Summer of Love (1967). In May 1964 the *Daily Californian,* the student newspaper at the University of California, Berkeley, published the exciting news that "Energetic Women Discuss the Role of Educated Wives." Less than six years later, in January 1970, the same newspaper announced a campuswide women's liberation conference titled "Women to Break Shackles." Accompanying the announcement was a photograph from a skit of a woman on her knees, her mouth open in a silent scream.

In the intervening years, some young women felt like they had lived several lifetimes. Outward appearance told part of the story. They had replaced matronly shirtwaists, tight undergarments, teased and sprayed hair, and heavily made-up faces with miniskirts, bell-bottom pants, granny dresses and granny glasses, long, dangling earrings, unshaved bodies, long, straight hair, little or no underwear, and faces without make-up. Their thinking had changed even more dramatically as their sense of entitlement had grown. By 1965 the Zeitgeist, that indescribable but palpable spirit of the times, was affecting much of college youth. Each year, college-educated young women—as well as the larger public—began to take seriously what was still referred to as the "modern woman's dilemma," shorthand for the debate over women's proper role in modern society. The younger generation of women emerging from the 1950s was shaking off the dust and detritus of that decade, and beginning to question all kinds of received wisdom. With one foot firmly planted in the world of their mothers, daughters of the fifties viscerally feared the constraints experienced by the adult women around them.

Women at a Free Speech rally, 1964.

HELEN NESTOR, PHOTOGRAPHER
OAKLAND MUSEUM OF CALIFORNIA, GIFT OF THE ARTIST

Fear of becoming an "ordinary housewife"—in the words of Berkeley feminist writer and antiwar activist Susan Griffin—is what fueled the female generation gap. Soon younger women began to enter the political, social, and cultural movements then sprouting on and around California college campuses. "The Movement," as it came to be called, included a network of friendships, sexual partners, spouses, and communal living arrangements in which the alienated daughters of the fifties had taken refuge. And it was here that the origins of the women's liberation movement would be found.

Nearly all the women who pioneered the women's movement learned to question conformity and conventional wisdom through their activism in the Civil Rights and antiwar movements, which were especially active on the Berkeley campus. It was here that they learned to question race supremacy, as well as the nation's foreign policy. It was here that they learned to speak to crowds, write position papers, and recruit

others into the movement. And, ironically, it was men in these movements who caused them to question their subordinate role as women.

Vivian Rothstein was typical of the women who passed through all these stages. Raised in Los Angeles, Rothstein went to Berkeley as an undergraduate in 1963 and soon joined the Congress of Racial Equality (CORE) demonstration against the discriminatory employment practices of Lucky Foods and the Sheraton Plaza Hotel. Along with five hundred other demonstrators, she was arrested for civil disobedience in an action against auto dealerships that refused to hire black salespeople and spent the summer of 1964 in group trials in San Francisco. She participated in the Berkeley Free Speech Movement, and in the summer of 1965, went to Jackson, Mississippi, as part of the second Mississippi Freedom Summer project. Later, she returned to Berkeley, where she joined a fledgling Students for a Democratic Society (SDS) project in Oakland, California. When that project failed, she moved east to organize poor white southern Appalachian migrants in Chicago.

By 1967 Rothstein had become deeply involved with the leadership core of SDS and the antiwar movement. Yet, like many women in the antiwar movement, she felt intimidated by the world in which she lived, but rarely starred. At national meetings, women felt especially intimidated by the long speeches and the intellectual competition among male leaders. When they did speak, they were often ignored.

Yet it was the war that propelled Rothstein in new directions. In 1967 she attended a conference in Bratislava, Czechoslovakia, between American antiwar organizers and North and South Vietnamese political activists. From there, she traveled to North Vietnam, where she spent nineteen days with a delegation of seven Americans visiting bombing sites, learning about Vietnamese history, studying American weaponry, and meeting women from the Women's Union of North Vietnam. "It was there," Rothstein later recalled, "that I was introduced to the idea of a women's union and the possibility of organizing women independently of men."

Anne Weills, then married to Robert Scheer, the editor of the leftist magazine *Ramparts*, also felt invisible at Bay Area antiwar movement meetings. "Even if you said it well," she recalled, "half the time people would ignore you. Invisibility. That's what was so painful."

Efforts to bring up these grievances failed repeatedly, at both local and national meetings. Women felt ridiculed and humiliated. Oddly enough, antiwar male activists inadvertently spread word of women's liberation, if only through repeated derision. In February 1968, for example, the left-wing Bay Area–based magazine *Ramparts* decided to "cover" the "sexy" story of the newly emerging movement. The resulting article, titled "Woman Power," proved to be a condescending, snide appraisal of the new women's movement. On the magazine's cover appeared a voluptuous female torso with a button "Jeanette Rankin for President," referring to the congresswoman who had voted against both world wars. The article ridiculed radical women as the "miniskirt caucus," and fell back on the Old Left cliché that women would be liberated after the revolution. *Ramparts'* cheeky coverage enraged many movement women, who denounced it as "a movement fashion report."

The angrier New Left women became, the greater their expectations. The higher their expectations, the more New Left men failed them. Consequently, women began exiting the antiwar movement to start organizing women against the war, as well as to seek greater equality with men. Some women simply stopped going to antiwar meetings. In Berkeley, for example, one woman in the campus Radical Student Union stood up and

Folk singer Joan Baez joins other protesters in blocking the entrance to the Oakland Induction Center, October 1967.

OAKLAND TRIBUNE COLLECTION, GIFT OF ANG NEWSPAPERS, OAKLAND MUSEUM OF CALIFORNIA

spoke about the need for a women's anti-imperialist contingent for an upcoming antiwar demonstration. The membership burst into laughter. She stormed out, precipitating an exodus by all the women. Afterward, when the organization collapsed, the president explained the cause for its demise: "What men would keep coming to meetings without women?"

Women who worked at *Ramparts,* like Susan Griffin, for example, also began to rebel against their subordinate status. "I went to work at *Ramparts* magazine," recalled Griffin, "and I loved working there and learned a great deal, but I learned something besides journalism and muckraking and all about the nasty stuff the CIA does, and that was the nasty stuff my buddies, my brothers on the left, were doing. They were getting twice my salary, they would ask me to rewrite their pieces and fully acknowledge that I wrote better than they did, but

no editorship, not a single woman was a full staff writer."

A good epidemiologist could have traced the rapid transmission of the infectious enthusiasm for women's liberation that swept the country and affected women in California around 1967. Networks of antiwar women activists, accustomed to traveling to national antiwar conferences and organizing local and national meetings, became the carriers of that enthusiasm. Letters, visits, and pamphlets flew back and forth between New York, Chicago, Washington, D.C., Boston, Berkeley, San Francisco, and Los Angeles. Soon California women of all ages and backgrounds were creating consciousness-raising groups, meeting in small numbers, usually in someone's living room, to discuss how "the personal is political," or the political dimensions of personal life. At the same time, pamphlets from other parts of the country, such as *The Politics of Housework* by Pat Mainaudi,

streamed into the state, were read and re-read, fueling a revolution that would soon affect people in their kitchens and bedrooms, not just in public places.

By 1968 some female antiwar activists were living a schizophrenic life. Once a week, they went to their women's groups, where their understanding of their lives and the world around them kept shifting. At night, they slept with men whom they had just criticized in front of other women. In the morning, they once again worked with antiwar men they had condemned the night before.

For these antiwar activists, Vietnamese women and their heroic struggle became a symbol of both American imperialism and the revolutionary potential of women. One of the most popular posters in the early women's liberation movement, regularly seen on the walls of bedrooms and makeshift offices, featured a Vietnamese woman with a baby on her back and a gun in her hand.

It was through their attempted solidarity with women of Vietnam that antiwar women activists hoped to link their commitments to both the antiwar effort and the new women's movement. On International Women's Day in 1970, for example, the Berkeley Women's Liberation Front circulated a pamphlet titled *Vietnamese Women: Three Portraits,* which told of their heroism and suffering as women. "What does the Vietnamese war have to do with women's liberation?" the pamphlet asked. The answer, to them, was obvious: "Everything!"

As anger at both the leftist and the countercultural press grew, the mushrooming women's liberation movement began creating its own publications, particularly in the San Francisco Bay Area. Laura Murra, a Berkeley activist, began to publish *SPASZM* in 1968, a newsletter that reported activities of women's liberation groups all over the country. In such publications as *It Ain't Me Babe, Mother Lode,* and *Tooth and Nail,* Bay Area feminists began to declare their independence, publicize their actions, explore new ideas, and offer referral services to the new women's centers, women's health clinics, battered women's shelters, and rape crisis centers that were sprouting throughout the region.

Within a year, Murra had changed her name to Laura X, in order to erase her patriarchal surname. Still other women's liberationists decided to go by a first name only, like the poet Alta, who created Shameless Hussy Press, one of the movement's first presses.

Historians will someday bless Laura X, a longtime antiwar activist, who had the foresight to attempt to collect every document that came out of the movement. The Women's Herstory Library, which took over her Berkeley hills home, became a repository of most of the tracts, publications, speeches, minutes, and newspapers of the second wave of feminism. Pamphlets and newspapers crisscrossed the country rapidly, read by women in distant cities, invariably ending up somewhere in Laura X's home.

What this mushrooming literature revealed was that which had been unspeakable. Between 1965 and 1980, tens of thousands of women participated in an enormous archaeological dig, excavating crimes and secrets that used to be called, with a shrug, "life." Together, these amateur archaeologists unearthed one taboo subject after another.

The cumulative impact was breathtaking. Once they had named so many specific injuries, mere "equality" with men would no longer be sufficient. Rather, they would insist upon a society that valued women's contributions, honored women's biological differences, and supported women's childbearing and sexual experiences. Soon, the general public would learn that sometimes a custom is also a crime.

California women played a key role in that archae-

It was through their attempted solidarity with women of Vietnam that antiwar women activists hoped to link their commitments to both the antiwar effort and the new women's movement.

ological dig. Consider just a few examples. Before the women's movement, rape had been a shameful secret. In "Rape: The All-American Crime," a groundbreaking essay published in *Ramparts* in 1970, Susan Griffin argued that rape was an act not of lust but of power in which a man attempted to gain ultimate control over a woman. Sandra Butler, the author of *The Conspiracy of Silence: The Trauma of Incest* (1978), helped end the silence that surrounded the subject of incest. Diana Russell, whose pioneering book *The Politics of Rape* (1975) reached a wide audience, should be credited as the major archaeologist to unearth the hidden trauma of marital rape.

The birth of the women's health movement was one of the greatest accomplishments of the women's movement. Health activists—influenced by the "barefoot doctors" of China's Cultural Revolution—not only disseminated biological knowledge; they also questioned why doctors controlled women's reproductive decisions. Only doctors could dispense the Pill or other contraception; only doctors could verify the need for a therapeutic abortion to save a woman's life. Why did doctors, rather than women, have this power? Couldn't women take back some control over their bodies?

To teach women about their bodies some activists began practicing "self-help gynecology." On April 7, 1971, at Every Woman's Bookstore in Los Angeles, Carol Downer inserted a speculum into her vagina and invited women to observe her cervix. Five months later, a similar demonstration took place at a national meeting of National Organization of Women (NOW) in Los Angeles. Within a year of Downer's first self-examination, over two thousand women had attended such self-help clinics.

Throughout the state, activists began to challenge how much the medical profession had ignored women's healthcare. Some created women's health clinics. Still, others exposed new dangers to health that had not yet been discovered. Pat Cody, an economist by training and a longtime antiwar activist in Berkeley, questioned the long-term effects of a drug called DES (diethylstilbestrol), which doctors had given her and many other women during the 1960s to prevent miscarriages. After careful research and organizing, Cody created a grassroots organization called the DES Information Group that, based on its suspicions that the drug had created a cohort of children particularly susceptible to a variety of cancers, began to lobby the government for research and to raise funds to educate the public. By 1975 Cody's group had published a pamphlet titled *Women Under Thirty, Read This!*

Aside from healthcare, activists organized around other hidden injuries women experienced. As a growing number of women "came out" as lesbians, they began to challenge the discrimination and anger they encountered. In April 1973, feminists in Los Angeles held the West Coast Lesbian conference, the largest of its kind ever held in the United States, which drew women from all over the country. At the same time, the Bay Area also sparked the first feminist antipornography organization, Women Against Violence in Pornography and the Media, which sponsored a national conference, Feminist Perspectives on Pornography, and organized

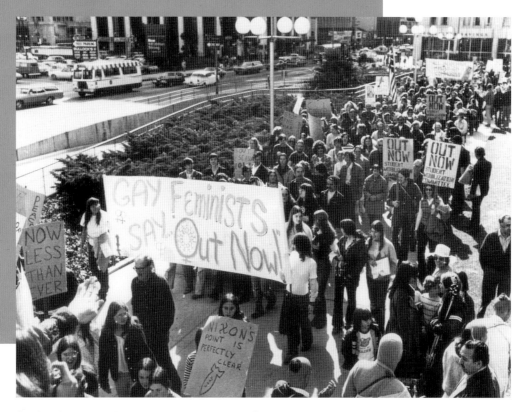

Gay feminists participating in antiwar march in Pershing Square, Los Angeles, 1972.
HERALD-EXAMINER COLLECTION, LOS ANGELES PUBLIC LIBRARY

the first Take Back the Night march, in which women marched at night to "take back" public space.

In San Francisco, the flamboyant and politically astute Margo St. James, herself a former prostitute, helped redefine prostitutes as sex workers when she organized a union of prostitutes in 1973 called COYOTE, an acronym for "Call Off Your Old Tired Ethics." COYOTE successfully provided prostitutes with adequate counsel and persuaded district attorneys to shift their attention to prosecuting crimes that had actual victims.

California feminist activists and intellectuals also challenged all kinds of cultural orthodoxy—in religion, the arts and education. By the early 1970s individuals and small groups began to challenge organized religions that diminished the role of women or reinforced patri-

archal domination. Many peace activists also began exploring—or inventing—new spiritual practices. Carol Christ extolled the psychic importance of rediscovering prehistoric female goddesses; Charlene Spretnak analyzed the politics of women's spirituality; and Paula Gunn Allen explored the place of the spiritual in Native American cultures.

The Bay Area, in particular, produced some of the most important writers in the women's movement. Alice Walker, Amy Tan, Alta, Sandra Gilbert, Maxine Hong Kingston, Pat Parker, Susan Griffin, Adrienne Rich, Angela Davis, Tillie Olsen—to name just a handful—used essays, poetry, and novels to explore women's hidden experiences and emotions.

During the first heady years of the women's movement, cultural events were often electrifying experi-

ences. Imagine the following scene. It is 1970 in Berkeley, California. Several hundred women have squeezed into a stifling room for a feminist poetry reading. The poets take off their shirts, some to cool off, some to protest a law that prohibits breast-feeding in public, and some because it feels deliciously sexual.

Provocative, sensual, thoughtful, serious, angry, snide, funny, a new poetic sensibility was emerging.

In addition to poetry readings, poster collectives, new women's music, feminist publishing presses, and record companies began to spread a new kind of women's culture around the state. This women's culture offered feminists a safe refuge from which to express new artistic visions, compose new styles of music, explore new literary themes, and develop a feminist sense of humor.

Nowhere did this burst of cultural creativity prove more exciting—and ultimately influential—than in Los Angeles, where a group of talented artists took over an old three-story brick building in 1973 and, in the words of one performance artist, created "an extraordinary community of women artists whose creativity and fierce living rocked the world from an old building in downtown L.A."

Artist Judy Chicago, graphic designer Sheila Levrant de Bretteville and art historian Arlene Raven essentially founded a women's art center—complete with poetry, painting, and performances. Three galleries featured women's art and three theater companies staged their productions. But the Woman's Building was more than what it housed. "The Woman's Building," recalled one artist, "was magical, like the Hollywood Sign and the Santa Monica pier. It was physical proof that the future was indeed here, now, and we were it."

At the heart of that community was the Feminist Studio Workshop, which Chicago, de Bretteville and Raven created as an alternative to conventional art institutes. From all over the country, women artists—many of whom had designed graphics or posters in the antiwar movement—flocked to this studio, creating an

Feminist information tables at the Bay Area Women's Coalition Meeting held at Grace Cathedral, San Francisco, February 7, 1970.

HELEN NESTOR, PHOTOGRAPHER
OAKLAND MUSEUM OF CALIFORNIA, GIFT OF THE ARTIST

The owners of the Sisterhood Bookstore in Westwood began their business primarily to serve the needs of the feminist community, September 1975.

LOS ANGELES TIMES COLLECTION, UCLA LIBRARY DEPARTMENT OF SPECIAL COLLECTIONS

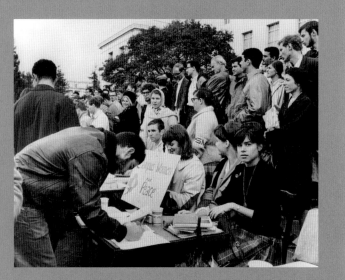

Campus Women for Peace participating in one of the Free Speech protests on the campus at the University of California, Berkeley, November 1964.

OAKLAND TRIBUNE COLLECTION, GIFT OF ANG NEWSPAPERS, OAKLAND MUSEUM OF CALIFORNIA

artistic community and tradition that would long influence the work of women artists everywhere.

This is where a community of artists encouraged each other to work collaboratively, to demystify the "lone genius" theory of art, to use autobiographic experience as the subject for art, and to restore the credibility of crafts, like quilting, which had long been devalued because of its association with women and domestic life.

It did not take long for feminists to challenge the substance of other forms of education. In the October 26, 1970, issue, *Newsweek* magazine spotlighted what it called "one of the hottest new wrinkles in higher education." In San Diego, then known as a conservative Navy town, the women's liberation movement, which included many antiwar activists, had launched the nation's first women's studies program at what was then called San Diego State College. Typical of the moment, their vision was not limited to courses, but also included plans for research, childcare, a culture center, and a storefront women's center. In the same year, Betty Friedan guest-lectured at Sacramento State College, the University of California, Berkeley, began to offer courses in women's history, and campuses across the state began to create a variety of courses on women and to establish women's centers.

The Bay Area, birth of the student movement, quite naturally became a hub of university and community feminist activism. In 1969, a group of UC undergraduates held a rally at which they issued a leaflet declaring, "We've been burned. We thought we were free human beings." Now they viewed themselves as brainwashed victims, trapped in an educational institution that refused to allow them to challenge the basis of knowledge. They then demanded that the ROTC building be converted into a space for women's studies, that the university provide child care, and that funds used

for "war-related and counter-insurgency research" be converted into stipends to support women's education. As the television cameras whirred, a group of women graduate students and young assistant professors gathered in a circle and burned their masters and doctorate degrees.

The campus protests even included a foray into what was exclusively male territory. Furious that the university refused to provide women with facilities for weight training and courses in self-defense, members of the Women's Liberation Front invaded the men's gym. Banging pots and pans, chanting "self-defense for women now," about fifty women charged into the men's locker room, surprising a group of half-dressed men.

Interest in women's past grew rapidly. Some protests and marches, in fact, grew out of a passion for discovering the previously hidden history of women. Laura X, Phyllis Mandel, and other members of Berkeley Women's Liberation, for instance, resurrected International Women's Day, a holiday that actually had its roots in American labor history, but was only celebrated in Communist countries. On International Women's Day in 1969, about fifty women, dressed in turn-of-the-century costumes, marched through the city of Berkeley. The following year, thirty other American towns and cities celebrated the day. By the end of the 1970s, nearly all schools and cities commemorated it.

Feminists not only studied their past; they also invented new historical traditions. By the end of the 1980s, millions of America school children would honor National Women's History Month. Molly MacGregor, who had worked on the Sonoma County Commission on the Status of Women, was partly responsible for the creation of that celebration. MacGregor had attended a Summer Institute on Women's History for Leaders of Women's Organizations at Sarah Lawrence College,

organized by Professor Gerda Lerner, a leading scholar in women's history. Together, these leaders adopted as their class project the idea of turning Women's History Week into an annual national event. They succeeded.

After her return to California, MacGregor and other activists formed the National Women's History Project (NWHP). By 1981 the national women's history network had successfully lobbied Congress to recognize National Women's History Week. By 1987 they had pressured Congress into expanding the week into a month. Eventually, the NWHP circulated women's history curricula to millions of children, from kindergarten through grade 12. Supported by scores of activist scholars, these determined women created a real revolution in the U.S. history curriculum.

All kinds of activists—lesbians, older women, younger women, African American, Chicanas, Native American, and trade union women were also busy reinventing feminism for themselves. The diffusion of feminism did not mean that a single movement, led by middle-class white heterosexual women, spread to other groups who then added or subtracted particular issues. On the contrary, different groups of women developed and spread completely new conceptions of "women's issues" throughout the state. In a stunningly short time—a few years at the most—and in areas of California where feminism had been unknown, then a joke, then a danger, new kinds of feminist sensibilities flourished.

Young Mexican American female antiwar activists, for example, began to address "women's issues" as early as 1967, questioning their role as cooks, caretakers, and secretaries within the newly organized Chicano movement. "We don't want to lead, but we won't follow," was the way one woman put it. Meeting separately, some of these young women decided they didn't want to split

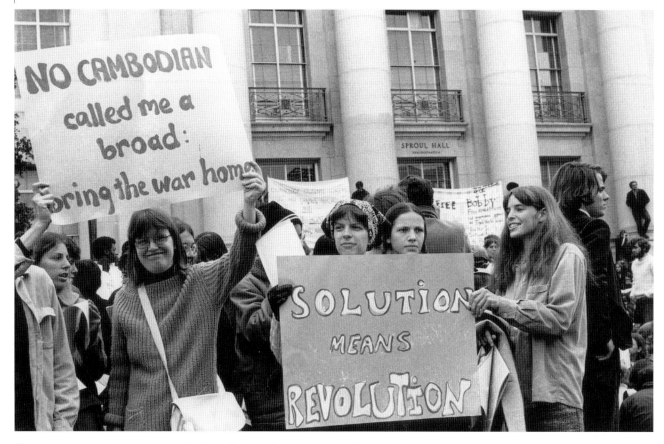

Many women continued their antiwar work while calling for a feminist revolution, Berkeley, 1971.

PHOTO BY RICHARD SAMMONS

the unity of the growing Chicano movement by joining the "white" women's movement. They were also not willing to be treated as second-class citizens.

Chicanas addressed the burden of a different history, that of a colonized people whose land had been stolen and that of an immigrant group who had faced fierce racial discrimination. Although they viewed the strong Mexican American family as the backbone of their resistance against white America, they also understood that the Chicano family was the bulwark of a Catholic and male-dominated culture that prevented them from using contraception, having abortions, and carving out more independent lives.

As they fought for better schools and against the Vietnam War, Chicanas became increasingly politicized. On August 2, 1969, The Chicano Moratorium, which

called for the immediate end of the war, held a peaceful antiwar protest rally in Laguna Park in East Los Angeles. Police rioted, fired on women and children, shot tear gas canisters into nearby bars, and ended up wounding sixty people and killing three Chicanos. The pivotal Moratorium radicalized both men and women and gave rise to a cultural nationalism that cast women as the followers of strong male warriors, which annoyed more than a few female activists.

By 1971 six hundred Chicanas met in Houston, Texas, to hold the First National Conference of Chicanas. Some of their male comrades, to put it mildly, were not pleased. Still, Chicanas fully embraced the credo of the Chicano movement—"Go back to the community with your education"—and concentrated on the needs of Mexican American women, particularly

in Los Angeles. They defended the rights of welfare mothers and lobbied for job training for women. Chicana activists also established health care centers and helped community organizing, including providing contraception and abortions.

In 1973 more than eight hundred Chicanas representing farm workers, trade unions, garment workers, college campuses, grassroots communities, and professional communities came together to create the Comisión Femenil Mexicana Nacional, in Goleta, California. "Our goal," recalled Yolanda Nava, one of the movement's leaders, "was leadership and economic development, legislative advocacy to upgrade the status of the Chicana."

Older women, too, first recognized their particular needs in California. In 1973, for example, at age fifty-seven, Tish Sommers, a longtime civil rights activist, and for twenty-three years a mother and housewife, ended her marriage. Newly enacted no-fault divorce law reforms left many a long-married but suddenly divorced homemaker like Sommers without any means of support. Her response was to found a NOW task force called "Older Women's Liberation" (OWL), defined tellingly, as women over thirty. She became the first activist to link issues of aging with feminism. Sommers also coined the term "displaced homemakers" to dignify the lives of women who unexpectedly found themselves on their own, with few marketable skills, and little self-confidence. By the mid-1970s she had created a model program on the Mills College campus in Oakland to provide displaced homemakers with job training and counseling.

The ideas of the women's movement gained greater recognition as feminists moved from living rooms to the streets. Within a few months, a small group might begin thinking how to raise the consciousness of the public, and emerge with a novel or striking way to gain attention. The protests, "zap" actions, "invasions," marches, and "guerrilla actions" organized by the women's movement ranged from the zany to the sublime. Cumulatively, they brought consciousness-raising out of the living room and into the public arena.

Political actions not only revealed the passions felt by protesters, but also those targets they viewed as symbolic of their inequality. Many California women, for example, attended the all-women Jeanette Rankin Brigade antiwar protest in January 1969 in Washington, D.C. It was here that many West Coast activists met their counterparts from other parts of the country and observed a ritual called "The Burial of Traditional Womanhood."

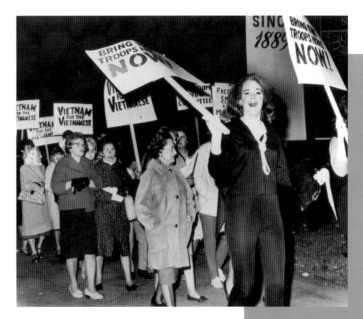

Women protesters from various peace organizations walk down Sunset Boulevard and Vine Street in Los Angeles voicing their opposition to the war in Vietnam, April 1966.

HERALD-EXAMINER COLLECTION, LOS ANGELES PUBLIC LIBRARY

A proponent of women's liberation, February 1970.

HELEN NESTOR, PHOTOGRAPHER, OAKLAND MUSEUM OF CALIFORNIA, GIFT OF THE ARTIST

Bridal fairs that literally "sold marriage"—or at least the products and services that went with it—became a favorite target of the women's movement. On February 15, 1969, women's liberation groups on both coasts disrupted gigantic bridal fairs. Targeting the marketers of gowns, wedding pictures, caterers, furniture, appliances, and honeymoon trips, the protesters condemned "consumer culture" for turning marriage into a compulsory exercise in conspicuous consumption.

Feminists also targeted media organizations. Tired of being trivialized or ignored by the *San Francisco Chronicle*, seventy-five members of Berkeley Women's Liberation went to San Francisco in 1970 and invaded its editorial offices. When the telephone rang, one activist simply picked it up, declared "the paper's closed down," and slammed down the receiver. The group demanded 50 percent women employees in all departments, a revision of the *Chronicle*'s women's pages, and

an end to the acceptance of any advertising that exploited women.

KPFA, the local listener-sponsored radio station in Berkeley, also became a target. After months of ignoring requests for programs by and about women, in 1970 five women calling themselves Radio Free Women invaded KPFA. Shortly afterward, KPFA began producing programs on women's history, poetry, literature, music, news, and public affairs.

The women's movement in California was so active and diverse that it attracted special attention from FBI Director, J. Edgar Hoover, himself. FBI agents recruited female informers, infiltrators, and observers—but the agency still refused to employ women as agents. These informants sent back reports about radio interviews with local feminists, clipped stories that mentioned the names of feminist or protest activities in the mainstream and alternative press, joined feminist reading groups,

and even sat through consciousness-raising groups. They collected flyers, the agendas and minutes of meetings, position papers, and conference programs.

In May 1969, the San Francisco regional office reported to the Bureau in Washington that the women's liberation movement "was mainly concerned with male chauvinism and didn't seem to require any investigation." In April 1970, the office again reported that "it does not appear appropriate to conduct an investigation."

The FBI director snapped back: "It is absolutely essential that we conduct sufficient investigation to clearly establish the subversive ramifications of the WLM and to determine the potential for violence presented by the various groups connected with this movement as well as any possible threat they represent to the internal security of the United States."

Hoover bombarded the FBI's San Francisco regional office with requests for lists of the names, membership, and leaders of what was, in fact, a highly decentralized and fragmented movement. In June 1969, for example, Hoover sent the San Francisco office this terse order: "San Francisco is instructed to identify the officers and the aims and objectives of this organization." But they could not. As one informant explained, "this movement has no leaders, dues, or organizations," which left FBI agents mystified. Nor could they make sense out of the names and references, which were an everyday aspect of movement life.

Informants—all of whom were women—sometimes converted to the cause and through agents, wrote Hoover that their surveillance should be discontinued. Told to carry on their work, they stuffed their reports with descriptions of what activists wore and details of their complaints about husbands and work.

Ironically, the FBI searched for evidence of subversion in the women's movement but could not recognize it when they found it. While the agency looked for Communists and bombs, the movement was shattering traditional ideas about work, customs, education, sexuality, and the family. Ultimately, this would prove far more revolutionary than the FBI could have ever imagined. Feminism would leave a legacy of decades of disorientation, debate, and disagreement, create cultural chaos and social change for millions of women and men, and, in the process helped ignite the culture wars that would polarize American society. But at the time this was not what the FBI considered subversive behavior.

The women's movement did, in fact, question nearly everything, transform much of American culture, expand the idea of democracy by insisting that equality had to include the realities of its women citizens, and catapult women's issues onto a global stage. The movement's greatest accomplishment was to change the terms of debate so that women mattered. But activists left much unfinished as well. They won the right to fight in the military, but not to stop war. They were unable to change radically many institutions. They failed to gain greater economic justice for poor women, or even to convince society that childcare is the responsibility of the whole society. As a result, American women won the right to "have it all," but only if "they did it all."

It is for a new generation to identify what they need to achieve greater equality. It may even be their solemn duty. As they do, they should remember the words of the poet Muriel Rukeyser, who asked, "What would happen if one woman told the truth about her life?" Her answer: "The world would split open." And so it has. There is a revolution under way, and there is no end in sight.

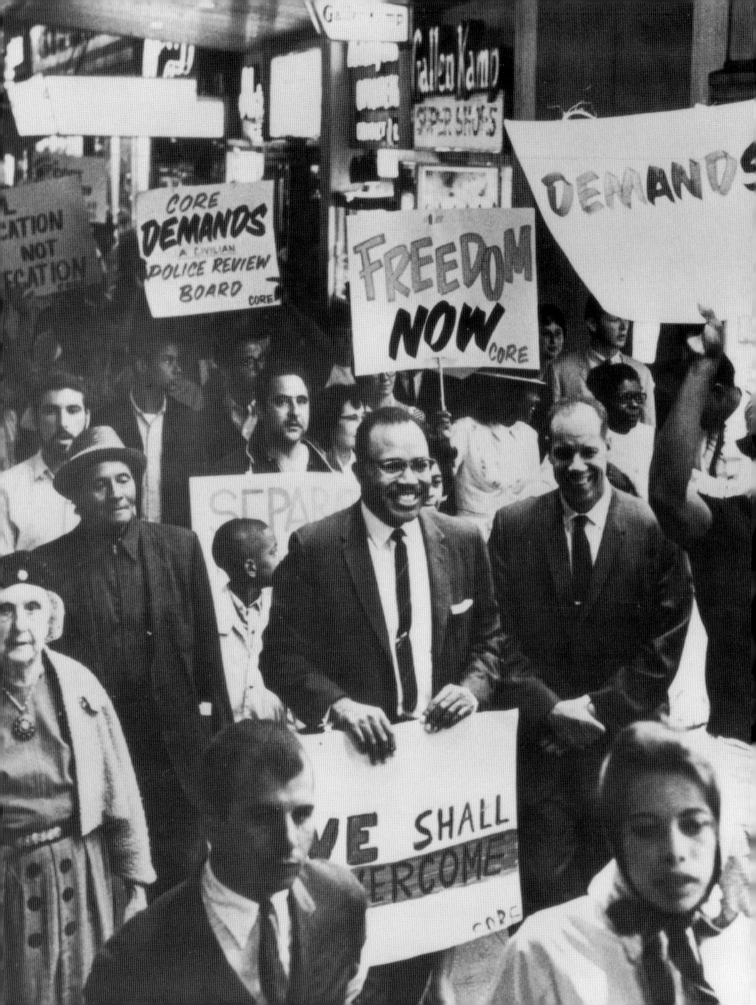

CHAPTER 6

Long, Hot California Summers:
The Rise of Black Protest and Black Power

Clayborne Carson

Civil rights marchers demonstrate in downtown Los Angeles, March 1965.

WHEN I CAME TO LOS ANGELES after flunking out of the Peace Corps during the fall of 1964, I regretted that my destination was not Berkeley, scene of the burgeoning Free Speech Movement that had captured my twenty-year-old imagination. I had become restless in Los Alamos, New Mexico, where I grew up imagining what I could be experiencing elsewhere. A year earlier, following my first year at the University of New Mexico, I had tasted the excitement of the southern black protest movement when I met Stokely Carmichael at a National Student Association conference in Indiana and then hitched a ride to the March on Washington for Jobs and Freedom. Stokely, then a Howard University philosophy student and a veteran of the Freedom Rides, ridiculed the "middle-class picnic" in Washington, but it was by a large margin the most exciting event of my life to that point. After leaving Martin Luther King Jr.'s closing oration to spend the next day as a solitary visitor amidst New York City crowds, I returned home determined to depart for good the too familiar world that had nurtured me. My impulsive choice would have been to go south to join the staff of the Student Nonviolent Coordinating Committee (SNCC), but I was not quite willing to postpone my ambition to become the first family member to graduate from college. When my older sister offered to let me stay with her family in Los Angeles, I eagerly accepted and arrived early in December expecting to continue my college career there.

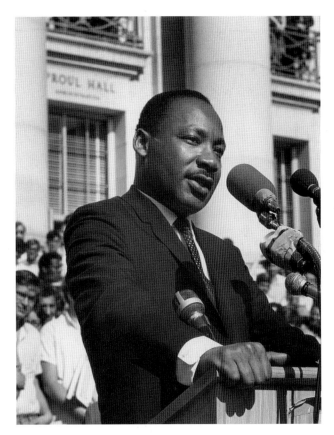

Martin Luther King Jr. speaking in front of Sproul Hall at the University of California, Berkeley, as part of a tour speaking out against the war in Vietnam, May 17, 1967.

HELEN NESTOR, PHOTOGRAPHER
OAKLAND MUSEUM OF CALIFORNIA, GIFT OF THE ARTIST

Southern civil rights protesters show their support for the antiwar movement at a rally in Berkeley, 1965.

PHOTO BY PAUL SEQUEIRA

Although Los Angeles was not a Deep South racial battleground, I was certain that it would be more interesting than the life I was leaving behind.

The civil rights activism I had read about was less visible in Los Angeles than in the Bay Area, but it did not take long to find a small community of militant activists who were doing their best to shake up the city. After I enrolled at UCLA—where only a handful of students protested for free speech in sympathy with their Berkeley counterparts—courses became occasional distractions from off-campus activities. My part-time advertising research job at Audience Studies, Inc., then located on the Columbia Pictures lot, enabled me to pay student fees and get a small place in Laurel Canyon near the coffeehouses and music clubs of Sunset Strip. I soon began to spend more and more of my time at work, where I earned a decent salary tallying audience responses to commercials and took advantage of opportunities to observe the film industry close-up. I arranged my classes to increase my work hours to the point where I eventually became a full-time employee at the same time I was a full-time student. The job also led to a friendship with Charlie Samuelson, a fellow employee who introduced me to the Nonviolent Action Committee (N-VAC), founded by three black activists—Woody Coleman, Robert Hall, and Danny Gray—who wanted to break free of the constraints of the predominantly white Congress of Racial Equality (CORE). N-VAC would soon become the center of my political life in Los Angeles. I was impressed that some members of the group had worked in the South with SNCC or CORE and was prepared to pay N-VAC's membership dues, which was to engage in civil disobedience. My initiation ceremony was a sit-in at a Thrifty-mart grocery store in suburban Santa Ana. Although police decided against arresting us that Friday night, I

Civil rights protesters in San Francisco, 1964.

PHOTO BY JEFFREY BLANKFORT

had become part of the Movement—an amorphous interracial community that included those in SNCC and those who wished they were.

This new identity was further strengthened when I made my first trip to the University of California's Berkeley campus in May 1965 to attend a teach-in on the Vietnam War. Along with thousands of others who sat in the plaza in front of Sproul Hall, I heard speeches by many leaders of the nascent antiwar movement. Although I had once wanted to attend the Air Force Academy, my political views had been profoundly affected by news reports of southern civil rights protests and by my friendships with activists affiliated with SNCC, CORE, or the Students for a Democratic

Society (SDS). I had already become skeptical of the notion that United States military forces had intervened to protect freedom and democracy in Vietnam when the federal government seemed unable to protect freedom and democracy for southern black people. One of the speakers on the program was SNCC's Bob Moses, who had greatly impressed me when I heard him speak at a New Orleans gathering held late in 1963 to formulate plans for the Mississippi Summer Project. As was the case for many other activists, I saw Bob as a role model—an organizer who had left a high school teaching job in 1961 to risk his life assisting the voting rights movement in Mississippi. I was one of many activists who would later mimic his quiet manner of speaking

but find it difficult to equal the integrity that underlay his deferential leadership style. During his brief but memorable Berkeley speech, he derided the lack of public response following the recent death in Alabama of black protester Jimmy Lee Jackson, especially when compared to the outpouring of national concern after the killing of the Reverend James Reeb, one of the many white activists who had subsequently joined the Selma voting rights campaign. Insisting that most Americans cared little about the lives of non-whites, Moses told the crowd, "You've got to learn from the South if you're going to do anything about this country in relation to Vietnam."

As the war in Vietnam escalated in subsequent months, there was a similar escalation of rhetorical and actual violence in Los Angeles. The inflammatory ideas of Malcolm X became more popular after his death than before. Alex Haley's newly published *Autobiography* became a guiding text for young black activists. Samuelson and several other N-VAC members were Jewish, but the group's black founders were influenced by black nationalist ideas and stressed the need to build broad support among black residents in South Central Los Angeles. N-VAC activities led me to expand my familiarity with Los Angeles beyond the Westwood area near UCLA and West Hollywood, where I worked, played, and (when necessary) slept, into the black neighborhoods southeast of my sister's home in the West Adams neighborhood. Having grown up with an understanding of urban black life that came mainly from books, my curiosity about the South Central area was boundless. I established contact with my uncle, Walt Walker, who was struggling to make a living as an artist; he and Aunt Jane were outspoken in their criticisms of the city's white leaders. I soon began attending black-nationalist rallies and readings by black writers at the Aquarius

Bookstore. Through my N-VAC acquaintances, I became increasingly aware of racial injustices. On one occasion I observed police searching every black person on an entire block in Watts. Initially a quiet tourist, I decided that part-time journalism would help satisfy my fascination with a black city that was a world away from Los Alamos, New Mexico.

In June 1965 I wrote a profile of Woody Coleman for the *Los Angeles Free Press* that opened with his bold forecast: "I'm looking for a bloodbath this summer. We're going to get tired of being peaceful and nonviolent without getting anything. We're still getting crumbs; we're going to get a big slice of that cake." I could not have realized then the accuracy of his prediction, but I had learned enough about race relations in the city to give it credence. The article included his description of N-VAC as a "mean and nasty organization" that would become the northern equivalent of SNCC or perhaps the political counterpart of the Nation of Islam, which, he said, lacked "an active program." The article concluded with another provocative prediction: "We won't get a solution until we put enough pressure, until the politicians realize that there's not going to be any peace until the Negroes get their freedom. The movement will probably come to bloodshed. We've tried enough nonviolence and seen that it doesn't work."

Despite Woody's prescience, I doubt whether any of us were prepared for the unprecedented black insurgency of August 1965. My political activism and my undergraduate career suddenly and unexpectedly reached a new intensity when a mass protest against police abuse engulfed a large section of the city. The Watts "riot" was actually an insurgency that briefly transformed large sections of South Central Los Angeles into liberated zones of the black freedom struggle. I recall standing outside N-VAC's Central Avenue head-

quarters trying to make sense of the fiery, deadly racial rebellion that made our nonviolent, interracial militancy seem so insignificant and inadequate. I can never forget the sight of Central Avenue buildings in flames as far as I could see (although the N-VAC headquarters was undamaged). The spreading violence attracted more community support than had all of N-VAC's organizing efforts. We did our best to show our sympathy for the rioters, but none of us actually joined in the looting and other popular forms of uncivil disobedience. Instead, we organized an ambulance patrol to assist injured people—an activity that resulted in a clash with police that left me and two other N-VAC members with wounds from billy-club blows to our heads. I felt fortunate to have been spared the fate of many other residents who became "justifiable homicides" after similar encounters with police. N-VAC member Jerry Farber wrote about this incident in a widely reprinted *Free Press* article that expressed both our sense of solidarity with the rebellion and our uncertainty about its consequences. When National Guardsmen arrived, we felt a sense of pride that the Los Angeles police had not been able to overcome the black community's resistance without military assistance.

During the year following the Watts riot, as the press referred to it, or the Los Angeles Rebellion, as we called it, N-VAC gradually disintegrated as an organization. Our faith in the power of interracial nonviolent direct action began to whither as members came to realize that black-white divisions inside and outside the group were deeper than we had imagined. While I continued to work closely with some former members for many years afterward, my sense of being an outsider grew stronger after I left the smoldering black ghetto to return to my life in the largely untouched white world. In the spring of 1966 I moved from Laurel Canyon to

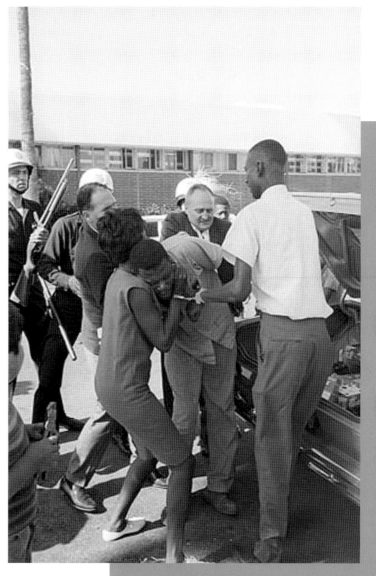

Los Angeles police officers grapple with a man arrested during the Watts riot, August 16, 1965.

PHOTOGRAPH COURTESY OF BETTMANN/CORBIS

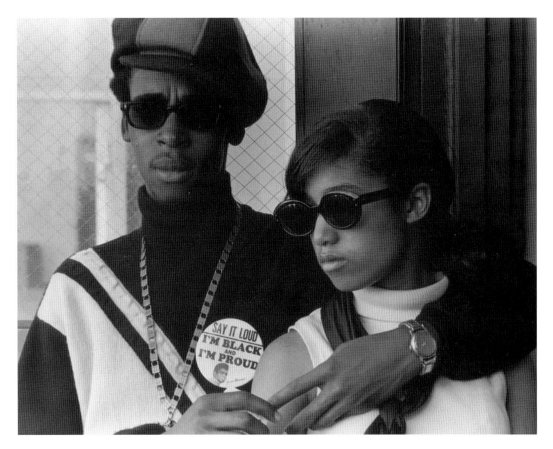

High school students proudly proclaiming their black identity, San Francisco, 1969.

PHOTO BY NACIO JAN BROWN

Venice, a beach community that offered cheap housing and an appealing unconventional style of life—especially casual sex and readily available marijuana—that attracted an older generation of beatniks and a younger generation of hippies. I did not identify with either group, but greatly enjoyed living there during those magical years before drug-motivated crime and rising rents destroyed the ambiance. My affiliation with the *Free Press* made possible many distractions during the year after the rebellion. I was able to witness an important cultural transformation—Nina Simone performing in a small club, Frank Zappa's Mothers of Invention being interrupted by fire marshals, the Beatles at Dodger Stadium, Joan Baez at a Venice beach sand castle, and love-ins at Griffith Park. As antiwar sentiment increased on the UCLA campus and as black students formed a cultural group called Harambee (we held weekly silent vigils on the walkway to the student union), I became more active in campus life and finally left my job at Audience Studies in an attempt to support myself as a writer.

The southern civil rights struggle that had once been a source of inspiration began to come apart in the mid-1960s. The racial tensions that had torn N-VAC apart also weakened many of SNCC's organizing efforts. In June 1966 Carmichael, by this time SNCC's chairman, provided a name for the new current of African American racial consciousness when he used the phrase

"Black Power" during a voting rights march through Mississippi. During the summer of 1966, I greeted him at a well-attended rally in Watts and responded enthusiastically to his call for Black Power. The rally attracted support from the numerous black political and cultural organizations emerging in the aftermath of the rebellion. Although there was widespread black support for the Black Power slogan, there was little agreement among black leaders about the meaning of the phrase. I noticed increasingly signs indicating that the ideal of black unity was illusive. Some proponents of black nationalism competed with or became government-funded antipoverty organizers. I was drawn to the new racial militancy, yet I was also aware that the anti-white tone of much Black Power rhetoric made it increasingly difficult for me to remain attached to the diverging worlds of the Black Power movement and the antiwar New Left.

Yet I did my best to master the art of identifying with black militancy while seeking to bridge the gulf that separated it from white militancy. My participant-observer articles for the *Free Press* and other periodicals traced my travels across the racial boundaries of Los Angeles. In an interview conducted during a poetry reading at the Venice West Café, John Haag told me about his activities in the Ad Hoc Committee to End Police Malpractice and the Du Bois Club. Carolyn Sweezey told me about her transition from Radcliffe College undergraduate to N-VAC militant. An article on newly formed Operation Bootstrap described the efforts of N-VAC's Robert Hall and Lou Smith to create job opportunities for South Central Los Angeles residents, using the model of Philadelphia minister Leon Sullivan's Opportunities Industrialization Center. In July 1966, I wrote a front-page *Free Press* article lauding the efforts of Cliff Vaughs, SNCC's Southern

California chairman, to incorporate Watts and the surrounding predominantly black areas as a new Freedom City. Another major article recounted Watts' development since its Mudtown origins at the turn of the century. Still another article on N-VAC's campaign to encourage a voter boycott of the November 1966 elections mentioned their controversial B—, B—, B— posters that were appearing in black neighborhoods. N-VAC leaders insisted they were an incitement to "Boycott, Baby, Boycott" rather than "Burn, Baby, Burn," but police were not amused, and I was later arrested for plastering one of the posters on a building.

During the summer of 1966, I also interviewed Ron (later Maulana) Karenga, the most influential of the black nationalist leaders in Los Angeles. The interview took place at the office of a group called Self-Leadership for ALL Nationalities Today (SLANT), headed by Karenga's friend Tommy Jacquette. I had known Karenga from his speeches on the UCLA campus, where he was a graduate student specializing in African languages. Earlier in 1966 he had founded US—"Anywhere we are, US is"—in order to "create a new sense of values" among African Americans. I was initially put off by exotic qualities of US members—their African-style green bubas and their use of Kiswahili terms—but I was also impressed by Karenga's intelligence and clear sense of purpose. During a period when many Black Power advocates seemed uncertain about the strategic and tactical implications of the phrase, Karenga and his disciplined cadre of followers offered a cogent philosophy of cultural transformation. Long after other Black Power advocates had receded from prominence, many African Americans would continue to celebrate the holiday he invented, Kwanzaa, often not realizing Karenga's progenitive role. My interview, the first on Karenga to appear in a publication intended for a predominantly

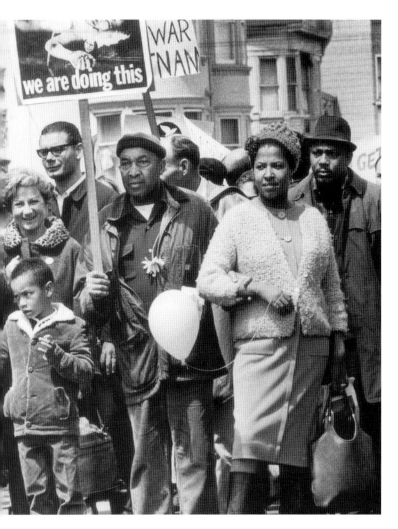

African American participation in an antiwar protest in San Francisco, 1967.

PHOTO BY NICHOLAS PAVLOFF

white readership, allowed him to describe the seven principles that would subsequently be celebrated during Kwanzaa: Umoja (unity), Kujichagulia (self-determination), Ujima (collective work and responsibility), Ujamaa (cooperative economics), Nia (purpose), Kuumba (creativity), and Imani (faith).

Impressed as I was by Karenga's cultural nationalism, I was nonetheless troubled by the type of racial separatism he seemed to promote. Although I readily accepted many of his views as a necessary antidote to feelings of racial inferiority, I felt comfortable in the racially fluid worlds of UCLA, West Hollywood, and Venice. Black nationalism offered an attractive new racial consciousness while also challenging the dual racial consciousness that had enabled me to cross racial boundaries and to report what I saw. Yet, in some respects I was an outsider on either side of the racial divide—a visiting journalist reporting the new currents of black nationalism and a black political activist reporting the rise of the white New Left and hippie counterculture. Especially among black militants, I felt vulnerable to the charge of being inauthentic because I lived among white people and by this time lived with one of them. My white girlfriend (Susan was also a UCLA student, although I had met her as a result of my N-VAC acquaintances) was part of my Venice social world but such liaisons were not accepted in the South Central Los Angeles black nationalist community. "Talking black but sleeping white" had become part of the blacker-than-thou invective of the period. Although I would later realize that few black militants were as secure as they seemed in their newly forged black identities, my constant border crossings contributed to a special sense of racial ambivalence.

Often during late 1966 and early 1967, I found myself in the role of racial diplomat, seeking to bring

together the Black Power and New Left movements in order to create a new national political force capable of challenging the Democratic and Republican Parties. During the summer, I flew to San Francisco in the private plane of Sy Casady, former head of the California Democratic Council, to attend a meeting called by Californians for Liberal Representation. The white New Left was well represented at the meeting—including congressional candidates Bob Scheer, Ed Keating, and Stanley Scheinbaum; San Francisco State's Marshall Windmiller; and Dave Jenkins of Harry Bridges's International Longshore and Warehouse Union. But there was little nonwhite representation at the meeting— myself, a man named Brother Crook from the Los Angeles Community Alert Patrol, which investigated police misconduct, and Delores Huerta of the Farm Workers movement in Delano. The white leftists had little sense of how a broad coalition could be put together in time to affect the November gubernatorial election pitting Democrat Edmond G. "Pat" Brown against Republican novice Ronald Reagan. Intending merely to write an article about the meeting, I became instead one of two cochairs of the California Conference on Power and Politics, a statewide gathering held a few months later in Los Angeles. Recognizing that black representation was a necessary component of the political movement they hoped to build, the white antiwar activists at the meeting turned to a twenty-two-year-old student who had never voted and had been in California less than two years.

During the period between the meeting in San Francisco and the much larger conference in Los Angeles, I was arrested again, this time while handing out antiwar leaflets at the Los Angeles train station. My antiwar sentiments intensified as the war escalated. My New Mexico draft board also got my attention with an

Antiwar activism in California was overwhelmingly dominated by white leaders, however, and I felt isolated as one of the few black activists to play a prominent role in antiwar demonstrations.

induction notice. Due to a combination of negligence and obstinacy, I did not apply for a student deferment, but I appealed my 1-A classification and began a years-long effort to gain conscientious objector status. By the time of my arrest, I had begun to see the antiwar movement as the best available substitute for the community I had once found in N-VAC. Antiwar activism in California was overwhelmingly dominated by white leaders, however, and I felt isolated as one of the few black activists to play a prominent role in antiwar demonstrations. I went to my draft physical examination alone after failing to recruit black students willing to offer support.

The antiwar movement was well represented at the Los Angeles conference in October 1966, but the 2,500 people who attended the gathering included few African Americans (although the keynote speaker was SNCC's Julian Bond, who had been denied his seat in the Georgia legislature because of his antiwar stand). When the attendees voted to support a motion rejecting both Brown and Reagan, most of the liberal Democratic leaders who had paid for the conference walked out. My participation in organizing the conference predictably did little to increase black attendance. Black nationalists were noticeably absent, although the resolutions passed during the meeting represented the white New Left's

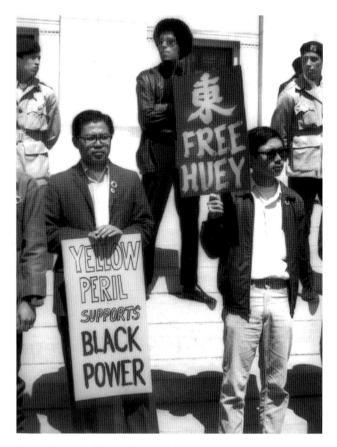

Brown Berets and Yellow Peril, an Asian American organization, show their solidarity with the Black Panthers during the "Free Huey" rally in front of the Alameda County Courthouse, 1968.

PHOTOGRAPH COURTESY OF ROZ PAYNE ARCHIVES

A month after the Los Angeles conclave, I attended another conference on the Berkeley campus that similarly failed to bridge the racial gulf, despite the fact that it focused on the topic of Black Power and featured a keynote speech by Carmichael. Organized by the Students for a Democratic Society (SDS), the day of speeches at the Greek Theater attracted a large audience that approached ten thousand by the time Stokely began speaking. Identified as a "Watts organizer," I was a warm-up speaker on the program, but I recognized that my comparatively mellow black militancy did not convey sufficient anti-white animus to persuade the mainly white audience that I was for real. Stokely was the person they wanted to hear, and he succeeded in convincing listeners that black-white alliances were "unrealistic" unless white radicals developed a "power base in their own community from which to coalesce." Stokely was the nation's most influential Black Power advocate, but he was himself torn between his roots in interracial socialistic activism and his pursuit of Pan-African unity. After his speech, Stokely and I spent the evening in San Francisco's Haight-Ashbury neighborhood at an interracial party of civil rights veterans. My subsequent article on the event ignored the complexity of Stokely's private life while reiterating his public stance: "The possibility of two separate radical movements, split on a racial basis, is a distressing but real possibility. A white radical response to Black Power is needed."

The Black Power conference revealed that most black militants were skeptical about building alliances with white leftists, but a newly formed black militant group was actually seeking white support in the Berkeley area. The Black Panther Party for Self-Defense, formed by Huey Newton and Bobby Seale, was hardly noticeable during the fall of 1966, but it would soon

best approximation of black militant demands. A short-term result of the conference was the formation of a New Politics movement, which in turn led to the creation of the Peace and Freedom Party, but the other short-term result was the election of Reagan, which in turn led to the Reagan-led conservative counter-revolution of the 1980s. The conference provided an early indication of the widening gulf between white leftists and black nationalists that would undermine many subsequent attempts to build a powerful new national political force on behalf of social justice.

become the largest black radical group and the most forceful opponent of Karenga's type of cultural nationalism. Although it was initially only one of several groups identified with the black panther symbol, the Panthers' Malcolm X–style rhetorical violence, their ruthless removal of competing groups, their brash willingness to stand up to police, and their unparalleled ability to secure white financial support enabled the Oakland-based party to grow rapidly during 1967 and 1968. After attending a speech by the party's most articulate recruit, writer, and ex-convict Eldridge Cleaver, I concluded that the Black Panthers were the group who best manifested the courageous militancy once displayed by SNCC and N-VAC. Cleaver and the other Panthers I met were intimidating figures; they displayed an aggressive self-confidence that did not encourage any questioning of their views—"You're either part of the solution or part of the problem," they both advised and warned. Yet, unlike Karenga's US organization, they were an all-black organization that did not seem to be antiwhite. Among the groups that emerged during the Black Power era, they were the most open to alliances with white leftists, particularly those willing to give the party contributions or publicity.

When the Black Panther Party expanded into Los Angeles during 1967, I became a supporter, but only from a distance. They demanded not only a willingness to risk death through armed clashes with police, but also a degree of uncritical fealty that I was not willing to offer, despite my general agreement with their ten-point program. I preferred their abrasive engagement with the American political system to the sullen separatism of US, but I questioned their unwillingness to see Karenga as a potential ally, rather than simply as another competitor. I continued to live in the diverging worlds of Venice and UCLA, of the New Left and Black

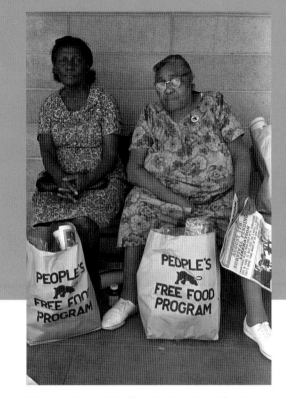

Elderly recipients of the Black Panther Party's Free Food Program, one of the many community programs the Panthers organized, 1971.

PHOTO BY STEVE SHAMES/POLARIS

Power. The black militant world was itself increasingly divided between self-described revolutionary nationalists, such as the Black Panthers, and cultural nationalists, such as US members. I thought that both groups served a useful purpose that was undermined by the infighting among dogmatic leaders seeking followers. The collapse of many of SNCC's organizing efforts in the South signaled the start of an era in which "the people" were no longer sources of innovative political ideals, but instead targets of consciousness-raising and ideological education. Black leaders competed to become the "messiah" that FBI Director J. Edgar Hoover imagined "could unify and electrify the militant Black nationalist movement." I admired the bravery and dedi-

cation of the Black Panthers, initially seeing them as SNCC's contemporary urban counterparts. I ignored signs that the party's leaders had little sympathy for SNCC's consensus style of decision making. Eldridge Cleaver later explained to me that a difference between SNCC and the Black Panthers was that the former had long meetings, while the latter had very short meetings. Stokely and other SNCC veterans tried to forge an alliance with the Black Panther Party, but ideological differences and FBI counterintelligence efforts quickly disrupted these ties.

On a personal level, I saw that my skills had declining usefulness in the new political climate. After 1966, I gave up political journalism, perhaps recognizing that I had little to say about all my previous areas of interest that could not be said with greater clarity and cogency by a native rather than a tourist. My deepening relationship with Susan, my desire to complete my undergraduate studies, and my pressing draft problems absorbed more and more of my energy. When Susan and I graduated from UCLA in June 1967, we acknowledged the likelihood that I would soon be faced with a choice between entering the military or going to jail. We decided to leave the United States with the intention of establishing residence elsewhere. We married in August 1967 and soon afterward began an extended sojourn through Europe and North Africa while Canadian officials considered our application for landed immigrant status. A few of my black activist acquaintances objected to my marriage to a white woman, who was moreover Jewish, but I felt fortunate to find someone willing to share my self-imposed exile. With ample opportunity to reflect on identity issues during our travels, we found temporary refuge from the intense internal conflicts that engulfed the black struggle during that period.

In the spring of 1968, after Canada rejected us and Susan discovered she had a serious case of diabetes, we were forced to return to the United States. Back in Los Angeles, distracted by the pressing need to earn a living and avoid arrest as a draft dodger, I found a political world very different from the one I left. Since then, Huey Newton's imprisonment on murder charges had stimulated an outpouring of support for the Black Panther Party. Stokely and other SNCC leaders came to California to participate in "Free Huey" rallies in February 1968. Soon after my return, local police forces and the FBI launched a violent campaign against the Black Panthers. The party's sixteen-year-old treasurer Bobby Hutton was killed in a shootout early in April, and two days later Martin Luther King Jr. was assassinated in Memphis. Although I attended rallies in support of the Panthers and embattled UCLA professor Angela Davis, I was no longer a political journalist or a member of any political organization. I contacted a draft lawyer and found work as a computer programmer on the UCLA campus. Only a year earlier I had been a student, but my previous movement experiences no longer seemed of much relevance to the new generation of black students who had arrived on campus in the aftermath of King's assassination. The student strike at San Francisco State had signaled the beginning of a concerted nationwide effort to establish black studies and ethnic studies programs.

In January 1969 I attended a meeting of the UCLA Black Student Union where Black Panthers and members of US stood glaring at each other from opposite sides of a classroom in which intimidated students discussed how to establish a black studies program. Although I continued to favor the Black Panthers, I was perplexed and disturbed by their vicious verbal attacks against Karenga, whom they labeled a "pork-chop nationalist" allied with "pigs" (police). I was not com-

pletely surprised when the escalating tensions between Black Panthers and US members exploded two days later into a deadly clash. Two members of US killed two Panthers, Alprentice "Bunchy" Carter and John Huggins, in a cafeteria near my office. I would later learn that the FBI's counterintelligence program fostered these hostilities. Subsequent police raids severely damaged both groups, but for me, the immediate consequence of the killings was that they reinforced my desire to maintain my distance from a Black Power movement that had become self-destructive. The Panther–US conflict also led me to become even more skeptical about the value of the prevailing, rhetorical style of black militancy, which had increased competition among black leaders while achieving scant power or racial unity.

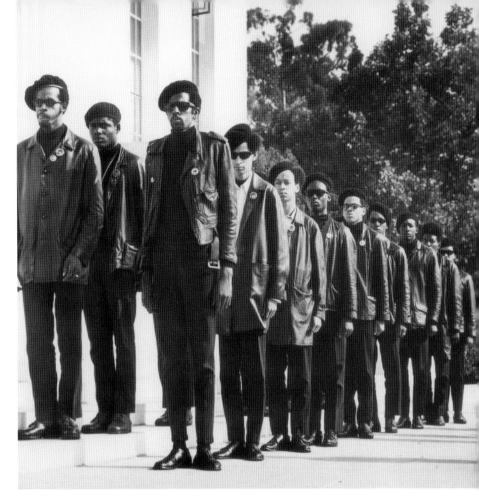

Black Panthers in formation during the "Free Huey" rally in front of the Alameda County Courthouse, 1968.

PHOTO BY JONATHAN EUBANKS

During 1969 I considered returning to political journalism, but the emergence of the Black Studies movement provided a new option. While continuing to work as a computer programmer, I began auditing Professor Gary Nash's new class at UCLA on race relations in the United States. As one of a small number of black college graduates on campus, I was soon recruited to be an informal teaching assistant, leading a section of Nash's course devoted to black political thought. Among the fifteen students in the section were the president and vice president of the Black Student Union as well as members of the Black Panther Party, US, and the Nation of Islam. Intense class discussions provided a brutal yet instructive introduction to teaching. Despite my earlier feelings of being an outsider, I had learned much as a result of my activist journalism. Realizing

that I knew more than my academic colleagues and certainly more than most students about recent African American history, I gradually became assured in the role of black intellectual providing historical perspective to black insiders as well as sensitive understanding to white outsiders. Political activism had once drawn me away from my undergraduate classes; now it gave me a reason to complete graduate studies and begin an academic career.

Just five years earlier, I had arrived in California and become immersed in its rapidly changing political culture. Having lived through a uniquely volatile period of the state's history, I felt fortunate to have witnessed the transformation. Although racial boundaries still remain, I have come to see California as a place where there is much to be learned by crossing them.

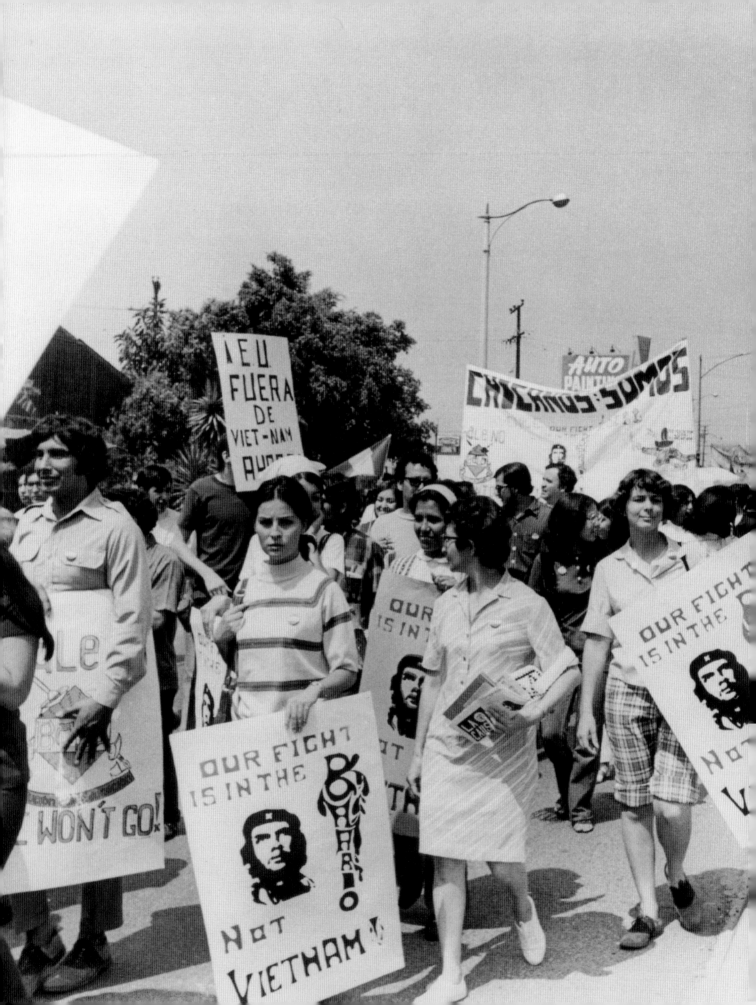

CHAPTER 7

Chicano and Chicana Experiences of the War

George Mariscal

The silver medals
Purple hearts
Medals of conquering heroes
Hung on Chicano homes
Another Mexican American hero
Brought home
Under the Stars and Stripes.

—María Herrera Sobek, "Silver Medals"

THE DARKEST AREAS on military casualty maps from the Vietnam War era reveal a dense concentration of fatalities in California's Central, San Joaquin, and Imperial Valleys. Home to large Chicano/a communities, these regions of the state sacrificed an unusually high percentage of their young men to the U.S. war in Southeast Asia. Together with urban areas like East Los Angeles, San Diego's Barrio Logan, and San Francisco's Mission District, rural California provided the ethnic Mexican youth who would populate combat units and eventually decorate the Wall that was transformed into a roll call of carefully etched Spanish surnames.

In this chapter, I will outline some of the contradictions that riddled Spanish-speaking communities as they negotiated traditional and emergent political and cultural forces. There can be no doubt that since the turn of the century, Mexican Americans have served in U.S. combat units in disproportionate numbers (*Hispanics* 1984; Robles 1994; Mariscal 2003). While there are many reasons that propel working-class men and women into the military, one factor that complicates the service of the Chicano community is the thorny issue of assimilation, its connection to patriotism and to the promise of full citizenship in the nation. For members of groups already marked as not fully "American," the desire to "fit in," not to call attention to one's self by refusing to practice conventional patriotic behavior, is especially strong.

Even the first antiwar plays staged in the late 1960s by the cultural arm of César Chávez's United Farm

Chicano Moratorium prior to violent confrontations with Los Angeles police officers, August 1970.

Rafael Anibal Mariscal Jr., a World War II veteran, poses with his father outside the family's print shop on 4th Street in East Los Angeles, 1945.

PHOTOGRAPH COURTESY OF GEORGE MARISCAL

George Mariscal with his father, Rafael Anibal Mariscal Jr., on graduation day from basic training at Fort Ord, 1968.

PHOTOGRAPH COURTESY OF GEORGE MARISCAL

Workers' (UFW) union—El Teatro Campesino—embody the tension produced by the desire to assimilate. In the 1971 acto (one-act play) titled *Soldado Razo (Buck Private)*, the narrator describes the departure of a young Chicano soldier: "So Johnny left for Vietnam, never to return. He didn't want to go and yet he did. It never crossed his mind to refuse. How can he refuse the gobierno de los Estados Unidos? How could he refuse his family?" (Valdez 1990, 132). The suggestion that his family's wishes coincide with those of the government, that the refusal to serve would disappoint both equally, reminds us that Latinos like other "unmeltable" ethnic groups are under immense pressure to assimilate and submit to the demands of state authority. In Luis Val-

dez's play, *The Dark Root of a Scream*, the death in Vietnam of the character Indio is attributed in part to the pressure to serve he felt from the community:

Gato—He rapped against the war, but his time came and he had to go a huevo just like everybody else.

Priest—He was concerned what the barrio would think if he refused induction.

Gato—If he'd gone to the pinta instead of the army, all the barrio would have said he was chicken.

Priest—He was considering fleeing the country, but he knew he'd never be able to return as a community leader.

(Salinas and Faderman 1973, 90)

In massive numbers, then, Chicanos faced with the prospect of going to Vietnam reacted with the same sense of duty and/or fatalism that had inspired their fathers, cousins, and uncles in World War II and Korea (Morín 1966).[1] In discussing Mexican American participation in U.S. wars, we must focus critical attention on the social networks that allowed some groups to resist the war while others were unable to do so. The conflation of duty to family and duty to country is strikingly present in one Chicano veteran's explanation of why he served: "I didn't have much of a choice. If I had refused to get drafted, what was I going to do? It would have been just as hard to refuse the draft as it was to go into the army. Where was I going to go? I had nowhere to go. That would have been real hard on my *jefitos* [parents]" (Trujillo 1990, 27).[2] The chant "You don't have to go!" directed at minority draftees by the relatively privileged student leaders of the antiwar movement wholly ignored the intense pressures and contradictions felt by members of working-class communities of color.

The material conditions of poverty, job discrimination, and educational tracking, together with what was felt to be the overwhelming obligation to serve and "prove" one's loyalty according to traditional notions of nation and masculinity, were responsible for the relatively low number of Chicano draft resisters during the Vietnam era. Nevertheless, as early as 1966, Chicano leaders such as Rodolfo Corky Gonzales, founder of the Crusade for Justice in Denver, spoke out against the war: "Would it not be more noble to portray our great country as a humanitarian nation with the honest intentions of aiding and advising the weak rather than to be recognized as a military power and hostile enforcer of our political aims?" (Vigil 1999, 28).

Chicano men slowly joined the ranks of those who refused to participate in the killing. Ernesto Vigil, of

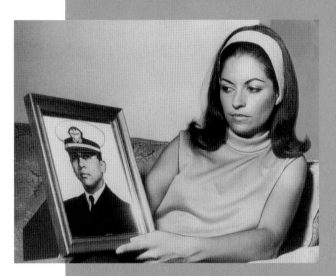

Tangee Alvarez holding a photo of her husband Everett Alvarez Jr., the second longest held American prisoner of war in North Vietnam, July 31, 1969.

OAKLAND TRIBUNE COLLECTION, GIFT OF ANG NEWSPAPERS, OAKLAND MUSEUM OF CALIFORNIA

Denver, was among the first to refuse induction, stating that he would not fight against his "brown brothers in Vietnam" (Ruiz 1968, 11). This sentiment and language were echoed by other resisters like former UCLA student body president Rosalío Muñoz, David Corona (son of longtime Chicano activist, Bert Corona), and Manuel Gómez. In a letter to his draft board in 1969 and published in *La Raza*, Gómez wrote: "The Vietnamese people are not my enemy, but brothers involved in the same struggle for justice against a common enemy. We are all under the same sky. East and West are one" (Gómez 1970, 7).[3] A combination of the language of Chicano nationalism and mythic images of a prelapsarian nature, Gómez's letter previews the major tropes of Chicano antiwar literature in the early 1970s.

By the late 1960s it had become evident to many in Mexican American communities that U.S. involvement in Vietnam was not a battle to defend democracy, as

New recruits and draftees being inducted into the Army at the Oakland Induction Center, 1968.
PHOTO BY MICHELLE VIGNES

World War II had been. The shift from an earlier generation's unqualified patriotism to the Chicano generation's ambivalent attitudes toward the war is illustrated by a letter written by a World War II veteran and League of Latin American Citizens (LULAC) activist father to his son, Douglas MacArthur Herrera, who was in the military but had refused to obey orders to ship out to Vietnam:

> Dear Son: Your Mom and I were very shocked to read your letter and you know we have never had a Herrera yet who has refused to serve his country. Your family

will never live it down and your life will be ruined. You should not question your country's motives and its foreign policy, and in the overall picture someone must suffer. . . . Your objections will be widely publicized here in Texas and your family will probably have to move out of Texas to get over the embarrassment and humiliation of what you are doing. Knowing your feelings your entire family will be more proud of you now if you go back and finish the few short months that you have to go. Think of your AGGIE BUDDIES! Your school has a glorious tradition almost as long as the Herrera family of serving our country always without

question. There has not been a single Aggie Buddy that has refused to serve, there has not been a single Herrera, don't be the first one son, don't make us ashamed of you. Go back and serve your country. Don't break our hearts. Please call us and tell us that you are going to do the right thing to your country and to your family.

(Herrera 1967)[4]

From the father's point of view, the son has brought such profound shame upon members of his family that they will feel compelled to leave their home, even move to another state. In effect, by disrupting the long line of Mexican American service in U.S. wars, the younger Herrera threatens to destroy one of the most important roads to assimilation.

Nowhere are the contradictions inherent in the Chicano soldier's position more explicit than in the story of Everett Alvarez, Jr. Born and raised in Salinas and held as a prisoner of war for eight-and-a-half years in North Vietnam, Alvarez's participation in the war in Southeast Asia spanned the early 1960s, when he became a navy aviator, through the Gulf of Tonkin incident, on to the release of the POWs in 1973, and the dedication of the Vietnam Memorial in 1982. Alvarez's account of this twenty-year period, the autobiographical *Chained Eagle,* is at once a conventional tale of heroism, an apology for the war, and a compendium of mutually exclusive positions regarding its meaning (Alvarez and Pitch 1989).[5]

Alvarez's prologue is a stunning example of patriotic discourse as it was reformulated in the 1980s by Reaganite ideologues and a large sector of Vietnam veterans. In their view, the problem with the war was that the men who fought it were not allowed to win. The fact that such an interpretation, as well as the following

analysis, was offered by a member of a relatively disempowered minority group, the grandson of Mexican immigrants, makes it both predictable and paradoxical:

> If wars bring the ultimate destruction, they also present the noblest challenges. Prolonged captivity under brutal conditions in a hostile land pits a man against overwhelming odds. My survival depended on much more than trying to satisfy a craving for food, and overcoming the emptiness of isolation and the pain of torture. My strength came from holding fast to my faith in God and belief in the values enshrined in our Constitution: duty, loyalty, unity, integrity, honor, allegiance, courage and hope. Without my absolute belief in these core virtues of our heritage I don't believe I would have pulled through alive and sane.

(Alvarez and Pitch 1989, 2)[6]

The juxtaposition of military values and the U.S. Constitution marks Alvarez's text as the product of a career navy officer. But it also suggests the easy connections made by many Americans between the modern responsibilities of citizens and ancient patriarchal and religious codes of conduct. As he stepped off the plane upon his return, Alvarez told the assembled crowd: "God bless the president and God bless you Mr. and Mrs. America" (Alvarez and Pitch 1989, 312).[7]

Several sections of *Chained Eagle* represent the divisions that separated U.S. society in general and the Alvarez family in particular. Although Alvarez was being held by the North Vietnamese, both his mother (Soledad) and sister (Delia) came to oppose the war publicly. The family was torn (and torn apart) by loyalty to its eldest son, their belief in the promises of U.S. liberalism, and serious questions about the morality of the war. As Delia Alvarez put it: "Everett will return when Vietnamese children will be able to look at the sky and

clouds and not fear that a bomb will drop that will burn and tear their bodies" (Moreno 1973, 86).

Much has been made about the fact that the Vietnam War has not been, and perhaps cannot be, absorbed by official U.S. history. Despite attempts to "get beyond Viet Nam" by conducting "more successful" wars against developing nations, the specter of Vietnam continues to inhabit the national psyche. Books such as Myra MacPherson's *Long Time Passing: Vietnam and the Haunted Generation* (1984; rpt. 1993) play upon the notion of lingering trauma and tragedy. But I would argue that the war cannot be "figured out" nor "factored in" because the war temporarily exposed the limitations of liberal democracy, that the sacrifices required of those American citizens without economic and cultural capital were not required of all citizens.

The racial, ethnic, and class composition of U.S. combat units and the final Vietnamese victory together revealed the hypocrisy and inefficacy of the ruling elites and their inability to comprehend the most basic causes of structural and class racism. That a disproportionate number of combat troops were poor, brown, and black should have forced (but did not) a total rethinking of American identity and the rights and responsibilities of citizenship. Instead, the economic and racial injustice that produced the debacle in Vietnam were restructured through the "all-volunteer" military (in reality, an economic draft) and played out in a new register in the invasions of Panama, Somalia, and Iraq.

¡RAZA SÍ, GUERRA NO!

Despite the long tradition of military service in California's Latino communities, the Vietnam era would witness a fundamental shift in the attitudes of Chicano/a youth toward U.S. foreign policy and the armed forces. It is a little known fact outside of the Southwest that Chicanas and Chicanos organized and demonstrated in some of the largest antiwar rallies of the late 1960s and early 1970s. The most famous demonstration, August 29, 1970, in Laguna Park in East Los Angeles, marked the high point of Chicano/a mobilization. Estimated attendance was between 20,000 to 30,000 people, and the march began peacefully with participants carrying signs in Spanish and English: "Traiga a mis carnales ahora" ("Bring my homeboys home now"); "A mí me dieron una medalla y $10,000 por mi único hijo" ("They gave me a medal and $10,000 for my only son"); and "U.S. out of Vietnam." In the police riot that ensued, three people died including Lyn Ward, Angel Diaz, and Rubén Salazar, a *Los Angeles Times* reporter who had returned from assignments in Saigon and Mexico City, and had begun to write investigative pieces exposing police brutality in the Chicano/Mexicano community.

News of the August 29 demonstration spread slowly across the country. The East Coast press, however, paid little attention to the event, in essence reproducing Los Angeles Police Department accounts of the clash between Chicanos and authorities. The *New York Times*, for example, ran a short piece the day after in which it reported that only seven thousand people attended the rally and "five hundred policemen and Sheriff's deputies tried to break up roaming gangs."[8] Mexican newspapers, such as *El Excelsior* and *Novedades*, published editorials on "La rebelión de los Chicanos" in which they astutely noted the role played by government agitators. Ironically, President Nixon was in Los Angeles the evening of August 29, attending a fund-raiser on the Westside. Two days later, he received a telegram from Herman Sillas, chairman of the California State Advisory Committee to the U.S. Civil Rights Commission, asking for a meeting to discuss recent events. Sillas never

received a reply. During the week that followed, smaller civil disturbances broke out across Southern California in Riverside, Barstow, and Wilmington.

The development of the Chicano antiwar movement in the Southwest followed the trajectory of more general antiwar activities across the nation insofar as its intensity did not increase until the election year of 1968. Although regional leaders such as Corky Gonzales and Reies López Tijerina, organizer of the New Mexico land movement, had declared publicly their opposition to Johnson's policy as early as 1966, the Mexican American community remained relatively quiet on the issue. In California, in particular, where radicalized Chicano communities lacked fully developed organizational structures such as those in Colorado, Texas, and northern New Mexico, antiwar activities began slowly. Chicano-organized demonstrations such as the one that drew approximately 150 marchers on Thanksgiving Day 1967 in the Mission District of San Francisco were small. By early 1968, however, Chicano magazines and journals were reporting accounts of draft resistance and refusals of induction. In both Spanish and English, young Chicanos were urged to just say no:

> Carnales, the government that seeks to induct you into military service is the same one that allows and promotes discrimination in employment, low wages for farm workers, one-sided and prejudicial educational programs, urban redevelopment, and a thousand other oppressive conditions. And then, they ask you to go defend and perpetuate this system with your life. ¿Qué creen que somos? ¿BURROS? Those Gabachos even ask you to impose this system of oppression upon the people of Vietnam, Santo Domingo, Bolivia, and many other countries, as well as upon our own people.

> Hermanos, the peoples of those countries ARE NOT our enemies. Our enemies are the racists and greedy GABACHOS, and their Tacos, who grow richer every day on the sweat, tears, yes, and on the blood of Chicanos, blacks, and other minorities. OUR WAR FOR FREEDOM IS HERE not in Viet Nam.

(*La Raza Yearbook* 1968, 3)

In their 1972 *La batalla está aquí (The battle is here)*, Lea Ybarra and Nina Genera produced a bilingual pamphlet calling for an end to Chicano participation in the war and offering "legal ways to stay out of the military." Together with fellow University of California Berkeley students Fernando Genera and María Elena Ramírez, Ybarra and Genera had been trained in antidraft counseling by the American Friends Service Committee. By 1969, they were advising young Chicanos in high schools and colleges throughout Northern California. Ybarra, who had eighteen cousins who went to Southeast Asia, recalls performing antiwar skits and reciting Daniel Valdez's popular "Corrido de Ricardo Campos":

> You are dead, Richard Campos, you are gone
> You are dead, and I bid you good-bye
> But now that you're gone, there's a doubt in my mind
> What would have happened if you never would have
> died?

> Would they treat you the same?
> Or send you on your way with a medal stuck in your
> hand
> Saying "Thank you, boy, thank you very much,
> You have paid your debt to Uncle Sam."

> Now should a man
> Should he have to kill
> In order to live
> Like a human being
> In this country?

(Ybarra 1997)[9]

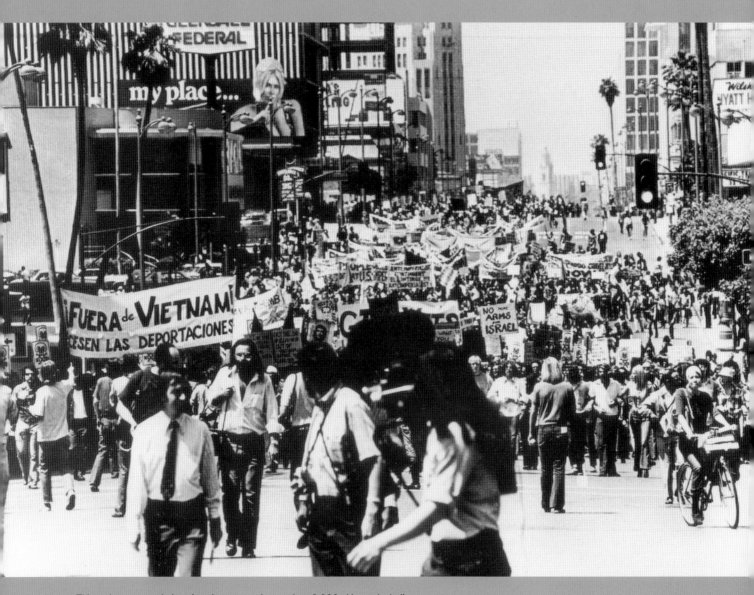

This antiwar protest in Los Angeles attracted more than 6,000 citizens, including a
large group of Latinos, April 1972.

By including in their pamphlet a number of graphic photographs of maimed and wounded Vietnamese children, Ybarra and Genera implicitly indicted Chicano soldiers in the commission of atrocities, and openly posed the question "What can you do to keep Chicanos from going to Viet Nam and killing or mutilating beautiful children? We only lose our men and our honor and pride by participating in or promoting the killing of thousands of men, women, and children" (Genera and Ybarra 1972, 5).[10]

The text included a complete explanation of deferments and strategies for avoiding the draft as well as, in the section written in Spanish, the interesting "Letter to the North American People from Vietnamese Catholics." The letter argued: "Aquellos que los EEUU acusan de comunistas son, en realidad, nuestros hermanos y hermanas, nuestros parientes y nuestros amigos. Ellos son campesinos y obreros quienes sólo piden una cosa: poder ganarse el pan con el sudor de su frente en un país libre de tropas extranjeras . . . Nosotros compartimos con ustedes la fe en Cristo y les pedimos que en nombre de la religión que compartimos nos ayuden a parar esta guerra cruel" ("Those whom the U.S. accuses of being Communists are, in reality, our brothers and sisters, our relatives and our friends. They are peasants and workers who only request one thing: to be able to earn their daily bread by the sweat of their brow in a country free of foreign troops . . . We share with you our faith in Christ and we ask in the name of the religion we share that you help us stop this cruel war") (Genera and Ybarra 1972, 34).

The appeal to the Chicano community's Catholicism as a source for antiwar activism was ironic given the official U.S. Church's hawkish stance. But by 1970 the Church hierarchy was increasingly losing its grip over its Chicano parishioners. Texts such as Luis

Members of El Teatro Campesino performing during a United Farm Workers rally, c. 1970.

PHOTO BY JEFFREY BLANKFORT

Valdez's "Pensamiento serpentino" consciously refashioned Christian values not according to official dogma but in order to demonstrate how they might serve as a source of strength for political action at home, the key examples being César Chávez's activism and the Vietnamese resistance.

Despite the radicalization of some segments of the Chicano community, the dominant institutions in that community were either openly or tacitly pro-war. The role of the Catholic Church is an interesting one in this regard. Without a single Spanish surname in its entire North American hierarchy (the first "Hispanic" bishop was appointed in 1970), the Church leadership was inattentive to political changes taking place among Mexican Americans. In 1970 the Los Angeles–based reform movement—Católicos por la Raza—demanded that the Church express public support for ongoing struggles such as the farm workers' boycotts and the antiwar movement. Cardinal McIntyre stated that the Church would remain "neutral" on the issue of the war, and the local Church hierarchy claimed to lack sufficient

Despite the radicalization of some segments of the Chicano community, the dominant institutions in that community were either openly or tacitly pro-war.

funding to provide support for such projects despite the fact that it recently had financed an opulent new church, St. Basil's, on the Westside. It was this volatile situation that led to the 1969 Christmas Eve demonstration and police riot described in the opening chapter of Oscar Zeta Acosta's novel, *Revolt of the Cockroach People* (1973).

McIntyre's response to the events of Christmas Eve was to compare the Chicano demonstrators to the "rabble" at the crucifixion of Christ who should be forgiven "for they know not what they do." Other Church officials were less abstruse, red-baiting the demonstrators as well-organized "revolutionaries." In direct contrast to their avowed neutrality on the issue of the war, at the level of the individual parishioner or member of the clergy, Church patriarchs exerted subtle pressure to support official U.S. foreign policy (Mosqueda 1986, 98).[11] McIntyre himself maintained close ties with the Nixon White House, a relationship alluded to by Acosta who referred to the Cardinal as "the holy man who encouraged presidents to drop fire on poor Cockroaches in far-off villages in Vietnam" (Acosta 1973, 13).

Among the antiwar clergy, Episcopalian pastor Father John Luce was a key player in virtually every aspect of the Chicano movement. Father Luce, who had been an associate of famed organizer Saul Alinsky in

New York, brought his politically engaged message to East Los Angeles in 1955, and by the late 1960s was supporting efforts such as the Brown Berets (a grassroots and self-defense community organization based in East Los Angeles), the high school blow-outs, the production of *La Raza* newspaper, and Moratorium Committee activities. His Church of the Epiphany in Lincoln Heights was a meeting place for the most progressive elements of the community, especially every January on the Día de los Reyes (Day of the Magi), which was often transformed into a combined religious celebration and political meeting (Luce 1996).[12] Working with Father Luce was a dedicated group of activists, which included Eliezer Risco, a former teaching fellow of Cuban descent at Stanford University's Bolívar House and cochair of the Stanford Committee for Peace in Vietnam. In the mid-1960s Risco advised Luis Valdez, founder of El Teatro Campesino, on his refusal of induction into the military. Valdez later convinced Risco to go to Delano to work with the United Farm Workers. By 1967 Risco was producing *La Raza* newspaper from Father Luce's basement and participating in a summer VISTA youth program that included Brown Beret founder David Sánchez and future film producer Moctezuma Esparza (Risco 1996; 2003).[13]

The United Farm Workers' union, despite El Teatro Campesino's explicitly antiwar plays, was itself riddled with contradictions with regard to the war. Because many of its supporters were drawn from other unions such as the Seafarers, the hawkish attitudes of the latter together with the traditional patriotism of some UFW members produced conflicts when juxtaposed to the radical views of student volunteers from college campuses. César Chávez recalled several tense moments from early in the movement: "When we started the strike, many volunteers were in and out.

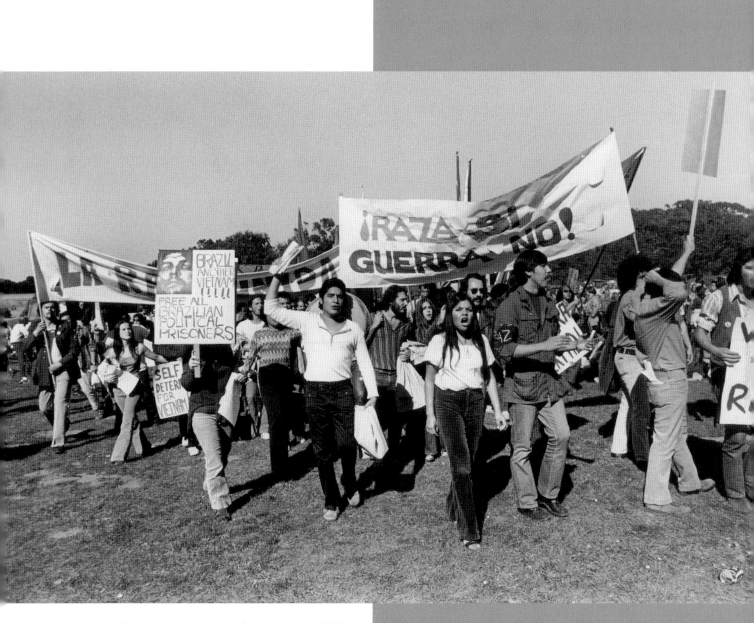

Latino contingent at an antiwar rally in San Francisco, c. 1970.

PHOTO BY HAROLD ADLER

California Veterans Memorial in Capital Park, Sacramento, c. 1985.
PHOTOGRAPH COURTESY OF JAMES CORWIN/CORBIS

Some of the volunteers were for ending the Vietnam War above all else, and that shocked the workers because they thought that was unpatriotic. Once, when there was a group more interested in ending the war, I let them have a session with the farm workers. After a real battle, the volunteers came to me astounded. 'But they support the war!' they said. 'How come?' I told them farm workers are ordinary people, not saints" (Levy 1975, 197). It was only through a concerted effort to prioritize political goals that such conflicts were resolved provisionally and fragile coalitions allowed to survive. When the Department of Defense openly supported the growers against whom Chávez was leading strikes by purchasing scab grapes and lettuce, it was clear that the UFW shared much in common with those who opposed the war.

As the antiwar movement became increasingly confrontational, however, Chávez further distanced himself from its tactical decisions. In a 1970 interview, he expressed his concern: "The real paradox here is that the people who advocate peace in Vietnam advocate violence in this country. Inconceivable; I don't understand it" (Fitch 1970; rpt. García 1973). Nevertheless, by the time of the August 29 Moratorium demonstration, Chávez wrote to organizers: "It is now clear to me that the war in Vietnam is gutting the soul of our nation. Of course

we know the war to be wrong and unjustifiable, but today we see that it has destroyed the moral fiber of the people" (Griswold del Castillo and García 1995, 118). After August 29, 1970, and the murder of Rubén Salazar, who had covered the farm workers' march in May of the previous year, the UFW's official newspaper, *El Malcriado,* began to take a more openly antiwar stance on its editorial page.

In the final scene of Corcoran native Charley Trujillo's novel, *Dogs from Illusion,* a Chicano veteran nicknamed Ese, recently returned from Vietnam, is stopped by the Border Patrol and asked where he was born. Perceived by authorities as a foreigner in his own land, Ese responds with anger and is beaten to the ground (Trujillo 1994, 199). The experience described here in fictional form is founded on the everyday reality of many Mexican American veterans. Whether they were hassled by local police or immigration officers, denied job opportunities or housing, the harsh reality of anti-Mexican racism in the Golden State affected them directly. Despite their honorable military service, a full recognition of their contributions and their rights as citizens continued to elude them.

The war in Vietnam transformed Chicano/a communities in California in multiple ways. The sacrifice of so many promising youth who died in combat formed the harsh backdrop to a profound series of changes at the level of politics, culture, and personal identity. It is difficult to imagine the development of the Chicano movement, a multifaceted social movement encompassing diverse agendas ranging from reform to revolution, without the war as a generative factor. Radicalized by their war and antiwar experiences, the Chicano/a "Sixties generation," in its vast majority a working-class generation unlike other sectors of the antiwar and countercultural movements, would become the teachers, organizers, and elected officials of the 1980s and 1990s. As the demographic reality of the Golden State continues to change (with Latinos expected to reach over 50 percent by the year 2030), the influence of this generation, inheriting their parents' and grandparents' history of immigration and labor and tempered by the formative years of war and protest, will be key to the creation of a multicultural and economically just society.

NOTES

1. José Montoya, a poet and Korean War veteran, reminds us: "Los Chicanos en Korea/Se portaron con honor/Ganaron muchas medallas/Hasta liberty in Japón/Pero al volver al cantón/Derechito a la prisión" ("Chicanos acted with honor in Korea. They won many medals and took leaves in Japan. But when they returned home they went straight to prison"). "Chicanos en Korea" in Montoya 1992, 251.

2. In their antidraft literature, Nina Genera and Lea Ybarra made the following point to Mexican American parents: "Parents must begin to place the love of their sons before their fear of the government" (Genera and Ybarra 1972, 7).

3. The premier issue of *La Raza* was "offered in memory of Chicanos who have died in the horror of the Vietnam War—a war created by their very own oppressors in the U.S. to further oppress and exploit those people it deems inferior."

4. For the difficult decisions faced by Chicano conscientious objectors, see the accounts in Ybarra 2004.

5. The sequel to *Chained Eagle* is Alvarez and Schreiner 1991.

6. Craig Howes has shown how Alvarez's story becomes the literary and ideological model upon which subsequent POW autobiographies would be based. See Howes 1993.

7. In *Code of Conduct,* Alvarez rejects the term "Chicano": "To me words like Chicano and La Rasa [sic] meant people who had come from Mexico. Period. I didn't like the sounds of a 'Chicano movement' or a 'Chicano manifesto'" (Alvarez and Schreiner 1991, 25).

8. For further information on the August 29, 1970, Chicano Moratorium demonstration, see the classic account in Morales 1972. See also Acuña 1984 and 2000, Marín 1991, Oropeza 1996, Pelayo 1997 and Mariscal 1999. David García's prize-winning documentary, *Requiem 29* (1970), is archived at the Chicano Studies Library of UCLA. Other films include Francisco Martinez's *August 29, 1970*, Thomas Myrdahl's *Chicano Moratorium: A Question of Freedom*, and *March in the Rain*, a record of the February 28, 1970, demonstration filmed by Claudio Fenner-López and Los Angeles Public Television station KCET.

9. The real Richard Campos, a native of Northern California, was killed by small arms fire in South Vietnam on December 6, 1966.

10. The printing of photos depicting atrocities perpetrated by U.S. soldiers had been a tactic of the earliest antiwar literature in the Chicano community. In 1968, for example, a group called the Chicano Liberation and Peace Movement had published such a photo in the Los Angeles newspaper *Chicano Student* (June 12, 1968), with the caveat: "The reason for printing this picture is not to put down GIs but just to point out the fact that the Army can mess up your mind if you let it" (2).

11. The official slogan of Católicos por la Raza was "Señalar y combatir los defectos de la Iglesia es servirla" ("To point out and fight against the Church's defects is to serve her").

12. An unsung hero of the Chicano movement, Father Luce remained in Los Angeles until 1974. He continues to support Latino causes in the New York area to this day.

13. Risco was the basis for the character of the same name in Acosta's *The Revolt of the Cockroach People*. He was ordained an Episcopalian priest in 1994.

WORKS CITED

Acosta, Oscar Zeta. 1973. *Revolt of the Cockroach People*. New York: Vintage.

Acuña, Rodolfo. 1984. *A Community Under Siege: A Chronicle of Chicanos East of the Los Angeles River 1945–1975*, Monograph no. 11. Los Angeles: Chicano Studies Research Center of UCLA.

———. 2000. *Occupied America: A History of Chicanos*, 4th ed. New York: Longman.

Alvarez, Jr., Everett, and Anthony S. Pitch. 1989. *Chained Eagle*. New York: Dell.

Alvarez, Jr., Everett, and Samuel A. Schreiner, Jr. 1991. *Code of Conduct*. New York: Donald I. Fine.

Fitch, Bob. 1970. "Interview with Cesar Chavez." *The Christian Century* (February 10).

García, F. Chris, ed. 1973. *Chicano Politics: Readings*. New York: MSS Information Corporation.

Genera, Nina, and Lea Ybarra. 1972. *La batalla está aquí: Chicanos and the War* (El Cerrito: Chicano Draft Help, 1972).

Gómez, Manuel. 1970. "Letter to Draft Board." *La Raza* 1.

Griswold del Castillo, Richard, and Richard A. García. 1995. *César Chávez: A Triumph of Spirit*. Norman: University of Oklahoma Press.

Herrera, John. 1967. "Letter to Douglas MacArthur Herrera." (October 25). Original correspondence in the John Herrera Collection, Houston Metropolitan Research Collection, Houston Public Library.

Hispanics in America's Defense. 1984. Washington, D.C.: Office of Deputy Assistant Secretary of Defense for Equal Opportunity and Safety Policy.

Howes, Craig. 1993. *Voices of the Vietnam POWs: Witnesses to Their Fight*. Oxford: Oxford University Press.

Levy, Jacques E. 1975. *Cesar Chavez: Autobiography of La Causa* New York: W.W. Norton.

Luce, Father John B. 1996. Telephone interview with author (December 11).

MacPherson, Myra. 1984; rpt. 1993. *Long Time Passing: Vietnam and the Haunted Generation*. Garden City, N.Y.: Doubleday; rpt. New York: Anchor Books.

Marín, Marguerite V. 1991. *Social Protest in an Urban Barrio: A Study of the Chicano Movement, 1969–1974*. Lanham, MD: University Press of America.

Mariscal, George. 1999. *Aztlán and Viet Nam: Chicano and Chicana Experiences of the War*. Berkeley: University of California Press.

Mariscal, Jorge. 2003. "They Died Trying to Become Students." *AlterNet* (April 20). www.alternet.org

Montoya, José. 1992. *Information: 20 Years of Joda*. San Jose: Chusma House.

Morales, Armando. 1972. *Ando sangrando (I Am Bleeding): A Study of Mexican American-Police Conflict*. La Puente: Perspectiva.

Moreno, Dorinda. 1973. *La Mujer—en pie de lucha ¡y la hora es ya!* Mexico City: Espina del Norte.

Morín, Raul. 1966. *Among the Valiant: Mexican-Americans in WW II and Korea*. 3d ed. Alhambra: Borden.

Mosqueda, Lawrence J. 1986. *Chicanos, Catholicism and Political Ideology*. New York and London: University Press of America.

Oropeza, Lorena. 1996. *La batalla está aquí! Chicanos Oppose the War in Vietnam*. Diss., Cornell University.

———. Forthcoming. *¡Raza Sí! ¡Guerra No!: Chicano Protest and Patriotism during the Viet Nam War Era*. University of California Press.

Pelayo, Jaime. 1997. "The Chicano Movement and the Vietnam War." Senior Essay, Yale University, Department of History.

La Raza Yearbook. 1968. (May 11).

Risco, Eliezer. 1996. Telephone interview with author (December 12).

———. 2003. Oral presentation, University of California San Diego (June 2). Videotape in author's possession.

Robles, Patricia A. 1994. "Hispanics' Contributions to the U.S. Military: An Annotated Bibliography." *Latino Studies Journal* 5 (May): 96–103.

Ruiz, Ramón. 1968. "Another Defector from the Gringo World." *The New Republic* (July 27).

Salinas, Luis Omar, and Lillian Faderman, eds. 1973. *From the Barrio: A Chicano Anthology*. San Francisco: Canfield Press.

Trujillo, Charley. 1990. *Soldados: Chicanos in Viet Nam*. San Jose: Chusma House.

———. 1994. *Dogs from Illusion*. San Jose: Chusma House.

Valdez, Luis. 1990. *Early Works*. Houston: Arte Público Press.

Vigil, Ernesto B. 1999. *The Crusade for Justice: Chicano Militancy and the Government's War on Dissent*. Madison: University of Wisconsin Press.

Ybarra, Lea. 1997. Telephone interview with author (June 2).

———. 2004. *Vietnam Veterans: Chicanos Recall the War*. University of Texas Press.

"Back in the World": Vietnam Veterans, California, and the Nation

John F. Burns

"ON YOUR FEET!" The drill instructor roared the command in a powerful, measured, and slightly menacing voice. For new Army Private Mike Bennett of Citrus Heights, California, it was his abrupt introduction to military life, to an entirely different state of being that soon led to Vietnam. To someone who has not experienced it, life in the armed forces is bewildering, and unfathomable, and astonishingly unlike being a civilian. Engaging in battle in a faraway land magnifies the difference between military and civilian a thousandfold. In *Dear America: Letters Home from Vietnam* one man wrote: "I'm closer to life and death every day than the majority of men are on their last day on earth." Immersed in this very foreign environment, veterans referred to the United States and any place outside of Vietnam as "back in the world." For most of them, the last part of the "world" they left and the first part of the "world" they saw upon their return was California.

Now a county museum director, Bennett never forgot his initiation into the lifestyle of the military, and he remembers well his sojourn in the alternate universe that was Vietnam. Assigned to the Ninth Infantry Division, Bennett roamed the Mekong Delta with other soldiers and sailors on an exotic array of armed watercraft, trucks, and helicopters with the mission of denying control of the Delta to the Vietcong. He was one of approximately 260,000 Californians who served within the

This couple found a little bit of privacy for their long-awaited reunion on the stern of the destroyer *James E. Kynes* after it docked at Long Beach Naval Base following a seven-month tour of duty in Vietnam, December 1966.

LOS ANGELES TIMES COLLECTION, UCLA LIBRARY DEPARTMENT OF SPECIAL COLLECTIONS

Distributing Bibles to inductees at the Oakland Induction Center, 1967.
PHOTO BY MICHELLE VIGNES

borders of Vietnam, 130,000 in varying degrees of combat. Over 5,800 Californians, about one out of forty-five who were sent in-country, or one out of twenty-two who went into battle, did not return alive, comprising almost exactly ten percent of the Americans killed. Three times as many suffered injuries, and some were permanently disabled. Others were held captive for long periods.

Since the war, Vietnam veterans have often been the subject of myth, misrepresentation and, more recently, reprehensible impersonation. This chapter has two aims. One is to unveil the reality of the war in Vietnam as seen through the widely varied experiences of Vietnam veterans. The second is to delve into the relationship of veterans with California, which was uniquely situated as the primary logistics depot and troop debarkation/reentry point for the war, as well as being a center of antiwar activity and stateside focal point for the national dilemma the war presented.

There are many thousands of distinctive stories about the Vietnam War that can be told by its veterans. No one situation is either typical or completely representative. A marine who was at Khe Sanh has very different memories than a supply sergeant in Saigon, or a sailor on the rivers, or aircrew flying over Hanoi, or a nurse in an army evacuation hospital. The time was also important, the optimism of 1965 melting into the cataclysm of 1968 and finally the cynicism and dissent of 1972. Each veteran was touched by the war in distinctive ways governed by the dates he or she was there, the amount and types of battle, overall risk exposure, incidence of close trauma, wounds received, location in the country, rear echelon or field duty, branch and specialty in the armed services, rank, the person's own values, or just luck.

Individualized experience is a fact of all wars, but it was magnified in Vietnam by the length of the war, the

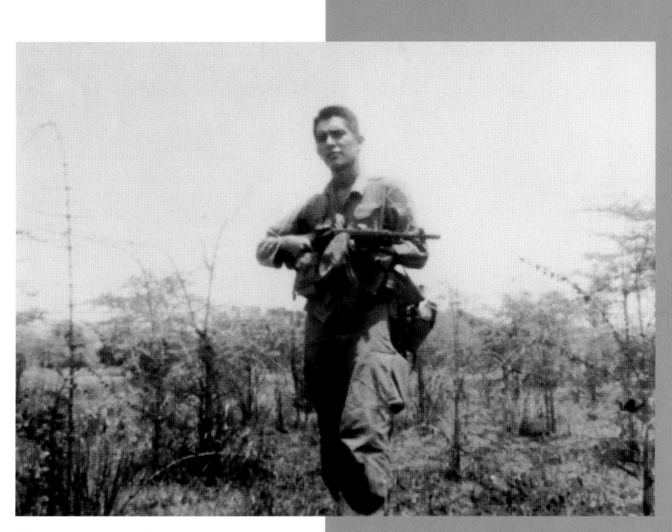

U.S. Army infantryman Eddie Morin, from East Los Angeles, poses with his M-14 near the Iron Triangle, Vietnam, 1965. Eddie said the terrain of Vietnam took a little getting used to.

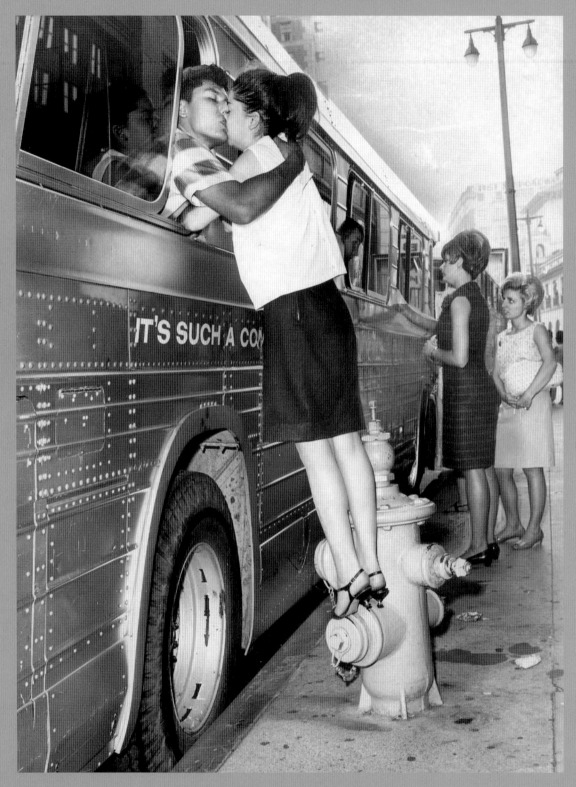

Mary Galaz, 20, of Los Angeles, stands on a fire hydrant to kiss her fiancé, Joe Mejia, 23, of Glendale, goodbye as he leaves for Army basic training at Fort Ord, August 1967.

way it strategically and tactically evolved, and the rotation system that put replacements individually into units and then "back in the world" if they survived for a year. At the same time, unifying elements have always existed among veterans, specifically the rigors of military life, training, and operations. But what most collectively distinguishes veterans from other people is that veterans belong to a group oriented to kill or to hazard being killed for their country, and to engage in lethal activity when necessary as the routine basis of their job. Whether volunteer or draftee, whether gung-ho for war or opposed to it, this is shared ground for veterans.

One of the many myths about Vietnam veterans is that the war was fought entirely by unwilling unfortunates who were dragooned by the draft into military service and immediately sent to Vietnam. In fact, the truth is rather more complicated. People entered the military for a large array of reasons. Veteran Charley Trujillo provides a quintessential example in his novel, *Dogs from Illusion*, centered on three men in one Los Angeles family: "Chuco and Ese's fathers and uncles had fought in World War II and Korea, so for them, it is a family tradition to fight in U.S. wars. Chuco and Machete have been drafted; and of the two, Machete is more reluctant than Chuco to serve in the army. Machete doesn't think it is his war and doesn't want to leave his fiancée, Tweedy. Chuco wouldn't have volunteered for the service, but doesn't fight the draft either. Ese, on the other hand, has volunteered for the army because he feels it is his patriotic duty to fight in Viet Nam."

In all eras, a mixture of motives inspires young people to join the military. There is no standard profile. Some are enthusiastic, patriotic volunteers. Others are adrift at the beginning of adulthood; enlistment for them seems like an alternative that would supply some

Three University of San Francisco students, Shelton Bunn (#131), Roosevelt Alexander (#264), and Mike Boland (#1), anxiously listening to a radio broadcast of the lottery, 1969. Selective Services initiated the lottery system for the draft starting in 1970 to establish who would be drafted by a random drawing based on date of birth.

PHOTOGRAPH COURTESY OF THE BANCROFT LIBRARY, UNIVERSITY OF CALIFORNIA, BERKELEY

direction and excitement. Marine veteran Joe Holt, who grew up in San Francisco, discussed his "recruitment" in an oral history: "I needed to kick-start myself. . . . None of this was conscious thought at the time. I was obviously mentally deranged to walk into the Marine recruiting office . . . once the hook, the idea of joining the Marine Corps gets into a guy's head, a young guy's head, there is no way to talk him out of it . . . There is something about an 18-year-old guy who has to prove his grit . . . "

Some Vietnam-era enlistees anticipated that being in the military would be one great adventure, like everyone saw in the movies. The films made by John Wayne had a special effect on veterans, and became a symbol in Vietnam of fantasy heroics. One veteran said in Christian Appy's book, *Working Class War:* "I watched John Wayne movies . . . and you start thinking, well, I want to be like my Old Man. I want to be a war hero . . . But when I got over there . . . war ain't like you see in

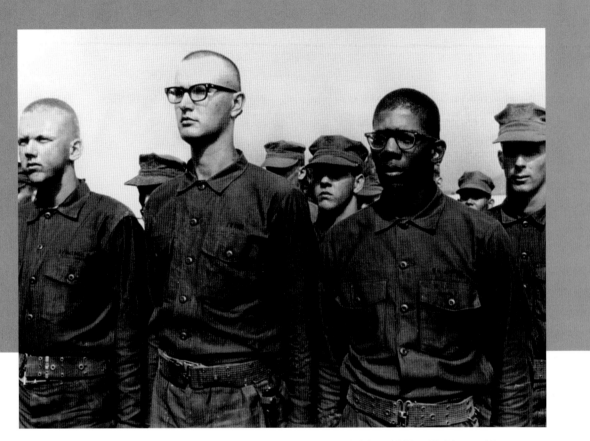

Three young men from Los Angeles, Richard W. MacLaughlin, 18, Ted W. Krok, 22, and William H. Johnson, 19, stand at attention after completing Marine boot camp in San Diego, November 1968.

LOS ANGELES TIMES COLLECTION, UCLA LIBRARY DEPARTMENT OF SPECIAL COLLECTIONS

John Wayne." A veteran on a web site noted that when the reality of war intruded, it felt more "like John Wayne playing Davy Crockett at the Alamo," rather than the movie representations of glorious victory. Yet another commented, "we were all like that, still full of little boys' ideas about war and valor. 'You don't know until you go' was the truth . . . John Wayne died in Vietnam."

A substantial number of young men were conscripted during the Vietnam years, and others volunteered for the military in recognition that draft day was coming. Actual draftees comprised 25 percent of U.S. forces, and they sustained about 30 percent of combat deaths. Reasons for submitting to the draft or volunteering in lieu of it were often vague. Tim O'Brien recalls in *If I Die in a Combat Zone:* "I was a confirmed liberal, not a pacifist; but I would have cast my ballot to end the Vietnam war immediately, I would have voted for Eugene McCarthy, hoping he would make peace. I was not soldier material that was certain. But I submitted . . . by a sort of sleepwalking default. It was no decision, no chain of ideas or reasons, that steered me into the war." A man could be drafted immediately after high school, or later. One of the most prevalent misconceptions about Vietnam is that all of the fighting was done by 19-year-olds. Actually, the average age of the

infantryman was 22 (in World War II it was 26). Of those killed, 61 percent were under 21; the youngest was 16, the oldest 62. Eight nurses died in the war.

Entrants into military service were not equally drawn from all sectors of society, though all classes did contribute to some degree. Appy contends in *Working Class War* that a sizeable majority of new soldiers "believed they had no real or attractive alternative. Even many who eagerly enlisted were drawn to the military as much by the pressures and constraints of their civilian lives as they were by the call of patriotism or the promised attractions of military life." Appy asserts that about two-thirds of all individuals who went to Vietnam were working class or below, and that 80 percent of African Americans were in that group. He concludes, "the odds of working-class men going into the military and on to Vietnam were far higher than they were for the middle class and the privileged." Though that was true, many of the middle and higher classes did voluntarily join despite readily available college deferments, and they amounted to about a quarter of the veterans who served in Vietnam. Soldiers from the highest third of America's income range totaled 26 percent of those killed in combat. B. G. Burkett notes in his book, *Stolen Valor,* "even Beverly Hills sent young men to the war. Actor Gregory Peck's son served in Vietnam . . . Jimmy Stewart lost a stepson . . ."

Once someone is involved in the intensity of war, regardless of the person's origins, experiencing battle and being enfolded in the camaraderie of those also in the fight is timeless, as renowned military historian John Keegan explains in *The Face of Battle:* "What battles have in common is human: the behavior of men struggling to reconcile their instinct for self-preservation, their sense of honor, and the achievement of some aim over which other men are ready to kill them." According to a veteran speaking in Eric Bergerud's story of the Twenty-fifth Infantry Division in Vietnam, *Red Thunder, Tropic Lightning,* combat exists in an atmosphere that "almost can't be described. What is so difficult about it is not only the intense fear, the sense of imminent injury or death to yourself, but that you can't get away, you can't avoid it. . . . In addition, you've got to somehow keep enough sense about yourself to do what you have to do to prevent it from happening. It's utter terror; when it's over, if you survived, the relief is almost impossible to describe."

Jonathan Shay, a psychiatrist who treated hundreds of veterans, clinically defines battle in *Achilles in Vietnam* as an "autonomic and endocrine hyperarousal" where the "heart pounds, the muscles tense, the senses are on extreme alert." One of his patients says: "Well, I mean, you're scared at the same time, but your adrenaline and the training makes you fucking mad, now." Dan Vandenberg, one of Bergerud's interviewees from

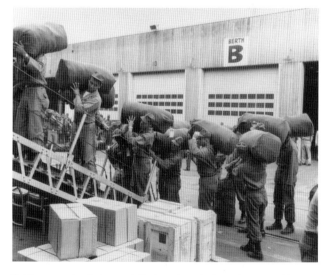

Soldiers carrying their own duffle bags board a troop transport ship at the Oakland Army Base for the long journey to Vietnam, 1966.
OAKLAND MUSEUM OF CALIFORNIA

the Twenty-fifth Infantry Division, graphically outlined a soldier's response to a combat situation: "You're all pretty jittery because you know Charlie is in there. . . ." When Vandenberg suddenly ran into another man, "I saw the ultimate look of fear. When I looked at his eyes, all I saw was white: I couldn't see any pupils. I imagine my face looked the same . . . I realized everybody over there was pulling an act. Everybody was walking around with a puckered up asshole. It shook me to think how close we came to emptying a magazine into each other. And it happened so damn quick . . . It makes your knees weak for quite a while after that."

Danger in Vietnam was pervasive and frequently indirect. Booby traps were especially nasty and deadly, provoking tremendous fear, anger, and frustration among soldiers. Only 3 to 4 percent of American casualties in World War II and Korea were from booby traps, while Appy calculated on the basis of estimates he studied that mines and booby traps in Vietnam "accounted for between one-fifth and one-fourth of all U.S. casualties." He observed, "hidden explosives were as significant for the demoralization they caused among the survivors as they were for the sheer number of casualties they claimed," as there was "no enemy in sight, no one clearly responsible for setting the trap."

Soldiers also felt disturbed by the strangeness of Vietnam, often describing it as alien. Eddie Morin of Los Angeles said in an oral history: "When we landed in Vietnam to me it was like landing on a foreign planet. The foliage was different . . . I never saw trees like that. They had what you call elephant grass, the average is chest high and in some cases it is even higher. You didn't know what to expect. They had lizards 24 inches long . . . more like snakes with legs. They moved real fast. They had these animals that would eat up the little ones. They had . . . stuff that we had never seen." Gary

Ernst, another Bergerud interviewee from the Twenty-fifth Infantry, found the odor and the people's living conditions disconcerting: "What struck me was the smell. Everywhere, it was like an overflowing septic tank or something rotting. . . . The poverty I saw when I arrived was unexpected . . . there were shacks of corrugated iron, mud, what have you . . . this place made Tijuana look like Palm Springs . . . it hit me that the stench and rot of the dead body was the smell of Vietnam."

Most veterans recognized that the odds of survival in Vietnam improved when soldiers protected each other. Appy found in his interviews that, despite the obstacles to solidarity caused by individual rotation into and out of units, veterans insisted, "they felt a profound comradeship." One veteran said: "Our sense of motivation was a buddy system: 'we are in this and nobody cares, but at least we can care about each other.'" Enlisted men principally bonded with people of similar rank, not as often with officers, who were frequently rotated out of combat duty after a few months, fueling resentment in the ranks and causing a lack of command continuity. A Twenty-fifth Infantry veteran in Bergerud's book pointed to the "reality in the field," explaining: "What did the men think they were doing over there? Just surviving. Making it through those 365 days. Your family was your squad, and that's who you looked after, that's who you took care of. Mom and apple pie and stuff, that was out the window. You were fighting for each other. You were trying to keep each other alive so you could make it home."

To certain individuals, unit camaraderie made the wartime experience genuinely positive. In Richard Holmes's *Acts of War,* a Vietnam veteran who gained both protection and great personal satisfaction from military comradeship said: "I enjoyed Vietnam. It was

Members of the 4th Battalion, 12th Infantry, 199th Light Infantry Brigade training for duty in Vietnam, 1966. James E. Berard of California (front row left side) was killed on Valentine's Day 1967.

the most vivid part of my life . . . You're living every minute. You're with guys who look after you. You can really trust them." Many units were a diverse cross section of America. Mike Bennett described his team: "We had a Navajo from Farmington, New Mexico, a bunch of rednecks from North Carolina, Blacks from Georgia, a teacher from Connecticut, the best thief in the 9th Division from New Jersey, a slug of white guys from the California central valley, a more mature guy of Mexican descent from the barrio of East L.A., a white logger from Washington, a gay senior NCO, and some incredibly experienced and dedicated 'lifers.' The ages of our unit ran from 17 to 62 and everything in between."

Race, although often a divisive problem away from battle especially later in the war, was rarely an issue when a unit was in a combat zone. The authors of *Charlie Company: What Vietnam Did to Us* found that soldiers of all colors "were made comrades and even friends by their common will to survive and their mutual dependence on one another if they were to do so. Death was democratic in Vietnam, and it was a democratizing force." In the base camps though, where the risk was much less, many of the same racial issues that America was confronting at home caused serious conflict. In a situation where it was difficult for the American military to tell friend from foe, racial stereotyping of Vietnamese raised its ugly head. The enemy, and at times even the South Vietnamese allies, were disparaged by some Americans as "slopes," "dinks," or "gooks" as soldiers attempted to cope with a confusing and alien environment.

In the American forces, non-Hispanic whites made

Military escorts salute as crates containing the caskets of servicemen killed in the Vietnam War were unloaded from a Southern Pacific train at Union Station in Los Angeles, March 1968.

up about 82 percent of the personnel in Vietnam. African Americans were another significant component. The army, with its integrated units, provided somewhat better equal opportunity for African Americans than existed in much of the outside world. Overall, 10.6 percent of those who served in Vietnam were African American, a lower percentage than their 13 percent representation in the general population. However, 12.5 percent of those killed were black. Disproportionately high casualty rates early in the war among African Americans, who tended to gravitate to the combat specialties that offered the best chance for advancement, account for the discrepancy. This prompted military commanders to provide greater racial balance in the field later in the war.

During Vietnam, statistics related to military personnel of Hispanic descent were not gathered separately as in the case of African American or Native American soldiers. Those of Hispanic descent were included in the figures for Caucasians. An estimated 170,000 people with Hispanic surnames totaled about 6.5 percent of the forces in Vietnam, although certainly more people with Hispanic ancestry but non-Hispanic surnames were also present. Most of those with Hispanic names were from California or only a few other states. An analysis of the Los Angeles names on the wall of the California Vietnam Veterans Memorial reveals that 22 percent of those killed had Hispanic names, although that figure does not necessarily represent other areas. The number of Native Americans serving in Vietnam was "exceptionally high," according to Tom Holm. In his study, *Strong Hearts, Wounded Souls*, which includes California tribes, he calculated that about "one out of four eligible Native Americans served in military forces in Vietnam, compared to one out of twelve in the general American population." Asian Americans also served, sometimes recalling incidents of prejudice due to their race. One, speaking at a symposium about the war, said that he was singled out in training "as the epitome of the Vietcong," and was told, "you don't know who you are going to be shot by—Americans or the VC."

Even away from direct combat, the work of the military was often exhausting and relentless. Award-winning reporter Bob Woodward, who served on a ship off the coast of Vietnam, said in a U.S. Naval Institute interview: "I did no real writing, particularly at sea, where I spent four years in a state of almost constant sleep deprivation. No matter what you have to do in civilian life, you can usually go to sleep. In the Navy, you can't." A California soldier told Christian Appy that he wondered if he would ever see the Golden Gate and Telegraph Avenue again, moaning "a good night's sleep is an unreality." Although patrolling in the boonies was vastly more dangerous than being on a base, no place in Vietnam was completely safe or outside the reach of the enemy. Even females, thousands of whom served in medical and other support specialties, armed themselves although technically not authorized to do so. Doris Allen remembered in *Piece of My Heart*, "it got so bad I used to carry weapons . . . women couldn't carry weapons. Make no mistake I carried a .45. A couple others of us, friends of mine, carried weapons."

There are many more shared elements of the Vietnam experience that no veteran will ever forget: the ubiquitous "whup, whup" of the helicopter; the soggy heat; the wire mesh over the windows of military buses to keep out grenades; the odor, described by one Twenty-fifth Infantry veteran as "sweat, shit, jet fuel, and fish sauce all mixed together"; and the disgust for Jane Fonda, photographed sitting at the controls of an anti-aircraft gun in North Vietnam. The things soldiers carried, including P-38 can openers for C rations,

U.S. Marines taking a break in Vietnam to celebrate the Marine Corps birthday, November 10, 1965.

PHOTOGRAPH COURTESY OF NICHOLAS DEL CIOPPO

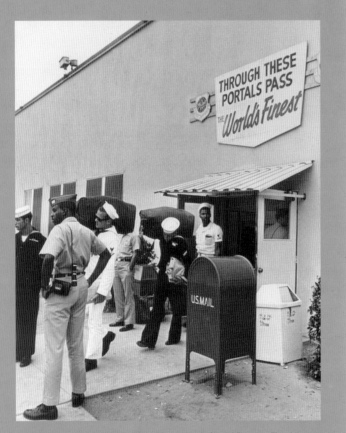

No bands or parades greeted most returnees from Vietnam, like these sailors leaving the processing center at Norton Air Force Base, October 1968.

LOS ANGELES TIMES COLLECTION, UCLA LIBRARY DEPARTMENT OF SPECIAL COLLECTIONS

ponchos and liners, weapons such as M-16s, M-60s, M-79s, .45s, and LAWS (light antitank weapons), MPC (military payment certificates which were required to be used instead of real money), and instamatic cameras are unifying aspects. So is the language of the war, specifically the incessant use of the "F" word, as in FNG (fucking new guy), REMF (rear echelon mother fucker), and SNAFU (situation normal all fucked up). Terminology such as 'don't mean nothing,' 'payback,' 'freedom bird,' 'dust-off,' 'slick,' 'short-timer,' 'R & R,' 'chopper,' 'million dollar wound,' 'friendly fire,' 'MIA,' *beaucoup,* 'boonies,' 'hootch,' 'klick,' 'incoming,' 'frag,' and 'Agent Orange' became part of the distinctive lexicon veterans still use today and often migrated into the national vocabulary.

Despite its negative popular image, Vietnam sometimes elicits agreeable recollections from veterans. Even in combat units, some people saw beyond the difficulties and danger. Robert Julian of the Twenty-fifth Infantry witnessed destruction but also said: "I thought Vietnam had a beautiful countryside . . . I would lie down on my poncho . . . look at the stars and just think how beautiful it was." Mike Bennett remembered, "we tried to inject some normalcy into a patently abnormal world by procuring some steaks and beer and producing a BBQ spiced up with cookies from home or other goodies from 'care packages.'" Rest and Relaxation (R&R) travel gave soldiers the opportunity to visit cultures and countries they probably would not have seen otherwise. Recreational drugs, particularly marijuana, were a shared pleasure for some and a coping mechanism for others, especially in the pessimistic later stages of the war, although they were generally used less in combat situations.

After a while, despite the perils and conditions, some veterans felt more comfortable in Vietnam than

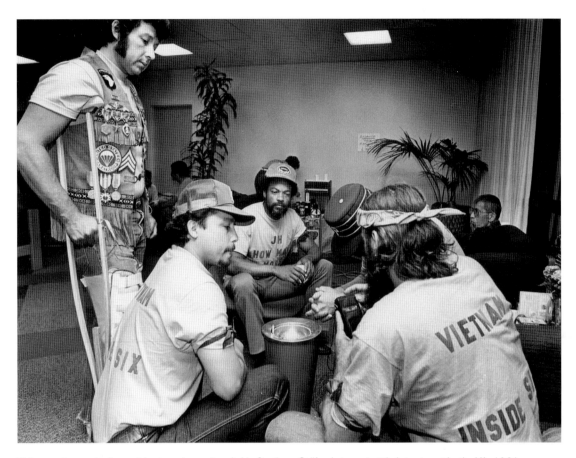

Vietnam veterans staging a sit-in at a veterans hospital in Southern California to protest their treatment by the VA, 1981.
HERALD-EXAMINER COLLECTION, LOS ANGELES PUBLIC LIBRARY

"back in the world," and several extended their duty there, sometimes for multiple tours. Peter Huchthausen described his return to California in *Echoes of the Mekong.* He "looked out over the San Francisco Bay area. It did not feel like home." At the San Francisco airport, "the crowd was unruly, unwashed and, to me, totally alien . . . I was lost (and) felt totally removed." Later, when asked what he would do differently, Huchthausen said: "I would have stayed until it was over." Infantryman-turned-actor Dennis Franz wrote in *Us:* "By the time I came back I was a lot more serious. But we vets did not get a very open-arms welcome. I thought I had done something good, and to be looked upon negatively confused and angered me."

Many veterans felt considerable ambivalence upon reentering the "world." When veterans came home, they rotated out of their units alone and were soon winging their way back to Travis in California or to another air base. Certainly, there was happiness and relief at being home, but the jarring situational change made the transition for many terribly uncomfortable. Mike Bennett recalled, "the signs and smells said home but the feelings of guilt at leaving buddies back in 'The Nam' were strong. It felt like a job unfinished and I still worried about my guys. There was also a sense of fear or dread. Just hours earlier we had handed over our weapons. My family and friends cared that I was back, but the rest were an ungrateful nation." Hostility on the part of other Americans made the transition back doubly difficult, although acts of disrespect, ignorance, or

belligerence were sometimes offset by acts of kindness and caring. One veteran in *Homecoming* reported that he was given "the dirtiest looks" and referred to as "baby-killing scum," only to have someone a short time later invite him to his home for Christmas dinner.

Like those who fought in other wars, Vietnam veterans found it difficult to talk about wartime memories with those on the outside, even to family and close friends. This was intensified by the escalating unpopularity of the war and by the uncertain and sometimes angry response veterans received after their return. Eddie Morin spoke about his transition from Vietnam to civilian life in the *barrio* of Los Angeles: "I love my family, but somewhere my life changed and I couldn't talk about it. I couldn't express it to them, and they couldn't give me sympathy or understanding; we just didn't know how to relate on either side." Morin went on to describe his later interaction with the wider community, "at California State University Los Angeles where I was attending there was a lot of antiwar activism. . . . I took some Chicano studies classes, and I didn't relate . . . I didn't like that people who had never served in combat [were] criticizing the GIs [who] were being stereotyped. Some of these movies . . . that came out later . . . are lies, just as phony as they could be . . . they just drew me more inwardly."

For many years the nature of the war precluded much communication between veterans and non-veterans. Californian Gerry Nicosia, author of *Home to War,* a history of the Vietnam veterans movement, talked with hundreds of veterans; he concluded that in Vietnam, a civil and guerilla war made "the killing of civilians and the destruction of villages and farmland inevitable." When distinctions between combatants and noncombatants were blurred, the question of atrocities arose. Americans became uncomfortable with the war's con-

duct, and made it very hard "for the men and women who fought the Vietnam War to tell us what they actually experienced." Mike Bennett points out, "many people back in the world didn't and probably still don't realize that women and children were often used to deliver grenades or satchel charges to a group of GIs. What was amazing was the extent that our guys would go to just providing a little kindness or care with those kinds of risks."

There is simply no point of reference that anchors wartime military experience to civilian life, especially in a war like Vietnam, where the national memory of systematic success in World War II collided with the messy reality of small-unit combat in an environment that made the enemy hard to confront or even to distinguish from the allies. For this reason, it is difficult to evaluate the actions of soldiers. Some war resisters trumpeted their moral choice to oppose the war. But many of the men and women who were in the war, eagerly or reluctantly, also made a moral decision—to serve their country. Moreover, their decision obligated them to make split-second life and death judgments and to put their lives in peril, risks that war protesters did not incur.

Although as capable as soldiers in other wars and victors in all major battles, Vietnam veterans felt they were blamed for the outcome of a war waged in a flawed, political fashion, with limitations on military operations leading to increased casualties without evident progress. Traditional veterans' associations often shunned them. Some Vietnam veterans continued to support the war upon their return. Many quietly disappeared into civilian work and others joined antiwar activities like those of the Vietnam Veterans Against the War, Black Panthers, and the Chicano Moratorium, and launched the veterans' movement, often using the disciplined skills and strong work ethic learned in the military. One

Young people were entranced by the promise that California represented, just as their ancestors were attracted by visions of gold over a hundred years earlier.

veteran summed up the national attitude as "confusion between the war and the warriors." Another expressed anguish: "The people of this great nation had turned its back on its sons. Somewhere in their anger and fear they forgot that we were their brothers, sons and fathers that they had sent off to war."

On the way to the war and arriving back in the "world," the Vietnam veteran's most common experience was the direct contact with California. More than anywhere else in America, California was at the center of the United States' interaction with Vietnam. In fact, California remains so today, due in large measure to the long-term effects of massive Southeast Asian immigration that occurred after the war. Nor is the state forgotten in Vietnam; a few years ago a fast food joint opened in Ho Chi Minh City (Saigon) called "Hambugo California." With supportive geography ideally suited to implement military operations in the Pacific, and with a long history of military presence and well-established bases and infrastructure, California became the major U.S. connecting point to Vietnam. Today, two-and-a-half-million veterans reside in California, about 40 percent from the Vietnam era, with considerable effect on the state. They are technicians, teachers, lawyers, politicians, actors, mechanics, postal workers, government employees, and people in business, literally the folks next door.

California has possessed a mythical attraction since the days of the Gold Rush when young men hurried to California to try their luck in the goldfields. Mark Twain claimed that the first wave of newcomers "gave to California a name for getting up astounding enterprises and rushing them through with a magnificent dash and daring." World War II, the Korean War, and the years thereafter, led many more people to the Golden State, causing famed California author Carey McWilliams to postulate that California was again "stimulating national curiosity and interest," and that it was the country's "pace-setter," being a "land of Visions, Dreams, Exaltations, and New Harmonies." California had jobs, a benign climate, mountains, beaches, the movie industry, great freeways, schools, and lots of exciting but sometimes troubling social experimentation, or so Americans believed they saw on their television screens every night. Nowhere else was like it.

With this national reservoir of reputation and with the intensive coverage California both generated and received as the home of the visual media, the state became especially attractive to the baby boomers coming of age in the 1960s. Young people were entranced by the promise that California represented, just as their ancestors were attracted by visions of gold over a hundred years earlier. One *San Francisco Chronicle* reporter recollected: "I came to California fresh out of high school, drawn by the popular image of sun and sand and golden futures. A cousin picked me up at a bus station and drove me across Los Angeles at night. Coming from a small town in the Midwest, I had never seen anything like this, nothing so futuristic, so excessive, so overwhelming. It was surely grand." More than their elders, who could be wary of the libertine side of the California image, young people gravitated toward portrayals by popular writers like Curt Gentry: "California was the

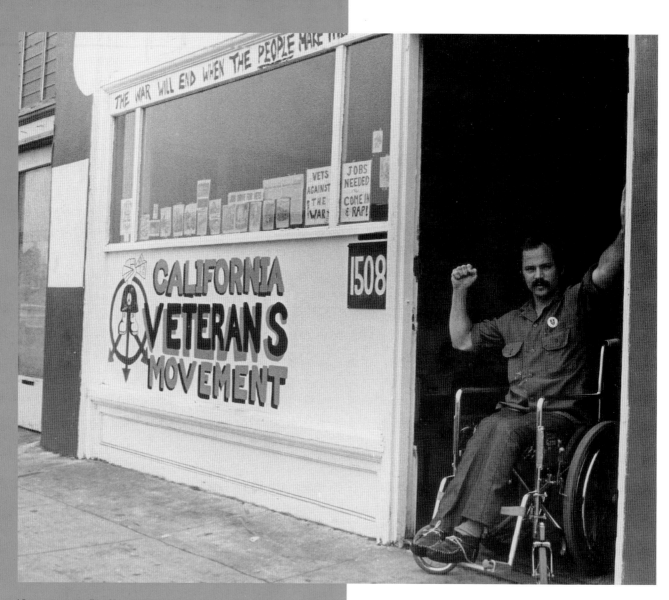

Vietnam veteran Ron Kovic posing at the door of the California Veterans
Movement offices, c. 1971.

superlative state . . . it contained the most people, who in turn enjoyed the most income, leisure . . . beaches . . . Californians were younger, healthier and better educated . . . the envy of the rest of the world."

Many young adults about to join the military were enticed by California. Nebraska's U.S. Senator and Vietnam veteran Bob Kerry wrote that he joyfully found "an ocean, sand, palm trees, and sunshine 365 days a year . . . From my balcony I looked west along a strand of beach that ran from San Diego in the north to Imperial Beach and Tijuana, Mexico . . . I watched my first sunset over the ocean. I thought the navy had sent me to paradise." When upstate New York veteran John Ketwig went to California on his way back from Vietnam, he exclaimed: "Look at the freeway! Biggest damned road I've ever seen, five lanes each way. Look! A Chevy. A Corvette. A convertible with the top down, and a blonde with hair dancing on the night air. Wow! Look! A hippie. Blonde Afro hairdo, beard, round glasses and a rainbow-striped shirt. Miniskirts. Jeesus!"

Vietnam veterans returned home and often made their homes in California. The remarkably low fees at state colleges and universities, including tuition-free community colleges, coupled with the GI Bill helped thousands to receive higher education. Somewhat later, the state legislature enacted a law setting a goal of reserving 3 percent of all state contracts for disabled veterans. California also maintained a sizable veterans department, home loan program, and veterans homes. Quite a few veterans were assigned after Vietnam to permanent military service at one of the many California stateside bases; others joined the National Guard or reserve units. Some of these veterans departed the state to return to their home state or seek other opportunities, and some of those later returned, because California afforded a person new beginnings and often

provided a greater comfort level than elsewhere. California veterans were also in the forefront of GI and veterans' antiwar activities and were initiators of the veterans' movement to secure better treatment by the government for service-related disabilities and to account for those still missing in action.

Listening to several California veterans' stories provides a more detailed glimpse into the extraordinary Vietnam and postwar experiences that veterans bring to the state. Nicholas Del Cioppo, born and raised in the North Beach area of San Francisco and one of the first marines in Vietnam, "grew up living the California image and joined the Marine Corps to do something exciting. It was a fluke; I went to join the Air Force but the recruiter was out and the Marine recruiter said I could wait in his office." Sent to Vietnam, "we fought the VC and the NVA; they were good and beat us up real bad but we got even. When I was there we still thought we could turn things around. We helped the Vietnamese with their crops, fix their roofs and so forth." Being Californian growing up and "adapting to California's ethnicity, including Asians, helped me adapt in Vietnam."

Coming home, though, Nick Del Cioppo found he was "a different person. I hid in a hotel for three days in San Francisco and refused to go home. I couldn't cope; the Beach Boys stuff was all gone, it didn't work anymore. I wanted to keep people at a distance. I realized there was a big gulf between other people my age and veterans." He became involved with the antiwar movement and "had things thrown at me for wearing my uniform to anti-Vietnam war events . . . later in the war guys hated Asians and the Vietnamese. I didn't. At the California Vietnam Veterans Memorial I was talking to this Vietnamese guy who thanked me for helping try to save his country." After going to college and spending years as a state archeologist, Del Cioppo was diag-

nosed with PTSD (Post-Traumatic Stress Disorder) and is retired on disability. He "admires people who elected not to go," and feels "the blood on his hands will never go away." He stayed in California because it was his home and because it was tolerant of difference and eccentricity, noting that "people who didn't come from here felt the same way."

Harold "Jo Jo" Bainesford was a World War II "military war baby" with an African American career army father who "started in the segregated Army and made a career of it despite racism because the Big Green Machine was his road to opportunity." After the young Bainesford had gotten in minor trouble, a judge in New York gave him a choice between the military and jail. Becoming a medic like his father, Bainesford served two tours in-country. Explaining his nickname, "Jo Jo," he says "many people picked up goofy nicknames [as] it was one way to avoid knowing who you were because as a medic I might have to deal with your remains, not that I didn't give a damn, I couldn't give a damn." However, he feels justifiably good about what he did to save lives. He defends the actions his unit was engaged in as "strictly a matter of survival."

Bainesford first lived in California immediately after Vietnam when he was stationed at San Francisco's Presidio army base, one of the nation's centers for the GI antiwar movement. Returning to the East following his discharge, in trouble with the law, on drugs, and eventually incarcerated, Bainesford went to school on the GI Bill while in prison and turned his life around. He came back to California "because I couldn't live nowhere else. I had no choice . . . it was like a magnet." Today he counsels veterans, back again at the Presidio, and is a member of the Veterans Speakers Alliance. He believes that "problem-solving through violence only leads to more death and destruction."

A drill instructor at the Marine Corps Recruit Depot San Diego shouts commands as his recruits practice drills, November 1968.
LOS ANGELES TIMES COLLECTION, UCLA LIBRARY DEPARTMENT OF SPECIAL COLLECTIONS

Another California transplant is Winnie Smith. From North Carolina, she attended nursing school in New York and joined the Army Nurse Corps, serving in Vietnam in 1966–67. Her parents thought that nursing was an avenue to marrying a doctor and becoming a "southern belle." After a year in Japan treating Vietnam wounded in an orthopedic ward, she was sent in-country where she "worked at the major center for chest and head wounds." She was also a triage nurse, dealing with the most gruesome injuries: "Too many casualties coming through, we couldn't handle them all. It really affected me. Expectants were the hardest, those beyond our ability to save or who would take so long to save that three or four others would die." She remembers working fourteen hours a day and picking up "the lingo of Vietnam where every third word was 'fuck.'" She said she felt "there could be no God for a place like this to exist."

Leaving the army in California, Winnie Smith returned to the East for a while but was soon disenchanted. In North Carolina, people were concerned

with her "shoes and her hairdo" and she concluded she "just didn't belong there anymore." Smith bumped up against what many veterans found in their return to civilian life. After being responsible for expensive equipment and making decisions and supervising people in life or death situations, the "duties" of civilian life seemed superficial and incredibly trivial. It became tough to settle down. Smith moved back to California "where people didn't care what you wore or looked like." She spent a lot of solitary time in the mountains and had a hard time staying with relationships, jobs, or living abodes, "finally realizing Vietnam affected me more than I thought." She eventually wrote the book *American Daughter Gone to War.*

Phil Gioia first saw California as an awed six-year-old steaming with his father on a troop transport under the Golden Gate Bridge. An army infantry officer in Vietnam, including a Special Forces tour, he was "one of the ten percent of the people at any time who were in close contact with the enemy," as opposed to those "back in the rear with the beer and the gear." He was a commander "who never had any misgivings about killing the enemy because they were terrific soldiers who were trying just as hard to kill us." He thinks that his unit had a below-average casualty count because they "were very aggressive" in engaging the enemy.

Gioia believes "it was inevitable that he would come back to live in California." Medevaced to Travis Air Force Base after being wounded in 1968, he remembers "the beautiful spring evening, the hills . . . it was amazing, like being born again. The air, the sun and the sky, the quality of light was like a Renaissance painting, like northern Italy. It was a magic place." Returning for good after the war, Gioia became president of a high-technology firm and was elected mayor of Corte Madera. He says he is "living the California dream" and

speaks out against the "myths about Vietnam veterans." Gioia cites "studies that show 91 percent of Vietnam veterans are proud to have served . . . about 88 percent have transitioned to civilian life without difficulty. . . . Fewer than 0.5 percent of them have been in jail, compared to the national lock-up rate of 1.5 percent. Men who served in Vietnam are also less likely to be homeless," a fact confirmed by the National Coalition for the Homeless.

In my own case, I had wanted to come to California since I was ten years old when a playmate traveled to Disneyland. Like many children in post–World War II America, I grew up patriotic during the cold war, saying the pledge of allegiance every day, hiding under my school desk during air raid drills in case of Communist attack, playing "John Wayne" at war with toy guns and

Ensign John Burns just prior to leaving for Vietnam, 1968.
PHOTOGRAPH COURTESY OF JAMES EDWARD GILES III

building elaborate forts in the field across the street. My childhood town of Joliet, Illinois, was full of World War II veterans. They worked hard to make a living, had traditional families, did not talk much to outsiders about their war, and were militantly anti-Communist. When I joined the Navy Reserve five days past my eighteenth birthday, the recruiter promised an irresistible package to a young man—travel to much of the world; clean bunks and hot meals; and, because we drilled with marines at a center with a shooting range, the opportunity to handle a variety of weapons. I did not realize how useful that weapons exposure was soon to become.

I was given a deal by the navy to finish college and become an officer. After training, I had a few days in California before reporting for the flight to Southeast Asia. I flew to San Francisco from icy Chicago in January 1968. When I landed in the Bay Area, the temperature was a balmy sixty-five degrees. My buddy was standing there in a short-sleeve shirt and cool California shades. The air was pristine, the colors on the hillsides magnificent, the atmosphere full of vibrancy and anticipation, the young women gloriously beautiful, and the sights spectacular. It hurt to leave California, which seemed to me so fantastic and so rich with possibility.

On my way overseas I thought of California and about living on the beach in my home port of San Diego when I returned. Reporting to the navy's little-known combat support forces in Vietnam, I quickly had to put aside the dreams of California and contend with a harsh and surprising new reality. Less than two weeks after I arrived, the Tet Offensive was launched and I was immersed in battle near the Cholon district of Saigon. The rest of the year took me to various assignments on land and water, from Cua Viet on the DMZ in the north, to the Mekong Delta in the south, and through an incredible range of emotions from accomplishment,

excitement, and adventure to fear, exhaustion, and disillusion, an inestimable learning experience that I was fortunate to survive. I came back to California and eventually stayed. I even finally went to Disneyland, courtesy of free admission for Vietnam veterans upon their return, the one perk we received!

California had a striking appeal to many veterans who were not born in the state but came to love its character. A few short examples are illustrative. Air Force helicopter pilot Russ Caylor rescued downed airmen, mainly in Laos. After his air force career, he stayed in California because of its tolerance and diversity, and now volunteers at the California Military Museum. Army mortarman Mo Wilson was brought to California from Alabama by his parents at age seventeen. Unhappy at first, California "grew on me," Wilson said. After Vietnam he came back to Sacramento, went to college, and taught high school, where he attempted to help his students comprehend the reality of Vietnam. It was twenty-five years before he again visited Alabama. Another Southerner, Ken Nelson, a retired marine gunnery sergeant with the Third Marine Division, called the "Walking Dead," became a volunteer sentry supervisor for the California Vietnam Veterans Memorial, and today does all that he can to assist visitors in understanding the war.

Most California veterans who originated from the state returned to it and its civilian lifestyle after their service. Michael Kelley, drafted after graduating from college in Sacramento, said in a *Sacramento Bee* interview that he "had no clue what I was going to do . . . the war offered me insight and adventure. I wouldn't trade those experiences for the world. Nothing in my life has approximated the intensity of the experiences I had in Vietnam." Wounded near the end of his tour with the 101st Airborne when a good friend stepped on a mine,

he recovered in Sacramento and "takes issue with the stereotype of the maladjusted Vietnam veteran." He has worked in the county assessor's office for over thirty years, raised a family, and recently published *Where We Were in Vietnam*, the definitive history of places and ships in-country.

When Mike Bennett, former army private from Citrus Heights came home, he too found success but also realized "there will always be something different about us. Maybe what we learned in war . . . made us more driven to achieve. The forced personal growth under combat conditions was required to meet the huge responsibilities placed on young men and women. All my veteran friends and acquaintances are not only employed but many are leaders in their career fields." The reasons these veterans, natives and newcomers, stayed in California and what he or she accomplished are as individual as the circumstances of the persons involved. Some still argue in favor of the war, some do not. These sketches of Vietnam veterans are but a sample of the many thousands of other veterans who are each contributing their unique experience to California's human landscape.

Many veterans did not stay in California, but remember well their temporary residency. For some, California's ambiance was distressing. One veteran confessed, "I left California because the pace of living was too fast." Mike Bennett remembers southern NCOs denigrating Californians: "The only things that come out of California are queers and hot rods and I don't see no tail pipes comin' out your ass." The response of Bennett and his fellow Californians was "we trained harder and set more records just to shove California and Californians down their throats." But, despite the antagonism some people felt, many other newcomers reveled in the vibrant lifestyle that California offered.

A California flag flying over Mike Bennett's bunker at Nha Be in Vietnam, 1969.

PHOTOGRAPH COURTESY OF MIKE BENNETT

James E. Giles III grew up in Massachusetts and went to school in Texas. After spending considerable time in California before and after Vietnam, he relocated to the East Coast for employment as a defense analyst. But his memories of California are still vivid: "spring of 1963—I was a college student in Abilene, Texas, without a summer job. I'd joined the Navy reserves to avoid the draft. My unit Chief said boot camp would be just the thing for me—a summer in San Diego. I was very excited about going to California. I did not see much of California that summer. It was a magic land of freedom

DUTY, HONOR, SACRIFICE
IT IS SOMETIMES SAID THAT HEROES ARE HARD TO FIND.
PEOPLE WHO UNDERSTAND THE MEANING OF DUTY, HONOR,
AND COUNTRY NEED TO LOOK NO FURTHER THAN THOSE WHO
FIGHT FOR FREEDOM AND DEMOCRACY.

CHAPTER 9

Memorializing Vietnam:
Transfiguring the Living Pasts

Khuyen Vu Nguyen

AFTER SEVEN LONG YEARS of bitter struggle and in-fighting, the Vietnamese American community, along with the city of Westminster in Orange County, California, in 2003 finally unveiled a twelve-foot bronze sculpture depicting two middle-ranking Vietnam soldiers, a white American and a South Vietnamese. The statue was placed in the 1.5-acre park located near Little Saigon, the symbolic capital of Vietnamese America. The installation of the sculpture partially completes the Westminster Vietnam War Memorial, making it the only memorial in the world that commemorates and honors South Vietnamese soldiers.

Indeed, past official memorializations of the Vietnam War have erased South Vietnam, the country and its soldiers, entirely from the war's history. Immediately following the Communist takeover of Vietnam in 1975, many South Vietnamese soldiers, officials, and civilians were forced to flee the country to avoid political persecution. Branded as "reactionaries" and puppets of the Americans, most of those who remained in Vietnam were brutally forced into so-called reeducation camps, a euphemism for the physically and psychologically dehumanizing prison system that exploited the prisoners' labor while stripping them of their humanity through nonstop surveillance and forced activities.

In Vietnam today, almost every district in every province has a monument to honor North Vietnamese

The Westminster Vietnam War Memorial opened in spring 2003.
PHOTOGRAPH COURTESY OF VĂN HÓA MAGAZINE/LÝ KIẾN TRÚC

soldiers who "died to liberate" their country from Western imperialism. By contrast, most of the pre-1975 South Vietnamese military cemeteries and memorials have been plowed under to make room for new housing and factory development. In a country with almost two-thirds of the population born after the Vietnam War, the "Republic of South Vietnam" is no more than a name fact whose history is mentioned in a sentence or two in standard high school history textbooks. Similarly, the Vietnam War, popularly referred to as the American War, is constructed simply as another event in the long history of Vietnamese resistance to foreign domination. (Certainly this was my experience going to school in Vietnam. I had finished the eleventh grade when I left the country in 1994.) Thus, the short-lived Republic of South Vietnam (1954–1975), as a former political entity, has disappeared from the memory of the young Vietnamese and officially vanished from the country's narrative of nationhood and remembrance.

In the United States, South Vietnam and South Vietnamese are erased from the "cartography of memory" in a different way. While the American War in Vietnam is discussed on occasion as a historical aside, the narratives and "lessons" of the Vietnam War continue to be controversial, divisive, and pervasive into the present. Although there is no singular narrative of the Vietnam War in America, Marita Sturken persuasively points out two uncontested elements within the often contradictory narratives of the war in her excellent study of the Vietnam Veterans Memorial in Washington, D.C.: (1) the scarring effects of the war on American politics and culture, and (2) the marginalization of Vietnam veterans in the years following the war.[1]

Indeed, the intensity of the social and political climate in the United States during the war created an environment extremely hostile toward the veterans.

Some scholars believe the American public at that time viewed the presence of the veterans as an anathema, a social plague to be denounced, condemned, and expelled from individual and collective consciousness.[2] A portion of the population, eager to move on from the traumatic experience, blamed the veterans for their participation in what was perceived to be a meaningless war. The veterans seemed to represent an indignity to the U.S. military and ideological prowess. Another point of view saw them as symbols of the immorality and consequences of American imperialism. For some Americans, the mere existence of the veterans served as a painful reminder of the lives lost in Vietnam and of a nation torn apart and forever changed.

However, despite the initial stigmatization of the Vietnam veterans in years following the war, the 1980s witnessed both national and individual efforts to integrate them onto the American historical landscape. Most notably, the 1982 construction of the Vietnam Veterans Memorial in Washington, D.C., although open to rift and dispute, recognized the sacrifice of the dead, immortalized the contribution of the living, and permanently secured the presence of Vietnam veterans in American society and history. Since then, there have been at least 145 state and regional memorials dedicated to honoring 58,000 American soldiers who lost their lives in Vietnam. In California alone, there are at least five official memorials, excluding the Westminster Vietnam War Memorial. Located in Long Beach, Sacramento, Berkeley, Salinas, and Porterville, these monuments commemorate American soldiers who fought in Vietnam. Today, the veterans' voices and experiences continue to play a central role in informing official and social debates about the Vietnam War.

Yet, remembering American veterans seems to require a deliberate erasure of the Vietnamese people in

the process. It is an example of Freud's formulation of forgetting as an active process of memory repression with the purpose of helping subjects cope with the anxiety and discomfort of painful memories.[3] The discomfort of Vietnam was ameliorated through repressing or "screening out" Vietnamese from the American conscience. The Vietnam Veterans Memorial Fund, the group in charge of the construction of the memorial in Washington, D.C., hoped that the memorial would transcend the national rift caused by the war and provide a space for healing. But one may mention the 250,000 South Vietnamese missing in action (MIAs) who died along with 1,300 American MIAs, or the 3 million Vietnamese civilians who lost their lives together with 58,000 American soldiers. The mere reference makes the act of remembering Vietnam both political and un-conducive. Thus, while the Vietnam Veterans Memorial in Washington inscribes the voice and presence of American veterans into the country's collective memory of the Vietnam War, it erases Vietnamese from the very national narratives.

Discussions of "the Vietnamese people" as an all-encompassing category to describe the Vietnamese experience do not allow for a more nuanced understanding of the ways in which South Vietnam and South Vietnamese are erased from official memorializations. Indeed, the homogenization of the Vietnamese experience highlights another uncontested element within the divisive Vietnam War narratives: the dismissal of South Vietnam from the Vietnam War discourse altogether. Contrary to popular representation, the role of the Republic of South Vietnam during the Vietnam War was far more complicated than the most Americans are willing to admit. Operating within the restrictive framework of cold war politics and postwar guilt, American social and intellectual discourse over the nature of the

U.S. involvement in Vietnam has generally neglected South Vietnam in its narratives. It is usually agreed that the corrupt and oppressive nature of the government made its defeat inevitable.

Accurate or not, this one-dimensional portrayal of South Vietnam by both the American left and right dismisses the complexity of Vietnamese postcolonial politics and nationalist discourse predating the arrival of the Americans. Yet, this inadequately examined portrait of South Vietnam continues to inform public debates about the Vietnam War, both at home and abroad, and ultimately explains the omission of the South Vietnamese experience from official war representations. Well-intentioned critiques of the United States' official erasure of a generic population called "the Vietnamese people" in the U.S. memorial practices unfortunately fails to grasp the specific obliteration of the Republic of South Vietnam.

Not only are South Vietnamese exiles faced with historical and official erasure by their host and home countries, but they are also confronted by an inevitable social eradication from within their own community. Characteristic of an aging diaspora, the transmission of ideas and memory from an older to a younger generation in the Vietnamese community is further complicated by the ever-broadening linguistic and cultural gap. Young Vietnamese Americans, shielded from the actual experience of the war, are less and less interested in pursuing an earlier generation's memory of the war. The lack of interest among their children, many Vietnamese veterans fear, presents the possibility of a final erasure of the South Vietnamese political and ideological *chinh nghia*, or legitimacy, from Vietnam War history.

Against this backdrop, the South Vietnamese in California came together to build a memorial that would honor their dead and heal their own deeply fractured

A crowd of ARVN veterans salute at the opening ceremony for the Westminster
Vietnam Memorial, April 27, 2003.

PHOTOGRAPH COURTESY OF VĂN HÓA MAGAZINE / LÝ KIẾN TRÚC

community. The Vietnam War Memorial disrupts the politics of remembering insofar as it challenges the cultural and historical amnesia that has defined past official representations of the Vietnam War. In addition, because memorials are pedagogical tools that "seek to instruct posterity about the past,"[4] the Vietnamese American struggle to build the Vietnam War Memorial is not only a defensive response to historical erasures, but also an active effort to ensure the existence of the South Vietnamese experience in the Vietnamese American collective memory. Shaped by power dynamics and mediated by the political milieu of a particular historical moment, memory is a carefully negotiated narrative rather than a replica of the past. Because past official

representations of the Vietnam War have made the South Vietnamese invisible, the Vietnam War Memorial challenges the historical amnesia embedded in the U.S. mainstream interpretations of the war.

"WHO NEEDS ANOTHER STATUE OF SOMEONE?"

In 1994 Tony Lam, the first Vietnamese American councilman of the city of Westminster proposed his plan to build a memorial to honor fallen South Vietnamese soldiers. For a myriad of reasons, Westminster seemed to be an appropriate home for this monument. It is a part of Orange County, the fifth most populous county in the United States and home of the largest concentration of Vietnamese living outside of Vietnam.

According to the 2000 Census, there are 1,122,528 people who identify themselves as Vietnamese Americans in the United States. Of those, 447,032 (39.8 percent) live in California. Orange County alone is home of approximately 135,548 Vietnamese Americans whose businesses are ubiquitous in Little Saigon, located in Westminster and Garden Grove, where they constitute 30.7 percent and 21.4 percent of the population respectively. Prior to 1975, most Vietnamese residing in the United States were students, spouses and children of Vietnamese diplomats. The fall of Saigon on April 30, 1975, which ended the Vietnam War, prompted the first wave of emigration. Many people who had close ties with the Americans feared Communist reprisals, of whom 125,000 left Southeast Asia during spring 1975. The year 1978 began a second wave of Vietnamese refugees that lasted until the mid-1980s. As people faced being sent to reeducation camps or forced to evacuate to "new economic zones," about two million fled Vietnam in small, unsafe, and crowded boats. Congress passed the Refugee Act of 1980 to reduce restrictions on entry while the Vietnamese government established the Orderly Departure Program (ODP), under the United Nations High Commissioner for Refugees, to allow Vietnamese to leave legally for family reunions and humanitarian reasons. Since then, additional American laws have been passed to allow children of American servicemen and former political prisoners and their families to enter the United States. Between 1981 and 2000, America accepted 531,310 Vietnamese refugees and asylum seekers, many of whom are now living in California. As a community who had fled Communism, many Vietnamese Americans are vehemently anti-Communist. Having lost the war and their homeland, some of them in the United States have recently lobbied many city governments to make the former South Vietnamese

flag instead of the current flag of Vietnam the symbol of Vietnamese in the United States.

Given the background, it is ironic that Tony Lam was forced to abandon his initial proposal to build a memorial to pay homage to the South Vietnamese war dead because a small group of Vietnamese Americans protested against his suggested location. Two years later, Frank Fry, a World War II veteran and a mayoral candidate, reintroduced the memorial proposal in his 1996 campaign platform and has since been recognized as the father of the project. However, Fry's initial vision of the memorial did not include honoring South Vietnamese soldiers. "At first, my thought was a memorial for Americans who had returned from that war. They were coming back unappreciated. But as I began to talk more to my Vietnamese friends, I realized we were not the only side that suffered losses; many Vietnamese lost loved ones, too." As a matter of fact, it was not long before the mayoral candidate announced to the city of Westminster, a constituency of more than 200,000 Vietnamese émigrés, that his new vision for the memorial was to "honor the bond between Vietnamese and American soldiers."[5]

In 1997, Fry, now mayor, encouraged artist Marge Swenson, United States Marine Corps Major General James J. McMonagle, and former Army of the Republic of Vietnam (ARVN) Lieutenant General Lam Quang Thi to form a preliminary committee to launch a national search for a design that would "depict friendship and camaraderie" between South Vietnamese and American soldiers. In August 1998, the committee selected Tuan Nguyen, a nationally known neoclassicist sculptor and a former refugee of Vietnamese descent, to design the memorial. Unable to find public funding, the project almost came to a dead end until Tuan Nguyen solicited help from his own publishers to organize a

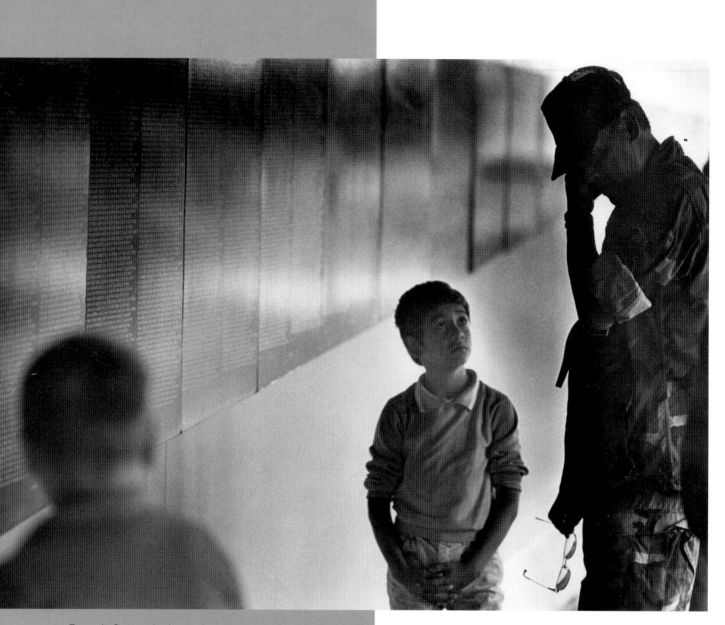

Fernando Gomez wiped a tear from his cheek when he visited
the traveling version of the National Vietnam Veterans Memorial
(The Wall) in East Los Angeles with his son Fernando Jr.,
November 11, 1988. He found the name of his best friend
who was killed in 1968.

fund-raising committee to launch a new campaign to raise money from individuals and private businesses.

With new fund-raising efforts underway, the committee began to lobby for city approval for the now private project. When the memorial design was first submitted, city officials claimed that they would not consider the project or give it a home unless the committee could raise at least half a million dollars for the estimated cost of the memorial. Once the money was raised, with more than 80 percent of the funding from the Vietnamese community, most city officials and close to 70 percent of non-Vietnamese residents in Westminster remained opposed to the project. Many of them worried that a Vietnam War Memorial in Westminster along with the Vietnam Veteran's Memorial in Washington, D.C., and others in California would renew and, once again, deepen the division in America over Vietnam.

After months of lobbying, the city finally approved the project, partly to appease frustrated Vietnamese Americans who threatened to move the project to Garden Grove where the memorial was promised prominent support and display. The project, no doubt, would help the city of Westminster in its efforts to revamp Little Saigon into a regional tourist attraction. However, a majority of local residents continued to oppose the project. In response to its choice of the City Hall area as the future home for the memorial, the city received 214 signatures from its residents objecting on the grounds that a private project should not be placed on public property or appear to have the support of the city. Reflecting on Vietnamese Americans' frequent anti-Communist demonstrations, Westminster councilwoman Joy Neugebauer voted against the proposed location out of concerns that the memorial would become a venue for public disturbances. She feared that the Vietnamese community might use the symbol of the memorial to launch their anti-Communist activities, which would prove damaging to local businesses.

The city faced mounting pressures from both the Left (anti-Vietnam War activists) and the Right (the American Legion 555 of Midway City). Two days before the unveiling of the wax model of the statue, the council angered the Vietnamese community by reversing its earlier decision to place the statue near the City Hall. To compensate for the reneged promise, the city "donated" a vacant lot "full of potholes and in need of leveling" on the far side of the Civic Center. This required the community to raise an extra $500,000 to cover the cost of improving the site for the statue installation. Despite the city's claim that the vacant lot offered more space than the previous location, many Vietnamese Americans perceived its decision as continued marginalization of the South Vietnamese experience during the war.

Yet, opposition to the memorial project was not limited to the realm of logistics. Beneath the official quarrel over the problems of funding and location lay bitter disagreements over the representation of memory. When the design of the statue was released, many residents voiced their dissatisfaction with Tuan Nguyen's portrayal of two soldiers standing as equals, side by side. In an interview with the *Los Angeles Times*, Mayor Fry confessed that "his council colleagues and other civic leaders always had a problem with the notion that statue would show the Vietnamese and American together."[6] While some suggested that the South Vietnamese soldier be eliminated altogether, others wondered whether it would be more appropriate to replace it with a South Vietnamese family group to convey the message that America freed them . . . and they are here now.

Despite the fact that more than 80 percent of the cost of the project was raised by and came from the

Vietnamese community, many Westminster residents "scoffed at the idea of building a monument to honor the fallen South Vietnamese using taxpayers' money." It did not seem to matter that 250,000 South Vietnamese soldiers lost their lives alongside 58,000 American soldiers during the war. Many American Vietnam veterans did not think that their South Vietnamese counterpart deserved a memorial because, in their view, it was populated by "corrupt Saigon generals, [timid] field commanders and frightened ARNV units letting Americans do the fighting."[7]

Yet, not all Westminster residents shared the view of these American Vietnam veterans. Rosalea Wilcox hoped that the memorial, by emphasizing mutual cooperation, would "help heal the American people and the Vietnamese people."[8] Retired Major General Eugene Hudson celebrated the theme of friendship among the soldiers, stressing that bonds formed during wartime can heal and outlast the wounds of war.[9] Similarly, not all Vietnamese Americans were in support of the project; the bickering and opposition were as pervasive and toxic within the community as they were without. Still many South Vietnamese veterans opposed the memorial, calling the community to look toward the future as opposed to "expending energy and resources to recreate painful memories of the past." Others criticized the design of the statue for its failure to emphasize the soldiers' bravery and prowess, suggesting rather for "stronger and more heroic" portrayals of the soldiers. Issues of financial control and personal recognition among Vietnamese American organizers further deepened the controversy and, at times, threatened to bring the project to a complete stop.[10]

The majority of the city did not embrace the memorial. Indeed, the overwhelming resistance of most of the non-Vietnamese community raised a set of obvi-ous questions: Why so much opposition to remembering South Vietnam? Why has the resurgence of Vietnam in the public conscience since the 1980s been received and lauded as important to national healing while the resurrection of South Vietnam in the late 1990s has been condemned as damaging to national reconciliation? Why were so many American veterans, at one point in time anathematized as society's waste, now ironically unable to acknowledge and honor the fallen soldiers of South Vietnam?

Perhaps there is something particularly conservative about Westminster that might explain the stubborn refusal to recognize the memory of South Vietnam. Yet, opposition to the memorial project did not only emanate from the conservatives. Instead, it encompassed a population of diverse political views which was nonetheless united in its position on the project. The reluctance to allow South Vietnamese to narrate their own history reflects the historical amnesia that had plagued official narratives and past memorialization practices of the Vietnam War, that is, forgetting the Vietnamese has been an essential component in constructing an American national memory of Vietnam. Past memorializing of Vietnam has separated "the warrior from the war in order to enable all Americans to honor those who sacrificed, regardless of one's feelings on the war."[11] Such observation, though accurate, relies on the assumption of a readily identifiable American collective. It is therefore, inadequate in addressing the implications of the specific relationship between South Vietnamese as members of a defunct political construct and Vietnamese Americans as "new Americans."

Vietnamese Americans' determination to include their experience in the American body of historical knowledge challenges the erasure of South Vietnamese allies from U.S. official Vietnam narratives. It also

reflects the continued exclusion of American ethnic minority voices and experiences from the larger American experience. From this perspective, the dispossession and physical segregation of Vietnamese American space of remembrance betray the marginal status of Vietnamese Americans as strangers in America. Their experience is regarded as distinctively non-American and is therefore banished from the dominant American Vietnam War landscape.

Ironically, in resurrecting their own memory of the past, South Vietnamese, too, needed to "screen out," to forget, details in the past that are inconvenient to remember. It is appropriate here to mention how women veterans of both countries are completely invisible in this particular memorialization narrative. Finally, it is necessary and crucial to highlight the invisibility of the Hmong, Laotian, Cambodian and other Southeast Asian veterans in the Westminster memorial as well as other Vietnam memorials nationwide. These are forgotten soldiers who fought alongside the Americans during the war and are now living in California and other parts of the United States. Their stories and experiences remain largely ignored in the existing narratives of the Vietnam War.

"I DESIGNED IT TO PAY RESPECT TO THOSE WHO DIED IN THE WAR. THE PEOPLE THEMSELVES GIVE MEANING TO IT"[12]

When the Preliminary Committee for the memorial project embarked on a national search for a design in 1997, it stipulated that the memorial would depict two soldiers, an American and a South Vietnamese, "shaking hands to honor the bond between the Vietnam War allies," with emphasis on friendship and cooperation between America and South Vietnam during the war. Yet, the blueprint that was selected featured a bronze statue of two soldiers in fatigues, standing shoulder to shoulder solemnly looking in the same direction to a distant land. In my most recent conversation with the architect, Tuan Nguyen explained his decision to deviate from the committee's original stipulation to depict the soldiers shaking hands: "Well, shaking hands would seem to indicate a celebration of victory between two equals. My research on the war shows that neither one was the case. I don't think that South Vietnam and America had an equal relationship during the war. So, even though I wanted to depict the friendship among the soldiers, I did not want to convey the message of equality and mutual cooperation. It's a lot more complicated than that."

Indeed, Tuan intentionally sought to highlight the complicated and distinct experiential and historical differences between two soldiers and their relations to the Vietnam War: "I wanted to portray both soldiers looking contemplative as if trying to make sense of what just happened. But the American soldier is portrayed with his gun down and his helmet off in a non-fighting position. [This is] because for the American, the war is over and he is going home. However for the South Vietnamese soldier, he remains fully armed and is still in the fighting position because for the South Vietnamese, the war is not yet over. It's like undone business."

Tuan pursued the theme of being "undone," or incompleteness in other ways as well. Playing on traditional Vietnamese beliefs that square and round shapes represent completion and perfection, Tuan positioned the statue in the middle of a two-third circle of black marble and granite wall and finished off both ends of the wall with two sharp triangular walls representing two national flags half-staff. Unlike other memorials, Westminster's is distinctly "ethnic" in its design. Besides the appropriation of shapes, at least two other

features of the structure reflect the influence of Vietnamese cultural practices on the design: the step entrance and the bronze urn. Three steps up and one step down lead to the approach of the statue. Such methodical stepping is said to originate from ancient Vietnamese practice to honor and show reverence to the deceased. In addition, a big bronze urn is installed in front of the statue and at the center of the memorial. It is said to help gather the spirits of the honored deceased.

Perhaps it is the "ethnic" quality of the memorial that challenges the humanist rhetoric of memorialization of the Vietnam War in the United States. Precisely because of the divisive nature of the war, memorializing the dead has entailed painstaking efforts to select not only what is deemed worthy of remembrance, but also what is capable of producing national healing or cohesiveness. Thus, memorializing Vietnam has necessitated the need to separate the war and warrior in order to pay proper homage to the dead, to ameliorate the wounds of their loved ones, to acknowledge the contributions of survivors and to bring together a divided nation despite its conflicting feelings about the war.

Yet, this humanist orientation toward healing and the emphasis on "apolitical" remembrance can produce a profound contradiction: how does America remember what it wants to forget? Thus, the Westminster Vietnam War Memorial challenges exclusive discourse that "forgets" to separate and honor the South Vietnamese warrior from the war. Moreover, while the aesthetically "ethnic" design of the memorial marks Vietnamese assimilated difference, it effectively underscores the particular sufferings experienced by South Vietnamese in contrast with their American counterpart both during and after the war.

"EVERY IMAGE OF THE PAST THAT IS NOT RECOGNIZED BY THE PRESENT AS ONE OF ITS OWN CONCERNS THREATENS TO DISAPPEAR IRRETRIEVABLY"[13]

In spite of its completion, the Westminster Vietnam War Memorial is still a work in progress. The original plan to include two computer kiosks that would store the names of all South Vietnamese soldiers who lost their lives has proven to be impossible to achieve. The records are still missing and the weary committee members are "in no hurry to meet again after seven years of meeting every week." In the meantime, far from being a site for collective healing, the memorial continues to generate the acrimonious interpretations of the past and contradictory visions for the future among the Vietnamese community.

Like other monuments that intend to transcend political and individual boundaries, the Westminster memorial distorts the past to satisfy the present. Coming to terms with human suffering through collective healing is one thing. Trying to induce collective healing by attributing meaning to stone and metal memorials is yet another. Perhaps it is our obsession with distorting the past to produce healing that must be transcended.

NOTES

1. Martia Sturken, *Tangled Memories: the Vietnam War, the AIDS Epidemic, and the Politics of Remembering* (University of California Press, 1997), 44–45.

2. Richard Morris and Peter Ehrenhaus, eds. *Cultural Legacies of Vietnam: Uses of Past in Present* (Ablex Publishing Corporation, 1990), 226.

3. Sturken, *Tangled Memories*, 4.

4. Charles Grisgold, qtd. in *Tangled Memories*.

5. Quyen Do, "Westminster Mayor Proposes Vietnam War Veterans Statue: His Aim Is to Honor the Bond between American and Vietnamese Soldiers," *The Orange County Register*, December 3, 1996, B-1.

6. Mai Tran, "Statue Donors Asked to Give Again: Why Is Still More Needed for the Westminster Memorial Featuring American and South Vietnamese Soldiers Together, They Wonder," *Los Angeles Times*, March 8, 2003, B-1.

7. Gordon Dillow, "South Vietnam Paid Dearly in Lost Cause," *Orange County Register*, March 21, 2000, B-1.

8. Quynh Giang Tran, "Though Cloaked, War Memorial Draws Visitors: Statues Built for Young Vietnamese Americans to Remember History," *Los Angeles Times*, September 25, 2002, B-3.

9. Anh Do, "Waxing Nostalgic about Vietnam: Westminster's Long-Awaited Tribute to Veterans Has a Colorful Unveiling," *Orange County Register*, October 1, 2000, B-1.

10. Mai Tran, "Groups Won't Be Singing Harmony at Statue Concert. Sunday's Benefit for Memorial to Honor Vietnam War Soldiers May Be Undercut by Rivals' Squabbling," *Los Angeles Times*, May 20, 2000, B-3.

11. Morris and Ehrenhaus, 226.

12. Tuan Nguyen, interview by author, October 21, 2003. (Interviews conducted both in English and Vietnamese. All translations are mine.)

13. Walter Benjamin, "Thesis on the Philosophy of History," in *Illuminations*, trans. H. Zohn (New York: Schocken Books, 1968), 255.

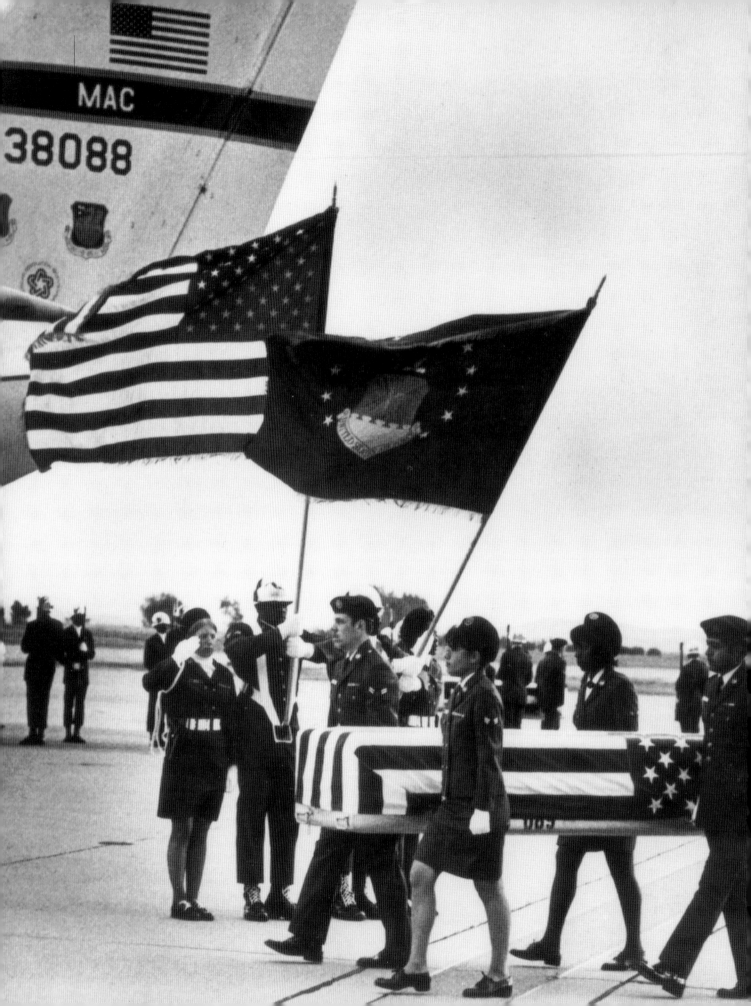

CHAPTER 10

Vietnam Legacy: The Role of California

Robert D. Schulzinger

MEMORIES OF AMERICA'S failed war in Vietnam reverberated for a generation after the last U.S. helicopters ascended from the roof of the American Embassy in Saigon in April 1975. Americans' faith in their public institutions plunged during the war. In its aftermath, Americans often viewed current international events through the prism of their unhappy experiences during the Vietnam War. Just as the war was controversial while it was being fought, it remained a contentious political issue afterward. Some of the war's fiercest advocates and opponents came from the Golden State. After it ended, California, the most populous state, played a prominent role in setting the boundaries of discussion about the Vietnam War. The controversy played out in Hollywood, that quintessential California industry, and in the state's politics. Californians took the lead in advocating both continuing hostility and eventual reconciliation with Vietnam. They also changed their minds about the meaning of the war. As the cold war ended, the wounds of the Vietnam War gradually healed in California as they did elsewhere in the nation.

Hollywood fought its own Vietnam War. The disagreements among movie people over the war began while the fighting raged, and continued after 1975. The Vietnam experience of John Wayne, the hawk, and Jane Fonda, the dove, two iconic figures from the film industry, illustrates the debate. The major studios avoided Vietnam subjects during the period of America's combat role from 1965 to 1973. Movie executives doubted that audiences would patronize films about an unpopu-

U.S. Air Force Color Guard salutes the return of MIAs from Vietnam at Travis Air Force Base, March 1977.

lar or, at least, controversial war. World War II–style patriotic films seemed dated and unappealing.

The exception was *The Green Berets* (1968) directed by and starring John Wayne. By the mid-1960s, Wayne had gained a huge international following for his heroic World War II films and westerns. Many critics thought his work was overblown, bombastic, and lacking subtlety or nuance—in a word, corny. But audiences flocked to his films. His conservative political views were well known. His biographers Randy Roberts and James Olson note "in an age where patriotism became suspect among liberals, he wrapped himself in the flag." The film historian Michael Anderegg observed that by the time of the Vietnam War his "image had hardened into a cliché-laden icon of the uncomplicated warrior hero." Wayne ardently backed the Vietnam War and expressed his disapproval and scorn for antiwar protesters. He once said, "I can't believe that people in the U.S. don't realize that we're at war with international Communism."[1]

In 1965 Wayne bought the rights from Columbia Pictures to produce a movie version of Robin Moore's 1963 novel about U.S. Army Special Forces in Vietnam entitled *The Green Berets*. The production and the film played out American rather than Vietnamese themes. Wayne hired his son Michael to produce. They obtained Pentagon support for the filming at Fort Benning, Georgia, where the piney woods bore little if any resemblance to Vietnam. It took years before his film was finally released in June 1968, after the Tet Offensive had convinced a majority of Americans that it had been a mistake to enter a war to which there seemed to be no end in sight. Wayne had no such doubts as he pressed forward with a project he hoped would change the minds of his fellow Americans in favor of the war effort.

The result was Wayne's own highly personal and hardly realistic picture of the war. Asian actors appeared in *The Green Berets*, but they were of Hawaiian, Japanese, Chinese, and Filipino origin. None were Vietnamese. John Wayne starred as Colonel Mike Kirby, gruff and tough, yet a tender father figure to both his troops and the almost childlike Vietnamese. The plot told two completely unrelated stories. One showed heroic Green Berets holding out against a Communist human wave assault on a training base. The other involved Colonel Kirby leading a daring aerial assault on a Vietcong base to capture an enemy general. Kirby is so kind and the Vietnamese so grateful that a liberal journalist, played by David Jansen, drops his opposition to the war. The film ends with the sun setting, absurdly, in the China Sea, which as many critics pointed out, was off the east coast of Vietnam.

Critics savaged *The Green Berets*. Writing in *The New Yorker*, Renata Adler called it "unspeakable, rotten, and false." Michael Korda's review in *Glamour* damned it as "immoral in the deepest sense. It is a simpleminded tract in praise of killing, brutality and American superiority." The movie and trade publications did not like it either. Wayne seemed out of touch with contemporary style and mores. The reviewer for *Cinema Magazine* derided the film as "so wretched and childishly sleazy that it is embarrassing to criticize its pretentiousness and banality." *The Hollywood Reporter* called *The Green Berets* "a cliché-ridden throw-back to the battlefield potboilers of World War II, its artifice readily exposed by the nightly actuality of TV news coverage."[2]

Reviewers may have dismissed *The Green Berets*, but the picture made money at home and abroad. It was one of the top-ten box-office draws in 1968. Some of the mostly young men who saw *The Green Berets* responded to its pro-American, pro-Vietnam War mes-

sage. Others simply liked the action. The Duke, as Wayne was known universally, had a ready following around the globe. Nevertheless, the critical pounding of Wayne and the movie convinced studio executives that making films about Vietnam was not worth it in the midst of the angry controversies surrounding the war.

At the same time Wayne spoke out in favor of the American effort in Vietnam, Jane Fonda, another prominent Hollywood actor and daughter of Wayne's old friend Henry Fonda, was just as actively opposing the war. Fonda had her own all-American, seemingly innocent persona, partly inherited from her father and partly her own. She said she never was ideological. Rather she came to oppose the war because it just made sense to do so. The war went on too long, cost too much in lives and money, and served no good end. She spoke at California antiwar rallies and organized a troupe of fellow Hollywood antiwar activists touring military bases, many of them in the Golden State, called FTA (for either Free the Army or, more colloquially, Fuck the Army). In the summer of 1972 Fonda brought her antiwar message to Hanoi. During her visit to the capital of the Democratic Republic of Vietnam, she made several radio broadcasts to American troops. A film clip showed her clapping and smiling in the seat of a North Vietnamese anti-aircraft gun ostensibly aimed at U.S. military aircraft. She also met with American POWs, who resented her presence as a propaganda coup for their captors. Supporters of the war called her Hanoi Jane and labeled her a traitor. For years after her visit to North Vietnam, Fonda was vilified as someone who had given aid and comfort to the country's enemy in wartime.[3]

Yet Fonda's career flourished in the 1970s despite the conservative onslaught. She wanted to make a Vietnam War film. She starred in *Coming Home,* released in

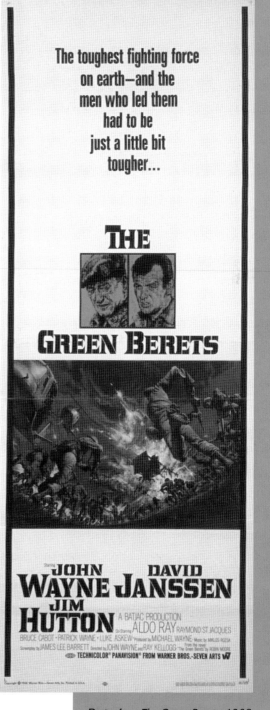

Poster from *The Green Berets,* 1968.
OAKLAND MUSEUM OF CALIFORNIA

1978. By that time Hollywood was finally making films about the Vietnam War. Most of them explored American themes and the cost of the war in the United States. Fonda played down some of her more outspoken antiwar views in order to reach a mass audience. Still, the film drove home the human costs of a pointless war. The drama of *Coming Home,* set in Southern California, involved a love triangle consisting of Fonda (Sally Hyde), her lover, a paraplegic Vietnam veteran (Luke Martin) played by Jon Voight, and Fonda's marine officer husband (Bob Hyde) played by Bruce Dern.

The film explores the feminist theme of a woman's growing autonomy while her husband is in Vietnam. Fonda works at the Veteran's Administration hospital near her Orange County home where she meets the embittered Voight, disillusioned with the war, furious at the loss of the use of his legs, fearful of being dependent. The film traces Fonda's growing independence, Voight's gradual ability to give and receive love, and the homecoming of Bruce Dern. The movie sets Voight's and Dern's characters as the opposite poles of the military experience. The former, an enlisted man, was physically broken but spiritually, intellectually, and politically liberated by the war. He becomes an antiwar activist who chains himself to the fence of the local marine base to protest sending men to their deaths. Dern, the officer who believed in the cause, returns home to find an unfaithful wife, who no longer is the submissive young woman he left behind.

Coming Home captured the sentiments of a majority of Americans in the years immediately after the Communist victory in Vietnam. They regarded the war as a mistake, but politics held little appeal. Who had been right and who had been wrong in deciding on the conduct of the war had faded as an issue. Instead, people focused on the human costs to those who had fought

and those who had stayed behind. The film also appealed to the changing views of veterans as victims of the government. All veterans, regardless of their opinions during or following the war, became objects of pity.

Some critics of *Coming Home* complained that the film had drained much of the politics of the film. *Ms. Magazine* objected that it reduced the plot to a pious and sentimental love story. Other conservative critics could not forgive Jane Fonda for her 1972 visit to Hanoi. For the most part, however, the critical reception, like that of the audiences who wept through it, was highly positive. The focus of attention was on the female lead, Fonda, who changed the most in the film. The movie was about America, a slice of Southern California suburbia, not Vietnam.

With the war over, Americans were ready for a kind of reconciliation about Vietnam. Wayne, angry at Fonda for having gone to Hanoi, made his peace with her when *Coming Home* drew huge audiences in 1978. He presented the Golden Apple from the Hollywood Women's Press Club to her as female star of the year. Ten years later Fonda sought reconciliation with American veterans and former POWs. She apologized for some of the things she said and did in Hanoi: "That was a thoughtless and careless thing to have done."[4]

In politics, too, Californians played prominent roles in defining the legacy of the Vietnam War for Americans. Ronald Reagan's career in electoral politics began in the midst of the turmoil in California over the war. He won the governorship in 1966 in part by appealing to voters angry at antiwar demonstrators at the University of California. For the next twenty-two years—first as governor, then while running for president in 1976 and 1980, and finally in the Oval Office—Reagan personified anti-Communism and backing for the war in Vietnam. He won the presidential election of 1980 in

part by promising to end the sense of national humiliation many Americans had felt in the loss in Vietnam. As president, however, Reagan took fateful steps leading to eventual reconciliation with Vietnam.

Hundreds of thousands of Vietnamese refugees came to the Unites States. The largest percentage of them settled in California where their presence had significant effects on political and social life. Vietnamese Americans' influence gradually increased during the twenty years before the United States and Vietnam restored diplomatic relations in 1995. Along that long, tortuous road to reconciliation, Americans remembered the soldiers who had fought in the war. Distorted recollections of men captured or missing in action became emblems of current political debates in which California politicians took leading parts.

Reagan was not alone in gradually, sometimes grudgingly, looking toward reconciliation with the victorious Communist government of unified Vietnam. The trend was national. It followed a trajectory of first avoiding the subject of Vietnam as too raw and hurtful to the memories of Americans who had fought the war. Then came a period of open anger and hostility. After that animosity ran its course, the United States and Vietnam restored trade and diplomatic ties in the mid-1990s.

Immediately after the end of the war, U.S. officials sought to turn Americans' attention away from Vietnam. President Gerald R. Ford and Secretary of State Henry Kissinger warned Americans against engaging in angry recriminations over responsibility for the loss in Vietnam. Better to forget about the past and turn attention to other foreign affairs issues. As the Ford administration sought to dampen public anger over the "loss" in Vietnam, it declared an embargo on all trade and travel to the country. The lingering question of the where-

abouts of U.S. servicemen listed as missing in action eliminated whatever sympathy American officials might have had for establishing economic aid and diplomatic relations. The Vietnamese negotiators hinted that they would provide information regarding the fate of the Missing in Action (MIAs) if the United States came up with economic aid.

In September 1975 the House of Representatives created a special committee to investigate the fate of MIAs. Members of the committee disagreed over how generous the United States should be toward the Socialist Republic of Vietnam (SRV). Some, like California Representative Pete McCloskey, who represented an affluent district near Stanford University where many constituents had opposed the war, favored lifting the economic embargo to encourage the SRV to account for MIAs. Others took a harder line. They demanded that Hanoi come forward with information on MIAs before the United States would consider economic ties. McCloskey argued for extending diplomatic relations to Vietnam to generate "commercial opportunities for American businesses." The Ford administration continued to oppose all American inducements to Vietnam. Instead, Ford asserted that the Vietnamese had "a clear, unequivocal and unilateral responsibility to account" for MIAs. To extend diplomatic relations before Hanoi made such an accounting would, Ford predicted, "dignify and reward their posture of linking an accounting for our men to our providing them money."[5]

The memory of the Vietnam War became an issue during the presidential election campaign of 1976. President Ford faced a strong challenge for the Republican nomination from Reagan, a prominent conservative. Reagan assailed the Ford administration's foreign policy record. He raised the issue of Vietnam when he demanded a full accounting of the fate of American MIAs

Home after six years of captivity in North Vietnam, Air Force Captain Michael Kerr hugs his son and daughter upon arrival at Travis Air Force Base, March 8, 1973.

in Southeast Asia. Addressing the National League of Families, an outspoken advocacy group for servicemen listed as missing, Reagan promised to obtain a full account of MIAs the first week he was president. Reagan's close connection with the League made it difficult for Ford to improve ties with Vietnam. Ford maintained this tough stance after he secured the Republican nomination in the summer. In September the United States vetoed the SRV's application for membership in the United Nations. But the memory of the Vietnam War and the fate of MIAs remained issues in the 1976 presidential election.

Jimmy Carter, Ford's Democratic opponent in the fall election, also made Vietnam an issue. Carter assailed the mistakes made by a generation of American leaders in Vietnam. He pledged not to intervene in other nations' internal affairs the way the United States had done in Vietnam's civil war. Carter administration officials hoped that the fresh start of a new presidency would overcome inertia. Secretary of State Cyrus Vance believed that diplomatic relations with the SRV would help stabilize Southeast Asia. The secretary predicted that normal diplomatic relations with Vietnam would "give the United States the opportunity to have more influence with a nation which obviously plays an important part in the future development of Southeast Asia." Assistant Secretary of State for Far Eastern Affairs Richard Holbrooke became the most ardent advocate within the Carter administration of normalizing relations. According to Holbrooke, the establishment of relations with Vietnam would encourage the SRV to "work in a cooperative and responsible manner as a member of the region."[6]

Vance and Holbrooke pressed for normalization of relations with Vietnam throughout 1977 and 1978. The road to reconciliation faced enormous obstacles.

Holbrooke met several times with representatives of the SRV, but the Vietnamese proved to be cantankerous negotiators. Within the U.S. government the National Security Council (NSC) thought it more important to improve relations with China. The domestic POW/MIA lobby adamantly opposed opening relations with the SRV.

In 1979 U.S. policy remained committed to strengthening relations with the People's Republic of China (PRC). Secretary of State Vance, on the other hand, kept trying to maintain contacts with Vietnam. He despaired of National Security Adviser Zbigniew Brzezinski's tilt toward the PRC. "I believe strongly," Vance wrote the president in May, "that we are on the wrong course and that we are driving the Vietnamese further into the arms of the Soviets." The secretary of state believed that "we are coming increasingly under attack from both the right and the left." Vance's pleas infuriated Michel Oksenberg, the China specialist on the NSC staff. He scrawled "other than Jane Fonda, who?" next to Vance's assertion that both the Right and the Left objected to the American isolation of Vietnam.[7]

Vietnam faded farther from public view as the Iran hostage crisis washed over the Carter administration. Yet during the election campaign of 1980, Reagan, the Republican Party's challenger to Carter, referred regularly to the lessons of the Vietnam War. He told the Veterans of Foreign Wars that the United States had fought for a "noble cause" in the Vietnam War. Reagan accused the Carter administration of learning the wrong lessons from the American military debacle in Vietnam. Instead of refraining from the use of military power in the wake of the disaster of Vietnam, Reagan recommended that the United States commit more resources to the armed forces. On Election Day 1980 Reagan easily defeated Carter.

At first, the Reagan administration paid limited attention to Vietnam. It sought to assert American power against the Soviet Union. President Reagan avoided attending the ceremony opening the Vietnam Veterans Memorial in November 1982. Insofar as the Reagan administration considered Vietnam, it tried to isolate the SRV. It strengthened the economic embargo. In 1982 the White House proclaimed that the United States would not consider normalization of diplomatic relations "as long as the Vietnamese occupation of its neighbor [Cambodia] continues."[8] The United States also denounced Vietnam for dragging its feet on accounting for the status of service personnel listed as missing in action. In 1983 Reagan told the National League of Families that receiving an accounting for the 2,200 MIAs had his highest priority.[9]

Paradoxically, what began as a political effort to consolidate support among ardent backers of POW families grew into political contacts with the government of the SRV. Relations improved between the United States and the Soviet Union after Mikhail Gorbachev's accession to power in 1985. In Vietnam, Vo Van Kiet, the new leader of the Workers Party, also promoted economic and political reform. In March 1987 the Reagan administration sent a delegation to Vietnam led by former Chairman of the Joint Chiefs of Staff John Vessey to receive a fuller accounting of the status of U.S servicemen listed as MIAs. Despite repeated assurances that Vessey's mission would deal only with unresolved MIA issues, some of Reagan's most conservative supporters believed that their political hero had gone soft on Communism.

No one expressed more fury at the possibility that Vessey's mission might lead to a restoration of diplomatic relations with Vietnam than California Republican Representative Robert K. Dornan. A decorated Korean

War veteran, Dornan represented Orange County, the epicenter of the Reagan revolution and also the home of the largest Vietnamese American immigrant community in the nation. He acquired a reputation for making inflammatory, hour-long speeches on the House floor at the end of each day's session. He had a rich baritone voice, flaming red hair, and an eye for the camera. He drove Democrats crazy.

On the MIA issue, the Reagan administration would suffer from Dornan's invective. He promised that a live American POW would come home from Vietnam. His face would be on the cover of *Time, Life, Newsweek, People, The National Review, The New Republic, U.S. News,* and "every other magazine in the world." Dornan accused administrations from 1973 to 1987 of concealing knowledge of Americans left behind in Vietnam and Laos. He recounted the history of the month before the signing of the Paris Accords in January 1973, when, he argued, the United States had won the war. "We had established total air supremacy, not superiority, supremacy, not a damn MiG was in the air." Then came the betrayal. "Under Nixon's orders, Kissinger, Bud McFarlane . . . Philip Habib . . . signed away our men." Dornan claimed that New York Representative Stephen Solarz, chair of a House Subcommittee investigating the fate of MIAs, held the key to exposing this terrible conspiracy. Now completely carried away, Dornan said, "I am begging you, Steve, subpoena Richard Nixon, subpoena Henry Kissinger, get [former Reagan National Security Adviser] Bud McFarlane in here to whine like he has done before other committees and flap his eyes at us."[10]

Officials of the Reagan administration with responsibility for Vietnam issues thought Dornan had become a nag more interested in self-promotion and feeding the anti-Communism of his Vietnamese American con-stituents than finding MIAs. They started calling him a leader of the "Rambo faction" of members of Congress who pretended to believe, in spite of all evidence to the contrary, that there were Americans still held prisoner in Southeast Asia. Dornan pushed back and kept harassing administration officials. In March 1988 he demanded a meeting with National Security Adviser Colin L. Powell. A furious Powell told Dornan that congressional delegations to Hanoi from the Rambo faction actually set back the cause of obtaining information about the eight men listed as MIA.

Despite Dornan's hostility to the Communist authorities in Vietnam, Hanoi actually gained advantages in hosting any sort of critic of the U.S. government. "The Vietnamese have different messages for different people," Powell said. They promised cooperation to official representatives like Vessey. Then they turned around and hinted to Dornan that Vessey, the State Department, and the NSC really had no interest in finding MIAs; they just wanted to end the controversy. The Rambo faction ran the danger of being used by the Vietnamese. The National Security Adviser could not resist a dig that visitors to Hanoi like Indiana Representative Frank McCloskey and New Hampshire Representative Bob Smith, two of Dornan's close associates in the Rambo faction, encouraged Vietnam "to attempt the same domestic strategies they used during the war." Likening Bob Dornan and his friends to Jane Fonda and other antiwar activists was guaranteed to make the mercurial congressman explode. He did, denouncing the NSC and the State Department as dupes of Hanoi.[11]

Dornan's theatrics were designed in part to appeal to the large, and predominantly anti-Communist, Vietnamese American community in California. Between 1975 and 1980 multiple waves of Indochinese refugees,

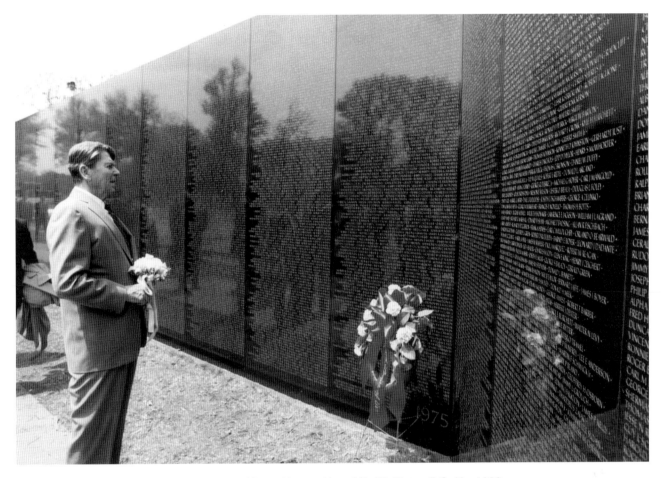

President Ronald Reagan pays his respects at the new Vietnam Veterans Memorial in Washington, D.C., May 1983.

PHOTOGRAPH COURTESY OF RONALD REAGAN PRESIDENTIAL LIBRARY

numbering more than 400,000, came to the United States. The largest percentage of them and their descendants eventually settled in California where they became a driving force in setting U.S. policy toward Vietnam. Both the Ford and Carter administrations sought to disperse the newcomers widely across the United States. Initially, in 1975 the government tried to limit the number of Indochinese in any state to no more than 3,000. Yet by 1980, when the last refugees had left the camps in Southeast Asia, eleven states, accounting for 58 percent of the Indochinese population in the United States, had more than 3,000 Vietnamese. Most of them came to the West Coast.[12] In 1979 some 71,000 Vietnamese lived in California, mostly in and around Los Angeles and San Diego. The city of Westminster in Orange County, the center of Reaganism, John Wayne's home, and Dornan's congressional district, became known as the largest Little Saigon in the United States.[13]

Local volunteer organizations helped smooth the initial transition of Vietnamese into American life. Reli-

gious organizations such as Catholic Charities, the Lutheran Church, the Hebrew Immigrant Aid Society, the Southern Baptist Convention, and the Church World Service Organization collected funds designated specifically for the refugees from Indochina. Many of the first wave of Vietnamese refugees had held white-collar jobs at home. None were available in the United States for people with limited or no English. Instead, those Vietnamese who could find work did so cleaning public buildings, washing and cooking in restaurants, or in any other field of manual labor that did not require English. In the beginning of their lives in America, many Vietnamese were forced to rely on public assistance.[14] Before 1980 these voluntary organizations often worked independently. In 1980 Congress created the Office of Refugee Resettlement under the terms of the Refugee Act. This office in the Department of Health and Human Services provided state and local governments with millions in aid. Over the next decade the office provided state governments with $710 million to provide social services to refugees.[15]

Vietnamese faced significant resentment in the United States. As one former South Vietnamese infantry officer put it: "we can accept. The problem for us, almost always, is being accepted."[16] Economic times were hard. Unemployment ranged as high as 11 percent in the six years after 1975, and it never fell below 7 percent. The national economy was abysmal with the manufacturing sector dramatically affected by overseas competition, much of it from Japan. Agriculture also was impacted as prices for most farm products fell even as inflation raged. In such a depressed economy Vietnamese found it difficult to find work and gain acceptance from their new American neighbors.

Anti-immigrant sentiment surged in the midst of the economic doldrums of the late 1970s and early 1980s. Asians became a special target of the wrath of American workers who believed that their jobs disappeared to Japanese firms. Never mind the fact that Vietnamese had as little in common with Japan as did Anglo-Americans. Maybe even less, since Vietnam was a poor, rural land and Japan a modern, industrial economy. Confusing Vietnamese with Japanese was not the only mistake nativists made when they lashed out at Vietnamese immigrants. Eerie echoes of combat reverberated when Vietnamese immigrants heard charges that they were Communists. Just as some American soldiers and marines considered all Vietnamese, including those whom they were supposedly protecting, to be sympathizers of the Vietcong, Americans in the United States often accused the anti-Communist immigrants of being Communist agents.

Antagonism erupted in some cities at Vietnamese

Vietnamese children learning English at Camp Pendleton, October 1975.

SACRAMENTO ARCHIVES AND MUSEUM COLLECTION CENTER, SACRAMENTO BEE PHOTO MORGUE COLLECTION

stores and restaurants. Local hoodlums sometimes assaulted Vietnamese shopkeepers or restaurant workers. The assailants turned over display carts, broke glass windows, and beat up workers. The complaints were typical anti-immigrant bigotry. Vietnamese were said to be too close-knit and to employ too many of the members of their extended families.[17]

Violence against Vietnamese spread across the country. A gunfight over fishing rights broke out in New Orleans between local shrimpers and Vietnamese refugees. Mississippi shrimpers printed up bumper stickers reading "Save Your Shrimp Industry: Get Rid of Vietnamese, Contact Your Local Congressman." A mob of young men in New York City roughed up a group of Vietnamese. There the issue was a different sort of racial antagonism. The attackers were African Americans who believed their victims to be Koreans. The fight occurred in the midst of severe antagonism between blacks and local Korean shopkeepers. The worst violence against Indochinese refugees took place on January 17, 1989, in Stockton, California. A man opened fire with an AK-47 on the playground of Cleveland Elementary School. He murdered five children and wounded another twenty-nine and one teacher. Nearly all of the victims were refugees from Cambodia, Laos, or Vietnam.

Vietnamese families adapted to life in the United States. Such families were smaller and more nuclear than the ones back home in Vietnam. One study of Vietnamese Americans in the mid-1980s found that household or family size ranged from one to eighteen people. About 34 percent of Vietnamese families had six to eight people; 32.4 percent had nine to eleven, and 12.5 percent contained twelve to fourteen people. The Vietnamese in the mid-1980s were quite young. The median age for all Vietnamese was 21.5; 20.6 for males and 22.7 for females. But the shape of the Vietnamese family in the United States differed from the family in Vietnam. In the mid-1980s 22 percent of Vietnamese households in the United States had one generation. In Vietnam only 7 percent of households were single generation.[18]

Many older Vietnamese felt increasingly lonely. They learned English slowly and with difficulty, if at all. The young people took to it easily. They had to drive their parents and grandparents to the store and interpret for them. The sense of dependence weighed heavily on older Vietnamese immigrants. Added to that were the other obvious manifestations of a generation gap. A Vietnamese woman told of the shock she felt when she heard the teenage daughter of her sponsoring family shout at her mother. "When I heard this I was in total disbelief. You see, obedience is taught to be a virtue in our culture . . . Believe it or not, a few years later my oldest daughter shouted at me in the same way."[19]

Vietnamese Americans also gradually became involved in politics. Some of their activities explicitly continued their animosity toward the SRV. In 1985 ten years after the Communist victory in South Vietnam, they created the National Congress of Vietnamese in America. In 1987 Vietnamese protested against a commencement speech by Tom Hayden, the prominent antiwar activist and former husband of Jane Fonda, at San Jose City College, which had an enrollment of over 40 percent Vietnamese.[20] In 1999 hundreds of anti-Communist Vietnamese protested outside the Hi Tek TV shop in Westminster, California, in the heart of Orange County's Little Saigon. The owner, Truong Van Tran, himself a Vietnamese refugee, had displayed a poster of the revolutionary leader Ho Chi Minh in a defiant plea to let bygones be bygones. Police had to rescue him from the angry mob. In 2003 Westminster, California, dedicated a memorial to the South Viet-

namese and United States service personnel who had died defending the Republic of Vietnam. City Councils in California cities with large Vietnamese populations demanded that the United States recognize the flag of the old Republic of Vietnam, not the current Socialist Republic, in schools and other public gatherings. Vietnamese Americans in California insisted that their children learn to appreciate the values and sacrifices made by their parents and other ancestors in defense of anti-Communist South Vietnam. Van Trem, the Vietnamese American mayor pro tempore of Garden Grove, California, another city with a large Vietnamese American population, said, "the war may have ended for the United States, but for many Vietnamese refugees the war still continues."[21]

Yet many Vietnamese Americans maintained ties to their homeland and wanted to move beyond the animosities of the war. The pull of family was just too great for politics to get in the way. One Vietnamese American explained how many of his friends and family sought to move beyond the horrors of the Vietnam War. The war, he said, "is an ugly scar we try to forget. If you keep touching a scar, you can't concentrate." Vietnamese living in the United States sent home $18 million each month, the bulk coming from California. The government skimmed off much of the money. Vietnamese Americans who wanted their relatives to benefit from their hard work in the United States actively advocated an end to the economic embargo, establishing diplomatic relations, and a trade agreement between the United States and the SRV.[22]

Vietnamese Americans participated directly in California politics. More supported Republicans than Democrats, although both major political parties sought their backing. Vietnamese military officers living in California actively recruited Army of the Republic of

Vietnamese American communities thrived in urban areas on the West Coast, especially California, where there were more than 300,000 Vietnamese Americans in 2000.

Vietnam (ARVN) veterans to the Republican side. A Vietnamese man who worked for a California Republican congressman said, "the Republicans have a staunch anti-Communist position. In essence, we are here because the Communists drove us out. We know the Republicans will stand up to the Communists." About 47 percent of Vietnamese voters in California registered as Republican. The Democratic Party had the support of about 20 percent.[23]

By the 1990s approximately one million Americans traced their heritage to Vietnam. Vietnamese American communities thrived in urban areas on the West Coast, especially California, where there were more than 300,000 Vietnamese Americans in 2000. They had adapted well to life in the United States. Educational and employment levels were high among Vietnamese Americans born in the United States. Vietnamese Americans continued to support the Republican Party and conservative political causes. They actively followed events in Vietnam. Most stridently opposed the policies of the government of the SRV and some actively sought its overthrow. Yet, at the same time, Vietnamese Americans traveled regularly to Vietnam. Once the United States and the SRV had formal diplomatic relations, more than 20,000 Vietnamese Americans visited Vietnam each year. By 2000 hundreds of Vietnamese Americans

had started joint businesses in Vietnam. Vietnamese Americans, particularly from California, became the principal bridge between the two old adversaries.

Vietnam played a significant role in the Clinton administration's effort to link foreign economic and political policy. American firms continued to look enviously on the direct investment in Vietnam by Japanese, Australian, and European firms. The Southeast Asian economies of Thailand, Malaysia, Singapore, and Indonesia boomed in the late 1980s and early 1990s. Together with South Korea and Taiwan, these nations came to be known as the

Street Scene in Little Saigon, Orange County, California, 1998.
PHOTOGRAPH COURTESY OF CATHERINE KARNOW/CORBIS

Asian tigers. Major U.S. firms urged the Clinton administration to end the embargo against Vietnam. On February 4, 1994, during the Vietnamese New Year holiday of Tet, the Clinton administration ended the embargo on trade and travel to Vietnam.[24] The lifting of the embargo proved widely popular. "We waited for this day for a long time," proclaimed a Pepsi Cola executive in Saigon.[25] Not everyone was happy, of course. Representative Dornan denounced the move as a craven betrayal of American POWs to obtain a few dollars in trade. But few people listened, even in California, where the allure of thriving commerce with a new Asian tiger proved especially enticing.

The end to the embargo represented a first step toward the restoration of full diplomatic relations between Washington and Hanoi. Now that the United States no longer considered Vietnam an economic pariah, only one issue stood in the way of diplomatic

relations. The Clinton administration inherited its predecessors' commitment to search for POWs and MIAs. The United States and Vietnam conducted negotiations in New York and Washington for seventeen months after lifting the embargo. The United States insisted that Vietnam expand the joint patrols searching for remains. The Vietnamese readily agreed. The Clinton administration, like officials in the Bush years, did not believe that any live Americans remained in Vietnam. But the Clinton administration wanted protection against charges from domestic critics like Rep. Dornan that it had abandoned servicemen in Vietnam.

In July 1995 the United States and Vietnam renewed diplomatic relations. President Clinton predicted, "Normalization and increased contact between Americans and Vietnamese will advance the cause of freedom in Vietnam." Once more Representative Dornan denounced Clinton for cowardly appeasement. Few

seemed to care. In 1996 he lost his congressional seat to Loretta Sanchez, a Democrat, who promised to promote greater cooperation between the two governments. Secretary of State Warren Christopher traveled to Hanoi in August 1995, and stressed that the restoration of diplomatic relations would increase political freedom in Vietnam. He told his uncomfortable hosts, "A powerful revolution of ideas has swept the world. Indeed, the main story of the late twentieth century is the ascendancy of open societies and open markets in country after country."[26] The United States pressed Vietnam to open both its markets and its political system. The secretary of state advised the Vietnamese that "the key to success in this rapidly changing world is the freedom to own, to buy, to sell: the freedom to participate in the decisions that affect our lives."[27]

The Vietnamese welcomed the restoration of diplomatic relations after twenty years, but they resented the lectures on political pluralism. General Vo Nguyen Giap believed that the opening of relations with the United States held as many dangers as opportunities. "We had problems in wartime and now we have to deal with the problems of peacetime," he said. Diplomatic relations with the United States made Vietnam feel less vulnerable to Chinese dominance. It also opened the way for Vietnam to join the Asian Pacific Economic Conference and the World Trade Organization. But participation in these prominent organizations of global economy carried grave dangers. Thousands of tourists visited Vietnam each week. Many of them were Vietnamese Americans from California returning to visit families and friends. They brought with them the clothes, videorecorders, still cameras, computer software, music cassettes, and cigarettes of the developed world. Many visitors were recent emigrants from Vietnam who told of life in the freer, richer West. Fax machines, email, cell phones, direct satellite TV all opened a window on the world.

The view from outside deeply distressed conservative Vietnamese who were afraid that their control over their country could be endangered. *Cong An*, the newspaper of the police department of Saigon, expressed dismay at how the youth of the country's largest city had been led astray by rap music. The pounding rhythms and profane lyrics made the listeners "crazy and stirs them to disrupt our peaceful social order." An official with the Union of Literature and Arts Association saw threats all around from Western culture. He saw a "dark scheme of imperialist forces which are intent on cultural aggression against our nation."[28]

The Clinton administration had no such qualms about the benefits of greater contact between the two countries. Secretary of State Madeleine Albright opened a U.S. consulate in Ho Chi Minh City June 1997. In November 1997 Vietnam opened a consulate in San Francisco. Under the Jackson Vanik Amendment passed in 1974, Vietnam, like the Russian Federation, remained on the list of countries whose exports were taxed at the highest rate until it relaxed its restrictions on free emigration. In March 1998 Clinton signed a waiver of the Jackson Vanik Amendment restrictions on trade with Vietnam. His move paved the way for the U.S. Export-Import Bank and the Overseas Private Investment Corporation to extend credit to Vietnam.[29]

Yet politics continued to interfere with better economic relations. A trade treaty between the United States and Vietnam remained blocked by the United States linking most favored nation status to Vietnam's policy on emigration. Richard Childress, the point man for the Reagan administration on POW issues, strongly opposed the Clinton administration's efforts to expand the trade relations between the two powers. Childress

had such a bad experience with the "Rambo faction," who insisted that live Americans remained in Vietnam, that he might have been expected to welcome the Clinton administration's efforts finally to resolve outstanding POW issues with Vietnam. Yet Childress derided the administration as rank amateurs in foreign affairs and complained that its efforts since 1993 had been built upon "false certifications" to Congress of Vietnam's compliance with American demands for free emigration.[30] Nguyen Dinh Thang, a Vietnamese American with close ties to the California anti-Communist Vietnamese community, agreed that Vietnam continued to harass would-be emigrants. He deplored the "rampant corruption" that "plagued Vietnam's emigration process." He also accused the State Department of turning a blind eye to the common practice of Vietnamese officials charging as much as several thousand dollars under the table for an exit permit.[31]

Such objections seemed not to matter in the hopeful era of globalization at the turn of the twenty-first century. The cold war was a fading memory. Most Americans believed that the Vietnam War should also be consigned to history. U.S. and Vietnamese negotiators signed the Bilateral Trade Agreement on July 13, 2000.[32] The BTA slashed tariffs from 20 percent to 3 percent and paved the way for Vietnam to enter the World Trade Organization. Charlene Barshevsky, the special trade representative in charge of the U.S. end of the negotiations, told Congress that the agreement would set Vietnam on "a course for greater openness to the outside world . . . and helping Vietnam to integrate itself into the Pacific regional economy and build a foundation for future entry into the World Trade Organization."[33]

The BTA set the stage for President Clinton's triumphal tour of Vietnam in November 2000. Clinton sought reconciliation—both with the Vietnamese and

President Bill Clinton speaking at the Vietnam National University in Hanoi during his visit to Vietnam, November 2000.
PHOTOGRAPH COURTESY OF REUTERS NEWS MEDIA INC./CORBIS

with Americans who still bore scars of the war. As he flew on Air Force One to Vietnam, Clinton expressed some empathy for President Lyndon Johnson, whose escalation of the war in Vietnam Clinton himself had opposed as a student: "He [Johnson] did what he thought was right."[34] Clinton pressed the same message of letting go of old animosities in Vietnam. He also told a cheering crowd of students at Vietnam National University in Saigon that they should embrace Vietnam's entry into the global market as the best way for prosperity and political freedom in their country. "I love him; he is so handsome" exclaimed one young Vietnamese woman. A seventeen-year-old high school student in Saigon summarized the views of many urban, educated Vietnamese eager to see the benefits of globalization, "America is a very modern country, and we want to be modern too." A seventy-year-old retired Saigon accountant also appreciated Clinton for being, he said, "the American who had done the most to heal Vietnamese American relations."[35]

The healing took twenty-five years, and California played an important role in that process. The divisions over the proper policy toward Vietnam had run deep through the state during the period of the war and remained for more than two decades after it ended. Californians were among the most prominent hawks and doves while the war went on. Some of them were the most prominent advocates of reconciliation with the SRV after 1975. Others took the lead in demanding that the United States take stern measures against the Communist government of Vietnam. Most notable were those Californians who adapted to changing international and local circumstances. Many of these people were the most ardent hawks before 1975. As the cold war ebbed and eventually passed into history, reconciliation with Vietnam became a reality.

NOTES

1. Randy Roberts and James Olson, *John Wayne: American* (New York: The Free Press, 1995), vii, 537. Michael Anderegg, "Hollywood and Vietnam: John Wayne and Jane Fonda as Discourse," in Michael Anderegg, ed., *Inventing Vietnam: The War in Film and Television* (Philadelphia: Temple University Press, 1991), 19.

2. Roberts and Olson, *John Wayne*, 547–48.

3. Anderegg, "Hollywood and Vietnam," 22–23. As late as 2002 a book appeared demanding that she be tried for treason. Henry Mark Holzer and Erika Holzer, *"Aid and Comfort": Jane Fonda in North Vietnam* (Jefferson, N.C.: McFarland and Co., 2002).

4. Roberts and Olson, *John Wayne*, 554. Anderegg, "Hollywood and Vietnam," 29.

5. T. Christopher Jesperson, "The Bitter End and the Lost Chance in Vietnam: Congress, the Ford Administration, and the Battle over Vietnam, 1975–1976," *Diplomatic History* 24, 2 (Spring 2000): 266.

6. Steven Hurst, *The Carter Administration and Vietnam* (New York: St. Martin's Press, 1996), 27.

7. Vance to President, with Oksenberg comments. May 16, 1979. Box 86. National Security Affairs. Brzezinski Files. Jimmy Carter Library, Atlanta, Georgia.

8. Vietnam: US-SRV Relations. January 13, 1982. Box OA 9076. Morton Blackwell Files. Ronald Reagan Library, Simi Valley, California.

9. POW/MIA Interagency Group meeting, January 19, 1982. Box OA 9076. Morton Blackwell Files. Ronald Reagan Library, Simi Valley, California.

10. "The Vessey Mission to Hanoi," *Hearing before the Subcommittee on Asian and Pacific Affairs of the Committee on Foreign Affairs.* U.S. House of Representatives. 100th Congress, First session, September 30, 1987, 102–3.

11. Talking Points for Use with Congressman Dornan. North Dakota [March 1988]. Childress to Powell. March 14, 1988. Box OA 92014. Alison Fortier Files. GIST, "Amerasians in Vietnam," August 1988. Box 72397. Richard Childress Files. Ronald Reagan Library, Simi Valley, California.

12. Jeremy Hein, *From Vietnam, Laos, and Cambodia: A Refugee Experience in the United States* (New York: Twayne Publishers, 1995), 51–52.

13. Bruce Grant, *The Boat People: An "Age" Investigation* (New York: Penguin, 1979), 161–62.

14. Paul James Rutledge, *The Vietnamese Experience in America* (Bloomington: Indiana University Press, 1992), 40–41.

15. Hein, *From Vietnam, Laos, and Cambodia*, 52.

16. Grant, *The Boat People*, 163.

17. Rutledge, *The Vietnamese Experience*, 41.

18. Hein, *From Vietnam, Laos, and Cambodia*, 121; Rutledge, *The Vietnamese Experience*, 43, 120; Bruce R. Dunning, "Vietnamese in America: The Adaptation of 1975–1979 Arrivals," in David W. Haines, ed., *Refugees as Immigrants: Cambodians, Laotians and Vietnamese in America* (Totowa, New Jersey: Rowman and Littlefields, 1989), 77.

19. Hein, *From Vietnam, Laos, and Cambodia*, 121.

20. Ibid., 102–3.

21. "Vietnamese Activists Push for Old Flag," May 23, 2003. www.cnn.com.

22. Hein, *From Vietnam, Laos, and Cambodia*, 103.

23. Ibid., 104

24. *Far Eastern Economic Review*, vol. 157. February 17, 1994, 15.

25. Ibid., 16.

26. "Remarks Announcing the Normalization of Relations with Vietnam," July 11, 1995. *Public Papers of the Presidents: William J. Clinton* (1995), 1073.

27. *Far Eastern Economic Review*, vol. 158, October 25, 1995, 51.

28. Ibid., 50.

29. "Chronology of Normalization of Relations between the U.S. and Vietnam." *Hearing before the Subcommittee on International Trade of the Committee on Finance*. U.S. Senate. 105th Congress, Second Session, July 7, 1998, 182.

30. Ibid., 32–33.

31. Ibid., 37.

32. "An Agreement between the United States and the Socialist Republic of Vietnam on Trade Relations." *Message from the President of the United States*. U.S. House of Representatives. House Document 107–85. 107th Congress, First session. June 12, 2001.

33. "Prelude to New Directions in United States–Vietnam Relations: The 2000 Bilateral Trade Agreement." *Joint Hearing of the Committee on International Relations*. U.S. House of Representatives. 106th Congress. Second Session. September 19, 2000, 6.

34. AP story, November 14, 2000.

35. *New York Times*, November 16, 2000.

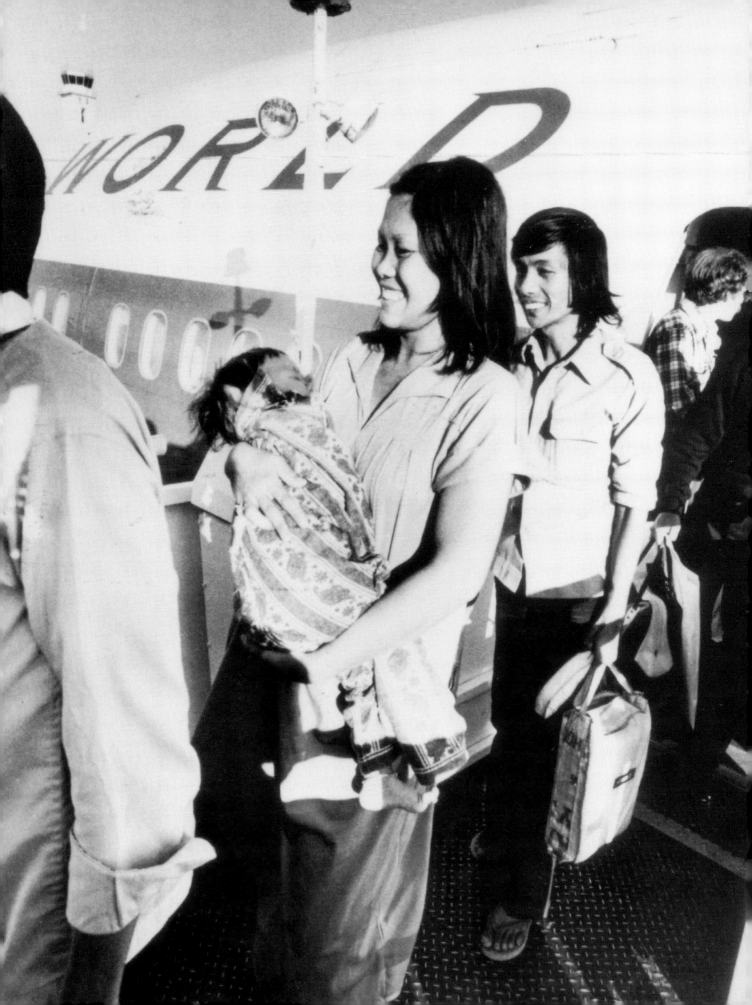

Vietnamese Diaspora and California

Andrew Lam

Refugee Truong Yen Kinh, followed by her husband, Phung That, carried their baby daughter, Phung Le Gia, off a World Airways plane at Travis Air Force Base, July 1979. The couple were ethnic Chinese who escaped from Vietnam.

I AM SITTING in a small, comfortable bus going north, with the nostalgic music of Trinh Cong Son, sung by a smoky-voiced Khanh Ly, echoing from the overhead speaker. Son was the most famous Vietnamese composer during the Vietnam War, and Khanh Ly the most famous singer. There are two old Vietnamese ladies next to me bragging about their children and grandchildren, how well they were doing, and so on. Behind me, a couple of middle-aged men are humming along with the song of their youth. And up front two Vietnamese kids are playing games on a handheld computer while their mother talks endlessly on her cell phone to someone about her restaurant business. Vietnamese voices rise and fall; I close my eyes, listen. I swear I could be in Saigon heading north to Da Nang.

Except, I am not. I am on the other side of the Pacific, on my way to San Jose from Orange County, going up Interstate 5 in a Vietnamese-owned bus, one of three competing Vietnamese companies that currently cater to Vietnamese Americans living in California.

If I am telling you this at the beginning of a chapter about the Vietnamese in California, it is because I find it a fascinating side of California's Little Saigon at the turn of the millennium. This bus, brand new and much more comfortable than your regular Greyhound —and they even give you a Vietnamese-style sandwich for lunch—is one of many bloodlines connecting the various Vietnamese communities in California and beyond. It is telling in terms of how far we have come as a community since the first wave of refugees arrived

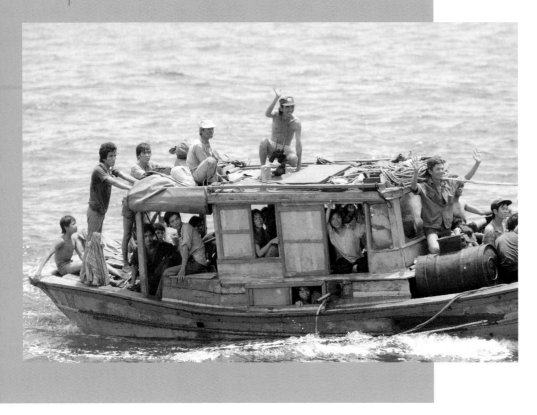

Boat with sixty-eight Southeast Asian refugees rescued in the South China Sea, 1987.

PHOTO BY JIM GENSHEIMER/
SAN JOSE MERCURY NEWS

in 1975 at the end of the Vietnam War, a huddled mass wearing donated clothes, frantically looking for homes and jobs.

In *Tribes,* author Joel Kotkin described a quintessentially cosmopolitan global tribe as an international community, which combines a strong sense of a common origin with "two critical factors for success in the modern world: geographic dispersion and a belief in scientific progress." Kotkin's primary examples include the British, Jews, Chinese, Japanese and Indians. These groups, relying on mutual dependence and trust, created global networks that allow them "to function collectively beyond the confines of national or regional borders."

In later writings, Kotkin added Vietnamese to the list. Nearly 3 million Vietnamese have fled abroad and scattered into five different continents. Many have re-established themselves elsewhere and these days you can find Vietnamese restaurants in South Africa, Brazil, and Israel. I myself have relatives living in six different countries and three continents. But almost half of the diaspora ended up in North America, and the largest portion of that population resettled in California.

Why California? It was, initially, a matter of luck. Camp Pendleton, near San Diego, was where the bulk of the first wave of Vietnamese refugees ended up. Tony Bui, Vietnamese American filmmaker, raised in San Jose, California, made *Green Dragon* as a tribute to the Vietnamese Americans' beginning, and it was the story of refugee life in Camp Pendleton circa 1975. Slowly, generous Americans outside of the camp sponsored refugees. Many resettled in nearby Orange and San Diego Counties. Others moved north, to the Bay Area, then, later on, to the San Joaquin Valley. To put it succinctly, California welcomed Vietnamese refugees and they, in turn, embraced the Golden State.

Starting with luck, it ended up by design. Many of those who originally landed in other states also made the

second migration here, to join their relatives, to escape the cold weather elsewhere, and to find jobs. Others, boat people, immigrants, Vietnamese living in Europe and Asia, also made their way here as well, all hoping to strike it rich.

When last counted—Census 2000—Vietnamese, while numbering around 1 million in the United States, ended up with the largest concentration in the Golden State, somewhere below half a million, making it the place with the largest population of Vietnamese outside of Vietnam.

And while Vietnamese are not nearly as wealthy or connected as Kotkin's prime examples, their trajectory increasingly fits his description of a global tribe. All of those sunburnt, scrawny boat people holding their SOS signs on their crowded boats seen on American television in the late 1970s and early 1980s have transformed themselves into a vibrant ethnic group in America, especially in California.

How vibrant? The *San Jose Mercury News* had a study done a few years back and found that "Santa Clara County's Vietnamese community is a major market, with an estimated buying power of $1.8 billion. Vietnamese represent 6% of Santa Clara County's total population [around 100,000]—a higher percentage than any other market in the nation. Growing in size and buying power, this is a valuable audience for any advertiser." It is why Knight Ridder, one of the largest newspaper chains in America and the *Mercury News*'s mother company, agreed to create a Vietnamese language weekly called *Viet Merc* to cater to this population. It competes with half a dozen Vietnamese dailies and weeklies for advertising dollars. And the *Mercury News*, always mindful of its Vietnamese American readership, is one of the few American newspapers that still have a foreign bureau in Vietnam.

THE TRANSITION: EXILE TO IMMIGRANTS

Yet ours is an epic filled with irony: traumatized by wars, bound by old ways of life where land and ancestors are worshipped, we nevertheless relocated to a state created by fabulous fantasies, high-tech wizardry, and individual ambitions. You only need to contrast Trinh Cong Son's music about war and death and broken love to the sophistication of the bus—it comes complete with a television set playing all sorts of Vietnamese music videos and kung fu movies—and with the kids playing video games, and their mother chatting on the cell phone. One of the two old ladies next to me comments that she cannot get over the fact that her son and her grandchildren live in this big house on a hill in Fremont. "To think my son back home wore shorts and played in the rice field, and all my kids studied by lamplight. Now, he's a big shot engineer. It's so different, our lives, all these machines," she says and looks out to the verdant knolls that blur pass us. Then instead of being relieved, she sighs and says in a voice full of nostalgia, "We've come so far from home." Very far indeed!

Personally, when I think of the Vietnamese narrative in California I think of my mother's ancestral altar. In her suburban home on the outskirts of San Jose with a pool shimmering in the backyard, my mother prays. Every morning she climbs a chair and piously lights a few joss sticks for the ancestral altar on top of the living room's bookcase and mumbles her solemn prayers to the dead. Black-and-white photos of grandpa and grandma and uncles on the top shelf stare out benevolently to the world of the living. On the shelves below, by contrast, stand my father's MBA diploma, my older siblings' engineering and business degrees, my own degree in biochemistry, our combined sports trophies, and, last but not least, the latest installments of my own unending quest for self-reinvention—plaques and

Family portrait taken in Kien Giang prior to leaving
Vietnam, 1977.

PHOTOGRAPH COURTESY OF BINH DANH

Family portrait taken in San Jose a few years after arrival
as refugees, 1982.

PHOTOGRAPH COURTESY OF BINH DANH

obelisk shaped crystals and framed certificates—my journalism awards.

What mother's altar and shelves with their various knickknacks seek to tell is the typical Vietnamese American transition, one where Old World fatalism finally meets New World optimism, the American dream. After all, praying to the dead is a cyclical, Confucian habit—one looks to the past for guidance, and one yearns toward that "common origin," which Kotkin talks about in his book to keep one connected to his community, his sense of self. Getting awards and degrees, on the other hand, is an American tendency, a proposition of ascendancy, where one looks toward the future and deems it optimistic and bright. Often, to be Vietnamese American, one lurks between these two opposite ideas, negotiating, that is, between night and day.

Many Vietnamese American immigrants, when they talk about their own lives, will often tell you how drastically different it was before and after they left Vietnam. "Before I left, I could not possibly imagine what my life in America would be like . . .": this sentence I often hear from my relatives and friends when they talk about the past. "It is like day and night." Trung Tran, the rice farmer's son from Quang Nam province, for instance, the one who brought only seven oranges with him onto a crowded boat thinking they should last him the whole journey across the Pacific—how big is the ocean anyway?—escaped to San Francisco. Instead of helping the old man plant next season's crop, he turned into an artist and architect who designs on his computer ultramodern museums and glassy high-rises.

What was transformed in the Vietnamese refugee psyche was a simple yet potent idea of progression. In the Golden State, where dreams do have a penchant to come true, he grows ambitious. He sees, for instance, his own restaurant in the "for rent" sign on a dilapidated store in a run-down neighborhood. He sees his kids graduating from top colleges. He imagines his own home with a pool in the back in five years' time—all things that are impossible back home.

A cliché to the native-born, the American dream nevertheless seduces the traditionally sedentary Vietnamese to travel halfway around the world. It is the American dream that kisses him hard, tongues him, and, in fact, in the morning he awakes to find, to his own amazement, that he can readily pronounce mortgage, escrow, aerobic, tax shelter, GPA, MBA, MD, BMW, overtime, and stock options. Gone is the cyclical nature of his provincial thinking and his land-bound mentality.

Why not? The American dream has over time chased away the Vietnamese nightmare. And compared to the bloody battlefields, the malaria-infested New Economic Zone and Communist gulags, the squalid refugee camps scattered across Southeast Asia, the murders and rapes, and starving and drowning on the high seas, California is still paradise.

The drama of the initial expulsion is replaced over the years by the jubilation of a newfound status and wealth. A community that initially saw itself as living in exile, as survivors of some historical tragedy—we were, after all, a people defeated in a civil war and forced to flee—slowly changed its self-assessment. It began to see itself as an immigrant community, to see America as home, and to reorganize and grow prosperous. Soon enough houses are bought, jobs are had, children are born, old folks are buried, businesses and malls opened, community newspapers printed, and economic and political organizations formed. That is to say, ours is a community whose roots are sinking, slowly but surely and deeply, into the American loam.

Pick up a Vietnamese Yellow Pages phone book in Santa Clara or Orange Counties these days and you will

When a Viet Kieu returns to Vietnam, especially if he is from America, he tends to serve as a romantic mirror in front of which his fellow countrymen measure their own potential.

be astounded how organized the community really is. Even when the economy is shaky, there is a kind of dynamic that seems unstoppable within the community. Full of businesses that cater to an immigrant's every need, the new arrival may not need to speak English at all, though of course, he should learn it—he just needs to pick up the Vietnamese Yellow Pages. From law to dentist offices, from restaurants to computer-programming training centers, from private school to car rental to real estate services, from funeral homes to wedding planning, from cosmetic surgery to travel agencies, he has an array of choices at his beck and call.

The pangs of longing are thus dulled by the necessities of living and by the glory and riches of a new life. The refugee turned immigrant (a psychological transition), turned naturalized U.S. citizen (more or less a transition of convenience), finds that the insistence of memories demands a little less as he zooms down the freeway toward a glorious cityscape of chimerical highrises to work each morning.

VIETNAM AND THE AMERICAN CONVERSION

Many of those Vietnamese who came to the Golden State yearned for it long before they even took the journey. They saw it from the photos of cousin so-and-so's two-story homes, of his expensive and shiny sport cars in front of which his tall and beautiful children stand waving, and gleaned it from the letters that accompanied the photos. Full of reports of whose son and daughter graduated summa cum laude and valedictorian, and whose husband has become a surgeon, and whose wife has become a successful real estate agent, the letters confirmed for the long-suffering relatives back home what they have suspected all along: anything is possible in America, especially in California.

In the dead of night, bent on an American conversion, thousands climbed on board old rickety boats and headed for the United States. "Go to America"—so goes the new Vietnamese mantra, where reincarnation can be had in one lifetime. Go to America and your sufferings end. Go to America and your sons and daughters will grow up to be astronauts or presidents of rich computer companies.

After the cold war ended, Vietnamese refugees were no longer welcome in the West, and, as forced repatriation became a new international policy by the late 1980s, boat people stopped coming. But the migration did not stop. In fact, it continues to this day, albeit in more orderly fashion. Relatives sponsor relatives; Vietnamese marry Vietnamese Americans; political and religious prisoners and Vietnamese Amerasians come under the U.S. special programs; and, the latest wave, well-to-do and bright Vietnamese foreign students apply to study in the United States—all are hopeful for a new beginning.

So much yearning for America changes the character of Vietnam itself. *Vuot bien*—to cross the border—for instance, became a household verb in Vietnam. The other was even more potent: *Viet Kieu*, which literally means Vietnamese nationals living abroad. It is universally understood that the Viet Kieu, with their wealth and influence, can change the fortune of their poor cousins back home.

Schoolchildren attending Thua Duc Vien Sunday Buddhist School in San Jose, California, 2001.
PHOTO BY BINH DANH

Some economists will argue that the remittances Vietnamese living abroad sent home alone helped Vietnam's economy stay afloat during the cold war, when the United States imposed an economic sanction on the country for occupying Cambodia. By conservative estimate, Vietnamese abroad still send around $2 billion dollars home yearly via formal channels, but others, including informal channels, place it as high as $5 billion, with the largest amount sent around Tet, the Vietnamese New Year. Yet the overseas influence on Vietnam is far more than remittances. It is, I would argue, profound. For the last three thousand years or so of Vietnamese history it was generally understood that a Vietnamese soul is tied to home and hearth. In the last three decades that old land-bound assumption has been radically subverted by the birth of the Viet Kieu. When

a Viet Kieu returns to Vietnam, especially if he is from America, he tends to serve as a romantic mirror in front of which his fellow countrymen measure their own potential. If they had escaped to America, many in Vietnam reasoned, they, too, would be rich and cosmopolitan and, to top it off, live in a free country.

Overseas Vietnamese began to return in droves to Vietnam in the late 1980s, and their existence radically changed the country's psyche. It is estimated that 200,000 return each year, bearing gifts and bringing cash. Some even stay to start new businesses, others return to marry. As it is, Vietnamese nationalism—that firebrand weapon that defeated the Chinese, Mongolians, French, and Americans—seems to have withered from old age. While old Communist leaders continue to emphasize the finer points of collective strength, involv-

Andrew Lam on his first visit back to Hue, Vietnam, 1991.
PHOTOGRAPH COURTESY OF ANDREW LAM

ing memories of a war against invaders, the young of Vietnam, modern and outward looking, have long moved away from a parochial us-versus-them mentality.

What has happened is that a new and radical idea has injected itself in the Vietnamese land-bound imagination. It is a powerful migratory myth, one that exhorts fabulous cosmopolitan endings. They diligently remove Uncle Ho's photo from their walls, and to replace the void they put up posters of *Baywatch*, AC/DC, and Kiss. They slip a video from Hong Kong or Hollywood into the VCR and marvel at the beauty and glamorous possibilities that exist in the outside world.

If Ho Chi Minh, the father of Vietnamese Communism, once preached independence and freedom to his compatriots, today it is the Viet Kieu who have taken on that role. Families like mine, once persecuted by Ho's followers and forced to escape overseas, upon return, exude freedom and independence.

It is still glamorous to be a Viet Kieu in Vietnam. Often for a Vietnamese woman to marry a Viet Kieu is akin to winning the lottery—it is an instant passport out of poverty and, of course, ultimately, out of Vietnam. "I have a relative in California," is a common boast that Vietnamese in Saigon will share with me when I tell them where I am from. The first fast-food joint opened in Saigon (few actually call it Ho Chi Minh City) in 1990, by the way, was called California Burger. To have some connection to the outside world elevates your status at home, increases your fortune, and California is the cream-of-the-crop destination.

As a journalist I have come back to Vietnam quite frequently since the cold war ended. In Vietnam my face and body often take on mythological proportions. When a cousin proudly introduced his "Viet Kieu cousin from California" to a friend, someone who has tried half-a-dozen times in vain to escape, the man promptly reached over to squeeze my thigh. No doubt this was an impersonal gesture. Visions of double-tiered freeways and glassy high-rises were to be extracted out of the Viet Kieu's flesh. Squeeze a little harder and, who knows, he might just see Disneyland.

At a dinner party thrown in my honor, my American passport was read like a comic book by my various Vietnamese relatives. As the entry and exit stamps of Greece, France, Mexico, Thailand, and a dozen other countries fluttered past one cousin's eyes, she looked up at me and declared dreamily: "Cousin, such happiness! It's as if you have wings!" Well, no wings sprout from my back. I nevertheless have brought a boon back to Vietnam: I am evidence that the outside world exists.

TECHNOLOGY, MEMORIES, AND COMMUNITY

Let us get back to Joel Kotkin's premise, where technology and memories mesh, and how the post–cold war era helps fuse and create a bona fide global tribe.

I remember very well the mid-1970s when I came here as a child. Back then a letter sent to Vietnam could take up to six months to get there, if at all. So far from

Vietnam, my parents fretted: they worried they would lose their children to America—me, especially, their youngest son who only spoke English when he came home from school. The first wave of refugees felt it had been stranded in America and that memories were the stuff told to one another only in private.

Fast forward thirty years and, lo and behold, it's a Brave New World, and memories have a retroactive role. How different? The other day I decided to make pho, the traditional Vietnamese noodle soup. I entered it in google.com, and I got 17,402 hits. Pho is the most classic of Vietnamese cuisine, and it now seems inevitable that tradition, memories, and technology would mesh.

A Vietnamese with a computer and modem can find practically everything "Vietnamese" online. From recipes to dating, from history lessons to information about stamps and ancient coins, from horoscopes to traditional music, from discussions of local entertainment to discussions of homeland politics, information abounds online.

So while other global tribes may have a strong "belief in scientific progress," as Kotkin would put it, in California, Vietnamese immigrants have turned this belief into a kind of religion, and it is most evident in Silicon Valley. Professor Chung Chuong, who teaches Vietnamese American studies at San Francisco City College, once told me that "Vietnamese have greatly benefited from the high-tech boom since the early '80s. It's not a mistake that the second largest Vietnamese population is situated in Santa Clara County."

For an immigrant population with low language skills but a strong desire to move ahead, the best route is to become technicians. "Back in the '80s, you could get trained for less than six months and make enough money working overtime to buy a house after a few years," observed Professor Chuong.

Nguyen Tan Bao, in the center with his six children, worked several jobs upon arriving in the United States, eventually going to school to become an engineer, c. 1995.
PHOTO BY THU HOANG LY/SAN JOSE MERCURY NEWS

Thuy Anh Nguyen receives hugs from her family after graduating from high school in California, c. 1995. She was one of three students in her class with a 4.0 grade point average.
PHOTO BY JIM GENSHEIMER/SAN JOSE MERCURY NEWS

Ngo Phan and Le Ngoc Thang are police detectives in San Jose, c. 1995. Both came to the United States in 1975.

PHOTO BY THU HOANG LY / SAN JOSE MERCURY NEWS

Nam Nguyen, editor-in-chief of *Calitoday,* a Vietnamese language newspaper in Silicon Valley, one of the largest of its kind in Northern California, agreed readily. "The strategy doesn't end there, of course. The adults tell their kids to study and study hard—the sciences, especially. One of the strongest Vietnamese cultural characteristics is that we put education above all else. In California many Vietnamese end up working both on the lower and upper tier of the high tech industry."

"The Information age is far more important to Vietnamese than the industrial revolution," Nguyen added. He came with his wife and two kids to the United States in the mid-1980s as a boat person. Today, the entire family works on the newspaper whose office is the size of a modest living room, with half-a-dozen computers humming all day long. Yet it has readers from San Jose to San Francisco and Sacramento. Like other mom-and-pop media outlets the Nguyens' newspaper survives solely on advertising. They will tell you they have benefited greatly from easy desktop-publishing software programs and affordable computers and printing press. In San Jose alone, there are ten Vietnamese newspapers, one television program, and two radio shows. In Orange County, you can easily multiply all that by three.

So while some native-born Americans may blame technology—the ATM, automated gas pumps, the home-shopping network—for breaking down community and family ties, many Asian immigrants will tell you it has often had the reverse effect on their lives. Not long ago the ocean was vast, homesickness was an incurable malady, and the immigrant had little more than memories to keep cultural ties alive. Today, after the cold war melted, jumbo jets have shrunk the ocean, the camcorder shows grandmother back home what life is like in America, and the Internet connects across the globe. With the advent of communication technology—cell phones, Internet, and VCR and DVD—a Vietnamese living almost anywhere can generate and disseminate his own media, especially information that is close to his heart.

When I graduated from the University of California, Berkeley, in 1987, almost three out of four of my Vietnamese friends were graduating with engineering degrees. Many graduates ended up in Silicon Valley; others went to Southern California to work. It is no surprise then that one of a handful of Vietnamese *ca dao* (or adages) coined abroad praises the good life in Silicon Valley: "Chong tach, vo li, di lam cung xep, con gi xuong hon?" "Husband technician, wife in assembly line, working on the same shift, is there anything better?"

The owners of a Chinese-Vietnamese restaurant in Little Saigon, Orange County, California, 1989.
SHADES OF L.A. ARCHIVES / LOS ANGELES PUBLIC LIBRARY

There is, of course, nothing like having your own business. David Le, president of Net Images, heads a company that builds and manages websites for a large overseas Vietnamese clientele. He said that for the Vietnamese community, the survival phase has long passed, giving rise to the entrepreneurial and self-searching phase where overseas Vietnamese, established and confident, want to reach out to one another. "I visited Vietnamese communities all over the U.S. trying to encourage small companies and businesses to get online," says Le. "These communities are doing very well. And as a people, we are using the Internet more and more to communicate, and to do commerce and grow."

A few years back, I visited a friend, a Ph.D. from MIT, who worked as a computer engineer designing microchips. In his off-hours he also designs software programs for horoscopes. He told me there is no contradiction between his daytime occupation and nighttime passion. In fact to him, and to many Vietnamese immigrants in America, they mesh.

"Technology is just a tool," my friend the horoscope reader said. "It's up to you to bring your passions and interests to it. It can pay your bills or it can store your cultural traditions and memories." He held up a microchip the size of a tear drop in which the software program for horoscopes is installed. I leaned down and looked. Under the lamplight and from a certain angle at least, the microchip with its tiny grits that store parochial memories resembled the rice field writ very, very small.

CALIFORNIA, OLD WORLD POLITICS, AND TRANSNATIONALISM

The reason I am on this bus is this: I went to Orange County to see for myself the Vietnam War Memorial, which I heard so much about from my parents. My father, once a high-ranking South Vietnamese officer, was on the advisory committee of this memorial-building endeavor. Within one evening, Vietnamese in Orange County raised more than $200,000. Well-known Vietnamese singers sang for free and ticket receipts all went for fundraising for the memorial. A decade in the making, a result of lobbying efforts that showed both political savvy and determination, two life-size statues were made—one a South Vietnamese, the other an American GI, standing side by side in combat fatigues adjacent to the city hall in Westminster.

Standing in front of it, however, I was of two minds. I felt something akin to patriotism for my homeland restir in my blood; I felt, at the same time, a dire need for distance. While I stood there on a Saturday evening, a couple of older women lit incense and prayed, and several older Vietnamese men wearing army uniforms stood guard nearby. Their sorrowful faces caused me to shudder. They reminded me of my father's face.

It suddenly occurred to me then that, while one strand of history still defines those men in army uniforms and, of course, my father, another strand of history was redefining me. Although my father considers himself an exile living in America, I consider myself an American journalist who happens to make many journeys to Vietnam without much emotional fanfare. The irony is that he cannot return to the country to which he owes allegiance so long as the current regime remains in power. His is a rage left over from the cold war that has no ending in sight. History, for my father and for those men still wearing their army uniforms three decades after the war ended, has a tendency to run backward, to memories of the war, to a bitter and bloody struggle whose end spelled their defeat and exile. It also holds them static in a lonely nationalist stance. They live in America but their souls are in Vietnam. The rest of the world, transformed by the various forces of globalization—mass movement, high-tech communications, integrated economy, the thaw of the cold war—has moved on beyond the old rancor.

For me, Vietnam, my country of birth, and its tumultuous history have become a point of departure, an occasional destination and concern, but no longer home. If I, as a boy, once sang the Vietnamese national anthem in the schoolyard in Saigon with tears in my eyes, the man who writes these words is affected by the slow but natural demise of the old nationalistic impulse. The boy was willing to die for his homeland. The man has become circumspect. The boy had believed that the borders, like the Great Wall of China, were real demarcations, their integrity not to be disputed. The man has discovered that the borders have always been porous. The boy was once overwhelmed by the tragedy that had fallen on his people, and resented history for robbing him and his family of home, hearth, and national identity. The man, though envious of the primacy of his childhood emotions, has become emboldened by his own process of individualization.

I am not alone. I am thinking of the "self searching" phase that David Le talked about. These days I tend to rattle off names of Vietnamese American artists and writers with glee, and a kind of satisfaction of someone who over the years had dearly wished for more voices from his people and his community. Kien Nguyen, Monique Truong, Truong Tran, Barara Tran, Dustin Nguyen, Tony Bui, Andrew Pham, Duc Nguyen, Trung Tran, Long Nguyen, Dao Strom, Le thi Diem

Thuy, Bao Long Chu—the list of writers, poets, artists, actors, and filmmakers, more than half from California, expand slowly but surely. If the Vietnam War is what they have in common for a past, that past is not the only thing that defines who they are now. They are creative forces that rise at a time when the East is growing in economic and cultural prowess, and the West increasingly relies on the imagination of the East as a source of musings and entertainment.

Nowhere is that more self-evident than in California. The black teenager down my block on Nob Hill practices tai chi, the Irish bartender up the street does his yoga exercise each morning, my Hawaiian neighbor has just converted to Buddhism, and the kids at the local kindergarten are fanatic fans of the Pokemon cartoon from Japan. In Berkeley every time the Zen monk Thich Nhat Hanh, who hailed from Vietnam, preached, it was standing room only. Last but not least, in Hollywood Asian themes—think *Mulan, Crouching Tiger, Hidden Dragon,* Jackie Chan, *Moulin Rouge, Matrix*—are being explored and exploited on a regular basis on the silver screen.

A while back I came across a passage in an F. Scott Fitzgerald essay in which he defined the test of a first-rate intelligence as "the ability to hold two opposing ideas in the mind at the same time, and still retain the ability to function." It seems to me that it is the same challenge for the Vietnamese as well. Ruled only by

Young patrons at a Vietnamese night club in California, c. 1995.

PHOTO BY JIM GENSHEIMER/SAN JOSE MERCURY NEWS

memories, you cannot change and adapt. Forget your past and you won't have a community to fall back on or a sense of your own history.

As it is, so many of us are negotiating between East and West, memories and modernity, traditions and individual ambitions, such that we are in the process of re-creating a whole notion of what it means to be Vietnamese, and it is, I believe, an inclusive definition.

Nam Nguyen, editor of *Calitoday,* told me that the Vietnamese myth of nation building should be revised. Instead of nation, it should be a story of people beyond geographical constraints. This is the old myth, the one where, as all Vietnamese school children were taught as their first history lesson, in ancient time a dragon named Lac Long Quan married a fairy named Au Co who gave birth to 100 eggs. These eggs hatched and became the Vietnamese people. Half went to the mountains and half went to the ocean, populating the country. A new Vietnamese is being "hatched" abroad, Nguyen said, beyond homeland. Who he is nobody knows, for he is not yet being described in any Vietnamese myth or literature.

THE NEW VIETNAMESE?

I have seen him. He is Eric my little nephew surfing the web while his grandparents watch Chinese martial art videos dubbed in Vietnamese. Nearby, the ancestral altar wafts incense, but on the computer screen, images of Japanese video games shift and flow, for this too is his new home. Seven years old, he is very much at home with all these conflicting ideas, dissimilar languages and sensibilities.

Eric plays the piano but his favorite instrument is the violin. He speaks English with Vietnamese words at home as if it is a single language. Ask him what he wants to do when he grows up and he shrugs. "Maybe an astronaut," he answers matter-of-factly, as if it is the simplest thing in the world. Yet going back three generations, he would stand knee deep in mud in his rice fields gawking at the moon and stars. But no more. His energy is free from the arduous grip of land-bound imagination, and it is growing and reconstituting in new and marvelous ways. For Eric, who knows, the moon may very well be possible. And may he inherit many additional homelands and languages as he journeys within and far beyond the Golden State.

EPILOGUE

Ben Tran

THIS COMPANION BOOK to the national touring exhibit *What's Going On? California and the Vietnam Era* offers a revised narrative of the Vietnam War through a California perspective. It looks at history through a myriad of viewpoints rather than attempting a single, authoritative narrative. Since its conceptualization, the project's organizers have insisted that the Vietnam War be told through personal stories and viewpoints. The collection of essays in this book reflects the collaborative spirit of this project and its goals: "not to help America 'get over Vietnam' or resolve the deep social divisions of the period, but to help Americans integrate the Vietnam years into both their national history and personal experience."[1]

The essays collected here either present the Vietnam War through personal paradigms and voices, or explain how the legacies of the war affect our personal lives. It is the differences and the personal aspect of these essays that foster inquiry, reflection, dialogue, and even criticism. Like their California setting, these essays serve as historical terrain to understand the transformation of American society, politics, and economics that took place during the war years. They urge us to reconsider the ironies and difficulties of the past, and they also show the impact of the war on the present.

But as John F. Burns suggests in his essay, "No one situation is either typical or completely representative"; each perspective must be contextualized, balanced, and countered by other perspectives. When juxtaposed, some essays complement each other, while others are in spirited dialogue. This approach—of various perspec-

tives—yields a narrative that challenges the Vietnam War too often projected by American cultural institutions, from educational textbooks to Hollywood.

* * *

It would, however, be idealistic to claim that the discourse on the Vietnam War and its legacy can be reduced to these articles. The innumerable sides, experiences, and viewpoints of this war make it nearly impossible to capture between the covers of a book. The project's focus on California centers it in the United States. This geographically oriented framework reduces the status of Cambodians, Hmong, Laotians, Mien, and Vietnamese merely to that of refugees who were displaced by the war's outcome and began resettling in California in the mid-seventies—as opposed to people deeply rooted in their own intricate culture and history. Community groups felt that their broader stories, like those of the people involved in the Civil Rights, feminist, antiwar, veteran, and conservative movements, should be part of the exhibit. After all, of those who participated in the war, who were the most affected?

As part of my work on this project I traveled to Orange County with Marcia Eymann, the exhibition curator and the co-editor of this book, to collect materials for the exhibit. During this time, I visited my aunt and her family less than a mile from Little Saigon. They live in a small two-bedroom apartment, their first and only home since their arrival in 1992. Much of the home is covered in different types of plastic—the carpet, the dinner table, the chairs, and even the remote

controls. Somehow this is supposed to preserve a kind of newness or cleanliness, but it was all quite stuffy, compounded by a clutter of things. On their living room wall were Catholic icons, ancestral portraits, a South Vietnamese flag forming an X with an American flag, and a Los Angeles Lakers poster. I didn't notice any significant changes since my previous visit three years earlier, when I had met them for the first time.

My second visit was not as welcomed as the first. Before I could sit down to a meticulously planned meal, my aunt immediately asked two questions: (1) "Have you been going to church every Sunday?" and (2) "Are you working for the Communists?" It was clear that my aunt and uncle had read of the controversy surrounding this project in local Vietnamese newspapers. They were in utter disbelief that I worked for the Oakland Museum of California. My uncle proceeded to explain the deplorable conditions under Communism, specifically his imprisonment in reeducation camps as an ARVN veteran. My aunt spoke of the poverty exacerbated by the absence of her husband and siblings (one of whom was my father). They then detailed their failed attempts to flee the country and ultimately their successful but torturous journey across the South China Sea.

My aunt and uncle's anecdotes and stories, which also intimately and dramatically detail my parents' escape before the fall of Saigon, brought out my personal connection to the war, and also to this project. I am a generation removed from the war and have grown up an ocean away from its setting and its aftermath. Nevertheless, I grew up with my relatives' war stories as the soundtrack of my youth, and simultaneously, I have encountered the most acute, yet often inaccurate accounts of the war through American film and literature. Given this middle ground between generations and cultures, I have been affected by the war, yet I experience it only through representations. And, as my relatives repeat, I know nothing of its tragedies.

This project does not incorporate all perspectives, including those of the people who experienced the war in their own country. Their personal stories, so common, yet rarely represented, point to what we do not know and the perspectives we fail to consider.

* * *

Simply put, we are not done integrating all the personal experiences and stories of the Vietnam War into our history. Consequently, twenty-nine years after the fall of Saigon, our attempts to address and to reflect upon the Vietnam War remain an arduous task, complicated by our own emotions, loss, impressions, or memories associated with the war. This, undoubtedly, has higher stakes when the responsibility of representing the war and its various human faces challenges our understanding and assumptions of the past.

The essays collected here are but a snapshot of our contemporary perspectives. Years later, when we look back—long after the exhibit has closed—the book will retain its shelf life as the exhibit's legacy. This "snapshot" will fade with time yet still reflect the efforts and framework that have brought this project to fruition in 2004. What it may not capture, however, is the project's role in the ongoing process of grappling with the Vietnam War. Exhibits such as this one, even if they result in travesty or failure, place us in the middle of our negotiation with the past—all the stories, the sides, the experiences, and the memories. It is a process, a struggle that will continue for some time, for we are nowhere near the endpoint.

NOTE

1. Charles Wollenberg, grant proposal to the National Endowment for the Humanities, for the Oakland Museum of California, 2002.

CONTRIBUTORS

JOHN F. BURNS is history and social science consultant for the California Department of Education. For sixteen years he served as the State Archivist of California. Recent publications include "Taming the Elephant: Politics, Government, and Law in Pioneer California," *California History* 81, nos. 3–4 (2003), the history essay in *Courthouses of California* (ed. Ray McDevitt, 2001), and *Sacramento: Gold Rush Legacy, Metropolitan Destiny* (1999). He was an officer in the U.S. Navy and served in Vietnam 1968–69.

CLAYBORNE CARSON was active in the Civil Rights and antiwar movements during his undergraduate years at the University of California, Los Angeles, and often wrote about these struggles in the *Los Angeles Free Press* and other periodicals. Since receiving his doctorate from UCLA in 1975, he has taught at Stanford University, where he is now professor of history and director of the King Papers Project. He has also been a visiting professor at American University, the University of California, Berkeley, and Emory University, as well as a Fellow at the Center for the Advanced Study in the Behavioral Sciences at Stanford. He is the author of *In Struggle: SNCC and the Black Awakening of the 1960s* (1981) and *Malcolm X: The FBI File* (1991).

MARCIA A. EYMANN is the Curator of Historical Photography at the Oakland Museum of California. She is the curator of the exhibition *What's Going On: California and the Vietnam Era*, and has also cocurated the exhibition *Silver & Gold: Cased Images of the California Gold Rush* and coedited the book by the same title (1998).

MARC JASON GILBERT, who received his Ph.D. at the University of California, Los Angeles, is professor of history at North Georgia College and State University and a codirector of programs in South and Southeast Asia for the University System of Georgia. His Vietnam-related publications include *The Vietnam War: Teaching Approaches and Resources* (1991), *The Tet Offensive* (1996), *The Vietnam War on Campus: Other Voices, More Distant Drums* (2001), *Why the North Won the Vietnam War* (2002), and the forthcoming *Almanac of the Vietnam War*. He also coproduced and cowrote *Lost Warriors*, an award-winning documentary film on Vietnam combat veterans among the homeless.

ANDREW LAM is an associate editor with the Pacific News Service, a short story writer, and a regular commentator on National Public Radio. Lam was born in Saigon, Vietnam, and came to the United States when he was eleven years old. His awards include the Society of Professional Journalist Outstanding Young Journalist Award (1993), The Media Alliance Meritorious Awards, The World Affairs Council's Excellence in International Journalism Award (1992), the Rockefeller Fellowship in UCLA (1992), and the Asian American Journalist Association National Award (1993 and 1995). He was honored and profiled on KQED television in May 1996, during Asian American heritage month.

R. JEFFREY LUSTIG, who received his Ph.D. at the University of California, Berkeley, is professor of government at the State University of California, Sacramento, and the current secretary of the California Faculty Association. He is the author of *Corporate Liberalism: The Origins of Modern American Political Theory* (1982), as well as numerous articles and reports.

GEORGE MARISCAL is associate professor of literature at the University of California, San Diego. He is the author of the award-winning *Contradictory Subjects: Quevedo, Cervantes, and Seventeenth-Century Spanish Culture* (1991), and *Aztlan and Viet Nam: Chicano and Chicana Experiences of the War* (Berkeley: University of California Press, 1999), from which his chapter in the present volume is drawn. The grandson of Mexican immigrants, he was drafted into the U.S. Army in 1968 and served the following year in Vietnam.

KHUYEN VU NGUYEN received her Bachelor of Arts degree and Masters in Political Science at the University of California, San Diego. She is completing her Doctorate in Ethnic Studies at the University of California, Berkeley.

RUTH ROSEN has written and taught courses on the comparative history of women for the past twenty-five years. As columnist for the *Los Angeles Times* and the *San Francisco Chronicle,* she has written more than 150 opinion essays, most of which address the political, social, and economic rights of women around the world. Her most recent book is *The World Split Open: How the Modern Women's Movement Changed America* (Viking, 2000; Penguin, 2001), on which her chapter in this volume is based. At the Mesa Refuge, Rosen will work on a new volume that addresses violations of women's rights and the challenging of global policies in an international arena.

ROBERT D. SCHULZINGER is professor of history at the University of Colorado at Boulder. He has been a staff consultant to the U.S. Senate Committee on Foreign Relations and a member of the U.S. State Department Historical Advisory Committee. His most recent book is *A Time for War: The United States and Vietnam, 1941–1975* (1997), for which he was awarded SHAFR's Robert H. Ferrell Prize. He is author of one popular textbook, *U.S. Diplomacy Since 1900* (1990), and coauthor of two others, *Present Tense: The United States Since 1945* (2d ed., 1996) and *Coming of Age: America in the Twentieth Century* (1998). His other books include *The Making of the Diplomatic Mind: The Training, Outlook, and Style of United States Foreign Service Officers, 1908–1931* (1975), *The Wise Men of Foreign Affairs: The History of the Council on Foreign Relations* (1984), and *Henry Kissinger: Doctor of Diplomacy* (1989).

BEN TRAN is currently a Ph.D. student in Comparative Literature at the University of California, Berkeley. His doctoral work focuses on twentieth-century Vietnamese novels and their sociohistorical context. He was a Fulbright Fellow in Vietnam in 1999 and has published short stories and translations of Vietnamese poetry.

JULES TYGIEL is professor of history at San Francisco State University specializing in the history of California and the United States in the twentieth century. He has written four books and numerous articles, many dealing with California history, including *Workingmen in San Francisco, 1880–1901* (1977) and *The Great Los Angeles Swindle: Oil, Stocks and Scandal during the Roaring Twenties* (1994). His chapter in the present volume is adapted from chapter 6 of his forthcoming *Ronald Reagan and the Triumph of American Conservatism,* Library of American Biography Series (New York: Longman, 2005); used by permission of Pearson Education, Inc.

CHARLES WOLLENBERG specializes in California social history of the twentieth century. He is chair of social sciences at Vista College in Berkeley, historical consultant for the Oakland Museum of California, and oral historian for the Regional Oral History Office at the University of California, Berkeley. Among his publications are *Golden Gate Metropolis: Perspectives on Bay Area History* (1985) and *Marinship at War* (1990).

INDEX

Page numbers in italic denote illustrations

DESIGNER/COMPOSITOR: GORDON CHUN DESIGN

INDEXER: SHEILA HUTH

TEXT: EHRHARDT REGULAR

DISPLAY: AG OLD FACE REGULAR AND BOLD

PRINTER/BINDER: FRIESENS CORPORATION